MASTERWORKS

MASTERWORKS

Iain Zaczek

Editor: Rachel Bean

THUNDER BAY
P·R·E·S·S

San Diego, California

Thunder Bay Press
An imprint of the Advantage Publishers Group
5880 Oberlin Drive, San Diego, CA 92121-4794
www.thunderbaybooks.com

All notations of errors or omissions should be addressed to Thunder Bay Press, editorial department, at the above address. All other correspondence (author inquiries, permissions) should be addressed to:
The Brown Reference Group plc
8 Chapel Place, Rivington Street, London, EC2A 3DQ, UK.
www.brownreference.com

ISBN 1-57145-947-2
Library of Congress Cataloging-in-Publication Data available upon request.

Printed in China

1 2 3 4 5 07 06 05 04 03

*I would like to dedicate this book to my old friend Emerson Peart,
in memory of happy times with the family at Blue Ridge.* Iain Zaczek

For The Brown Reference Group plc:
Editor and additional text: **Rachel Bean**
Editorial Assistant: **Tom Webber**
Art Director: **Dave Goodman**
Designers: **Joanna Walker, Iain Stuart**
Picture Researcher: **Susannah Jayes**
Picture Research Assistant: **Susy Forbes**
Production Director: **Alastair Gourlay**
Indexer: **Kay Ollerenshaw**
Editorial Director: **Lindsey Lowe**
Managing Editor: **Tim Cooke**

CONTENTS

Introduction 7

Giotto di Bondone
The Lamentation 10
The rebirth of painting 13

Fra Angelico
The Annunciation 14
The Annunciation in art 17

Jan van Eyck
The Arnolfini Wedding 18
The development of oil painting 21

Sandro Botticelli
The Birth of Venus 22
Venus in art 25

Hieronymus Bosch
Hell 26
Images of hell 29

Leonardo da Vinci
Mona Lisa 30
The world's most famous painting 33

Albrecht Dürer
Christ among the Doctors 34
A Renaissance master 37

Raphael
The School of Athens 38
The Vatican *stanze* 41

Michelangelo Buonarroti
The Creation of Adam 42
The Michelangelo legend 45

Titian
Bacchus and Ariadne 46
Classical legends 49

Hans Holbein
The Ambassadors 50
Portraits and propaganda 53

Pieter Bruegel
Hunters in the Snow 54
The seasons in art 57

El Greco
The Burial of Count Orgaz 58
Art and the Counter-Reformation 61

Michelangelo Merisi da Caravaggio
The Crucifixion of Saint Peter 62
Shocking realism 65

Peter Paul Rubens
The Descent from the Cross 66
Baroque splendor 69

Frans Hals
The Laughing Cavalier 70
A new spontaneity 73

Anthony van Dyck
Equestrian Portrait of Charles I 74
Equestrian portraits 77

Nicolas Poussin
Et in Arcadia Ego 78
French classicism 81

Rembrandt van Rijn
The Night Watch 82
Dutch group portraits 85

Diego Velázquez
The Maids of Honor 86
Jesters and dwarfs 89

Jan Vermeer
Maid Pouring Milk 90
Everyday symbols 93

Canaletto
A Regatta on the Grand Canal 94
Topographical art 97

William Hogarth
The Marriage Contract 98
Moralizing art 101

Thomas Gainsborough
Mr. and Mrs. Andrews 102
The conversation piece 105

Jean-Honoré Fragonard
The Swing 106
The rococo style 109

Benjamin West
The Death of Wolfe 110
Modernizing history painting 113

Jacques-Louis David
The Death of Marat 114
Neoclassicism and revolution 117

Jean-Auguste-Dominique Ingres
The Valpinçon Bather 118
Orientalism 121

Francisco de Goya
The Third of May, 1808 122
Images of war 125

Caspar David Friedrich
**The Wanderer above a Sea
 of Mist** 126
Landscape and romanticism 129

Théodore Géricault
The Raft of the Medusa 130
Marine disasters 133

John Constable
The Hay Wain 134
A fresh approach to landscape 137

Eugene Delacroix
Liberty Leading the People 138
Romanticism and rebellion 141

Thomas Cole
The Oxbow 142
The Hudson River school 145

Joseph Mallord William Turner
Snowstorm 146
The sublime 149

Gustav Courbet
The Bathers 150
An affront to taste 153

Jean-Françoise Millet
The Gleaners 154
Peasant life 157

Edouard Manet
Luncheon on the Grass 158
Tradition and modernity 161

Dante Gabriel Rossetti
Beata Beatrix 162
The Pre-Raphaelite sisterhood 165

Thomas Eakins
Max Schmitt in a Single Scull 166
Art and medicine 169

Edgar Degas
The Rehearsal 170
Snapshots of life 173

James Abbott McNeill Whistler
Nocturne in Black and Gold 174
Pushing the boundaries 177

Pierre-Auguste Renoir
Dance at the Moulin de la Galette 178
Scenes of contemporary life 181

Georges Seurat
**Sunday Afternoon on the
Island of La Grande Jatte** 182
Science and color 185

John Singer Sargent
Carnation, Lily, Lily, Rose 186
The American abroad 189

Paul Cézanne
Mont Sainte-Victoire 190
Postimpressionist landscapes 193

Vincent van Gogh
Sunflowers 194
Insanity and creativity 197

Edvard Munch
The Scream 198
Expressionism 201

Paul Gauguin
Where Do We Come From? 202
Primitivism 205

Claude Monet
The Water Lily Pond 206
Monet's Garden at Giverny 209

Pablo Picasso
Les Demoiselles d'Avignon 210
The birth of cubism 213

Gustav Klimt
The Kiss 214
Sezession: art and decoration 217

Henri Matisse
Dance 218
Images of dance 221

Piet Mondrian
**Composition in Red, Yellow,
and Blue** 222
The birth of abstraction 225

René Magritte
The Treachery of Images 226
Image and reality 229

Salvador Dali
The Persistence of Memory 230
Mind games 233

Georgia O'Keefe
Ram's Head with Hollyhock 234
The regionalists 237

Edward Hopper
Nighthawks 238
Chronicles of urban life 241

Jackson Pollock
Autumn Rhythm 242
Abstract expressionism 245

Andy Warhol
**Two Hundred Campbell's
Soup Cans** 246
Pop art 249

Further Reading and Websites 250

Index 252

Picture credits 256

INTRODUCTION

The notion of a masterwork, or masterpiece, has changed significantly over the centuries. When the term is used today, it usually refers to an artist's greatest work or to one that has fetched a very high price at auction. Equally, it might apply to a painting that encapsulates a new way of seeing the world or an innovative approach. However, its origins are more mundane, dating back to the Middle Ages, when painters were organized into guilds.

Among other things, these bodies regulated the training of young artists. Initially, an aspiring painter was apprenticed to a master, in whose workshop he carried out menial duties as he learned his trade. The "masterpiece" was the test picture that he had to produce at the end of his training in order to qualify as an independent master. When assessing this masterpiece, the guild was not looking for originality or inventiveness. Painters were regarded purely as craftsmen, and as such, technical competence was prized far more than individualism.

These conformist tendencies were reinforced by the fact that the major source of patronage came from the church. When commissioning a work from an artist, the religious authorities would draw up a detailed contract in which they set out their requirements. This document covered theological issues—specifying the subject matter and the way that it should be represented—as well as stating the amount of money that was to be spent on more expensive materials, such as gold and the precious blue pigment lapis lazuli.

Below: Fra Angelico, The Annunciation, c.1432–33 (detail, see page 15). For centuries religious subjects dominated the work of artists under the patronage of the church.

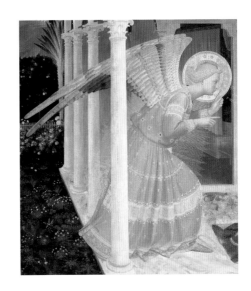

The church continued to exert close control over its works of art in the Renaissance, but by this time painters themselves were enjoying more freedom. The rise of secular patronage offered a wider

range of opportunities. In Italy, in particular, artists could free themselves from many of the restrictive practices of the guilds by attaching themselves to one of the princely courts. The great patrons of the age—families such as the Medici in Florence, the Sforza in Milan, and the d'Este in Ferrara—still exercised a huge influence over the subjects that painters tackled, but they placed a higher value on both their creativity and their virtuosity. They also called for works with a wider range of subject matter, notably portraits and scenes from classical myths.

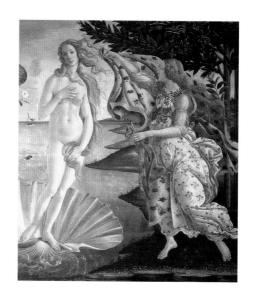

Above: Sandro Botticelli, The Birth of Venus, *1485 (detail, see page 23). In the fifteenth century secular patrons began to commission paintings with new subjects like classical myths.*

As competition for the services of the finest painters increased, so the status of the artist began to improve. Some rose to become courtiers, and their new standing was reflected in the books written by commentators such as the sixteenth-century painter and art historian Giorgio Vasari (1511–74), who heaped praise upon their achievements. Even so, the change was a gradual one. Throughout the Renaissance, painters were often still employed on minor decorative tasks. Workshops accepted commissions to paint a variety of objects, such as banners, wedding chests, and bridal plates. Even great artists could be sidetracked into other fields. One of the reasons Leonardo da Vinci (see pages 30–33) produced so few paintings was

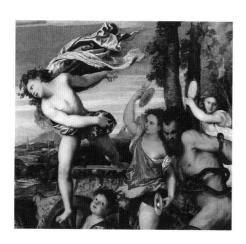

Above: Titian, Bacchus and Ariadne, *1520–23 (detail, see page 47). Titian's work was highly sought after by patrons, and he was one of the first artists to enjoy great wealth and status.*

that his patrons preferred to employ him on a range of other duties, such as designing war engines, inspecting fortifications, and planning waterway systems.

It was only with the creation of an independent art market that painters were truly able to shape their careers. In Holland, for example, the emergence of an art-loving merchant class enabled painters to specialize in new fields, such as landscape, marine pictures, scenes of everyday life, flower paintings, and more general still lifes. Even if they were well executed, however, none of these works would have been considered a masterpiece. For, by the seventeenth century, paintings were judged according to their subject matter. Only intellectual and morally uplifting themes—such as histories, allegories, mythologies, or biblical scenes—were classified as high art.

This hierarchy of subject matter was maintained by the official schools and exhibiting bodies, such as the Paris Salon and the Royal Academy in London. It survived until the nineteenth century, when artists began to rebel against such authorities. Rather than focusing on the past, they wanted to portray the world around them or to explore new modes of perception. Barred from participating in the official shows, avant-garde artists set up their own exhibiting bodies, where there were far fewer restrictions. The impressionists, the alternative salons—such as the Salon des Refusés and the Salon des Indépendants—and the various secessionist organizations were the most important of these groups. Under their auspices, artists could express themselves freely. These developments helped give birth to the modern idea of a masterwork, where a picture is judged solely on its own merits, rather than on its subject matter or the aesthetic preferences of its patron.

Below: Gustav Klimt, The Kiss, *1907–08 (detail, see page 215). Klimt was the first president of the Vienna Secession, a group set up to provide a forum for avant-garde artists and designers.*

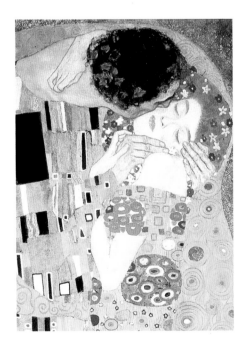

GIOTTO DI BONDONE
THE LAMENTATION
c. 1 3 0 5 – 0 6

 he work of Giotto (c.1267–1337) ushered in a new era in Western art. His paintings display a naturalism and an emotional power that set them apart from the stylized images of his predecessors. Nowhere are these qualities more apparent than in *The Lamentation*, one of the most heartrending depictions of grief ever produced. The picture is part of a cycle of frescoes (see page 12) illustrating the life of Christ. This episode occurs immediately after the Crucifixion, when Christ's body has been taken down from the cross and is mourned over by his friends and family. The main focus is on the Virgin, who cradles her dead son gently in her arms, but several other figures can also be identified. Mary Magdalen holds Christ's feet, Saint John stands in the center with outstretched arms, and the bearded figures at right are probably Nicodemus and Joseph of Arimathaea.

Giotto's main achievement in this picture is his compelling portrayal of the participants' sorrow, conveyed through their varied gestures and expressions. Some of the figures raise their arms in disbelief, some wring their hands in despair, while others meditate silently on their loss. A similar range of emotions can be witnessed in the angels, hovering in anguish above the scene. Even the two anonymous figures in the foreground exude a quiet pathos, their backs hunched as they tenderly support Christ's body.

The Lamentation forms part of Giotto's supreme masterpiece: his spectacular decorations at the Arena Chapel in Padua, so-called because it was erected on the site of a Roman arena. The building and its frescoes were commissioned by a wealthy businessman, Enrico Scrovegni. His father had been a notorious moneylender, and the splendor of this family chapel, dedicated to the Madonna of Charity, was probably intended as repentance for his parents' sinful lifestyle. Giotto adorned the interior of the chapel with several fresco cycles, featuring the life of the Virgin and her parents, the Passion of Christ, and a series of allegorical figures of the Vices and Virtues. A huge Last Judgment, covering most of the west wall, provided a fitting climax to these scenes.

In spite of his immense fame, few facts are known about Giotto's life. One popular tale suggests that his skills were recognized when he was ten years old and working as a shepherd. The painter Cimabue (c.1240–1302) spotted him sketching a sheep on a rock and was so impressed that he immediately offered to train the boy as an artist.

Giotto di Bondone, *The Lamentation*, c.1305–06, fresco (Arena Chapel, Padua)

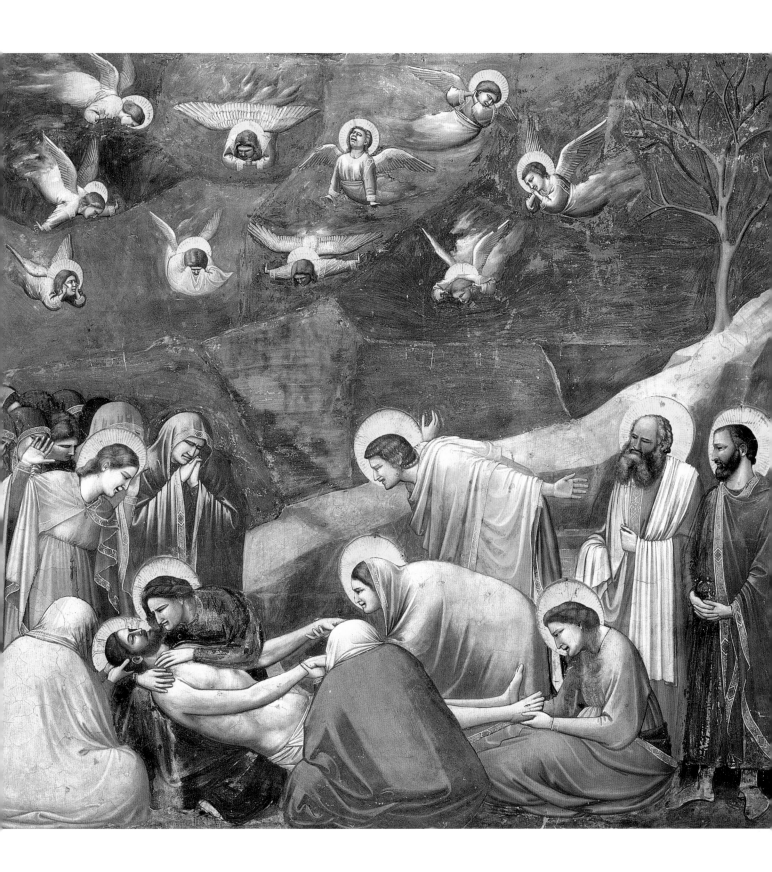

Style and technique

Giotto was the first great Italian exponent of fresco. Unlike his master Cimabue, who worked on dry plaster, he preferred to paint when the material was still wet. This technique, known as buon fresco (true fresco), meant that Giotto had to apply his pigments much more quickly, before the plaster dried. However, it also ensured that his colors were richer and that the completed fresco was far more durable, since the pigment combined with the plaster. His skill at fresco helped him to outshine his contemporaries, aiding him in the creation of more lifelike figures and a more convincing sense of space.

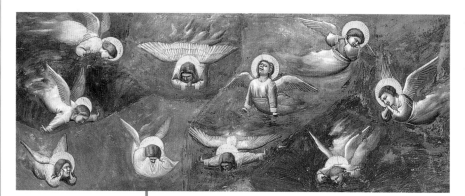

Although divine, the angels betray raw, almost human emotions with their bodies and faces twisted in grief. One weeps into its gown, while another thrusts itself upward, unable to gaze upon the dead Christ.

A bare tree grows from a barren, rocky hillside, echoing the theme of death. However, a few leaves sprout from the tips of its branches, hinting at rebirth and Christ's resurrection.

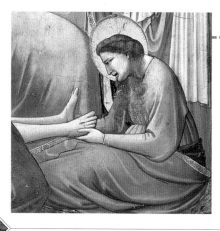

Mary Magdalen is identifiable by her long, loose hair and her position at Christ's feet. Although the woman who anointed Christ's feet is unnamed in the Bible, she is traditionally identified as Mary Magdalen.

Distraught at Christ's death, Saint John throws back his arms in grief and dismay. As well as conveying the disciple's sorrow, the pose is an ambitious attempt to create a sense of space within the picture.

The rebirth of painting

Giotto is traditionally hailed as the founder of Western art. The warmth and humanity of his frescoes, combined with his handling of form and space, signaled a new phase that heralded the ideals of the Renaissance.

Italian painting had its roots in the art of the Byzantine Empire (330–1453), which grew out of the former Eastern Roman Empire. Although the political influence of Byzantium gradually waned, its capital Constantinople (present-day Istanbul) remained a beacon of civilization for westerners. This influence was reinforced by its strong trading links with the west, particularly Venice and Sicily, and by the sack of Constantinople in 1204, when Crusaders returned home with a wealth of fine artifacts.

Byzantine religious art had a long tradition, but its character was very different from the style that was to emerge in Western Europe. Symbolism and dogma lay at its heart. Every detail, every gesture had a precise, spiritual meaning that was designed to educate the congregation and maintain orthodoxy. For this reason, any signs of artistic inspiration or individuality were discouraged; indeed, they might easily expose the painter to accusations of heresy. Similarly, there was no significant interest in modeling or perspective. Icon painters were anxious to depict a spiritual plane rather than the real world.

Early Italian art displayed many of these qualities, but in Giotto's time

there were moves to make Christianity more accessible to the faithful. Some sacred texts were translated into the vernacular, while the teachings of Saint Francis of Assisi (c.1181–1226), which were notable for their simplicity and directness, gained great popularity with the public. Giotto's art echoed these developments. He tried to enhance the effect of his pictures by making them seem as realistic as possible. His figures appear more solid than those of his contemporaries, and he experimented with perspective, in order to create a sense of pictorial space. Most important of all, he replaced the austere, hieratic images of Byzantine art with scenes that were full of human drama and emotion.

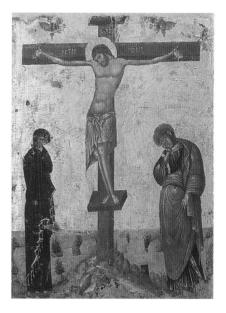

Above: A fourteenth-century Byzantine icon of the Crucifixion. Its flat, linear style and stylized figures are typical of Byzantine art.

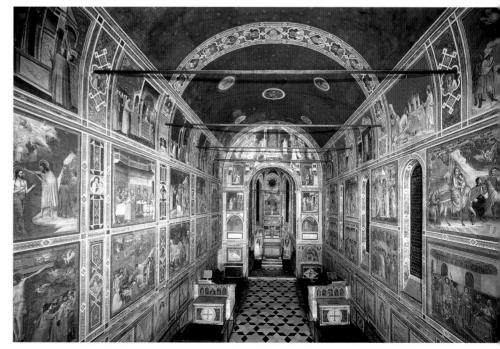

Right: The interior of the Arena Chapel looking east toward the altar. The fresco cycles decorating its walls were painted between 1305 and 1308, and are the only major work universally accepted as Giotto's.

FRA ANGELICO
THE ANNUNCIATION
c.1432–33

This jewel-like painting is one of the finest achievements of the early Renaissance. In it, Fra Angelico (c.1400–55) created an image of immense visual appeal, while also conveying the mystery and the sanctity of a key episode in the Christian story. The picture was originally commissioned as an altarpiece for the church of San Domenico in the Italian town of Cortona. In the early fifteenth century the Catholic Church was the principal patron of art, as it had been for centuries. It mainly employed secular craftsmen, but there were also a number of painter-monks, who combined an artistic career with their religious vocation and duties. Fra Angelico was one of the most gifted of these men. Born Guido di Pietro, he became a Dominican friar, taking orders in c.1418–21. For most of his life he was attached to the monastery of San Domenico at Fiesole, just outside Florence, eventually becoming its prior in 1450. His activities as a painter, however, took him to many other religious establishments. He could number the popes Eugenius IV and Nicholas V among his many distinguished patrons, although his most celebrated achievement was a magnificent series of frescoes for the monastery of San Marco in Florence. He gained his "angelic" nickname for placing his artistic skill at the service of his faith.

Fra Angelico's ecclesiastical background is immediately apparent from the deeply religious character of this painting. Many artists chose to portray the Annunciation in a naturalistic way, emphasizing the Virgin's surprise at the miraculous appearance of the angel Gabriel (see page 17). Fra Angelico's approach was more doctrinal, however, focusing on the sacred significance of the event. In the upper left-hand corner of the picture, he took the unusual step of including a scene of the Expulsion of Adam and Eve from the Garden of Eden. Their souls, along with those of their descendants, were forced to dwell in limbo until they were redeemed by Christ's sacrifice on the cross. By including the expulsion, Fra Angelico stressed the real importance of the Annunciation, namely its promise of redemption for all humanity. He further underlined this message by including a palm, a traditional symbol of Christ's victory over death, and in the pious gesture of the Virgin, who folds her arms across her chest in the sign of the cross.

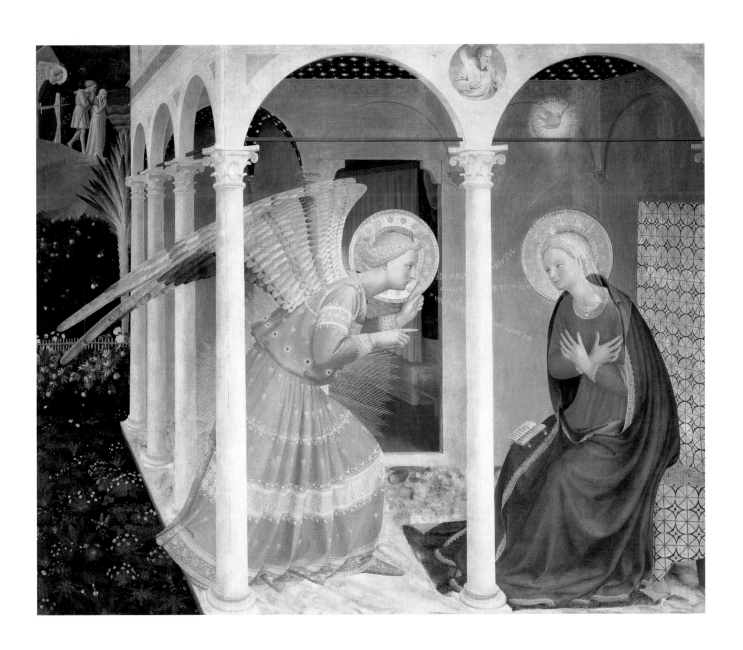

Fra Angelico, *The Annunciation*, c.1432–33, tempera on panel (Diocesan Museum, Cortona)

Style and technique

Fra Angelico's work forms a bridge between the elegant, courtly style known as international gothic and the Renaissance. The former is evident in the graceful gestures of his figures and his obvious taste for decoration. There is also an archaic quality about the painted speech and the inclusion of Adam and Eve, which makes the scene appear symbolic rather than naturalistic. On the other hand, the solid forms of Mary and Gabriel, and the bold attempt to show the receding colonnade in true perspective indicate that Fra Angelico was in touch with the latest artistic developments.

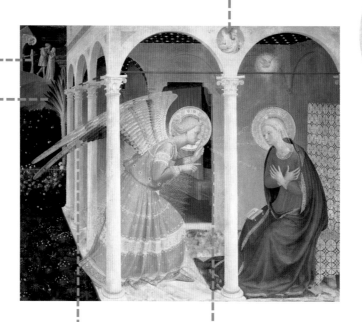

A carving of the Old Testament prophet Isaiah is included in a roundel adorning the colonnade. Isaiah is associated with the Annunciation because he had prophesied: "A virgin shall conceive and bear a son" (Isaiah 7:14).

Adam and Eve wring their hands in despair as an angel bearing a sword expels them from the Garden of Eden. Fra Angelico depicts their bodies clothed, a feature more typical of medieval than Renaissance art, in which they are often shown naked.

Gold lettering shows the dialog between the angel Gabriel and the Virgin, which takes the form of quotations from the Bible (in Latin). Gabriel announces to Mary: "The Holy Ghost shall come upon thee, and the power of the highest shall overshadow thee." She replies: "Behold the handmaid of the Lord; be it unto me according to thy word." Her words are upside-down so that they can be read more easily by God.

A palm tree grows in the garden. In Christian art the palm has many associations; Fra Angelico included it here because it is an attribute of the Virgin of the Immaculate Conception and a symbol of Christ's victory over death, which ties in with the theme of redemption in the painting.

A garden fence can be seen just behind the tips of the angel Gabriel's wings. It is a reference to the hortus conclusus, or enclosed garden, which is a traditional symbol of the purity of the Virgin.

The Annunciation in art

Fra Angelico painted several notable versions of the Annunciation, which proved a rich source of inspiration for scores of Renaissance artists. In doing so, he helped to popularize one of the central themes in Christian art.

Traditionally, paintings of the Annunciation illustrate the passage in the Gospel of Saint Luke (1:26–38) in which the angel Gabriel announces to the Virgin Mary that she will bear a son. More importantly, from a doctrinal point of view, they also represent the Incarnation of Christ, when the son of God assumed human form. This meaning is often conveyed by the inclusion of a dove– the traditional symbol of the Holy Ghost–that flies toward Mary or hovers above her, as in Fra Angelico's painting. In many pictures of the Annunciation, the halo surrounding the dove emits rays of light, which touch the Virgin.

The church decided to celebrate the Annunciation on March 25, nine months before Christmas. This is popularly known as Lady Day. Artists frequently chose to emphasize the date by setting the occasion in a garden, full of spring flowers. Often Mary herself was shown holding a flower– usually a lily, symbolizing purity. Fra Angelico gave the idea an added dimension by including images of Adam and Eve to imply that this garden was an echo of Eden itself.

Invariably artists tried to include secondary themes within their versions of the Annunciation. In particular they liked to stress how the event fulfilled the prophecies made in the Old Testament. The figure of the prophet Isaiah was frequently incorporated into the surrounding architecture, as in Fra Angelico's picture (see detail on page 16), and the Bible on the Virgin's lap was often open at the relevant passage (Isaiah 7:14). In northern European art, Mary was often shown holding a distaff or a basket of wool, rather than a book. These attributes referred to the old belief that she was raised in the Temple of Jerusalem, where she made vestments for the priests.

Below: Leonardo da Vinci, The Annunciation, c.1472–75. Sitting outside, Mary looks up in surprise from her Bible as Gabriel kneels before her in a flower-filled garden.

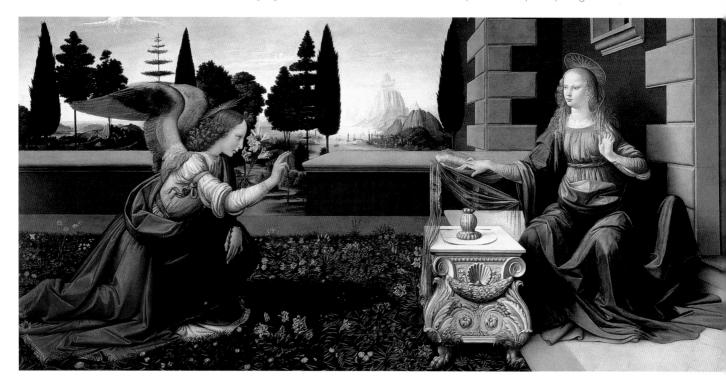

JAN VAN EYCK
THE ARNOLFINI WEDDING
1434

The technical mastery of Jan van Eyck (c.1390–1441) led a contemporary to describe him as "the king of painters, whose perfect and accurate works shall never be forgotten." His stunning sense of realism is perfectly expressed in this captivating double portrait, *The Arnolfini Wedding.* The couple portrayed in the picture are thought to be Giovanni Arnolfini, a wealthy merchant, and his wife, Giovanna Cenami. Originally from Lucca in Italy, Giovanni settled in Bruges, in present-day Belgium, in 1420, remaining there until his death in 1472. Most scholars agree that the painting was commissioned to mark the couple's marriage, although in many ways it is a very unconventional wedding portrait. There is no real air of celebration. Instead the couple pose solemnly, aware of the serious nature of their undertaking.

For decades critics have debated whether or not the painting represents the actual wedding ceremony. Giovanni's raised hand could be interpreted as the taking of the marriage vows, but it might also be a sign of greeting to two newcomers, whose reflection can be seen in the mirror. Just above the mirror, there is a Latin inscription that reads: *Johannes de Eyck fuit hic, 1434* ("Jan van Eyck was here"). Some regard this inscription as evidence that van Eyck was a witness to the marriage and that he is one of the figures reflected in the mirror, while others believe that it is just a variation on the artist's normal signature.

It is probably unlikely that van Eyck intended to portray the event itself, although the painting does underline the sacred nature of marriage. Matrimony was one of the seven holy Sacraments recognized by the church, and the religious character of this picture is emphasized by the rosary on the wall, the scenes of the Passion that decorate the mirror frame, and the solemn expressions of the couple. Immediately below their joined hands, there is a little dog, a conventional symbol of fidelity. Above, the chandelier holds a single lit candle, possibly a reference to the marriage candle that was carried at the head of bridal processions. It is unlikely that the bride is pregnant—the full form of her stomach simply reflects contemporary notions of female beauty. Nonetheless, her shape doubtless alludes to fertility, and the bed and the carving just behind her of Saint Margaret, patron saint of childbirth, emphasize the importance of her childbearing role.

Jan van Eyck, *The Arnolfini Wedding,* 1434, oil on oak panel (National Gallery, London)

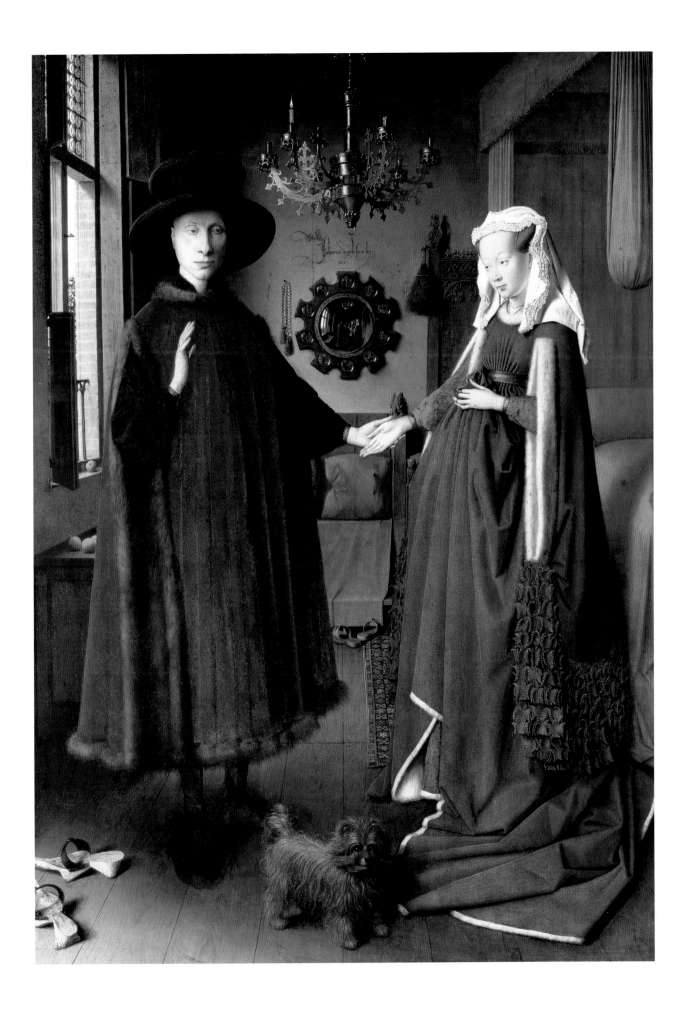

Style and technique

Although van Eyck did not invent oil paint (see page 21), he developed its use to far greater effect than his predecessors. Using layer upon layer of translucent glazes, he managed to achieve an astonishing sense of realism in his pictures. He was particularly gifted at capturing the texture of materials: the burnished brass of the chandelier, the fur trimmings on the couple's clothes, and the bright sheen of the mirror. Often he used his hands to manipulate the paint. Traces of fingerprints can still be seen on the lady's green gown.

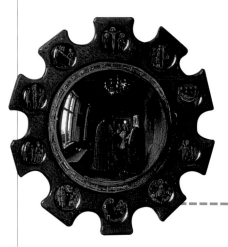

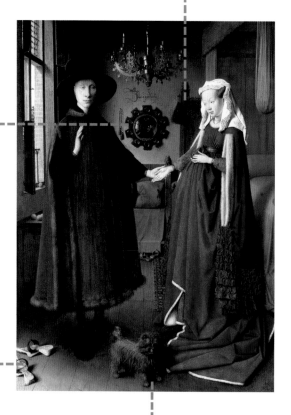

A convex mirror, its frame decorated with ten scenes from the Passion of Christ, hangs on the back wall of the room. In it can be seen the reflections of two people entering the room. Some scholars have suggested that the man in blue is Jan van Eyck.

The carving on the finial of the chair shows Saint. Margaret, patron saint of childbirth, and her attribute, a dragon. Artists showed her in this way because, according to legend, Satan had confronted her in the form of a dragon and devoured her. However, Margaret was protected by the crucifix she was holding and the beast's stomach burst open, allowing her to emerge unscathed.

The discarded wooden shoes, known as pattens, probably refer to a passage in Exodus: "Put off thy shoes from thy feet, for the place whereon thou standest is holy ground," underlining the pious character of the picture.

A small, rough-coated dog stands at the couple's feet. Dogs were a conventional symbol of fidelity and so the animal's inclusion here is entirely appropriate for a picture of a newly married couple.

The development of oil painting

The sixteenth-century art historian Giorgio Vasari hailed van Eyck as the inventor of oil painting, although it is now clear that the medium evolved much more gradually.

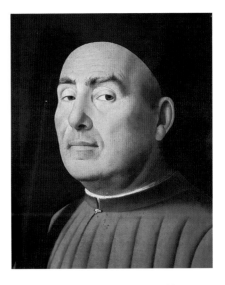

According to Vasari, van Eyck had been experimenting with various oils in order to find a varnish for his paintings that would dry naturally without having to be placed in the sun. During his research, he found that linseed oil, which is extracted from the seeds of the flax plant, suited his needs admirably, and this became the medium with which he mixed his pigments, or powdered colors.

In fact, this discovery had been made several centuries earlier. A passage in an influential twelfth-century treatise on medieval craft techniques, *De Diversis Artibus*, recommended that painters should grind their pigments into walnut or linseed oil. Some artists also experimented with poppy oil, although linseed oil ultimately proved the best option, because it was less likely to crack after it had dried.

Oil paint eventually replaced tempera as the most popular artistic medium. Tempera was made by dissolving pigments in a mixture of water and egg yolks or organic gum. It was widely used from the late twelfth century to the early fifteenth century, but proved incapable of conveying minutely detailed effects. The sheer realism of *The Arnolfini Wedding* could never have been achieved in tempera.

Van Eyck certainly revolutionized the technique of oil painting and, although the precise nature of his innovations are unknown, he used them to create rich, glowing colors, subtle gradations of light and tone, and meticulous detail. Van Eyck's ideas were eagerly taken up by his contemporaries in northern Europe, but were slow to catch on in Italy. There, the pioneer of oil painting was Antonello da Messina (c.1430–79).

Below: In Chancellor Rolin's Madonna *(c.1435), van Eyck used oil paint to capture the glowing color and detail of the foreground and the hazy landscape beyond.*

Above: A painting by Antonello da Messina that is thought to be a self-portrait. Influenced by northern European art, Antonello developed oil painting in Italy.

SANDRO BOTTICELLI
THE BIRTH OF VENUS
c.1485

 his deceptively simple scene may well be the most famous mythological painting in Western art. Botticelli (1445–1510) painted it at the height of his career for one of his most important patrons, Lorenzo di Pierfrancesco de' Medici. Along with two of his other mythological masterpieces—*Primavera* (see page 49) and *Pallas and the Centaur*, both probably dating from c.1482—it was commissioned to hang in the young man's sumptuous new residence, the Villa di Castello, in the countryside outside Florence.

In purely narrative terms, the picture shows Venus, goddess of love and beauty, being carried ashore on a giant scallop shell a few moments after her birth—according to legend she was born out of the foaming sea. Zephyr, the west wind, wafts her ashore with his breath, where a young woman who personifies spring is about to cover her with a flowery robe. In the fifteenth century mythological scenes were normally used for decorative purposes, but Botticelli worked for an extremely cultivated circle of patrons, who associated classical legends with the latest currents of Neoplatonic philosophy. Under their influence, the artist created a complex allegory in which Venus represented Humanitas, an ideal union of spiritual and sensual qualities. Marsilio Ficino, Lorenzo's tutor, expanded on this theme, advising his young pupil to "fix his eyes on Venus, that is on Humanitas. For Humanitas is a nymph of excellent comeliness, born of Heaven and more than any other beloved by God on high. Her soul and mind are Love and Charity ... her whole is Temperance and Honesty, Charm and Splendor. Oh, what exquisite beauty!"

Botticelli sought to convey this elaborate concept by placing his Venus between the opposing sides of her nature. The embracing couple on the left suggest sensual passion, and their link with fertility is further emphasized by the flowers that flutter around them, while the female attendant is decidedly more chaste. Venus herself is a model of grace and nobility, and it is significant that Botticelli endowed her with the same facial features and modest demeanor as his images of the Virgin.

Although he is now best remembered for his mythological scenes, Botticelli tackled many different themes. He built up his reputation through a series of impressive altarpieces, which brought him to the attention of the Medici, the greatest patrons of the age. He also ran a thriving workshop, producing devotional images and portraits.

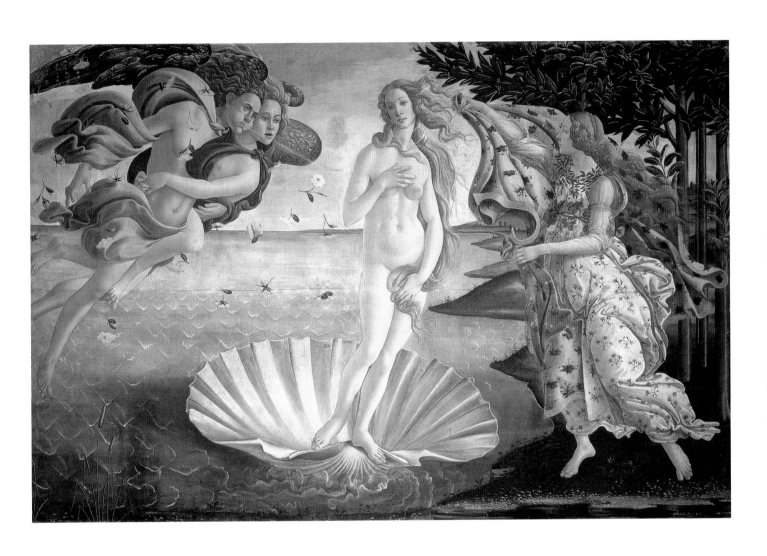

Sandro Botticelli, *The Birth of Venus*, c.1485, tempera on canvas (Uffizi, Florence)

Style and technique

Botticelli's art is characterized by an exquisitely delicate, linear approach, which may be a legacy of his brief apprenticeship to a goldsmith. His figures are sometimes slightly elongated, but they are always extremely graceful, exuding an air of sweetness and melancholy. Botticelli showed little interest in some of the more technical developments of the Renaissance—in the naturalistic treatment of space using perspective, for example—but he imbued his paintings with an otherworldly sense of mystery, which has ensured their timeless appeal.

Botticelli added realistic touches to his painting, such as the way Venus's hair is blown by Zephyr's breath. However, the picture's overall effect is one of decorative elegance—the length of Venus's neck and the slope of her shoulders are exaggerated to make her form more graceful.

The entwined figures of Zephyr, the west wind, and his wife Chloris, Greek goddess of flowers (known to the Romans as Flora), blow Venus ashore. The pink roses that shower down around the couple are associated both with Chloris/Flora and Venus: According to legend, the red rose gained its color from Venus's blood.

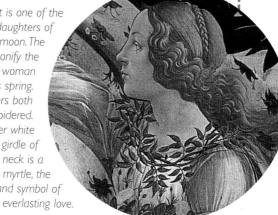

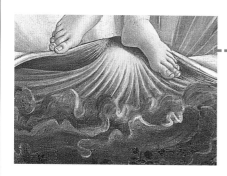

The agitated water under the scallop shell relates to the story of Venus's birth. Greek legend told how she had been born of the sea, from the foam produced after the god Uranus's genitals had been cut off and thrown into the sea. Venus's Greek name, Aphrodite, derives from aphros, or "foam."

The figure at right is one of the Horae, or "hours," the daughters of Luna, goddess of the moon. The Horae came to personify the seasons, and the young woman shown here represents spring. She is covered in flowers both real and embroidered. Cornflowers adorn her white robe, and she wears a girdle of pink roses. Around her neck is a garland of evergreen myrtle, the tree sacred to Venus and symbol of everlasting love.

Venus in art

Botticelli breathed new life into mythological painting. He was the first artist to portray ancient legends on a grand scale, giving them the same weight and importance as his altarpieces.

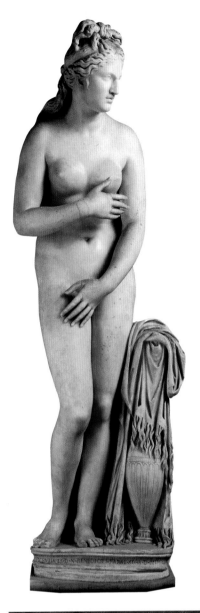

Above all, Botticelli is famed for his depictions of Venus, the deity at the heart of his two most celebrated paintings: *Primavera* and *The Birth of Venus*. The goddess of love and beauty had been a popular subject with sculptors and painters since antiquity. During the Renaissance, when scholars rediscovered the glories of the ancient world, artists began to revere the work of these early masters, emulating them in their own creations. Indeed, it became traditional for painters to base the poses of their figures on classical statues, a practice that survived intermittently until the nineteenth century. The gestures of the central

Left: The Capitoline Venus, *an example of the type of antique sculpture known as the* Venus Pudica, *or "Venus of Modesty," which influenced Renaissance artists.*

character in *The Birth of Venus*, for example, are derived from a type of sculpture from antiquity known as the *Venus Pudica*, or "Venus of Modesty."

By the Renaissance the ancient sculptures of Venus had lost their original, religious significance. Artists adapted classical legends about the goddess, using them as symbols of emotions or ideas. One of the most popular themes was Sacred and Profane Love. This subject focused on the distinction between spiritual love, usually portrayed as a nude Venus, and earthly or material love, depicted by a Venus clad in rich clothing.

Alongside serious topics of this kind, Venus also featured in more lighthearted forms of art. Pictures such as the Triumph of Venus or Venus and Mars were often given as wedding or betrothal gifts, usually with the bride portrayed as the goddess. Similar scenes might also be painted on marriage chests or bedsteads. More generally, the goddess became a vehicle for the portrayal of idealized female beauty. Gradually, this approach became the norm and by the nineteenth century, "Venus" was widely used as a blanket term for any female nude.

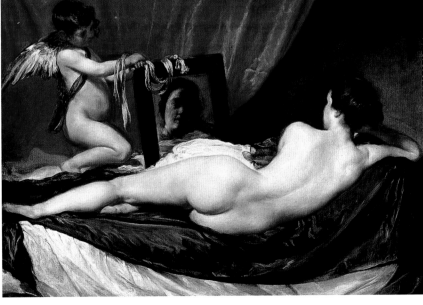

Left: In Diego Velázquez's The Rokeby Venus *(1647–51), the goddess is used as the pretext for a sensual portrayal of female beauty. She is shown reclining on a bed with her son Cupid holding up a mirror.*

HIERONYMUS BOSCH

HELL

c.1500–10

Few artists have exerted a more lasting influence than Bosch (c.1450–1516). His grotesque fantasies were admired and imitated by his contemporaries and continued to haunt later generations of artists. The symbolists and the surrealists, in particular, hailed him as a forerunner of their own movements. Bosch produced several paintings of hell, but this is undoubtedly the goriest. Throughout the picture, the damned are suffering a variety of cruel torments, all of which they have brought upon themselves through their folly and sin. Many of their transgressions are specified by references to the seven deadly sins. Sometimes these associations are conveyed through symbols: bagpipes, for example, were a conventional token of lust, because of their resemblance to genitalia. At other times, the references are conveyed through tiny, narrative incidents: a miser, guilty of avarice, is forced to excrete his gold, while a lady representing pride stares at her reflection on the backside of a demon.

The landscape of Bosch's *Hell* is most unusual. In the distance, it resembles a city under siege. Buildings explode, fire erupts through roofs and windows, and the remaining fragments of architecture are lit up by eerie shafts of light. Moving closer to the viewer, however, the conditions turn from fire to ice. A tree-man is perched on foundering boats, while around him sinners slip or fall on the frozen surface. In the foreground, the terrain is normal but the tortures are, if anything, even more sadistic.

The composition is anchored around the hollow tree-man. He turns his head to stare dispassionately at the scenes of torment all around him, perhaps reflecting on the human causes of this misery. His significance is unclear, although some writers have suggested that he represents a tree of death, a nightmarish counterpart to the tree of life in the Garden of Eden. It may also be that he is intended to represent both sexes—trees can be linked with male symbolism, while the creature's egglike body has female overtones.

Hell is the right-hand panel of a triptych (a painting comprising three separate panels) known as *The Garden of Earthly Delights*. The title refers to the scene shown in the central panel, while the left wing bears a depiction of paradise. Triptychs were normally used as altarpieces, but it seems unlikely that the extreme symbolism in this painting would have been deemed suitable for a church. No details of the commission survive, but by 1517 the picture seems to have been owned by Hendrick III of Nassau.

Hieronymus Bosch, *Hell*, c.1500–10, oil on panel (Prado, Madrid)

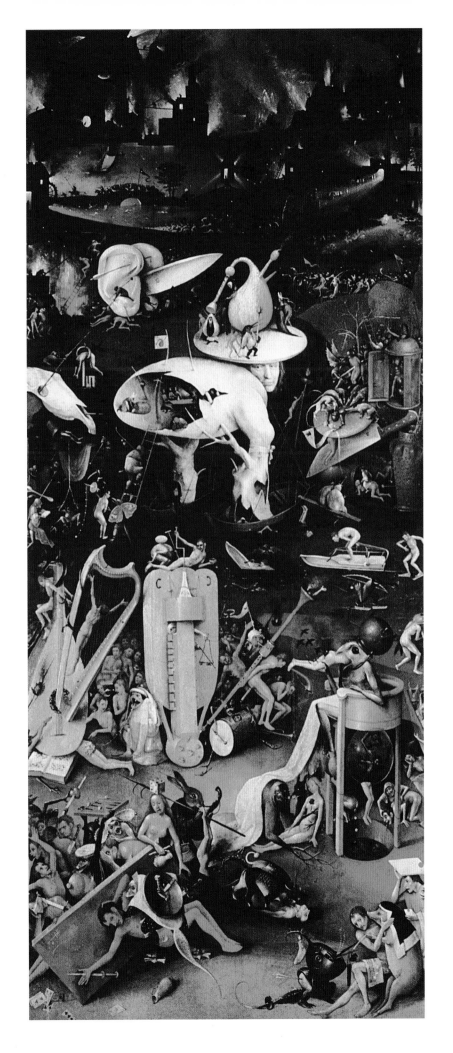

Style and technique

In contrast to the painstaking approach of his Netherlandish predecessors Jan van Eyck (see pages 18–21) and Rogier van der Weyden (c.1399–1464), Bosch worked very quickly, using thin layers of paint. Indeed, his underdrawings are frequently visible on the finished picture. For this painting of hell he made a number of sketches in which he experimented with the look of his strange monsters. One of these drawings depicts the tree-man. It is very similar to the painted version, except for a spindly branch growing out of the creature's back, on which there is an owl—a symbol of death.

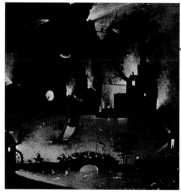

An army advances over a bridge through a nightmarish landscape, like that of a flaming, war-torn city. In contrast to the damned, who are naked victims of torture, these armed warriors are tormentors.

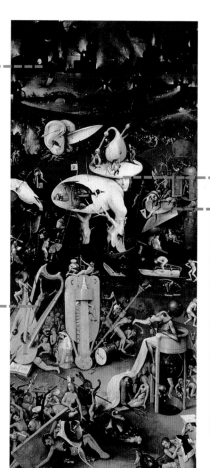

The enigmatic tree-man is the most enduring image in Bosch's Hell. No one has ever found an entirely satisfactory explanation of its meaning. The most feasible suggestion is that it represents a tree of death, a nightmarish counterpart of the tree of life shown in the paradise panel.

One man is impaled on a harp while another is lashed to the neck of a lute. In a horrific piece of role reversal, the musical instruments that have given pleasure during a lifetime of sensual excess are now transformed into instruments of torture.

A sow wearing a nun's veil forces herself on an emaciated man. This scene is a reference to the corruption of the religious orders and, like many of the other details in the painting, to lust.

A knight is torn apart by dogs. Bosch's hell is a topsy-turvy world in which the hunter becomes the hunted and is devoured by his own hounds.

Images of hell

Bosch's ability to dream up a fantastic array of demons and monsters made his depictions of hell extremely memorable as he transformed a long tradition.

The threat of damnation was ever present in the medieval mind. The church waged war against sin, leaving its followers in no doubt about the terrible cost of transgressing. Artists played their part in this moral crusade, and although it was unusual to find entire paintings devoted to hell, its torments were graphically portrayed in other themes.

Many churches, for example, had a large wall painting of the Last Judgment facing the congregation. These pictures included scenes of the blessed being received into heaven, but also of the damned being cast into hell, where a fearsome assortment of demons awaited them. Scenes of the Apocalypse were also very common, particularly in Bosch's day, when a famous set of woodcuts on the subject by Albrecht Dürer (see pages 34–37) were widely circulated.

Hell itself was often represented by Leviathan, the awesome sea-monster described in the Book of Job, which spouted fire from its mouth and steam from its nostrils. The concept of the hell-mouth was closely linked to this creature. When hell was portrayed in public processions or morality plays, it was usually shown as a huge, gaping pair of jaws.

Bosch's vision of hell has affinities with a number of visual themes, such as the seven deadly sins and the Triumph of Death, but there are even stronger links with literary sources. Tales of travelers who had witnessed the afterlife were extremely popular in the Middle Ages. Dante's *Inferno* is the best-known example, but Bosch's pictures were much closer in spirit to an anonymous account called *The Vision of Tundale*, a Dutch translation of which was published in 1484.

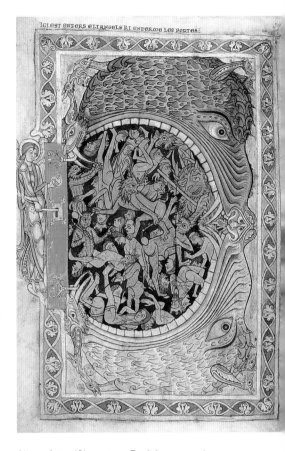

Above: A twelfth-century English manuscript illumination in which hell is shown as the gaping jaws of a monster. Inside this hell-mouth, devils torture the damned.

Below: A fifteenth-century Italian manuscript illumination made to illustrate Dante's Inferno. *The picture shows the center of hell in which huge monsters devour sinners.*

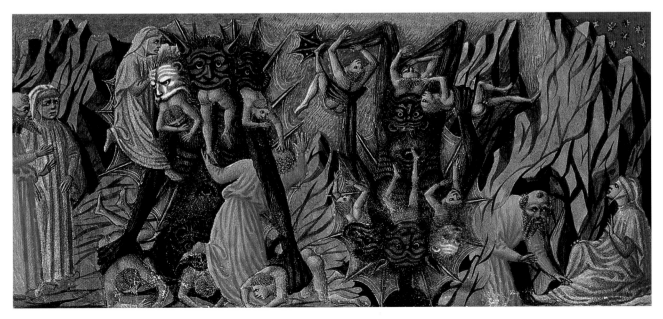

LEONARDO DA VINCI
MONA LISA
c.1503-06

This painting is the most instantly recognizable image in Western art. Yet for all its fame, it remains mysterious and inaccessible, as enigmatic as its creator. Writing in his *Lives of the Artists* (1550), the Italian art historian Giorgio Vasari identified the sitter as Lisa Gherardini, the wife of a Florentine merchant called Francesco del Giocondo—"Mona" is short for Madonna, or "Madam." This identification has given rise to the painting's alternative title, "La Gioconda," which has punning overtones, since in Italian *giocondare* means "to enjoy oneself." Indeed, Vasari specified that Leonardo employed musicians, singers, and jesters to keep the model amused while he painted her. Some critics have speculated that these entertainments were necessary because the woman was in mourning. Ultimately, there is no way of verifying this assertion, although it is true that the sitter is wearing a black veil and that the real Lisa did lose a child at a young age.

Vasari also noted that Leonardo worked on the painting for four years, but did not manage to finish it. It seems that the artist never delivered the picture to its patron, but took it with him when he moved to Milan in 1506 and, subsequently, to France in 1516. Yet even though Leonardo's meticulous technique would certainly have slowed his progress, many critics have wondered why he spent so long on the picture, particularly when there were many other demands on his time. Accordingly, they have questioned both the date of the painting and the identity of the woman. There is, for example, some documentary evidence that the portrait was commissioned by Giuliano de' Medici. Commentators have also suggested that Leonardo never parted with the picture because it was of special significance to him; that, rather than being a straightforward portrait, it was his vision of the ideal woman.

The *Mona Lisa* as we know it today is slightly different from the painting that was so admired by Leonardo's contemporaries. Originally the figure was framed by two columns, but these were lost when the painting was trimmed on either side. Only parts of their bases are still visible, on the ledge behind the sitter. Age and poor restoration have also dimmed the coloring of the model's skin, which a contemporary described as so "rosy and pearly" that it "appeared to be living flesh rather than paint."

Leonardo da Vinci, *Mona Lisa*, c.1503-06, oil on panel (Louvre, Paris)

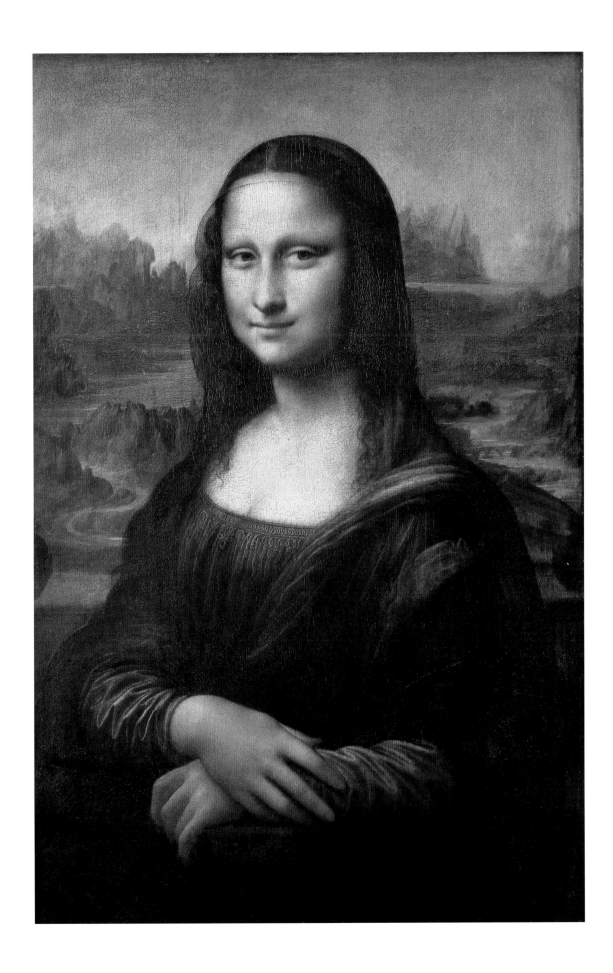

Style and technique

The Mona Lisa *is an outstanding example of Leonardo's sfumato technique. The term refers to the blending of tones or colors in such a subtle way that, in Leonardo's words, they appear to melt into each other "without lines or borders, in the manner of smoke"—*fumo *is Italian for smoke. He achieved this effect by using tiny amounts of pigment in a very fluid medium. Leonardo applied these colors in glazes so light that they barely register when examined by X ray. Unfortunately some of these layers of paint were later removed by restorers, who mistook them for varnish.*

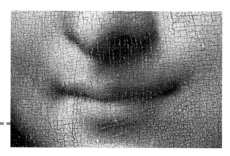

The sitter is wearing a fine black veil, which has given rise to suggestions that she is in mourning.

The enigmatic smile is the most celebrated element of the picture. The sixteenth-century writer Giorgio Vasari declared it "so pleasing that it seemed divine rather than human," while the nineteenth-century critic Walter Pater described it as "unfathomable … with a touch of something sinister in it, which plays over all Leonardo's work." The effect may be partly due to the fact that the smile is not quite symmetrical.

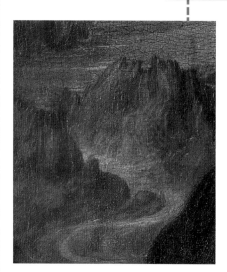

The backgrounds in several of Leonardo's pictures are rocky fantasies rather than realistic scenes. They seem to have an allegorical purpose, epitomizing the wild, uncharted possibilities of human existence. Here the landscape is utterly deserted. The only links with humanity are the winding road and the bridge at right, both of which appear to lead nowhere.

Subtle knotwork decorates the top of the sitter's gown. Leonardo included knotwork designs in a number of his works, as a punning form of signature. The Italian words vinco *and* vincolare *both refer to knots.*

The world's most famous painting

Such was the early renown of the *Mona Lisa* that Vasari wrote in lavish praise of the picture without ever having seen it; by the twentieth century the painting's fame had become universal.

The *Mona Lisa* has always been greatly admired. Renaissance artists recognized that the pose was revolutionary and many tried to copy it. The painting's owners also appreciated its worth. It was acquired by the French king Francis I, probably from Leonardo himself. After this, it remained in the hands of the French monarchy, even though Charles I of England attempted to purchase it (see page 74). For a time it was in Napoleon's private rooms in the Tuileries palace, before going on public display at the Louvre.

The painting's rise to true iconic status began in the nineteenth century, however, when critics began to talk of it as something exceptional. In particular, it was the subject of an essay by the critic Walter Pater (1839–94), who said of the figure: "Hers is the head upon which all the ends of the world are come ... She is older than the rocks among which she sits; like the vampire, she has been dead many times and learned the secrets of the grave."

Fame of a very different kind occurred in 1911, when the painting was stolen. An Italian housepainter named Vincenzo Perugia tucked it under his arm and walked out of the Louvre with it. Despite a nationwide search, the painting remained hidden in his Paris apartment for two years, until he tried to sell it to the Uffizi. In gratitude for its return, the French authorities allowed the picture to be exhibited in various Italian galleries, where it drew record crowds. More recently, Leonardo's masterpiece has received ironic accolades from a succession of modern artists, including Marcel Duchamp, Fernand Léger, Salvador Dalí, and Andy Warhol.

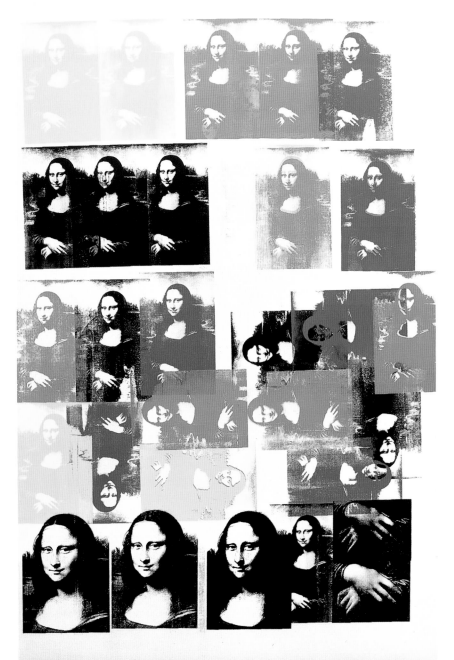

Right: Andy Warhol, Mona Lisa, *1963. Warhol was one of many twentieth-century artists to draw on and subvert the iconic status of Leonardo's famous painting.*

ALBRECHT DÜRER
CHRIST AMONG THE DOCTORS
1 5 0 6

lbrecht Dürer (1471–1528) was the greatest German artist of his time and the leading light of the Renaissance in northern Europe. His visits to Italy added a new dimension to his work, transforming his style and endowing him with a greater breadth of vision. This unusual picture, which was painted during Dürer's second stay in Venice, bears the influence of both German and Italian traditions. It illustrates a passage in the Gospels describing the very start of Christ's ministry. At the age of twelve, Jesus accompanied his parents to Jerusalem. There, they became separated, until Mary and Joseph found their son in Solomon's Temple, engaged in debate with learned Jewish doctors. In the center, Christ recites his argument impassively, counting off the points, one by one, on his fingers. Around him, there is mounting confusion as the doctors flounder in their futile attempts to contradict the youngster. A hideous old man tries to stop him from talking, pulling at his hands. Others retreat into their books, trying to use the force of authority where their own arguments have failed. Only the man on the left appears to have accepted the wisdom of Christ's words. He has closed his book and is listening intently.

Dürer mentioned the picture in a letter to a friend, describing it as a painting "the like of which I have never done before." This remark may refer to the speed of its execution; next to the date and Dürer's monogram at the bottom left of the picture, he proudly added a brief inscription: *opus quinque dierum* ("the work of five days"). Presumably this brief period did not include the planning stages, for several highly detailed preparatory drawings have survived.

The rapid execution of the painting is most apparent from the background of the composition. Instead of placing the figures in a realistic setting, Dürer compressed them into an airless vacuum, so that the picture resembles a comparative study of different facial expressions. This approach has prompted suggestions that he was inspired by Leonardo da Vinci (see pages 30–33), who made many studies of this kind. It has even been claimed that this is a copy of one of Leonardo's lost paintings. Equally, however, the idea of surrounding Christ with a sea of hostile faces had long been popular in northern European art. Hieronymus Bosch (see pages 26–29), in particular, had exploited the theme in his depictions of the events leading up to the Crucifixion.

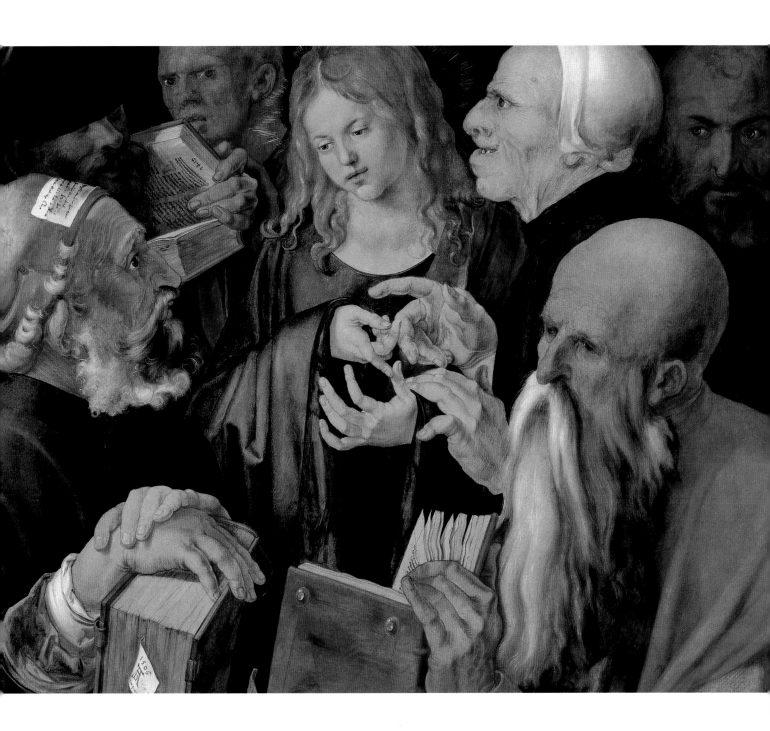

Albrecht Dürer, *Christ among the Doctors*, 1506, oil on panel (Thyssen-Bornemisza Collection, Madrid)

Style and technique

Dürer may have painted Christ among the Doctors *very quickly*, but his preparations were as thorough as always. Four detailed drawings have survived—showing Christ's head, his hands, and the hands of the scribes—and there may well have been others. The picture itself is a different matter. Dürer applied the paint more thinly than usual, although the brush strokes are broad and confident. The absence of a naturalistic setting also meant that there was no need to worry about creating a sense of space. However, the powerful, incisive use of line that characterizes all Dürer's work shines through.

One of the doctors is depicted as a grotesque old man, his exaggerated profile set next to the youthful face of Christ. Renaissance artists often used caricatures to underline their message, and here the ugly, aggressive grimace suggests that the man's attitude is unreasonable.

This doctor's hat is pulled down over his eyes, making it hard for him to read his book. This may be a reference to his spiritual blindness. In Christian art, personifications of Judaism were usually shown blindfolded.

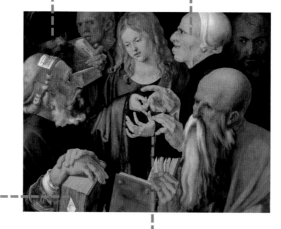

Dürer used this slip of paper sticking out of one of the doctor's books as an unobtrusive method of adding his monogram and the date to the picture. It also carries the inscription opus quinque dierum, or "the work of five days"—the time it apparently took Dürer to paint the picture.

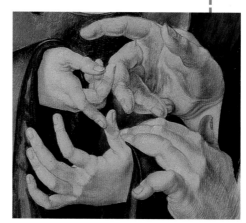

This group of four expressive hands lies at the center of the composition. Christ is enumerating the points of his argument on his fingers, but his neighbor is unwilling to listen and tries to pull them away. Compared to Christ's youthful hands, those of the old man appear large and crude; Dürer has modeled them with clearly hatched lines, in a style similar to that used in his drawings and prints.

A Renaissance master

Dürer was fascinated and inspired by the developments taking place in Italian art, and he led the way in introducing Renaissance ideas to northern Europe.

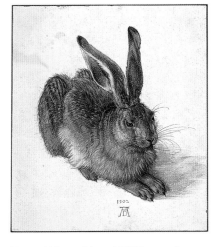

Dürer made two extended trips to Italy. In 1494, after completing his artistic training, he traveled to Padua, Mantua, and Venice. Much taken with Venice, he returned there during his second Italian trip (1505–07), when he also visited Bologna and perhaps Milan and Florence.

Dürer's experiences in Italy had a significant impact on his style. His figures became more monumental and solid, and he developed a fine understanding of perspective. His palette also became brighter under the influence of Venetian painters, who were renowned as great colorists. More than this, Dürer deliberately went in search of the "secrets" of the Italians, rather like an alchemist seeking the philosopher's stone. His quest focused, in particular, on a mathematical formula for the measurement of human proportions and perspective, and a deeper understanding of the mystery of ideal beauty. His findings were published in his *Treatise on Measurement* (1525) and *Four Books on Human Proportion* (1528).

Like Leonardo, Dürer developed an endless curiosity about the world, depicting a wide variety of flora, fauna, and landscapes in his sketchbooks and watercolors. Unusually for the time, he made these studies for his own interest rather than for use in larger compositions.

Not only was Dürer struck by the work and ideas of Italian artists, he was also impressed by their social status, noting that they were treated as gentlemen rather than craftsmen— the lot of artists in northern Europe. Dürer himself was held in extremely high regard both north and south of the Alps. Patrons and artists alike recognized his prodigious gifts as a painter and as a printmaker.

Above: A Young Hare (1502), one of Dürer's earliest studies of the natural world.

Below: Dürer's engraving Knight, Death, and the Devil (1513). Much of his fame rested on his brilliant work as a printmaker.

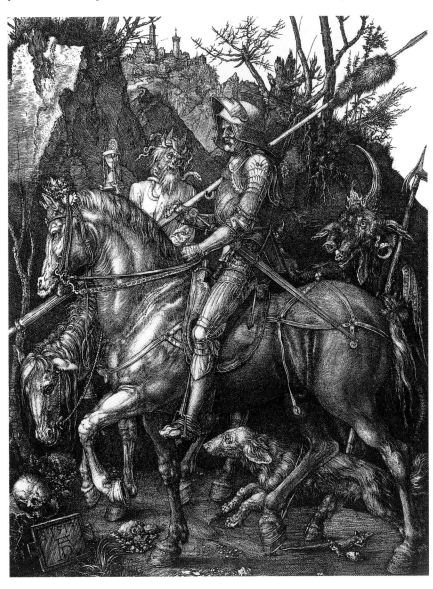

RAPHAEL

THE SCHOOL OF ATHENS

1510-11

he Renaissance reached its peak in the early years of the sixteenth century, when its three greatest masters—Leonardo da Vinci (see pages 30–33), Michelangelo (see pages 42–45), and Raphael (1483–1520)—were all active in Rome. Raphael was the youngest of the trio, but his marvelous frescoes in the Vatican proved beyond all doubt that his artistic skills could bear comparison with those of his great rivals. Known today as *The School of Athens*—the title is actually a later invention—this magnificent painting was designed as a tribute to the achievements of earthly learning. Congregating inside a spectacular architectural fantasy, the greatest philosophers, scientists, and thinkers of the ancient world discuss their theories in an atmosphere of enlightened debate. At the heart of the composition stand Plato and Aristotle, the most celebrated of all the Greek sages. Plato holds a copy of his *Timaeus* and points upward, to signify his preoccupation with celestial matters. His companion and pupil, meanwhile, also carries one of his own works, the *Ethics*, and gestures before him, to demonstrate his concern for the material world.

Around these two giants of philosophy, other masters explain their theories to eager students. On the left, Socrates presents an argument to a small group of listeners, counting off the points on his fingers. Below him, Pythagoras demonstrates one of his mathematical theories. In the center, the old man sprawled on the stairs is Diogenes the Cynic, while the mathematicians Euclid and Ptolemy can be seen on the far right. Joining these great figures from antiquity are some of Raphael's own contemporaries. Experts have identified portraits of Leonardo da Vinci and Donato Bramante, the leading architect of the day, and the powerful, brooding figure in the center is probably Michelangelo, shown in the guise of the philosopher Heracleitus. Given the fierce rivalry that existed between Raphael and Michelangelo, this prominent tribute may seem surprising. It appears, however, that Raphael added the figure at a very late stage, after witnessing the splendors of the Sistine Chapel (see pages 42–45) for the first time.

The School of Athens is one of four paintings by Raphael decorating the Stanza della Segnatura, or "Signature Chamber," the room where the Pope signed important documents. It was designed to complement the *Disputà*, "The Disputation over the Sacrament," Raphael's fresco on the facing wall, in which saints and theologians glorify the Eucharist.

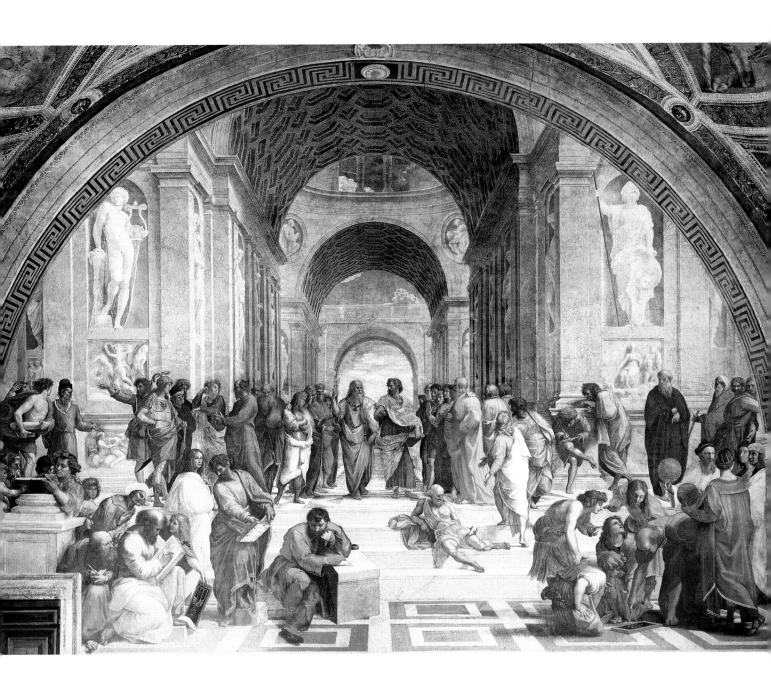

Raphael, *The School of Athens*, 1510–11, fresco (Stanza della Segnatura, Vatican, Rome)

Style and technique
Raphael's compositions often have a strong geometrical basis. Here, the three barrel-vaulted arches of the temple echo the lunette shape of the fresco. The figures are arranged in two friezes parallel to the picture plane, but the poses of the scholars in the foreground form a semicircle, providing a further link with the architecture. Raphael learned much from his two great contemporaries Leonardo and Michelangelo, but he also led Italian art in a new direction as he sought to create an idealized vision of beauty.

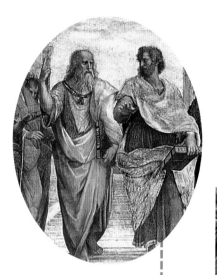

Raphael worked as an architect as well as a painter, and his paintings often feature elaborate architectural details. This imaginary setting was inspired by a mixture of elements from antiquity—including the Baths of Caracalla in Rome—and from Raphael's own time, such as Bramante's designs for the new Saint Peter's basilica.

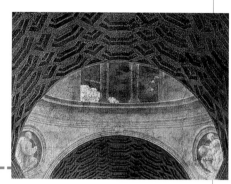

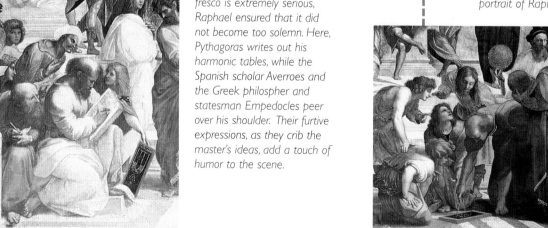

The two men at the center of the composition are Plato— pointing upward—and Aristotle, the two greatest philosophers of the ancient world. Raphael's Plato is generally regarded to be a likeness of Leonardo da Vinci.

The focus of the group at bottom right is the Greek mathematician Euclid, who reaches down to a slate with a pair of dividers as he explains the principles of geometry to those gathered around him. In the group of men standing behind Euclid, the youthful figure, second from the right, is a self-portrait of Raphael himself.

Although the subject of the fresco is extremely serious, Raphael ensured that it did not become too solemn. Here, Pythagoras writes out his harmonic tables, while the Spanish scholar Averroes and the Greek philospher and statesman Empedocles peer over his shoulder. Their furtive expressions, as they crib the master's ideas, add a touch of humor to the scene.

The Vatican *stanze*

Raphael's arrival in Rome marked his coming of age as a painter. He was just twenty-five when he was entrusted with the commission that was to consolidate his reputation: the frescoes in the apartments, or *stanze*, at the Vatican.

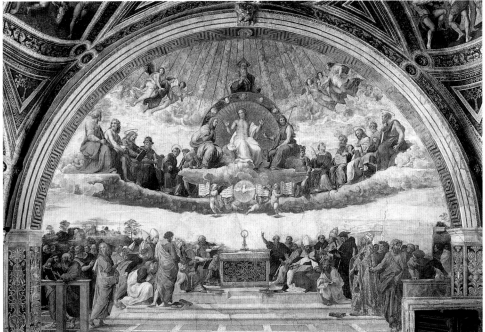

Left: Raphael's Disputà, *or "The Disputation over the Sacrament" (1508–11), which adorns the wall opposite* The School of Athens *in the Stanza della Segnatura.*

In the years leading up to 1508, Raphael had developed his talent as a painter in the Italian cities of Urbino and Perugia before making a name for himself in Florence. Ambitious to reach the summit of his profession, however, he was drawn to Rome, which was then being dramatically remodeled by Pope Julius II. During his time in office (1503–13), Julius commissioned Bramante to design the new Saint Peter's and engaged Michelangelo to paint the Sistine Chapel. As part of the same rebuilding program, he was also anxious to redecorate the papal apartments in the Vatican, replacing the pictures that had been installed by his hated Borgia predecessors.

In spite of his youth, Raphael was given the task of producing a set of frescoes in one of the most important rooms, the Stanza della Segnatura. These paintings were devoted to four important branches of learning: philosophy (*The School of Athens*), theology (the *Disputà*), poetry, and law. Raphael was given detailed instructions about the content of the pictures. He was obliged, for example, to include a portrait of Francesco della Rovere, a member of the pope's family, in *The School of Athens*—Francesco is the handsome youth standing on the left, just to the right of Pythagoras. Nevertheless, Raphael managed to interpret the complex themes with such skill that he won the commission

to decorate three further rooms in the pope's apartments: the Stanza d'Eliodoro, the Stanza dell'Incendio, and the Stanza di Constantino.

The later *stanze* are less impressive, if only because Raphael's growing fame and volume of work meant that he had to make increasing use of assistants. Even so, *The Fire in the Borgo* (1514) is a vivid drama, displaying Michelangelo's influence, while *The Liberation of Saint Peter* (1513–14) is one of Raphael's most poetic creations.

Below: The highly decorated Stanze della Segnatura has become one of the most celebrated Renaissance interiors.

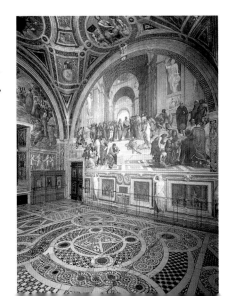

MICHELANGELO BUONARROTI
THE CREATION OF ADAM
1511

For many people, Michelangelo's (1475–1564) decorative scheme on the ceiling of the Sistine Chapel constitutes the greatest masterpiece of Western art. A herculean task, it took him four years to complete (1508–12), as he worked virtually unaided in extremely difficult conditions. The design of the ceiling is centered around nine large paintings based on the Book of Genesis, beginning with the first day of creation in *The Separation of Light and Dark* and ending with man's fall and degradation in *The Drunkenness of Noah*. The fourth of these scenes, showing God creating Adam on the sixth day, has become the most famous. Indeed, the image is so familiar that it is easy to underestimate the revolutionary nature of its composition.

Michelangelo's compelling depiction of God in *The Creation of Adam* and the other early episodes shows him very much in his Old Testament guise: stern, patriarchal, and full of dynamism and energy. His vigorous movement contrasts sharply with the languid figure of Adam. Michelangelo also endowed him with an added majesty by surrounding him with angels. These wingless beings are varied in conception, including several cherubs, along with a muscular young man and a beautiful woman. Together they represent the angelic host. In the context of the painting, their precise role is unclear. Some seem to be supporting God, while others appear to be sheltering under his mantle or trailing in his wake.

The most striking element of the painting is the act of creation itself. Elsewhere on the ceiling, God's tunic has sleeves, but here his right arm is bare, perhaps to emphasize its sheer muscular power. His hand is extended toward Adam, almost touching his forefinger. This detail, however lyrical, does raise one question. Adam is clearly alive, so unless the fingers have already touched, their impending contact was not designed to animate him. Instead, scholars have suggested that Michelangelo drew inspiration from a Latin hymn, "Veni Creator Spiritus," which describes how the frail flesh of humanity may be reinvigorated by a touch from God's finger.

The decorations in the Sistine Chapel were commissioned by Pope Julius II as part of his grandiose scheme to enhance the Papacy's prestige (see page 41). When Michelangelo's ceiling was unveiled in 1512, it was hailed as the work of a consummate genius.

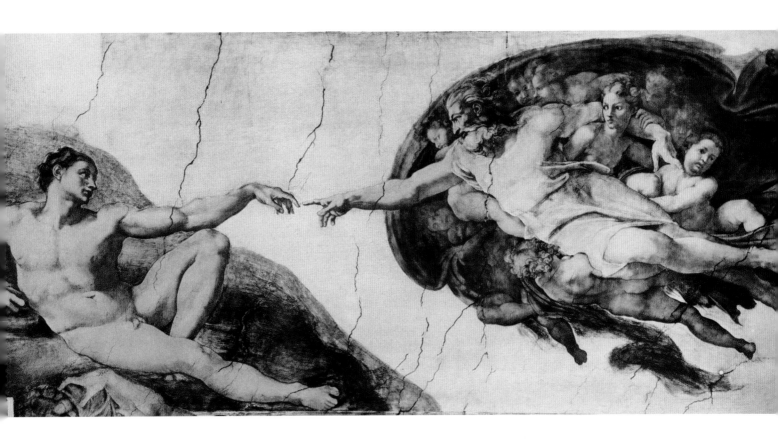

Michelangelo Buonarroti, *The Creation of Adam*, 1511, fresco (Sistine Chapel, Vatican, Rome)

Style and technique

Michelangelo was supremely gifted as a painter, an architect, and a poet, but above all he considered himself a sculptor. Accordingly, his paintings were invariably based around muscular, sculptural figures—he produced a vast number of figure studies in red chalk for the Sistine Chapel. He made designs called cartoons, but also painted directly onto the wet plaster of the ceiling, lying on a scaffolding and working alone. Michelangelo's contemporaries were overwhelmed by his awe-inspiring work and they coined the term terribilità to describe his style. Recent restoration has added to the reputation of his achievement, highlighting the vibrancy of his colors and the expressive power of his figures.

Few modern commentators can resist the temptation to describe this poetic image anachronistically, as the spark of life passing like an electric current from God the Father to his creation.

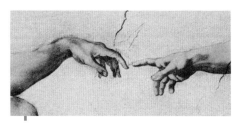

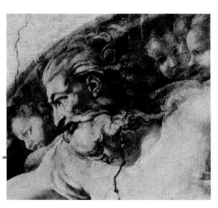

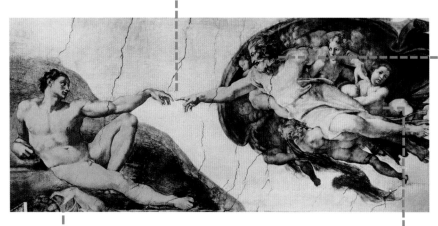

With his flowing white hair and beard, God is portrayed as God the Father, the first person in the Holy Trinity. Although this might seem an obvious point, before the fifteenth-century artists had portrayed him as Christ, even in subject predating the birth of Christ.

Although Adam rests on the barren clay out of which the Bible tells us humanity was formed, Michelangelo has placed a cornucopia, symbol of the earth's richness and plenty, immediately beneath his languid body.

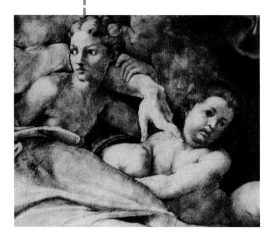

In a magnificent invention, a swirl of angels both support and attend God, sheltering beneath his cloak. The female figure is probably the as-yet uncreated Eve.

The Michelangelo legend

Up until the sixteenth century painters and sculptors were regarded as little more than lowly craftsmen. No artist did more to change the way artists were viewed than Michelangelo, who was hailed in his own lifetime as "divine."

The enduring image of Michelangelo is of a tortured genius who lived purely for his art. The origins of this view lie largely with the art historian Giorgio Vasari, who wrote a glowing account of Michelangelo in his book, *Lives of the Artists* (1550). "There can be no doubt," he claimed "that Michelangelo was sent into the world by God as an exemplar for those who practice the arts, so that they might learn from his behavior how to live and from his works how to perform as a true and excellent craftsman." Describing Michelangelo's painting *The Last Judgment* (1534–41) on the altar wall of the Sistine Chapel, Vasari wrote that it was the product of "an artist of sublime intellect, infused with divine grace and knowledge."

Vasari presented Michelangelo as one so engrossed in his art that he shunned the company of others, preferring to work alone and in secret, without even an assistant to grind his colors. Some of these claims are supported by Michelangelo himself; in his letters he writes of his love of solitude and of the physical suffering that the work on the Sistine Chapel caused him. Nevertheless, modern critics are skeptical about Vasari's account, claiming that it resembles the hagiography of a saint—an observation borne out by the section of text dealing with Michelangelo's death. According to Vasari, his body was smuggled out of Rome by the Florentines, who wanted to bury the remains as if they were a holy relic. Their high opinion of the artist seemed to be confirmed when, three weeks later, the coffin was opened and Michelangelo's body was still in a perfect state of preservation.

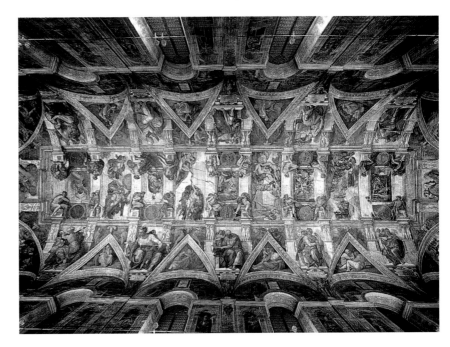

Left: Michelangelo's most famous sculpture: David (1501–04). Strong, expressive male nudes were a central theme in his art.

Above: A view of the Sistine Chapel ceiling (1508–12), showing the complex scheme in which Michelangelo set his narrative scenes.

TITIAN
BACCHUS AND ARIADNE
c.1520–23

uring the Renaissance, artists became aware of the immense achievements of their predecessors in the classical world. They paid homage to them by trying to recapture the spirit of early Greek and Roman work in their own age. This stirring scene is one of the most memorable examples of the trend. In it, Titian (c.1485–1576) brings an ancient story vividly to life, using dazzling colors and dramatic, eye-catching gestures. The painting depicts an improbable romance from classical mythology and is based on passages from texts by the Roman poets Ovid and Catullus. Ariadne, a Cretan princess, has been abandoned by her lover Theseus after helping him to defeat the Minotaur–Theseus's departing ship is shown as a tiny detail to the left of Ariadne's shoulder. While she is reflecting on her loss, a rowdy group of revelers arrives on the scene. Bacchus, the god of wine, is at their head, and he is followed by an assortment of satyrs and maenads (his female followers). In their intoxicated state, they have just torn apart a wild animal. Bacchus, however, is immediately smitten with Ariadne and leaps from his chariot to declare his love. In Ovid's version of the tale, he takes the crown from her head and hurls it into the heavens, where it becomes a constellation of stars—a permanent symbol of his undying affection for her.

Bacchus and Ariadne is one of a trio of mythological paintings that were commissioned from Titian by Alfonso d'Este, the duke of Ferrara. Along with two other scenes of riotous celebration–*The Worship of Venus* and *The Bacchanal of the Andrians*– it was designed to hang in the Alabaster Room, a sumptuous chamber in the duke's castle. The subject was undoubtedly devised by Alfonso himself. He had previously ordered a Triumph of Bacchus in India from Raphael (see pages 42–46), and might well have offered him the Alabaster Room commission but for the artist's untimely death in 1520.

Titian was the greatest Venetian painter of the Renaissance. He trained under Giovanni Bellini (c.1430–1516), succeeding him as the official painter of the Venetian Republic. In addition to his mythological scenes, Titian produced a stunning array of altarpieces and portraits. His work brought him international renown, leading to commissions from both the pope and the Holy Roman emperor, Charles V (1515–58). Charles invited Titian to his court at Augsburg and bestowed the title of Count Palatine upon him, making him the most famous artist of his time.

Titian, *Bacchus and Ariadne*, c.1520–33, oil on canvas (National Gallery, London)

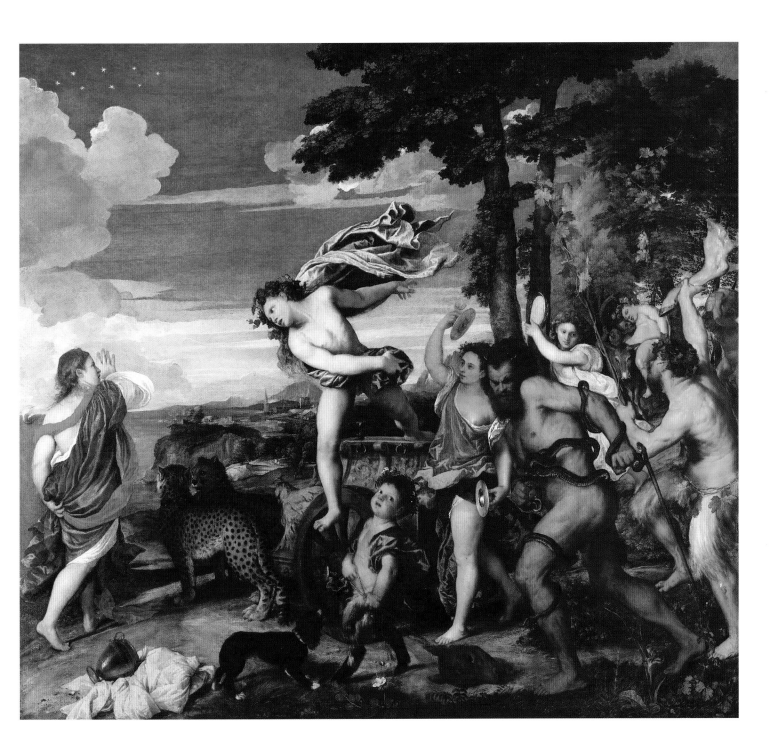

Style and technique

Titian's work was in high demand because of the color, drama, and energy he instilled into his paintings. Venetian artists were renowned as great colorists, and Titian was the finest of them all. In Bacchus and Ariadne he used brilliant colors to delight the eye and underline the story—drawing attention to the main characters by setting them against an intense blue sky and draping them in robes of shimmering hues. He was equally adept at creating a dynamic sense of movement, here achieved through the boldness of his poses—notably the daring contrapposto (twisting motion) of the two main figures.

In the sky is a shining circle of stars, the constellation created when Bacchus threw Ariadne's crown into the heavens.

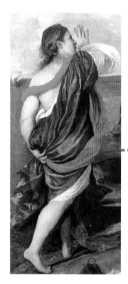

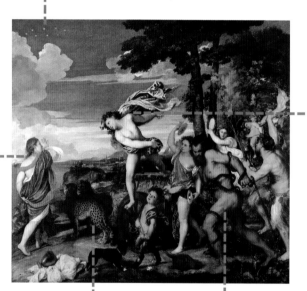

Frozen in midair, the youthful Bacchus is shown leaping from his chariot to greet Ariadne. He is right at the center of the painting and is further highlighted by his pale, marble-like skin and the pink robe that billows behind him.

The twisting pose of Ariadne perfectly complements that of Bacchus. Although she is isolated at the left-hand edge of the painting, Ariadne is the focal point toward which all the activity is directed.

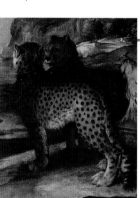

The two cheetahs that draw Bacchus's chariot are based on animals in Alfonso d'Este's private zoo. They add a touch of exoticism, which conformed with Renaissance ideas about the classical world.

The prominent male figure whose limbs are entwined with snakes was inspired by the classical marble sculpture the Laocoön (see page 49).

Classical legends

In the fifteenth and sixteenth centuries artists began to use ancient Greek and Roman myths for their subject matter, reflecting the Renaissance love of the classical world.

Before the Renaissance, Western art had been dominated by Christian themes. However, the princely rulers of the new Italian city-states demanded a broader repertoire. In particular, they wanted to show their awareness of the most fashionable intellectual topic of the day: the rediscovery of the ancient world.

Painters tended to focus on the visual art that had survived from antiquity. They studied the statues of classical gods and goddesses, and incorporated the poses into their own work. In the case of *Bacchus and Ariadne*, for example, the foreground figure of the satyr with the snakes carries strong echoes of the *Laocoön*. This marble sculpture, thought to date from somewhere between the second century B.C. and the first century A.D.,

shows a Trojan priest and his two sons entwined in serpents, and had created a huge stir when it was discovered in Rome in 1506. Its subject has no particular relevance to the theme of Bacchus, but such a reference to antiquity would certainly have been understood and appreciated by Titian's patron.

Frequently artists attempted to re-create the lost masterpieces of antiquity, basing their compositions on descriptions by classical authors. Titian's *Aphrodite Anadyomene* (c.1525), for instance, was meant to be a reconstruction of a picture by Apelles (active in the fourth century B.C.). Apelles was seen as the greatest painter of ancient Greece, but none of his work had survived.

Above: The powerful muscular figure of the priest Laocoön at the center of this antique sculptural group influenced many Renaissance artists, including Titian.

As a rule, Renaissance patrons were more interested in the literary than the visual sources of antiquity. In some cases, classical legends were reinterpreted for a modern audience, as in Botticelli's complex Neoplatonic mythologies *The Birth of Venus* (see pages 22–25) and *Primavera* (c.1478). More often, though, patrons simply wanted a lifelike illustration of their favorite passages from classical literature. This appears to have been Alfonso's principal motive when commissioning the pictures for his Alabaster Room.

Titian went on to create many celebrated works with mythological subjects. He painted sensuous female nudes under the guise of Venus and, toward the end of his life, a series of seven pictures he termed *poesie*, poetic visions of the ancient world.

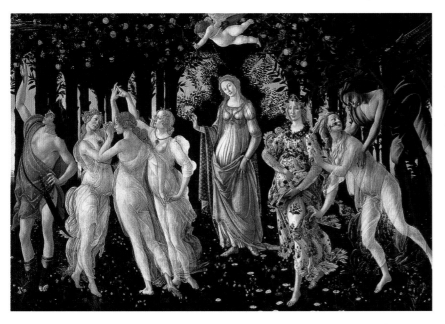

Left: In Botticelli's Primavera *(c.1478), classical deities are used to embody complex moral and metaphysical truths.*

HANS HOLBEIN
THE AMBASSADORS
1 5 3 3

portrait can sometimes serve as a vehicle for complex ideas and messages. The two young men in *The Ambassadors* were by no means Holbein's (c.1497–1543) most distinguished patrons, but their image is more ornate and has more layers of meaning than anything the artist produced for his royal clientele. The painting was commissioned by Jean de Dinteville, the French ambassador in England, who is pictured at left. With him is his friend Georges de Selve, the Bishop of Lavaur, whose visit to London in 1533 the picture commemorates. Clearly, though, this large and detailed work—the likenesses are life-size—is no ordinary portrait. Between the two men, Holbein has depicted a remarkable array of musical and scientific instruments, including a celestial and a terrestrial globe, a portable sundial, various astronomical devices, a lute, and a case of flutes.

Items of this kind were frequently depicted in a *vanitas*, a type of still life that emphasized the brevity of life and the ultimate futility of all human endeavor. This theme is reinforced by the strange pale image in the foreground. Viewed from the bottom right, this shape is revealed as a human skull, a conventional emblem of mortality. Offsetting this somewhat gloomy message, Holbein's painting offers the consolations of religion. Beside the lute, a Lutheran hymn book is open at "Veni Creator Spiritus" (a hymn which begins: "Come Holy Ghost our souls inspire ..."), while in the top left corner of the picture, half-hidden behind a curtain, there is a crucifix.

Even though the detail is unusually elaborate, the content of this *vanitas* is fairly conventional. *The Ambassadors*, however, displays yet another refinement. The lute has a broken string, and when examined closely, it becomes clear that most of the scientific instruments display impossible settings. The purpose of these deliberate errors has been the source of much debate, some of it highly speculative. Dinteville may have wished to indicate that the times were out of joint—in the wake of the Reformation, divisions within the Catholic Church had reached unprecedented levels. Alternatively, he may simply have wanted to stress the imperfection of human knowledge and achievement.

The portrait was destined for Dinteville's family home, the château of Polisy, which Holbein actually included on the terrestrial globe. The painting remained in France until 1808, when it was brought back to England. The National Gallery purchased it in 1890.

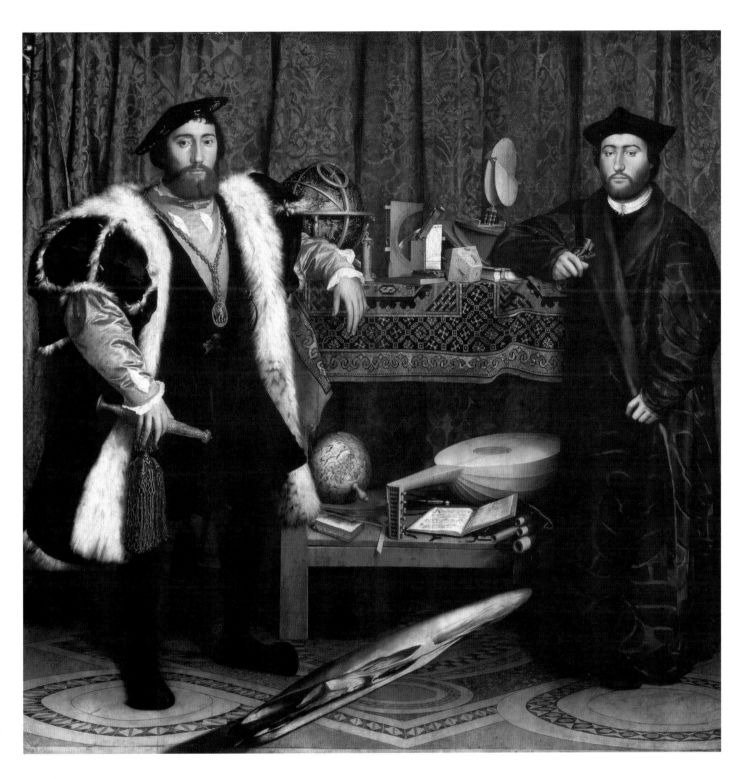

Hans Holbein, *The Ambassadors*, 1533, oil on panel (National Gallery, London)

Style and technique

The painting is a tour de force of Holbein's portrait style, with its clear draftsmanship, powerful composition, and meticulous rendering of detail, color, and texture. Yet the element that most attracts the modern viewer's attention is the distorted form of the skull in the foreground. This type of image—known as anamorphosis—was popular in the sixteenth century and would have been inspected from the side, using a viewing device attached to the frame. The image was probably created by projecting an undistorted drawing through a pinhole at an angle and then tracing its elongated form.

In the corner of the picture, almost hidden away behind the green curtains, a tiny crucifix is visible.

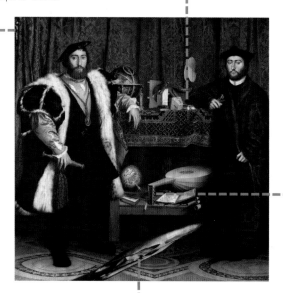

Holbein included inscriptions giving the two men's ages among the details in the painting. Lettering on the pages of the book under De Selve's elbow reads: Aetatis suae 25, Latin for "In his twenty-fifth year." Dinteville's age—twenty-nine—is given in a similar inscription on his dagger, just by his forefinger.

The shape of the skull only becomes apparent when viewed from the right side. This feature suggests that Dinteville may have had a very specific location in mind for the picture. The motif of the skull is repeated—undistorted—on the badge pinned to Dinteville's hat.

The lute has a broken string, one of the many signs in the painting that something is awry. Because of the sound of the word, the instrument was sometimes used as a punning reference to Lutheranism.

Portraits and propaganda

Before the emergence of the mass media, portraits played a key role in promoting the image of the sovereign. Holbein painted some of the most powerful images of royalty ever created.

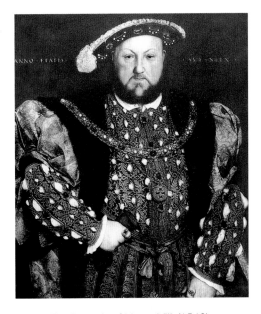

Above: This Portrait of Henry VIII (1540), usually attributed to Holbein, is closely based on his Whitehall image of the king.

Holbein was the first court painter of any significance in England. He began to attract the patronage of King Henry VIII (1491–1547) in the 1530s. In engaging his services, Henry had two main priorities. He wanted Holbein to provide images that would emphasize his power and authority, and he also needed portraits of potential brides.

In the first category, Holbein's most important creation was a monumental wall painting of the Tudor dynasty, produced for the Privy Chamber in Whitehall Palace, London. Sadly, this work was lost in a fire that destroyed most of the palace complex in 1698. However, a fragment of Holbein's cartoon, or design, for the painting, survives and along with copies gives some impression of its scale and grandeur. It is an image of Henry that exudes grandeur and magnificence: His massive frame dominates the picture and he wears ornate, jewel-encrusted robes.

Portraiture was an important diplomatic tool at a time when royal marriages formed part of political alliances and the parties in question might never have met. Only three of Holbein's bridal pictures have survived. The finest is his sumptuous portrait of Christina, duchess of Milan, who, in the end, did not marry Henry. The painting is all the more remarkable given that the artist was only granted one three-hour sitting with the subject. More infamous, perhaps, is Holbein's portrait of Anne of Cleves, Henry's fourth wife. The king had only seen Holbein's flattering portrait prior to the marriage and was horrified when he actually met Anne, describing her as a "fat Flanders mare."

Henry VIII's successors did not enjoy the services of a court painter of Holbein's stature, but they employed artists in a similar fashion. From the many portraits of Elizabeth I (1533–1603), for example, it is clear that she had little interest in commissioning a close likeness of herself. Instead, she wanted hieratic images that stressed her regal qualities. In the "Ditchley portrait" (c.1592), she stands commandingly on a map of England as thunderclouds gather overhead, while the "Armada portrait" links her with her most famous victory.

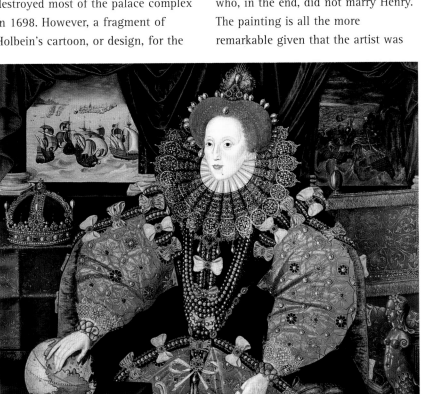

Left: The "Armada Portrait" (1588), attributed to George Gower, is a dazzling celebration of Elizabeth I's sovereignty and the English defeat of the Spanish armada.

PIETER BRUEGEL
HUNTERS IN THE SNOW
1565

his magnificent winter scene is a milestone in the history of landscape painting. When Bruegel (c.1525–69) painted it, such subjects were normally regarded as unsuitable for a serious artist, but he helped to change this attitude, paving the way for the landscape tradition that came to dominate the art of Holland and the Low Countries. Although today the painting is known as *The Hunters in the Snow*, it actually belonged to a series of pictures representing the months of the year. The original set probably consisted of twelve paintings, although a few critics have argued that there were just six. Either way, only five have survived. Most authorities believe that this particular panel represents January. This conclusion is based partly on the nature of the winter activities featured in the painting and partly on the composition. The huntsmen and their dogs lead the spectator's eye toward the right, forming an ideal introduction to a sequence of paintings. In addition, the distant mountains link up well with a similar range situated on the left-hand side of the picture thought to represent February—or *The Gloomy Day*.

Hunters in the Snow was commissioned by a wealthy Antwerp banker, Niclaes Jonghelinck. He was one of Bruegel's most important patrons and is known to have owned at least sixteen works by the artist. The Months were designed to be hung in a frieze above the paneling in his palatial residence.

Bruegel was the greatest Netherlandish painter of his age. Early in his career, he was strongly influenced by Hieronymus Bosch (see pages 26–29), specializing in humorous morality pictures packed with tiny, animated figures. A visit to Italy in the 1550s, however, transformed Bruegel's art. The journey across the Alps awakened his interest in landscape, while his exposure to the masterpieces of the Italian Renaissance encouraged him to produce larger, more monumental figures.

In his day Bruegel was renowned for his colorful scenes of rural life, typified by *The Wedding Feast* (c.1567) and *The Peasant Dance* (see page 93). Some early commentators suggested that he used to disguise himself as a rustic in order to research his material, or even that he came from peasant stock himself. Modern historians have shown, however, that he was a learned man, in contact with humanist circles, and that his pictures often contained serious comments on the political and religious follies of the time.

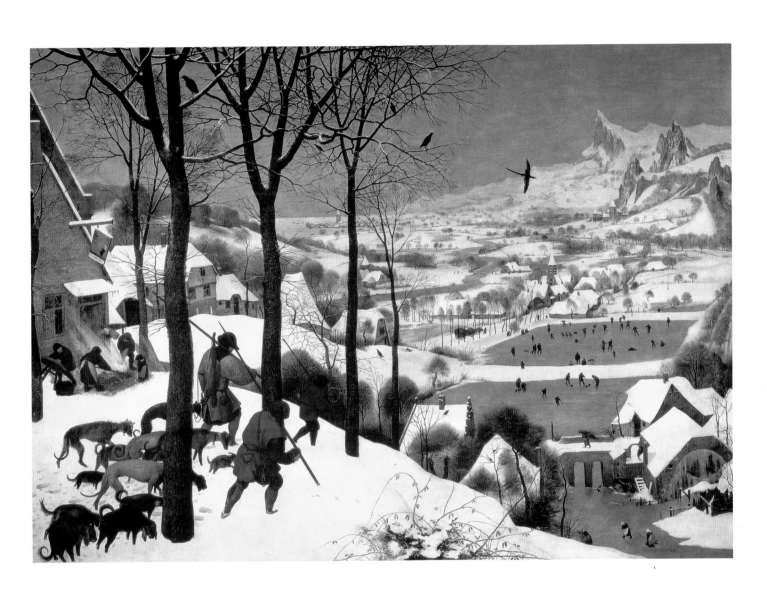

Pieter Bruegel, *Hunters in the Snow*, 1565, oil on panel (Kunsthistorisches Museum, Vienna)

Style and technique
Hunters in the Snow *presents a perfect synthesis of the different elements in Bruegel's art. With the figures on the ice, he satisfied his penchant for crowded, miniature scenes full of lively, anecdotal incident. The sweeping landscape and the huntsmen, on the other hand, owe much to his Italian experience. Typically, the larger figures are more notable for their striking silhouettes than for their detail. To some extent, this characteristic was due to Bruegel's remarkable speed of execution. He painted quickly and thinly, often allowing the undercoat to show through as part of the finished composition.*

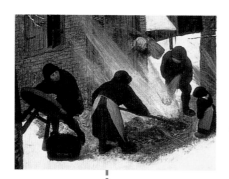

In this scene people are singeing a pig to remove its bristles, a detail frequently cited by critics as evidence that the picture represents January. In calendars the slaughter of pigs was usually associated with January. Images of killing or bleeding the animal were more common, but singeing was also sometimes shown.

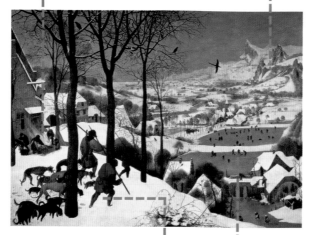

Rocky mountain peaks rise in the distance, a legacy of Bruegel's journey across the Alps in the 1550s. In the sixteenth century, landscapes were composite images rather than an accurate record of any particular place, so it is not unusual to see this Alpine detail grafted onto an otherwise typically flat Dutch scene.

The dark figures of the hunters and their dogs appear almost as silhouettes against the snow, their forms rendered with fluency and precision, creating an elegant pattern of shapes. Like the trees through which they walk, the hunters and their dogs are arranged on a diagonal, leading the viewer's eye into the painting.

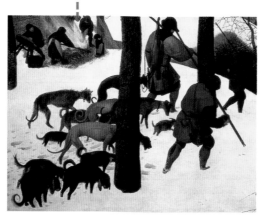

On the frozen waters in the middle distance can be seen the tiny figures of the villagers skating, curling, tobogganing, and playing kolf—a form of golf played on the ice. These activities are associated with winter, in general, rather than January, in particular, and they later became a typical feature of Dutch winter scenes.

The seasons in art

Paintings of the four seasons had long been popular, particularly in decorative schemes and as book illustrations. In his portrayal of the months, Bruegel tapped into this tradition but transformed it with his own unique approach.

In Western art, depictions of the seasons can be traced back to ancient Rome and Pompeii, where they featured in both frescoes and mosaics. In these works, as in many later versions of the theme, artists used symbolic figures to identify the relevant season. In some cases, they used portraits of individual deities. Spring was represented by either Venus or Flora, summer by Ceres, autumn by Bacchus, and winter by Vulcan or Boreas.

More often the symbolic figures illustrated some aspect of the agricultural cycle. Accordingly spring might be shown as a maiden wearing a garland of flowers or carrying a hoe, summer was a harvester, wielding a sickle, while autumn was related to grapes or vines. Winter, on the other hand, was wrapped up in warm clothing or seated by a fire. Occasionally, there was some overlap with depictions of the Ages of Man. Spring might be portrayed as a young woman, for example, while winter was represented by an old man.

The practice of painting individual months, rather than the seasons, resulted from the rising popularity of Books of Hours. These elaborate prayer books often included a calendar to remind the owner of major holy days. In the most lavish examples, these calendars were decorated with hand-painted illustrations. Here, rather than resorting to symbols, many painters preferred to depict seasonal activities. Netherlandish artists, in particular, excelled in this field. The finest exponents were the Limbourg brothers, who produced the famous *Très Riches Heures* (begun c.1413) for the French nobleman, Jean duc de Berry.

Bruegel's paintings of the months were, in effect, enlarged versions of these traditional calendar scenes.

However, they are so impressive in their own right, offering such a realistic picture of country life, that without the written evidence of Jonghelinck's commission, it would be virtually impossible to identify their original subject matter.

Below: July from the Limbourg brothers' Très Riches Heures *(begun c.1413). The month is represented by shearing and harvesting.*

EL GRECO
THE BURIAL OF COUNT ORGAZ
1586

his hallucinatory image is the most famous picture by El Greco (1541–1614). Painted when the Counter-Reformation had reached its peak, it is the perfect evocation of his eerie, mystical style. Stunningly original in its conception, it shows a miracle relating to the burial of a Spanish noble, Don Gonzales Ruiz, Count of Orgaz, at the church of Santo Tomé in Toledo. According to legend, Orgaz was a man of such piety and charity that, during his funeral, God decided to reward him. The heavens opened up and Saint Stephen and Saint Augustine descended to earth to lower his body into the grave. El Greco also depicts an angel ushering the dead man's soul toward heaven, where Christ the Judge awaits. At left, the Virgin leans down to receive the wraithlike soul while, opposite her, John the Baptist is interceding for God's mercy.

Count Orgaz had actually died in the fourteenth century, but El Greco portrayed the scene as a contemporary event, with all the earthly participants in modern dress. It is likely that most of the mourners are genuine portraits, although few can be identified with certainty. Behind Saint Stephen (the younger saint at left), the man looking out is thought to be El Greco, while the boy in front of the saint is believed to be the artist's son, Jorge. Jorge points toward the miracle, implying that there is a lesson here for the viewer. The message is a piece of Counter-Reformation propaganda. The Protestant church had argued that faith alone would ensure salvation, while Catholics stressed the importance of charity and doing good works.

El Greco settled in Toledo in 1577 and Santo Tomé was his local parish church. He received the commission for this painting in 1586, after the church authorities had won a long-running legal battle. In his will, Orgaz had granted an annuity to the church, but in the sixteenth century, his descendants attempted to discontinue the payments. They were unsuccessful, and in celebration the priest of Santo Tomé decided to honor the church's benefactor. The choice of the two saints was determined by the count's endowments. He had granted land to the Augustinian order and had asked for the church to be dedicated to Saint Stephen. The composition of El Greco's painting owes something to its intended location, for the picture was hung directly above the count's tomb so that it appeared as if the saints were lowering the body into its actual burial place.

El Greco, *The Burial of Count Orgaz*, 1586, oil on canvas (Church of Santo Tomé, Toledo)

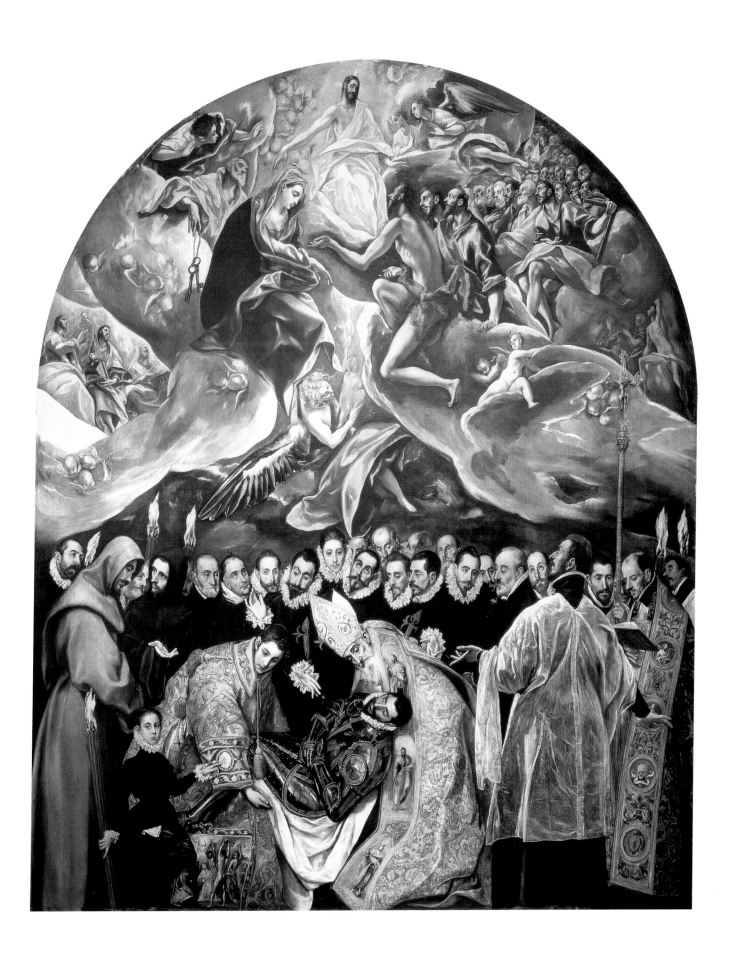

Style and technique

El Greco adopted two distinct styles in this picture. He depicted the earthly realm in a solid, friezelike band, portraying the faces and costumes of the mourners realistically and instilling the scene with an overall mood of stillness and quiet reflection. By contrast, he painted the spiritual sphere in a much more ethereal fashion. Among the swirling, heavenly forms, there is an otherworldly light and a sense of billowing movement. This distinction was not always appreciated. In the nineteenth century, critics hailed the lower section as a masterpiece, while dismissing the upper portion as the work of a deranged man.

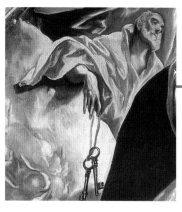

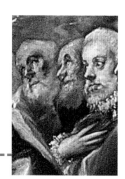

The figure wearing the ruffed costume is the Spanish king, Philip II (1555–98). He is shown sitting in heaven among the elect, even though he was still alive when El Greco was working on the painting.

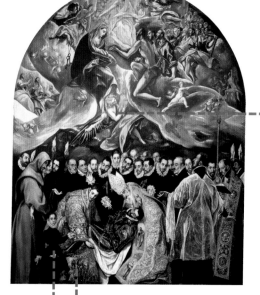

The bearded figure holding the string of keys is Saint Peter, the gatekeeper of heaven. He awaits the outcome of the judgment of the count's soul before admitting him to paradise.

An angel guides the unshaped, babylike form of the count's soul upward to be judged by Christ before the count is admitted to heaven.

The boy looking out and pointing at the burial draws the viewer into the picture and is thought to be the artist's son, Jorge. The white handkerchief poking out from his pocket bears the date of his birth, 1578.

An embroidered panel on the bottom of Saint Stephen's ornate vestment shows his martyrdom, when he was stoned to death by a crowd. Stephen was the first Christian martyr and one of the first seven deacons appointed by the apostles. Artists traditionally showed him as a young man in deacon's vestments, as here.

Art and the Counter-Reformation

The tortured spirituality that is evident in much of El Greco's work signals a new approach in religious art. Much of this change can be attributed to the policies of the Counter-Reformation, in which the Catholic church reinvigorated itself.

The start of the Reformation is traditionally dated to 1517, the year when the German monk and theologian Martin Luther (1483–1546) wrote his 95 Theses, criticizing the state of Catholicism. The ensuing rise of Protestantism had a profound impact on religious art. Many works of art were removed from churches or destroyed, and commissions for new altarpieces were severely restricted. The Catholic church responded to this challenge, however, and launched its own reform program. Many of the measures it implemented were decided at the Council of Trent, a meeting of church leaders first assembled in 1545.

Several new religious orders acted as the spearhead of the Counter-Reformation. The most important of these was the Society of Jesus, also known as the Jesuits, which was founded by Saint Ignatius of Loyola in 1534. Their primary influence was in the field of education, but as part of this they commissioned many new works of art. Indeed, their patronage reached such a level that for a time the baroque style (see page 69) was dubbed *le style jésuite*.

Within the Catholic church there was a tacit acceptance that much religious art had become stale and repetitive. Accordingly, a conscious attempt was made to reinvigorate Christian themes. Subjects were carefully monitored to ensure that no indecent or unsuitable material was depicted, and in some areas this policy was enforced by the Inquisition.

Conversely, there was also a conscious attempt to promote a new type of image that would have a strong emotional effect, making the viewer feel personally involved in the scene depicted. Paintings of martyrs, saints, and the Virgin Mary were all encouraged, particularly if the individual was portrayed in a state of deep meditation or spiritual ecstasy. El Greco's images of the Assumption and the Immaculate Conception of the Virgin are typical of this new kind of subject. The quintessential work of this kind, however, is a sculpture rather than a painting. It is Gianlorenzo Bernini's *Ecstasy of Saint Theresa* (1645–52), which shows Theresa experiencing a vision of God as an angel pierces her heart with an arrow.

Below: Bernini, Ecstasy of Saint Theresa (1645–52). With consummate mastery, Bernini expresses the pain and bliss felt by Theresa in her vision of God.

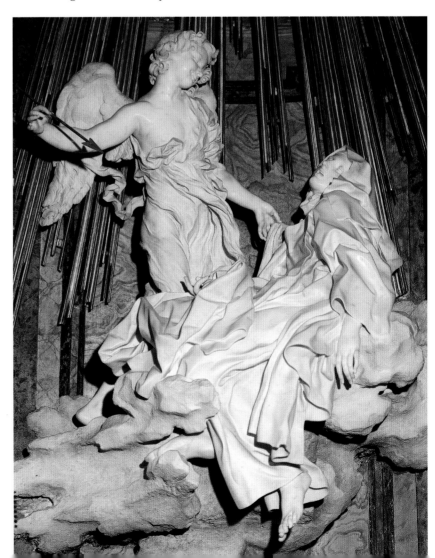

MICHELANGELO MERISI DA CARAVAGGIO
THE CRUCIFIXION OF SAINT PETER
1600–01

aravaggio (1571–1610) created some of the most powerful and original paintings of his day. He introduced a bold sense of drama and realism into his depictions of religious subjects, as in this scene of the brutal martyrdom of Saint Peter. According to tradition, the apostle ended his days in Rome, perishing during the persecutions of the emperor Nero. He is said to have asked to be crucified upside-down, as he felt unworthy of sharing the same fate as Christ. As his ordeal begins, the saint remained steadfast in his faith. This is underlined in Caravaggio's painting by the rock, prominently displayed in the foreground, which refers to Christ's comment in the Gospels: "Thou art Peter, and upon this rock I will build my Church; and the gates of hell shall not prevail against it" (Matthew 16:18). In showing the moment when Saint Peter's cross is raised—and the way he strains his head to look out of the painting—Caravaggio was drawing on, and inviting comparison with, a famous fresco of the subject by Michelangelo (see pages 42–45) in the Pauline Chapel of the Vatican.

The Crucifixion of Saint Peter is one of a pair of paintings commissioned from Caravaggio by Tiberio Cerasi, the Treasurer-General of Pope Clement VIII. They were destined to hang opposite each other, in the chapel bearing Cerasi's name, in the church of Santa Maria del Popolo, Rome. The other picture is *The Conversion of Saint Paul* (see page 65), a logical companion piece, since both saints had strong connections with Rome and were said to have been martyred on the same day.

The contract for the commission, which was dated September 24, 1600, stipulated that the pictures were to be painted on cypress panels and that the designs had to be approved by Cerasi himself. The latter added spice to the commission by ordering an altarpiece for the chapel, to stand between Caravaggio's pictures, from the artist's great rival, Annibale Carracci (1560–1609). Cerasi doubtless hoped that the competitive spirit of the two men would provoke them into producing exceptional work.

In fact, the commission was complicated by the death of Cerasi in May 1601. His heirs rejected Caravaggio's original pictures, for reasons which are unknown. Their replacements (shown here), painted on canvas rather than panel, were completed by November 1601. They are among the starkest and most dramatic of Caravaggio's works, contrasting sharply with the idealized classicism and bright colors of Carracci's altarpiece.

Caravaggio, *The Crucifixion of Saint Peter*, 1600–01, oil on canvas (Cerasi Chapel, Santa Maria del Popolo, Rome)

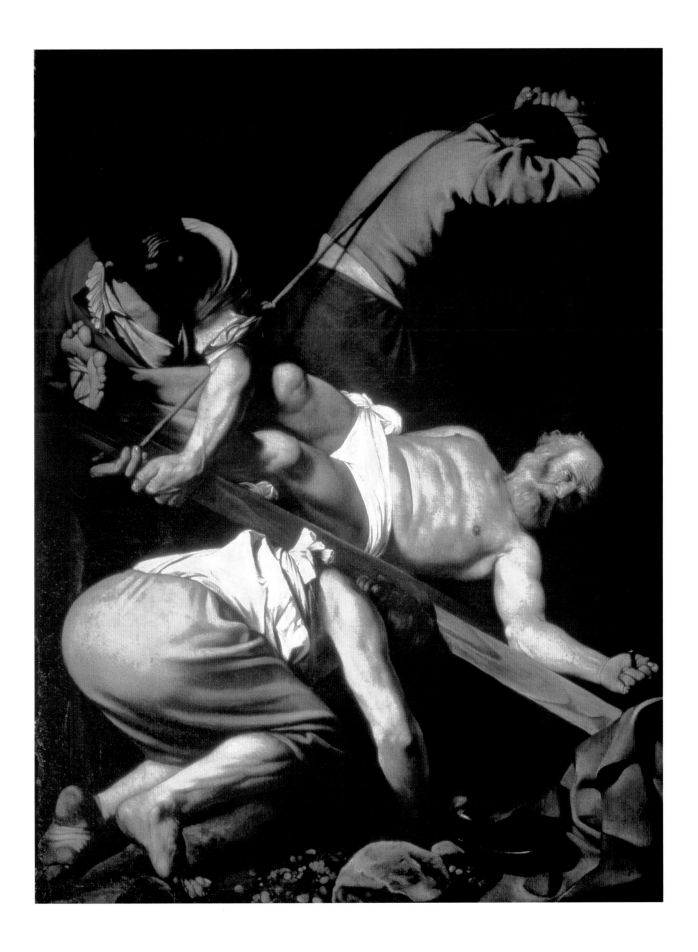

Style and technique

Caravaggio gave his name to a specific style of painting: Caravaggism. This approach was based upon his dramatic use of chiaroscuro, or the contrast between light and shade. A contemporary commentator explained that he achieved this effect by posing his models in "the darkness of a closed room, placing a lamp high so that the light would fall straight down, revealing the principal part of the body and leaving the rest in shadow." Caravaggio's striking chiaroscuro, combined with his unstinting sense of realism, and his dramatic, pared down compositions, ensured that his pictures created a powerful impact.

The face of this executioner is hidden behind his arm as he hauls up the cross. In contrast to Saint Peter, whose features are shown in agonizing detail, the executioners are anonymous, their faces either hidden or obscured by shadows.

Saint Peter strains to raise his head, his face lined with suffering and pain. His gaze is focused outside the picture to the right, where the altar in the Cerasi Chapel stands. In looking to the altar, the saint indicates the route to salvation for ordinary mortals.

Contemporaries accused Caravaggio of cheapening his religious subjects by introducing sordid and unnecessary details. They particularly disliked the emphasis on this figure's dirty feet, even though he was only an executioner. The way the man's bottom is thrust into the foreground as he strains to raise the cross also challenged conceptions of decorum.

A shovel, Saint Peter's discarded robe, and a scattering of stones form a still life at the bottom right of the painting. Caravaggio treats this arrangement with as much conviction as the figures, rendering it in muted colors with crystal clarity. The large stone refers to Christ's comment in the Gospels that Peter is the rock upon he will build the Christian church.

Shocking realism

Few artists have aroused as much controversy as Caravaggio. His paintings sold well, but many contemporaries felt that he degraded his subject matter, creating religious pictures more notable for their sensationalism than their spirituality.

Caravaggio was a violent man living in violent times. He was frequently in trouble with the authorities, usually for acts of sudden aggression. He assaulted a waiter for bringing him the wrong food, he threatened a prostitute who offended him, and he spent the last four years of his life on the run, after killing a man in a dispute over a tennis match. Caravaggio's quarrelsome nature was reflected in his art. His scenes of martyrdoms were painted with a relish bordering on the obscene.

These pictures seemed all the more shocking to the artist's patrons, because they showed religious themes as if they were contemporary events. The executioners in *The Crucifixion of Saint Peter* were not depicted as evil men in historical costume; they were Roman laborers, with dirty feet and shabby clothes. Worse still, they were completely unaffected by the horror of the situation. Other artists portrayed the enemies of the Christian cause as ugly, impassioned caricatures (see Dürer's *Christ among the Doctors*, pages 34–37), but these men show no signs of any emotional involvement. For them, the killing of an old man is just a job. Indeed, the picture seems to be more about the physical effort involved in raising a cross than the significance of martyrdom.

Caravaggio also heightened the shock value of his paintings by the drama of his compositions. While most of his rivals set their religious scenes

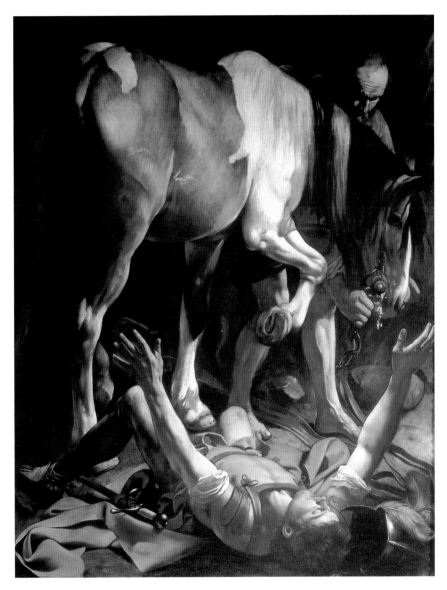

in realistic environments, his resemble dramatic tableaux. There are no backgrounds or subsidiary figures to distract attention. Instead, his scenes are dark and claustrophobic, with the action thrust so close to the viewers that they are forced to confront it.

Above: Caravaggio's The Conversion of Saint Paul *(1600–01), the companion piece to* The Crucifixion of Saint Peter. *In this dramatic rendering of the subject, Paul is shown flung on his back, his arms raised up toward the heavenly light that has temporarily blinded him.*

PETER PAUL RUBENS
THE DESCENT FROM THE CROSS
1611-12

ew artists can compare with Rubens (1577–1640) in terms of range and versatility. An outstanding painter of mythologies, portraits, and landscapes, he was equally capable of producing somber and emotive religious scenes. This magisterial work shows the most moving of the episodes from the Passion of Christ. In contrast to the Raising of the Cross, where Christ is surrounded by cruel enemies, the Descent shows him in the company of friends. All is tenderness and sorrow, as the limp body is passed down from the Cross with infinite care. Most of the figures can be identified. The Virgin, dressed in blue, stands opposite Saint John. Beneath them, Mary Magdalen supports Christ's feet, while Mary Cleophas (the Virgin's sister) looks on. Further up, the men in rich attire are Joseph of Arimathaea (left) and Nicodemus. The former gave Christ his own tomb, while the latter was a converted Pharisee. At the top, two workmen lend their assistance to Christ's followers. In keeping with the account in the Gospels, the action takes place at twilight.

The Descent from the Cross is the central panel of an altarpiece commissioned by the Guild of Arquebusiers (musketeers) for their private chapel in Antwerp Cathedral. Rubens was a friend of the guild's chairman, Nicolaas Rockox, and probably received the commission through him. The choice of subject was an ingenious tribute to Saint Christopher, the guild's patron saint. The reputation of this figure had recently been called into question by the church, and indeed, some believed that he was a purely mythical character. As a result, the cathedral authorities barred the guild from including any image of the saint on the front of the altarpiece—he is depicted on the back. However, the guild managed to get around this ruling by using themes that related to his name. His Greek name, Christophoros, means "Christ-bearer," and the wings and central panel feature scenes in which Christ is carried. The left wing shows the Visitation, in which Christ is borne by the pregnant Virgin as she visits her cousin Elizabeth; the right wing features the Presentation at the Temple, in which the high priest Simeon holds the Christ child.

The Descent from the Cross was installed in the cathedral in September 1612, exactly a year after the original contract had been signed. The wings, for some unknown reason, were not completed until 1614. Records show that the guild presented Rubens's wife with the traditional gift of a pair of gloves in 1615, but that the artist himself did not receive full payment for his work until a further six years had elapsed.

Peter Paul Rubens, *The Descent from the Cross*, 1611–12, oil on panel (Antwerp Cathedral, Belgium)

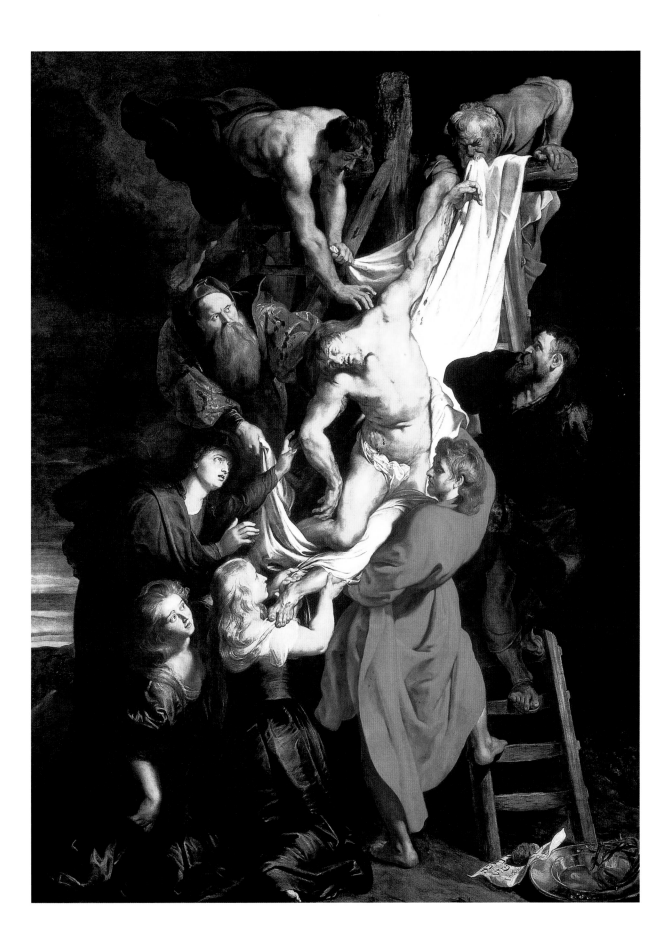

Style and technique

Many of the roots of The Descent from the Cross *can be traced back to Italy, which was Rubens's principal base until 1608. The basic composition of the picture is loosely based on a pen-and-wash drawing that he executed in the country in c.1601–02. In addition, individual details seem to be derived from works of art that Rubens would have seen during his time in the south. The figures of Christ and Nicodemus appear to be modeled on two of the figures in the antique sculpture the Laocoön (see page 49). Similarly, the workman leaning over the top of the cross is taken from a famous fresco in Rome of the Descent by the Italian painter Daniele da Volterra.*

Christ's foot rests on Mary Magdalene's shoulder as she holds his left leg and wraps it in the sheet. Rubens portrayed Mary in this way as an allusion to her original penitent gesture, when she came to Christ in the house of Simon the Pharisee and kissed and anointed his feet in repentance for the sins of her life as a prostitute.

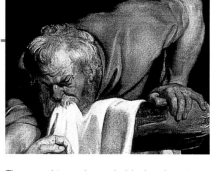

The way this workman holds the sheet in his mouth, because his hands are full, adds an unusual but realistic touch. To some degree artists were limited when portraying major biblical characters, since much of the image was dictated by convention. With minor figures such as this one, however, they had a much freer hand.

The youthful Saint John takes the weight of Christ's body as it is lowered from the cross, his important role emphasized compositionally by his brilliant red robes. In depictions of the Crucifixion and Descent, artists traditionally showed John as young and beardless, with long, flowing hair, and dressed in red—in his role as the evangelist, he is portrayed as an old man with gray hair and beard.

In this still life Rubens has included the instruments of the Passion, in keeping with tradition. A basin contains Christ's crown of thorns and the nails removed from his body. Next to it lies the inscription from his cross, which reads "Jesus of Nazareth, King of the Jews," and on it the sponge that, soaked in vinegar, was offered to him just before he died.

Baroque splendor

Rubens was the supreme exponent of baroque painting. His fluent, exuberant technique and monumental compositions perfectly encapsulate the style that dominated Western art in the seventeenth century

The term "baroque" appears to owe its origins to a Portuguese word, *barroco*, which describes a rough or irregularly shaped pearl. Initially it was used as a term of abuse, implying that the artwork in question was grotesque or tortuous. This meaning dates from the late eighteenth century, when the neoclassical style was in vogue. Since then, the term has lost its pejorative overtones, although its rather broad application is sometimes confusing. Principally it refers to a style that flourished in architecture, sculpture, and painting in the seventeenth century, one that stressed large, grand, theatrical compositions characterized by a dynamic sense of movement and dramatic use of light and shade—and, in painting and sculpture, extreme emotionalism. The term is also applied more generally to the age in which the style flourished and to works of art from other periods where the main features of the style are apparent.

The baroque style emerged in Italy in the late sixteenth century, in part as a reaction against the more artificial aspects of mannerism, a style which had become popular in Florence and Rome. One of the first and most original exponents of the baroque was Caravaggio, who combined drama with a stark realism (see pages 62–65).

Many baroque features satisfied the artistic preferences of the Catholic Church as it sought to renew and assert itself in the Counter-Reformation (see page 61). By contrast, the grandiose nature of the style was less popular in Protestant areas. At the same time, the absolutist rulers of the period also recognized that it could serve as a useful tool for glorifying their regimes. Some of the finest baroque schemes were created for such purposes, including the French king Louis XIV's palace at Versailles and Rubens' cycle of paintings celebrating the Italian wife of Henry IV of France.

Above: Rubens, Marie de' Médici Arriving at Marseilles, *1622–25. With a flourish typical of the baroque, Rubens enhances this scene of Marie's arrival in France with a host of reveling mythological figures and a dramatic low viewpoint.*

Below: The Palace of Versailles, designed by Louis le Vau and Jules Hardouin-Mansart between 1655 and 1688. It is one of the finest baroque ensembles ever created.

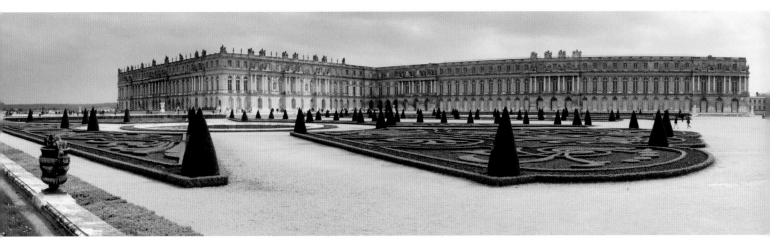

FRANS HALS
THE LAUGHING CAVALIER
1624

fter the *Mona Lisa* (see pages 30–33), *The Laughing Cavalier* is probably the most famous portrait in Western art. Even though the identity of the sitter is unknown and the picture's title is open to question, it remains one of the most endearing character studies ever produced. Among other things, the portrait provides a salutary lesson on the frailty of personal reputations. The sitter, who exudes confidence and good humor and was clearly a man of substance in his day, is now entirely anonymous. The reputation of Frans Hals (c.1582–1666) himself suffered a similar decline. His work was greatly in demand during his lifetime, but he was rapidly forgotten after his death and only rediscovered in the nineteenth century.

The painting, too, lingered in obscurity for many years. Although it was executed in 1624, its history can only be traced back to 1770, when it appeared in the salerooms. Over the course of the next century, it changed hands several times. In 1865 it was the subject of a spectacular bidding war between two wealthy collectors, Lord Hertford and Baron James de Rothschild. The latter had given his agent carte blanche to secure the picture, and as a result, the price soared from the catalog estimate of 8,000 francs to a phenomenal 51,000 francs. This remarkable contest captured the public imagination and helped launch the painting on its road to fame.

On the picture's numerous appearances in the auction rooms, its sitter was variously described as a "soldier," an "officer," and a "captain." It was not until an exhibition of 1888 that he was dubbed "the laughing cavalier." This title, as many commentators have pointed out, is not strictly accurate. The man is smiling, rather than laughing, and his sash and sword do not necessarily prove that he belonged to the military. Instead, the title was probably inspired by the figure's cavalierish attitude, which is epitomized by his extravagant outfit and manner.

Certainly, the cavalier's lavish attire is one of the most remarkable aspects of the picture. His sleeve, prominently displayed for the viewer, is embroidered with a dazzling array of symbolic devices. They include flaming horns and arrows, bees, and lover's knots, most of which relate to the pangs of passion. The symbolism of these emblems has raised further questions about the purpose of the portrait. Was it designed as a love-gift for a partner, or did the sitter simply want to advertise his amorous nature? Tantalizingly, we shall never know.

Frans Hals, *The Laughing Cavalier*, 1624, oil on canvas (The Wallace Collection, London)

Style and technique

It is no accident that the impressionists were among the first to appreciate Hals's unique style. Unlike many of his Dutch predecessors, he did not seek to portray his sitters in a solid, sculptural style. Instead, his light, flickering brush strokes give his pictures an animated and spontaneous appearance. The assurance of Hals's style is all the more remarkable, given that he seems to have carried out little or no preparatory work. No drawings or sketches of his compositions have been found, so it is probable that he worked directly onto the canvas.

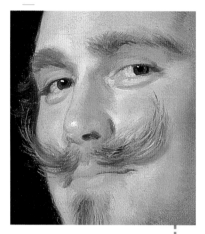

The Dutch were extremely fond of using symbols in their paintings (see page 93). The meaning of these symbols would have been understood by educated observers and was explained in various anthologies of emblems such as Alciati's Emblematum Liber (1531). In this book, the winged staff of the god Mercury, entwined by snakes and topped by his hat—which features prominently on the cavalier's sleeve, on the panel of fabric between the slashes—was linked to the motto Virtuti fortuna comes ("Fortune, companion of manly virtue").

While the sitter's animated face conveys a vigorous love of life, his expression has been the cause of much discussion. His eyes seem to sparkle with mischievousness, some say arrogance, but he is not laughing. Indeed, if his flamboyant moustache was pointing downward, rather than upward, he might not even appear to be smiling at all.

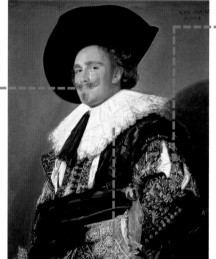

The metal top of a sword handle sticks out from under the sitter's arm, its form rendered with free, broad brushwork. The sword is the main reason that the man has been described as a "cavalier," although in reality it does not prove that he was a military man—it could simply have been a sign of high social status.

The fashionable white lace collar shows the boldness and finesse of Hals's style. Deft strokes of thick white paint, rapidly applied with a fine brush, suggest the layers of delicately patterned material.

A new spontaneity

In Frans Hals's day there was already a strong tradition of portraiture in Holland, but he created work with an informality and freshness that had not been seen before.

During Hals's formative years, the Dutch taste in portraiture was typified by the work of Michiel van Miereveld (1567–1641) and his pupil Paul Moreelse (1571–1638). Their figures displayed considerable finesse, although the compositions themselves were often staid and repetitive. Hals, on the other hand, devised a more direct and personal approach. In many cases his pictures resembled modern snapshots, capturing a transient image of his sitters—one reason he was greatly admired by the impressionists.

Hals used a number of artistic tricks to create a feeling of spontaneity. Instead of giving his models a blank expression, which would make them look as if they were posing, he used momentary looks—a smile, a laugh, a glance. Often, he underlined this effect of immediacy by setting the figure at an oblique angle to the picture. In *The Laughing Cavalier*, for example, the subject stands diagonally to the canvas, but his head is turned to the left, giving the impression that the viewer has just caught his attention.

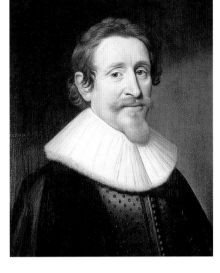

Above: Michiel van Miereveld's Portrait of Hugo Grotius *shows the formal, polished style popular in Holland in Hals's time.*

Gesture and pose were equally important. On many occasions, Hals deliberately chose compositions that presented technical difficulties, simply to lend an air of informality to the scene. In the cavalier's case, the position of the left arm, with the elbow thrust toward the spectator, called for considerable skill in rendering the correct foreshortening.

Hals brought the same informality to the man and wife he portrayed in *The Married Couple* (1622). Unlike traditional wedding portraits, their faces are animated with warm smiles and their poses are relaxed, the man lolling back with contentment.

Hals's penchant for depicting smiling or laughing faces may have caused some confusion about his own lifestyle. His copious portraits of merry drinkers helped to foster the widely held view that he himself was a boorish drunk, although there is very little evidence to support this.

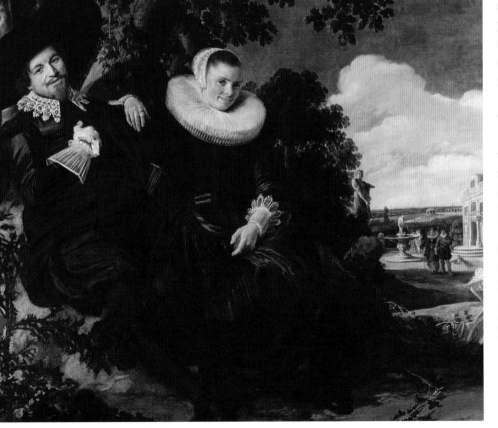

Left: In The Married Couple *(1622), Hals brought warmth and immediacy to the traditionally conservative wedding portrait.*

ANTHONY VAN DYCK
EQUESTRIAN PORTRAIT OF CHARLES I
c. 1 6 3 7 – 3 8

Although an accomplished painter of religious subjects and landscapes, van Dyck's (1599–1641) true forte was portraiture. He depicted many of the greatest figures of his age, but is most closely associated with the court of King Charles I (1600–49) in England, where he spent the most fruitful part of his career. Van Dyck portrayed the king in many different guises, emphasizing both his public and his private roles. In this elegant equestrian portrait, he showed Charles in his official capacity, as the nation's military leader. The king wears the finest, Greenwich-made armor and his page is about to hand him his helmet. In his right hand, he carries the commander's baton, and around his neck, he displays a locket known as the Lesser George, one of the insignia of the Order of the Garter, the oldest and most distinguished of the chivalric orders of knighthood. During Charles's lifetime, the portrait hung at the royal palace of Hampton Court, just outside London.

Van Dyck's decision to settle in England in 1632, even though he already had a thriving business in Antwerp, was undoubtedly due to Charles's reputation as a major patron of the arts. Within the space of a few years, the king amassed one of the most impressive art collections in Europe. He also offered commissions to most of the leading painters of the day and thoroughly deserved the accolade given by Peter Paul Rubens, who described him as "the greatest amateur of painting among the princes of the world."

Charles's political skills, however, did not match his aesthetic sensibilities. During the latter part of his reign, the nation became embroiled in a disastrous civil war (1642–49), which ultimately cost him both his throne and his life. In 1649 he was beheaded outside the Banqueting House in Whitehall, the scene of one of his grandest artistic commissions. For it was here, ironically, that Charles had hired Rubens (see pages 66–69) to decorate the ceiling with a series of paintings celebrating the benefits of wise rule.

In the aftermath of the Civil War, much of the royal collection was dispersed. This painting, along with many others, was sold off in 1650. It was later owned by Maximilian II, elector of Bavaria. Subsequently, it was looted from Munich by Emperor Joseph I, who presented it to the Duke of Marlborough in 1706. The National Gallery purchased the painting from the eighth Duke of Marlborough.

Anthony van Dyck, *Equestrian Portrait of Charles I*, c.1637–38, oil on canvas (National Gallery, London)

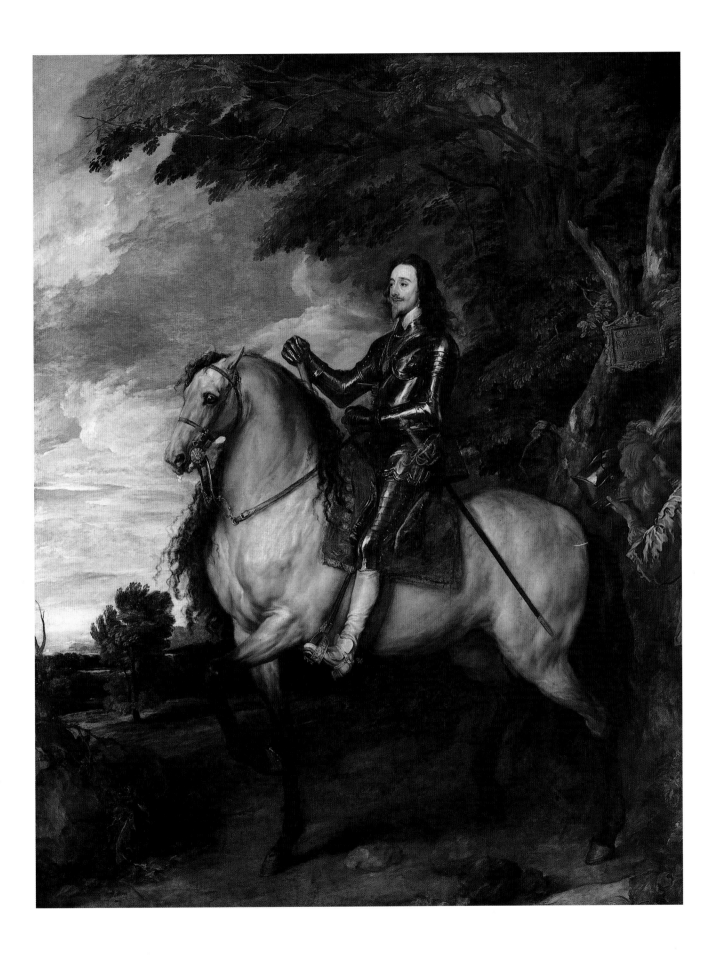

Style and technique
Van Dyck transformed the standards of portraiture in England. His dazzling Italianate style, much influenced by his admiration for Titian (see pages 46–49), inspired the next generation of portraitists, most notably William Dobson (1611–46) and Peter Lely (1618–80). Some of van Dyck's preparatory works for this picture have survived. They include a modello, a type of drawing—usually highly finished—that was designed to be shown to a patron to gain his approval for the commission to proceed. There is also a separate study of the horse, executed in pen and sepia wash.

The horse, with its flowing mane and huge, muscular neck, adds both to the elegant beauty of the portrait and to the impression of power. By showing Charles on horseback, van Dyck emphasized the king's authority and disguised the fact that he was only five feet tall.

Charles wears a gold locket bearing the image of Saint George and the Dragon, which is traditionally known as the Lesser George. Although it was important as an item of military regalia, the locket also held considerable personal significance for Charles. Inside, there was a portrait of his wife, which he kept with him until the day he died.

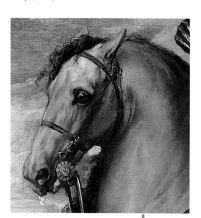

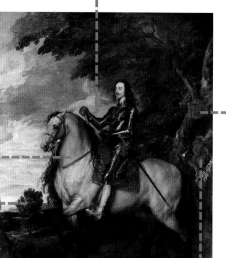

A plaque identifies the sitter: Carolus Rex Magnae Britanniae ("Charles King of Great Britain"). It has added significance because England and Scotland had only recently been unified by Charles's father, King James VI of Scotland and James I of England.

The quality of the landscape backgrounds in some of van Dyck's portraits is often underrated. While living in England, he produced a series of vivid, watercolor landscapes, but they remain one of the least-known aspects of his art.

This splendid plumed helmet, passed to Charles by his page, emphasizes the king's role as military leader. The figure of the page is cropped by the edge of the picture, so as not to detract attention from the king.

Equestrian portraits

Before the arrival of van Dyck, equestrian portraits were something of a novelty in England. His elegant versions of the theme endowed the English king with a powerful sense of majesty and authority.

As a subject, the equestrian portrait dates back to antiquity, when Roman emperors were immortalized with statues of gilded bronze. The most celebrated example is that of Marcus Aurelius, dating from about A.D. 166. This sculpture owed its survival to the mistaken belief that it represented the Christian emperor Constantine. As such, it helped inspire the revival of equestrian monuments in the Renaissance and became the model for many royal portraits.

Van Dyck had already painted several equestrian portraits of Italian nobility before his arrival in England. For Charles, he produced two superb examples, showing the king in his full military regalia, and a third in which the monarch has just dismounted. All of these equestrian pictures were based, to a greater or lesser extent, on earlier prototypes. This borrowing did not indicate any lack of imagination on the artist's part. Instead, it was a conscious attempt to emphasize Charles's greatness by associating him with other imperial images.

In this particular instance, there were links with a portrait of the king's father-in-law, Henri IV of France, and with the traditional image of the monarch on the Great Seal of England. The crucial association, however, was with Titian's equestrian portrait of the Holy Roman emperor Charles V (1548). Although the pose is different in van Dyck's painting, both the armor and the woodland setting are highly reminiscent of Titian's famous image. This connection was significant, because the emperor's portrait had been commissioned to

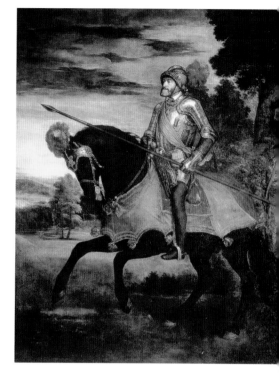

Above: Titian's Charles V after the Battle of Mühlberg *(1548) set the precedent for painted equestrian portraits. It presents a powerful image of the warrior king, clad in armor astride a prancing steed.*

celebrate a famous victory he had won at the Battle of Mühlberg. There was, thus, an unspoken suggestion that Charles would also prove a great military leader.

When producing equestrian portraits, most painters employed a number of artistic tricks. They would deliberately portray the horse on a slightly smaller scale, so that the sitter appeared taller and grander. They also tended to include a figure on foot to hint that their patron existed on a higher plane.

Left: The bronze statue of the emperor Marcus Aurelius (c. A.D. 166) on horseback, one of the most important and influential Roman sculptures to survive into modern times.

NICOLAS POUSSIN
ET IN ARCADIA EGO
c . 1 6 3 8

This reflective, melancholy scene is one of the defining images of French classicism (see page 81). In it, Poussin (1594-1665) created an elegant and thoughtful reminder about the frailty of the human condition. The subject was not an entirely new one in art and literature, but Poussin's painting is its most perfect expression and it has long been identified with his name— a bronze plaque of the picture adorns his tomb. The painting shows a group of Arcadian shepherds gathered around a funerary monument. Arcadia, or Arcady, was a region in central Greece in ancient times, but it was also the name of a timeless, earthly paradise, described by generations of poets. In their happy wanderings, the rustics have come across an ancient tomb, which bears the Latin inscription: *Et in Arcadia Ego*. This unexpected incident shatters their carefree mood. Suddenly, they are reminded that their blissful existence will one day come to an end.

The precise significance of the inscription has been the subject of much scholarly discussion. The phrase does not appear to have been used in antiquity and may have been invented in Poussin's time. It is frequently translated as "I, too, was once in Arcady," referring to the occupant of the tomb. In this case, however, the correct grammatical form should be *Et Ego in Arcadia*. Alternatively, the inscription may be a warning from Death itself, meaning "Even in Arcady, I exist." This interpretation made more sense in earlier depictions of the theme, which featured a human skull—a conventional symbol of Death— lying on top of the monument. Poussin omitted the skull in this picture, although it has been suggested that the solemn female figure may be an allegory of Death.

Poussin painted two versions of this subject, deriving his inspiration from a picture made in c.1620 by the Italian painter Guercino (1591-1666). Poussin's initial attempt dates from just a few years later, in the late 1620s. It is more conventional in character, depicting the moment when the shepherds arrive on the scene and including the skull. The Louvre version is more noble and imposing. It dispenses with the melodramatic elements of the theme, concentrating instead on a mood of quiet contemplation.

Et in Arcadia Ego was painted when Poussin was at the height of his powers. Although born in Paris, he spent most of his career in Rome. There, he formulated the basic principles of classicism, marrying the colors of Titian with a love of the antique and an admiration for clarity and restraint.

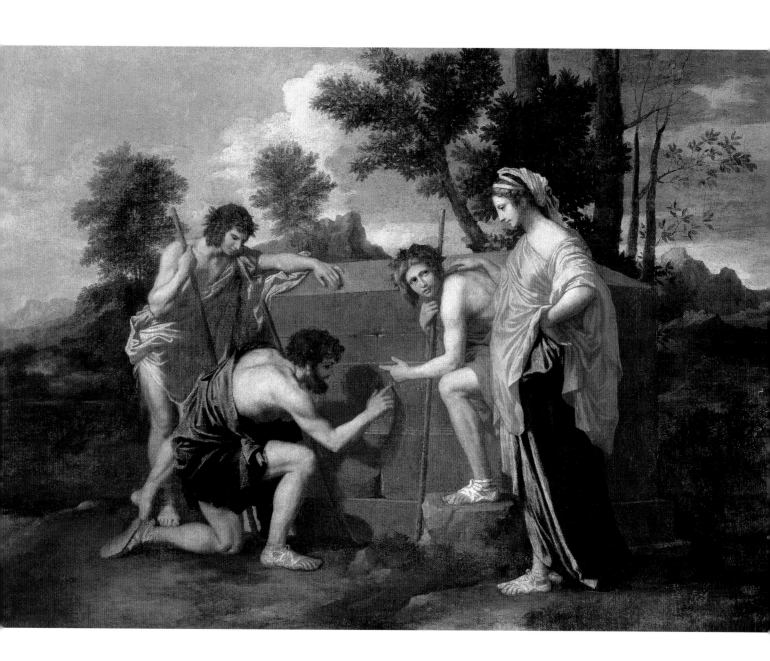

Style and technique

The guiding principles of French classicism were order, clarity, and calm. In his finest works, Poussin strove to avoid any hint of flamboyance or melodrama. Instead, he made his pictures as simple and uncluttered as possible. To help achieve this aim he adopted a painstaking preparatory routine. After making numerous sketches, he fine-tuned the composition by arranging tiny wax models on a miniature stage. This boxlike construction had grid lines on the base and adjustable slits on the side, so that the artist could figure out the perspective and lighting effects of his pictures with absolute precision.

The landscape is rocky—mountains rise in the distance and the foreground is mostly bare of vegetation. It is quite unlike the lush pastoral countryside usually associated with the earthly paradise of Arcadia, and appears to relate more to the arid lands of Greece. More generally, the sparse setting focuses attention on the picture's solemn subject.

This young shepherd looks on with an expression of calm contemplation as his companions read the inscription. His standing pose, with his arm resting on the tomb, balances that of the female figure on the right. The thoughtful expressions of these two figures set the mood of reflection that pervades the image.

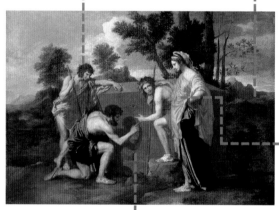

As the kneeling shepherd traces the inscription Et in Arcadia Ego with his finger, he casts a shadow on the tomb. The shadow of his arm has often been likened to a sickle, a traditional symbol of death.

The woman, lost in solemn contemplation, is usually described as a shepherdess, although her dress and bearing suggest she has a higher station in life. Some scholars have also suggested that she might be a personification of death.

French classicism

Poussin and his fellow countryman Claude Lorrain were the greatest exponents of French classicism in the seventeenth century. Poussin also had a profound influence on later generations, his theories forming the basis of French academic art.

In essence, classicism may be described as a style that was designed to appeal to the intellect rather than the senses. Classical artists worked from a well-defined set of aesthetic principles, which revered order, harmony, and clarity above all else. Form and draftsmanship were regarded as superior to eye-catching displays of color or excessive emotion. In the seventeenth century, classicism was contrasted with the flamboyance of the baroque style (see page 69), while in the nineteenth century it was regarded as the antithesis of the romantic movement, with its emphasis on individualism. Classical art was also frequently linked with a love of the antique, although this was not a vital element of the style. Many painters did seek to recapture the spirit of Greek and Roman art, but the work of later masters, such as Raphael (see pages 38–41) and Michelangelo (see pages 42–45) was also revered.

During the course of his career, Poussin formulated a set of aesthetic guidelines that enshrined his classical ideals. He recommended that painters should concentrate on serious, morally uplifting subjects, and should tackle them in an orderly, rational manner. Compositions were to be simple and direct, conveying their message through gesture and expression rather than showy effects. Poussin's ideas shaped the teachings of the Academy in France and underpinned academic art until the nineteenth century (see pages 114–17 and 118–21). Even an

artist as modern as Paul Cézanne paid tribute to him, declaring that he wanted "to do Poussin again, from nature" (see pages 190–93).

Claude Lorrain (1600–82) was the chief exponent of classical landscape painting, and his work also had a great influence on later artists, particularly in Britain. His subjects were drawn from the Bible or mythology, but his pictures are remarkable as idealized visions of a golden age, in which classical forms are bathed in the warm glowing rays of an Italianate dawn or sunset.

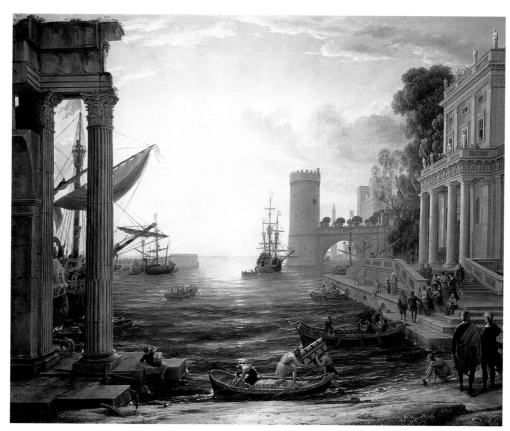

Right: Claude, Seaport with the Embarkation of the Queen of Sheba, 1648. *This idealized world of classical architecture bathed in golden light is typical of Claude's poetic version of classicism.*

REMBRANDT VAN RIJN
THE NIGHT WATCH
1642

his is both the most famous and the most original painting by Rembrandt van Rijn (1606–69), described by one commentator as "a thunderbolt of genius." The picture was commissioned as a group portrait of the leading members of the Kloveniers Company, one of the many local militia groups in Holland. At the heart of the composition, illuminated by a shaft of light, are the company's commanders, Captain Frans Banning Cocq and Lieutenant Willem van Ruytenburch. Cocq, who is wearing a black tunic with a red sash, holds the captain's baton in his right hand. He gestures forward with his other hand, as if giving the order for the company to march—the foreshortening of this hand is a bravura display of artistic skill. Beside Cocq, van Ruytenburch is dressed in a dandyish yellow outfit. He carries a partisan—a ceremonial halberd—as a symbol of his office.

Although the painting is now universally known as *The Night Watch*, the title is not strictly accurate. Cleaning has revealed that underneath the accumulated dirt and varnish, it is actually a daytime scene that is shown. Nor is it really a watch. Rembrandt's figures are involved in a complex variety of actions, some real and some symbolic, and the picture does not represent any single event. The present title only dates from the end of the eighteenth century, when night patrols were virtually the sole remaining function of the militia groups.

Portraits of civic militia were commonplace in Holland, but this painting is unlike any other. Rather than simply presenting a repetitive line of faces, Rembrandt illustrated several different facets of the company. There is particular emphasis on the skills associated with using muskets, the Kloveniers' specialty weapon. Three of the figures show different aspects of using the firearm while immediately behind Cocq, a man in ancient dress is firing one. This figure is allegorical, a personification of musketry itself.

The Night Watch was displayed at the Klovenierdoelen, the company's headquarters, until 1715, when it was transferred to Amsterdam town hall. In order to fit into its new location, the painting was trimmed on the left-hand side and the portraits of two militiamen were lost. It is possible to gain some impression of the missing section from a small copy of the painting that Cocq commissioned from Gerrit Lundens.

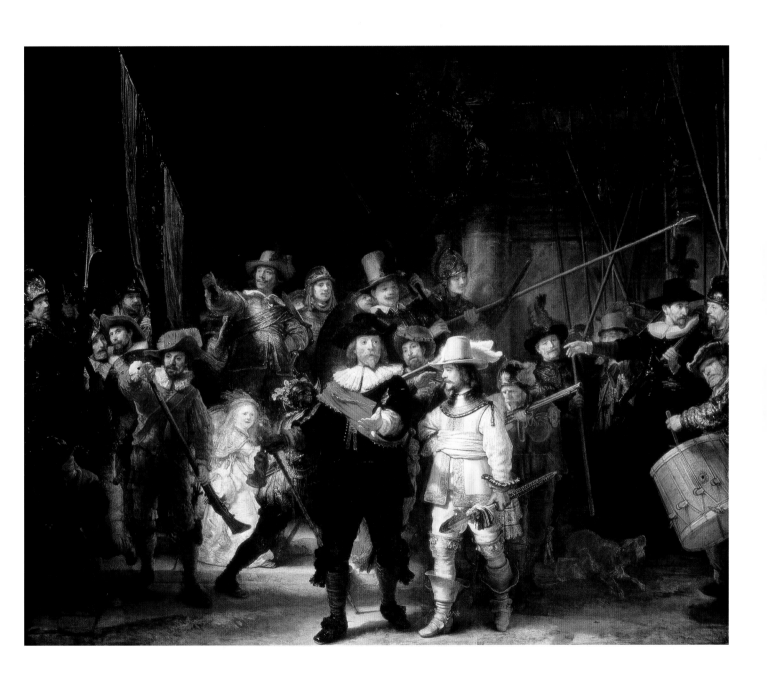

Rembrandt van Rijn, *The Night Watch*, 1642, oil on canvas (Rijksmuseum, Amsterdam)

Style and technique

Very little is known about Rembrandt's preparations for this work. Normally, an artist carrying out this type of commission would have submitted a detailed drawing for approval, but no such sketch is known. Indeed, only two rather general studies of individual militiamen have survived. The Night Watch was painted on three separate canvases sewn together. Rembrandt used a dark ground, sketching in the figures roughly in black or brown before touching in the light areas with white paint. From this very basic layout, he then painted the entire composition directly onto the canvas. X ray tests have revealed only a few minor changes, most of which involved slight shifts in the position of the lances to create a greater sense of space.

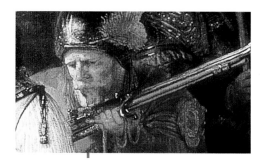

A plaque behind the company contains the names of the men featured in the painting, listed in order of seniority.

An elderly militiaman cleans his musket by blowing out the used gunpowder. Rembrandt included several details of musket work in the painting, probably based on illustrations from contemporary arms manuals.

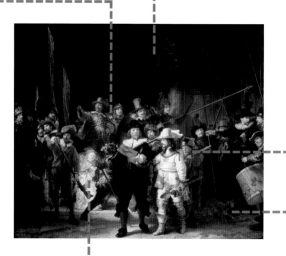

The figure in a cap, peeping out from the back of the company, is thought to be a partial self-portrait of Rembrandt himself.

The figure of an elaborately dressed young girl is spotlighted among the militiamen. She appears to be a symbolic figure or a mascot. She stands beneath the company's blue-and-gold banner and the dead chicken hanging from her belt refers to the Kloveniers' emblem—bird-claws. There is a second girl, barely visible, just behind her.

Rembrandt included several incidental details, which add a touch of humor to his grand composition. Here a small brown dog barks at the drummer, while in the left corner of the picture, a dwarf runs ahead of the militiamen.

Dutch group portraits

Group portraiture was a major artistic theme in seventeenth-century Holland. Pictures of the militia companies were the most lucrative and prestigious public commissions of the period, and they attracted the greatest artists.

The Dutch militia companies had their origins in the Middle Ages, when groups of citizens formed military guilds to defend the local community in times of crisis. They had their own meeting places, or *doelens*, as well as shooting ranges, where they developed their martial skills. Each guild was named after its specialty weapon. The main Amsterdam guild was originally a crossbow unit, until the switch to firearms in 1522, when it adopted the name of Kloveniers—*kloven* is Dutch for a type of musket.

By Rembrandt's day the guilds had evolved into militia companies, and their duties were largely ceremonial. Until the creation of the United Provinces in 1581, places like Amsterdam had been independent city-states, free of all national control, and they maintained a strong feeling of civic pride. As a result, the company halls were treated as showplaces and were adorned with imposing group portraits. These paintings usually featured the leading members of the militia, each of whom paid a sliding scale of fees to the artist, according to his prominence in the picture.

For all their grandeur, many of these portraits appeared very static, since the figures were invariably posed in rows, either standing or seated, or else at their ceremonial banquet. Frans Hals (see pages 70–73) and Rembrandt broke new ground by introducing movement and variety into this format. Hals's depiction of the Saint George's militia displays particular verve. *The Night Watch* goes a step further, making the portrait into a dynamic and theatrical outdoor scene, with the militiamen wearing a colorful array of historical outfits. Yet remarkable though it is, the painting was also something of a swan song for this type of portrait, as the militia companies declined after 1650.

Below: Frans Hals's The Banquet of the Officers of the Saint George Militia Company *(1616) broke new ground with its informal composition and vigorous handling.*

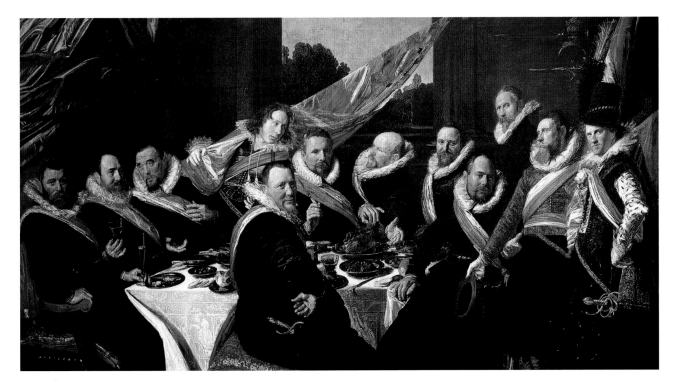

DIEGO VELÁZQUEZ
THE MAIDS OF HONOR
1656

T his multilayered painting is one of the greatest masterpieces of Western art. Although the figures are readily identifiable, it is far more than a simple portrait. Instead, Velázquez's (1599–1660) intricate composition hints at a variety of different meanings. The picture is certainly about the act of painting itself and also seems to address the status of the artist. The left-hand side of the canvas is dominated by the artist, who stands with his brush and palette in front of an enormous canvas. But who exactly is he painting? At first glance, it might seem that the obvious candidate is the golden-haired princess Margarita, the daughter of King Philip IV of Spain. She seems to be the center of attention at the heart of the composition. She is accompanied by her maids of honor, and on the far right by a dwarf, Mari-Bárbola, and a midget, Nicolás de Pertusato. Behind her, a chaperone and a bodyguard melt into the shadows, while at the far end of the room, the palace marshal stands on the steps and glances back over his shoulder.

The marshal's stance suggests that something of interest is happening at the near end of the room, outside the confines of the picture. The key to this mystery may lie in the mirror, which is situated to the left of the door. It shows the reflections of the king and queen, positioned beneath the folds of a red curtain. Have they just entered the room or are they, perhaps, posing for the picture that Velázquez is painting? The latter seems the likeliest option, although teasingly the artist leaves an element of doubt.

There was nothing new about using reflections in pictures and Velázquez may well have been inspired by Jan van Eyck's famous painting *The Arnolfini Wedding* (see pages 18–21), which was in the Spanish royal collection at the time. However, no other artist had dared to employ the idea in such a novel fashion. It says much for the status Velázquez had achieved that he could relegate his royal masters to a tiny, blurred image in the background, while he himself played such a prominent role in the work. There is also an added refinement. The artist's gaze, together with that of the princess and her attendants, is directed toward the spectator. For a brief moment, therefore, viewers are given the impression that Velázquez is actually painting them.

For many years, the painting was listed in the royal archives as a portrait of the princess. It only gained the wholly misleading title of *The Maids of Honor* in 1843.

Diego Velázquez, *The Maids of Honor*, 1656, oil on canvas (Prado, Madrid)

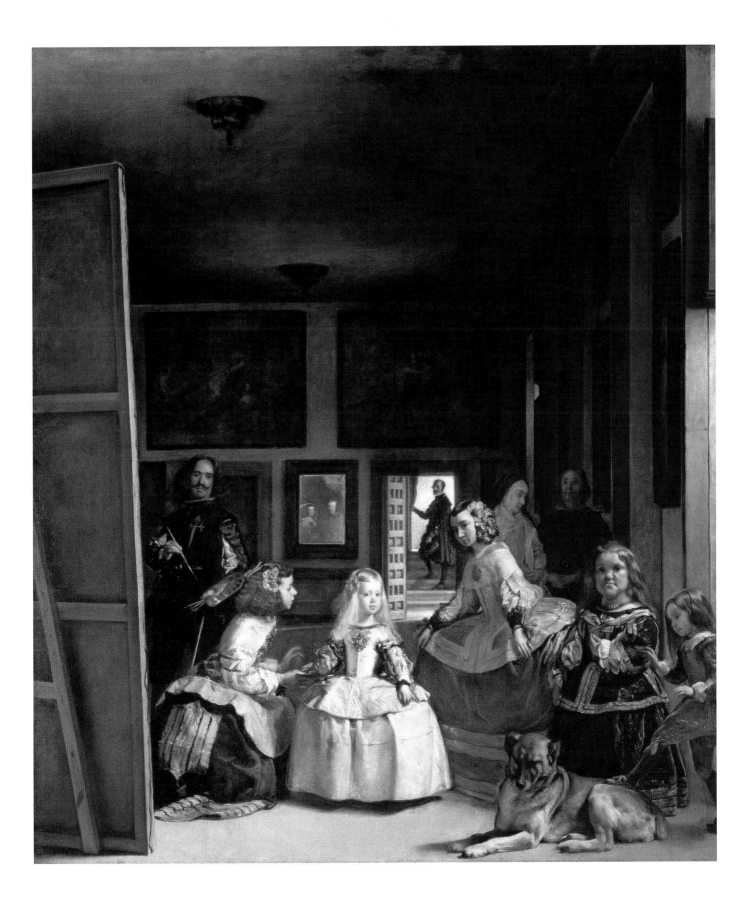

Style and technique
Stylistically, Velázquez's greatest achievement was to inject a new sense of realism into Spanish art. He applied this approach not only to the likenesses of his sitters, but also to their poses and to the distribution of light. Here, for example, the chinks of light from the back window and the open doorway are just sufficient to show the reflection in the mirror, while the paintings on the wall and the figures at the back remain half-hidden in the shadowy gloom. The poses are equally varied and natural, ranging from the discreet curtsy of one of the maids to the playful antics of the midget at right.

Velázquez has included genuine paintings in the background of his masterpiece. These two pictures have been identified as Pallas and Arachne and Apollo and Pan. In both cases, they were copies of Rubens's sketches by Velázquez's pupil Juan Mazo.

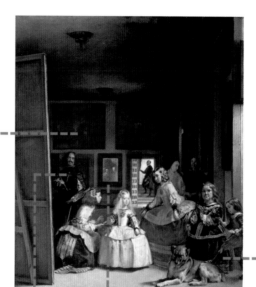

Velázquez took care to make even the subsidiary figures seem realistic. In a typically lifelike gesture, the midget Nicolás de Pertusato mischievously prods the sleeping dog with his foot.

The emblem of the red cross on Velázquez's chest was added after the picture was completed. It indicates membership of the prestigious Order of Santiago, an honor Velázquez was only awarded in 1659.

The mirror shows a reflection of King Philip IV and Queen Mariana. Some writers have suggested that this detail is not a mirror, but is a painting or even a reflection of a painting. However, the blurred image and the light around the edge of the rectangle belie this.

Jesters and dwarfs

Velázquez's paintings provide a fascinating record of life at the Spanish court.
He did not restrict his portraits to members of the royal family, but also depicted
many of their less fortunate retainers, investing them with a rare dignity.

Even in his early *bodegones* (kitchen or tavern scenes), it was obvious that Velázquez was determined to portray all his sitters, however humble their origins, in a sympathetic and non-judgmental fashion. He maintained this attitude when he became court painter in 1623. The king surrounded himself with a variety of dwarfs, buffoons, and jesters, many of whom suffered from mental or physical disabilities. At various times, he called upon Velázquez to paint them, and the resulting portraits are, in their own way, every bit as impressive as those of the artist's royal patrons.

There was nothing new about the depiction of court fools, but in earlier times there had been a tendency to reduce these subjects to caricatures or comic grotesques. However, Velázquez treated each of them as individuals, depicting their infirmities with an unsparing sense of realism. In the portrait of Francisco Lezcano, for example, his brush was so accurate that doctors have been able to diagnose a thyroid deficiency as the precise cause of the sitter's ailment.

More impressive still was the artist's delineation of character. His portrait of Don Sebastián de Morra (c.1643–49) shows a figure bristling with resentment and defiance at his lot. The dwarf had good cause, for he was passed from one royal master to the next like a piece of property. Nor does it come as a surprise to find that, instead of the usual gifts of extra food and wine, Don Sebastián preferred to receive swords and daggers.

In sharp contrast, Velázquez's portrait of El Primo (c.1636–44) shows the sitter with a calm and learned expression, as he leafs through what for him is a giant ledger. Unlike his fellow dwarfs, he was employed as one of the king's secretaries, and his pride in this responsible work is reflected in his sober expression.

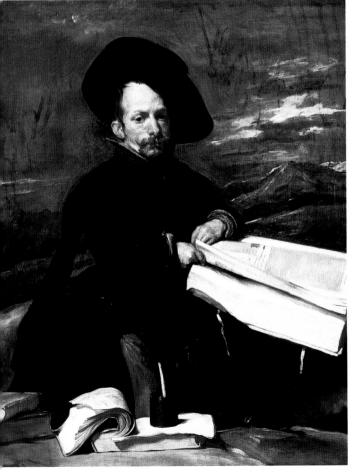

Left: Velázquez, El Primo, c.1636–44. In this dignified image, El Primo is shown from a low viewpoint; he wears formal clothes and appears lost in contemplation.

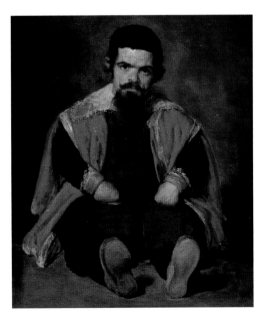

Right: Velázquez, Sebastián de Morra, c.1643–49. Using a plain background and strong tonal contrasts, Velázquez portrays Morra with intense gaze and clenched fists.

JAN VERMEER
MAID POURING MILK
c. 1658-60

his picture has always been regarded as one of the most exceptional works by the Dutch painter Vermeer (1632–75). Even when the artist's reputation was at its lowest ebb, the painting invariably drew warm praise from the critics. It highlights Vermeer's particular talent for depicting the finest nuances of light and texture, while also epitomizing his tranquil view of the world. The enduring popularity of *Maid Pouring Milk* is due, in part, to its humble setting. In most of his canvases, Vermeer depicted elegant and well-appointed interiors. Here, almost uniquely, he portrayed a modest household. In place of the usual rich furnishings, embroidered textiles, and stained-glass windows, the artist focused on a bare and shabby kitchen. The nails banged into the far wall, the cracks in the plaster, the dirt above the tiles and on the floor, the clumsy joinery of the window, and the soiled panes of glass—one of which is broken—are all reproduced with painstaking care.

The maid herself has coarse features and a robust physique, but also displays a serene grandeur. Some commentators have suggested that she may have been the Vermeers' own maid, Tanneke Everpoel. The most impressive feature of all, however, is the way that the artist rendered the fall of light within the room. It illuminates part of the wicker basket and the brass utensil, which are both hanging on the wall, but leaves the tiny picture above them hidden in the shadows. In the same way, Vermeer added flecks of white pigment to the bread, the basket, and the earthenware pitcher, to convey the glints of sunlight flickering across the table.

Vermeer's output appears to have been small—only about thirty-five to forty paintings by him are known—and he rarely left his native city of Delft. After his death, his reputation plummeted, and he was only rediscovered in the nineteenth century. Despite this obscurity, *Maid Pouring Milk* was always greatly admired. It was auctioned four times in the eighteenth century, attracting respectable prices on each occasion, and Joshua Reynolds, president of the Royal Academy, singled it out for praise in his account "Journey to Flanders and Holland," published in 1797. The true celebrity of the picture became apparent in 1907, when it seemed likely that it would be sold abroad. This prospect provoked a national scandal, as art lovers bemoaned the loss of a painting that seemed to encapsulate the spirit of Holland. Eventually, the government relented and Vermeer's masterpiece was purchased for the Rijksmuseum in 1908.

Jan Vermeer, *Maid Pouring Milk*, c.1658–60, oil on canvas (Rijksmuseum, Amsterdam)

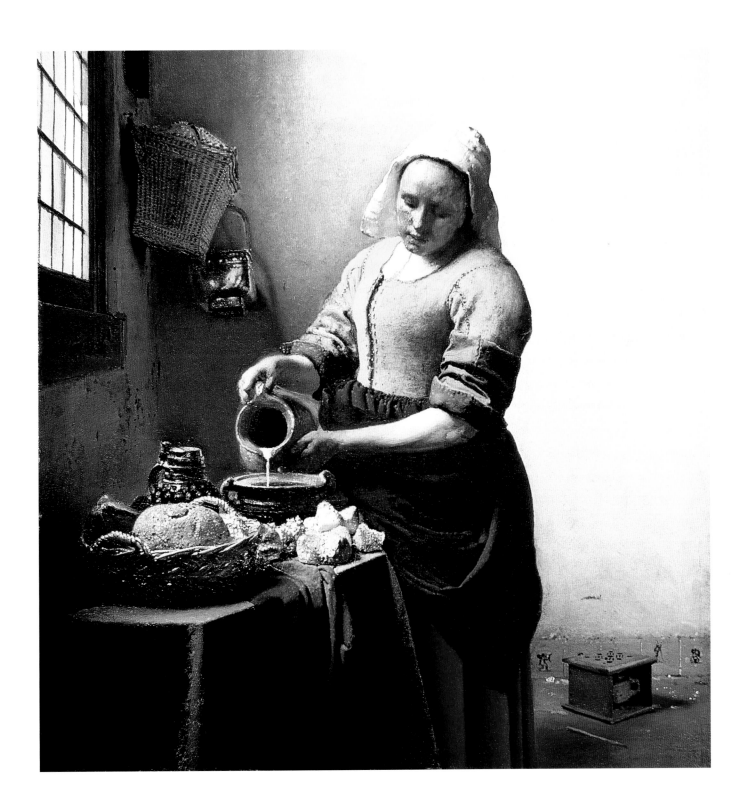

Style and technique

Little is known about Vermeer's working methods and no drawings by him survive. Historians have long suspected that he made use of a camera obscura, a mechanical copying device, to trace the outlines of some of the objects in his pictures. It was certainly not a major factor in his work—X ray examinations show that he made copious modifications to his compositions—but it may explain some of the unusual effects in his paintings and the way he rendered light and surfaces. In this picture, for example, the slightly out-of-focus appearance of the still life might reflect the effects of crude lenses.

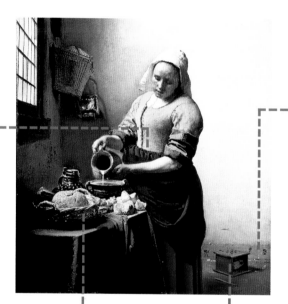

Vermeer's use of color enhances the apparent simplicity of the image and its subject. The painting is centered around yellow and blue, which are set against more muted pinky reds, creams, and ochers.

A row of tiles lines the bottom of the wall. Delft was famous for its pottery, and tiles like these could have been found in any household, rich or poor.

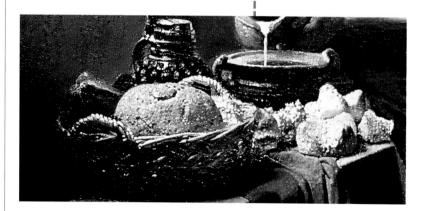

Vermeer created the remarkable lifelike appearance of the still-life details by focusing on the highlights that reflected off their surfaces. Rather than delineating them with the precisely modulated style popular at the time, he used loosely applied combinations of yellow, beige, and white that blend when seen from a certain distance. Some commentators have seen Vermeer's broad handling as evidence that he used a camera obscura.

A foot warmer is displayed prominently, if somewhat incongruously, on the kitchen floor. Educated contemporaries would have known that it was a conventional emblem signifying a lover's desire for constancy.

Everyday symbols

Today Vermeer's refined depictions of quiet domestic scenes appear so natural that it is hard to believe they carried any hidden messages, but they are part of a long tradition of symbolism in Dutch art.

Painters in the Low Countries—present-day Holland, Belgium, and Luxembourg—had always been fond of portraying their subject matter, whether serious or lighthearted, in the guise of everyday life. In early Netherlandish art, for example, depictions of the Annunciation were often set in a normal domestic interior, where the purity of the Virgin was symbolized by everyday items, such as a lily or a ewer and basin. A similar form of symbolism was also apparent in secular art. The scenes of peasant dances and carnivals by Pieter Bruegel (see pages 54–57) were packed with tiny symbolic details relating to contemporary sayings and proverbs. As such, they conveyed moral lessons, which would have been readily understood by Bruegel's public, but which are far less obvious to a modern viewer.

By the seventeenth century this trend had mushroomed, stimulated by the rise of the emblem book. This curious form of publication, in which the illustrations were part puzzle and part sermon, became immensely popular in Holland. More than two thousand different emblem books were published, containing tens of thousands of individual symbols. Small wonder that Roemer Visscher, the author of one of the most popular titles—*Sinnepoppen*, or "Mind Games"—remarked that "no objects are empty or meaningless."

Above: Jan Steen, Beware of Luxury, *c.1663. Everything in this crowded, untidy household has a symbolic meaning.*

Some artists were very open in their use of symbols. Jan Steen (c.1625–79), for example, gave his pictures explicit titles, such as *Beware of Luxury* or *The Dissolute Household*, which he inscribed on reckoning slates within the paintings. Most artists, however, preferred a more enigmatic approach, and as a result, the dividing line between reality and symbol is often unclear. Vermeer's *Lady Standing at the Virginals* (c.1670–72), for example, features an obvious emblem in the form of a painting of cupid holding an ace, signifying that "perfect love is for one alone." In *Maid Pouring Milk*, the purpose of the foot warmer, another amorous emblem, is far less certain.

Left: Pieter Bruegel, The Peasant Dance, *c.1567. The scene underlined people's folly by reference to contemporary proverbs.*

CANALETTO
A REGATTA ON THE GRAND CANAL
c.1735

analetto's reputation is unique. No other artist has become so closely identified with the place where he lived and worked. There is no definitive painter of New York, London, or Paris, but Venice will always be seen through the eyes of Canaletto (1697–1768). This painting shows one of the artist's most popular views of his native city, rendered with the linear precision and detail typical of his style. It depicts the gondola race, which is a highlight of the annual regatta. The course runs from eastern Venice, along the full extent of the Grand Canal, and then back to the Volta (the turn in the canal) and the *macchina*, which is pictured here on the far left. The *macchina* was the winners' pavilion, a grand temporary structure erected on a floating platform next to the Palazzo Balbi. At the top, Canaletto shows it decorated with the arms of the doge, Alvise Pisani. Here, the victors were greeted following their success, receiving prizes of colored pennants and money, along with the acclamation of the crowd.

The regatta took place on February 2, the feast day of the Purification of the Virgin, during Venice's carnival season, and Canaletto has taken pains to capture the festive mood. Many of the spectators wear the "domino," the white mask, black cape, and tricorne, which was the traditional costume of the carnival. In addition, balconies are festooned with colorful banners, and some private boats are gaily decked out with elaborate plumes. The canal itself seems much narrower than usual, because of the veritable flotilla of spectators who are competing for the best possible view of the race.

It is not difficult to see why Canaletto chose to portray this particular scene. Venice was flooded with tourists during the carnival season, and many of them were eager to take away some memento of their visit. Several versions of this painting are known, all very similar in composition, though with some minor variations in color and detail. More significantly, perhaps, an engraving of the scene was included in the *Prospectus Magni Canalis Venetiarum*, a collection of the artist's best-known views of the Grand Canal, which was first published in 1735. The composition of the painting may owe something to Luca Carlevaris (1663–1730), who had produced several versions of the subject earlier in the century.

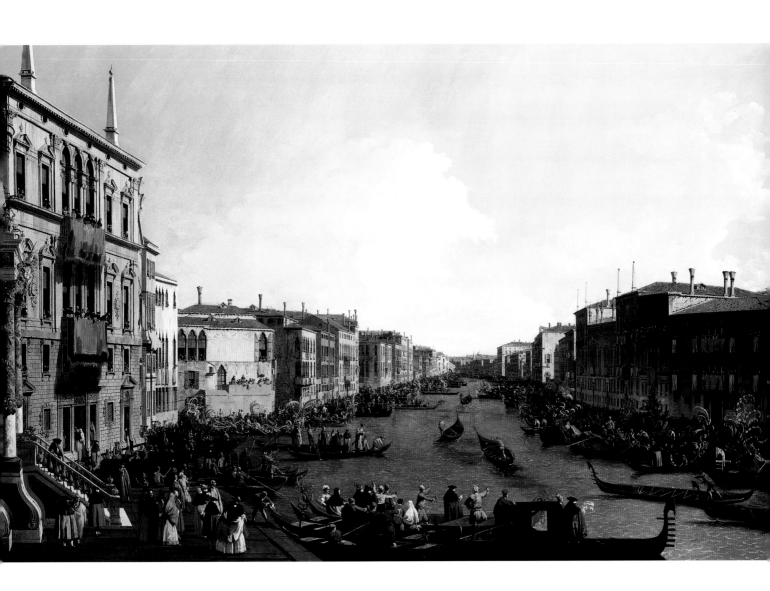

Canaletto, *A Regatta on the Grand Canal*, c.1735, oil on canvas (National Gallery, London)

Style and technique
Canaletto owed his success to his remarkable eye for detail. His paintings are notable for their precise draftsmanship and their wealth of tiny, lifelike incidents. There is some dispute about the way he achieved his meticulous style. It seems quite likely that he used a camera obscura (see page 92) to assist him in the delineation of the views he recorded. However, it is equally clear that preparatory drawings played an even greater part. Canaletto made countless sketches of Venice, which he annotated carefully, noting the business of particular shops and the color of their shutters.

Rapidly applied flourishes of paint convey the flamboyant figureheads of the boats, such as the dragonlike creation in the foreground and the golden bird in the middle distance. Along with the crowds of spectators, they are included to cater to the tourist's desire for a memento of the carnival.

The low sun casts a warm golden light on the palaces lining the left bank of the canal. The windows and architectural details of the palaces are rendered with precise lines of thin black paint, and their hangings are conveyed with broad strokes of color.

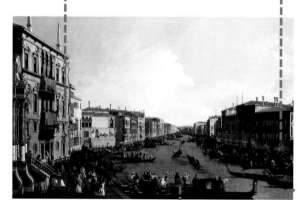

The waves on the canal are conveyed with little more than flickering lines of white paint over the blue-green water, an effective shorthand device.

Spectators wave and point excitedly as the gondoliers race away, and the gestures of these three figures in the foreground lead the eye into the composition. The animated poses and varied costumes of the onlookers—including the traditional carnival garb of tricorne hat, mask, and cape—enliven the scene.

Topographical art

Canaletto achieved lasting fame through his *vedute*, or views, of Venice. His success is all the more remarkable, given that this particular type of painting was normally held in very low esteem.

In most European countries topographical art was regarded as the province of the journeyman. It was the poor relation of landscape painting, which itself was the poor relation of most other forms of art. Topographical painting contained no grand ideas or heroic gestures; it inspired no profound emotions or thoughts. In short, it was seen as a copyist's job. The work was plentiful, particularly for depictions of country houses and their estates, but its lowly reputation meant that it was poorly paid, and this, in turn, ensured that it mainly attracted artists of limited ability. There were exceptions, most notably the Bohemian artist Wenceslaus Hollar (1607–77), but these painters generally struggled to make a living.

This situation began to change as people traveled more and wanted souvenirs of the sights they had seen.

Above: David Roberts, Hebron, Jerusalem, *1839. Roberts made a fortune with his precisely observed scenes of the Holy Land.*

It was also improved by developments in printmaking, which enabled artists to achieve far better returns on each image. The vogue for this type of topographical art can be traced back to Braun and Hogenberg's *Civitates Orbis Terrarum* (Cities of the World, 1572–98), a groundbreaking collection of topographical views, which employed the talents of artists such as Joris Hoefnagel.

Left: Piranesi's Roman Forum *from* Vedute di Roma, *a series of etchings of Rome published from 1745 onward.*

The most lucrative market for topographical art sprang up around the Grand Tour, a cultural journey around the major cities of Europe, which flourished in the eighteenth century. Canaletto soon won renown for his views of Venice, while Piranesi (1720–78) achieved similar fame in Rome. In the following century, art lovers developed a taste for more exotic subjects (see page 121) and scenes. One of the leading painters to depict views of this kind was the Scotsman David Roberts (1796–1864), who traveled widely in the Middle East. Like Canaletto, his work sold well both as paintings and as prints.

WILLIAM HOGARTH
THE MARRIAGE CONTRACT
c.1743

ailed as the leading British artist of his day, William Hogarth (1697–1764) was instrumental in bringing art to a far wider audience. While his paintings were purchased by the wealthy, the engraved versions of his images sold in the thousands, gaining him immense popularity with the public. *The Marriage Contract* is the first of a set of six paintings entitled *Marriage à la Mode*, which provided a satirical look at a fashionable modern relationship. The series tells the story of a disastrous arranged marriage, involving the foppish son of Lord Squanderfield and his middle-class bride. In this particular picture, the earl is shown at right, seated under a grand canopy, pointing to his impressive family tree. Facing him is a bespectacled city merchant, who peruses the contract. Under its terms, the merchant's daughter will gain a title, becoming a member of the aristocracy, in return for a rich dowry, which will solve the earl's pressing financial problems—Hogarth shows a clerk handing the earl a mortgage. The young couple, pictured at left, display no interest in the arrangement. The narcissistic viscount stares at his own reflection in a mirror, while the girl is being accosted by the lawyer Silvertongue, who will become her lover.

In the remaining pictures of the series, Hogarth outlined the rapid, downward spiral of the marriage. Squanderfield takes up with a child prostitute, but is killed in a jealous clash with Silvertongue, who in turn is executed for murder. In despair, the young widow commits suicide by taking poison.

Hogarth had already made his name with similar sets of pictures satirizing social and moral shortcomings—*A Harlot's Progress* (1731) and *A Rake's Progress* (c.1733–35)—which he had made into engravings. As a result, he was well aware that he would earn his money from the prints, rather than the paintings, of the Marriage series. So, although the latter were probably completed in 1743, Hogarth made no immediate attempt to sell them. Instead, they remained on display in his showroom until 1745, when the engravings were ready for sale. This proved a sensible strategy, for when the paintings were eventually offered for sale, the response was extremely disappointing. In 1751 Hogarth put them up in a blind auction, hoping that the set would raise around £600. He received only a single bid, offering a paltry £120.

William Hogarth, *The Marriage Contract*, c.1743, oil on canvas (National Gallery, London)

Style and technique

Many of Hogarth's pictures were effectively painted stories, particularly those that formed part of a series. As a result, the artist's most difficult task was to compress a considerable amount of narrative detail into each scene, while ensuring that it still looked as natural as possible. In tackling this problem, Hogarth used his love of the theater to make his compositions resemble episodes from a play. The actors convey their characters through significant gestures—such as the viscount's effete manner of taking snuff or the merchant's punctilious adjustment of his spectacles—and the plot is underlined by background details, such as documents or paintings on the wall.

The lavish new house seen through the window is the cause of the earl's debts—building work has stopped because he has run out of money. The architect looks on while holding ambitious plans for the project. The mortgage the earl receives in return for his son's hand in marriage will enable work to proceed.

Hogarth used pictures to comment on the scene. Immediately above the young couple is a painting of the head of Medusa, the terrifying snake-haired gorgon of classical mythology, which looks on aghast at the proceedings. All around are images of martyrdom and suffering, and to the left of the window is a bombastic portrait of the earl posing on a battlefield.

Hogarth uses feet as a quick guide to character. Here, the earl's gouty foot, which he rests on a stool, signifies a life of excess, while on the other side of the painting, the viscount's dandyish tiptoeing signifies his effete manner. The family tree next to the earl pokes fun at his pretensions to a long and noble lineage—it springs from the body of William the Conqueror.

At the viscount's feet, two small dogs are chained together, an obvious symbol for the marriage. Like the couple, they show no interest in each other.

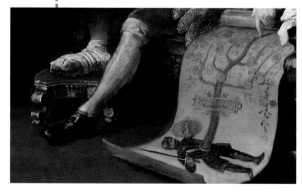

Moralizing art

Hogarth's main ambition was to be a history painter, tackling serious issues in a high-flown manner, but he found success in a very different vein—portraying the foibles of society in series of humorous, moralizing pictures.

Moral themes had long been popular in Western Europe, developing as the secular equivalent of religious art. In the Middle Ages artists began to produce allegorical figures of the Virtues and Vices, sometimes showing them doing battle with each other. During the Renaissance, these qualities were often represented by classical deities, and there was a growing taste for the depiction of moral dilemmas. One of the most popular examples was Hercules at the Crossroads, in which the hero was confronted with a choice between Virtue (a difficult, rocky path) and Vice (an easy, downward slope).

Gradually artists began to work their moral messages into scenes of everyday life. These pictures invariably had to be "read" by the spectator, since the moral was conveyed through symbols or literary references. The peasant scenes of Pieter Bruegel, for example, were often linked to popular proverbs (see page 93), as was much of the work of his predecessor Hieronymus Bosch (see pages 26–29). The latter was one of many artists to draw inspiration from *The Ship of Fools* (1494), an allegorical poem satirizing human folly by the German writer Sebastian Brandt. In Hogarth's case, comparisons have often been drawn between the satirical attacks in his work and those in John Gay's *Beggar's Opera* (1728) or the novels of Henry Fielding—notably *Joseph Andrews* (1742) and *Tom Jones* (1749). Indeed, even the title *Marriage à la Mode* was borrowed from a play by John Dryden.

Hogarth's humorous moral pieces were both more biting and more topical than those of his predecessors. His decision to produce them as sets of pictures enabled him to develop a substantial storyline, while their production as prints found a broad and ready market.

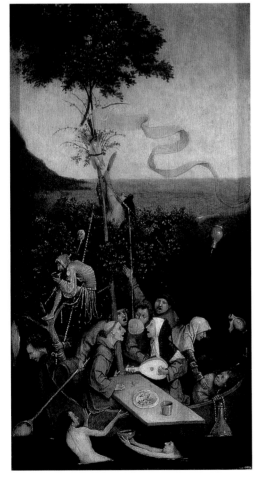

Left: Hieronymus Bosch's The Ship of Fools *(c.1500) satirizes the vices of fifteenth-century society.*

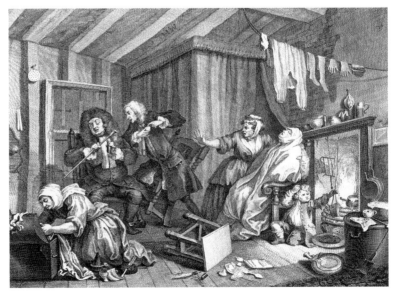

Below: A plate from Hogarth's A Harlot's Progress *(1731) showing the death of M. Hackabout, whose demise the series charts.*

THOMAS GAINSBOROUGH
MR. AND MRS. ANDREWS
c.1748–49

T his is the masterpiece of the English artist Gainsborough's (1727–88) early career, painted while he was still essentially a provincial artist. It illustrates not only his gift for capturing a fine likeness, but also his blossoming talent as a landscape painter. The young couple are Robert Andrews and his wife, Frances Carter. They were married in Sudbury, Suffolk, in November 1748 and it is highly probable that this picture was painted shortly afterward to commemorate the event. Gainsborough portrayed the elegantly dressed couple in the fashionable rococo style (see page 109) on the grounds of their estate, The Auberies. Indeed, the whole of the right half of the picture is devoted to a lyrical depiction of the farmland and woods that they owned. The view can still be identified today: The church towers of Sudbury (center) and Lavenham (left) can be seen in the background.

Gainsborough had known the couple since childhood, though not as their social equal. They were landed gentry, while he was the son of a failed businessman. So, although he and Andrews had both attended the local grammar school, Andrews had gone on to Oxford University while Gainsborough had become a lowly apprentice. This division in status may account for the sitters' somewhat disdainful expression.

The portrait contains other, more tangible evidence of the couple's class. Robert nonchalantly holds a gun—an indication that he enjoyed the privilege of owning a license to shoot game. He also stands with a proprietorial air in his fine estate. In Gainsborough's childhood, much of this countryside would have been common land, but Andrews was one of a new breed of "improving" farmers, who enclosed their land and ran it in an ordered, profitable manner. The prominence of the estate is particularly appropriate, given that this is a marriage painting. For it appears that both the Andrews and the Carters had interests in the land, and the match may have been conceived as a marriage of convenience, designed to rationalize the estate, which would account for the frosty atmosphere that seems to exist between the couple.

If Gainsborough had any reservations about his patrons, he certainly had none about their setting. Sudbury was his birthplace, and from the moment he became an artist, he desired nothing more than to paint the countryside around it. There was little demand for landscapes in this period, however, so reluctantly he was obliged to make his living as a "face-painter."

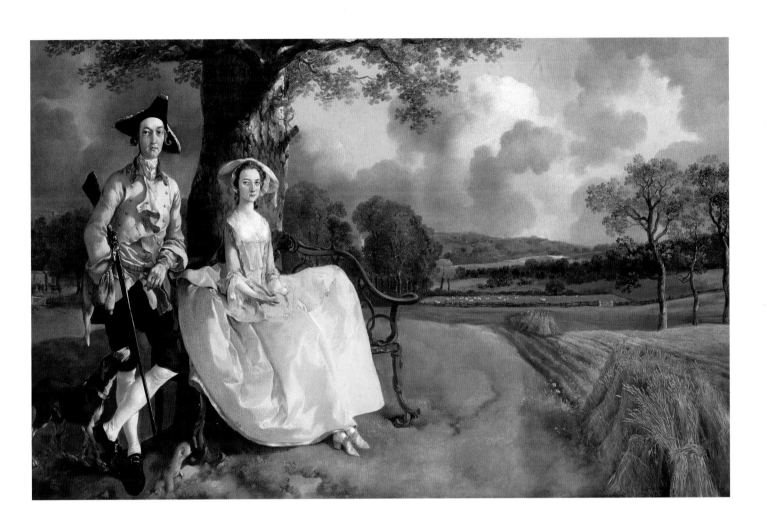

Thomas Gainsborough, *Mr. and Mrs. Andrews*, c.1748–49, oil on canvas (National Gallery, London)

Style and technique

In keeping with the artistic practice of his time, Gainsborough worked separately on the figures and the landscapes in his paintings. In spite of his skill at portraying faces, he was far less confident about depicting the remainder of the anatomy. He used "lay figures"—miniature, jointed mannequins—in a bid to overcome this problem, but the figures in his early portraits still display a doll-like stiffness. His landscapes, however, are far more freely handled. Gainsborough went on sketching trips in the countryside and often brought back clumps of foliage or pieces of bark to the studio to copy in greater detail.

The section of the painting showing Frances Carter's lap is unfinished. Writers have suggested that the artist intended to show a book here, or else a bird that her husband had just shot. It is not known why Gainsborough left such a tiny part of the painting incomplete. However, the couple appear to have been happy to accept the painting in this state, and it remained with their descendants until 1960.

Bundles of corn are stacked in the field to the right of the couple. Their inclusion in a marriage picture is appropriate, as sheaves of corn were a conventional symbol of fertility.

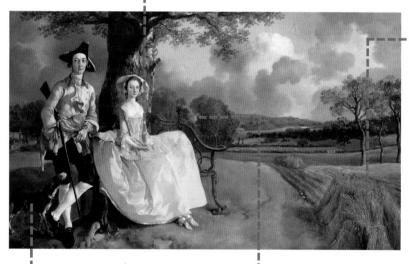

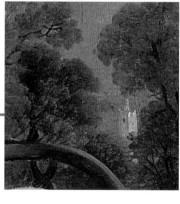

A gundog stands at his master's side, a subtle variation on the traditional inclusion of dogs in marriage portraits as symbols of fidelity (see Van Eyck's Arnolfini Wedding, *pages 18–21, and Hogarth's* The Marriage Contract, *pages 98–101).*

The setting of this picture can be identified precisely. The church tower in the center belongs to Saint Peter's in Sudbury, the town where Gainsborough was born.

The conversation piece

With its air of informality and its glorious setting, the portrait of Mr. and
Mrs. Andrews is Gainsborough's finest conversation piece, an elegant form
of portraiture that became fashionable in the eighteenth century.

A conversation piece is a group portrait of two or more figures, shown conversing or socializing with each other in a leisurely manner. The sitters are posed in a detailed setting, which may be indoors or outdoors and in most cases is their family home or estate. These backdrops enabled people to show off their possessions and wealth—a long tradition in portraiture—while landscapes reflected the rococo taste for parkland settings.

The keynote of the conversation piece is informality, and this type of portrait evolved specifically as an antidote to the pomp and grandeur of baroque portraiture (see page 69). For this reason, perhaps, the genre gained early acceptance in Holland, where the art market was dominated by a wealthy bourgeoisie, who were unimpressed by the pretensions of aristocratic portraiture.

The conversation piece was introduced into England in the early years of the eighteenth century by foreign artists such as Philippe Mercier (c.1689–1760) and Joseph van Aken (c.1699–1749). The theme was rapidly taken up by a number of native painters, including William Hogarth (see pages 98–101), although the real pioneers were two comparatively minor artists, Arthur Devis (1711–87) and Francis Hayman (c.1707–76). Gainsborough met Hayman when he was studying at Saint Martin's Lane Academy in London.

By the 1740s the conversation piece was beginning to fall out of fashion in the big cities, although it remained popular in the provinces. Gainsborough's portrait of Mr. and Mrs. Andrews may be a late example, but it is also one of the most elaborate. The decision to place the figures at the side of the composition is unique. The patron may have been persuaded that this was a good way of showing off his property, but there has to be a suspicion that Gainsborough was simply far more interested in painting the landscape.

Below: Francis Hayman, George Rogers with His Wife Margaret and His Sister Margaret Rogers, *c.1748–50.*

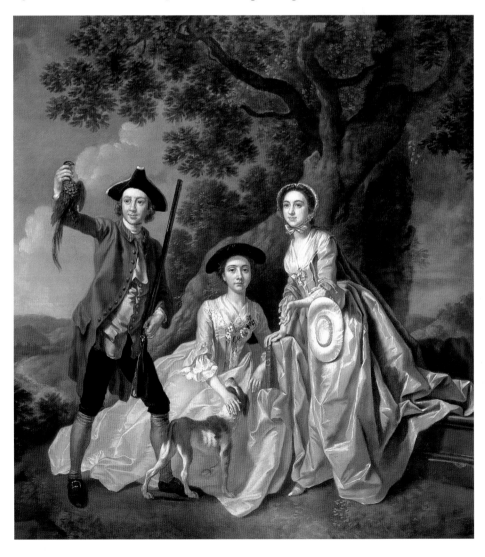

JEAN-HONORÉ FRAGONARD
THE SWING
c.1766

his mischievous slice of light-hearted eroticism epitomizes the elegance and frivolity of the rococo style (see page 109), which flourished in France in the years leading up to the French Revolution (1789). The mood of the painting is witty and carefree, although inevitably it is tempting for modern spectators to view it as the product of a society that was living on borrowed time. The basic theme of the picture was conceived by its patron, the Baron de Saint-Julien. He wanted it to show his mistress on a swing, being pushed by a bishop, while he himself was portrayed as an onlooker in the bushes. The presence of the bishop was meant as a harmless, private joke, as Saint-Julien held the post of receiver general of the French clergy. Even so, the subject was sufficiently risqué to deter the first artist approached by the baron. He was a painter named Gabriel-François Doyen, who recommended Fragonard (1732–1806) instead. At this stage, the latter was a rising young artist who had just become a member of the French Academy. He had no qualms about accepting the commission, although he did insist on making a number of changes to the composition.

Fragonard dispensed with the bishop and transformed the picture into a more conventional theme: a pair of young lovers outwitting an aging husband. The swing itself was a traditional symbol of inconstancy, and the artist reinforced this notion with a number of charming details. The girl's missing shoe, kicked playfully into the air, symbolizes her loss of innocence, while the lover's outstretched arm has obvious phallic overtones. Even the statue of Cupid (at left) joins in the conspiratorial mood, raising a finger to its lips to signal secrecy.

For all its playfulness, *The Swing* has a somber history. By the time of the French Revolution the picture was owned by Ménage de Pressigny. He was guillotined in 1794, however, and the painting was confiscated. It was later offered to the Louvre in 1859, but the gift was rejected. Fragonard suffered a similar decline in fortune. He trained under François Boucher (1703–70), an immensely successful and prolific artist and a leading light of the rococo style. He went on to win the coveted Prix de Rome, a scholarship to study in Rome awarded by the French Academy, and spent five years in Italy before returning to France to forge a hugely successful career as a purveyor of exuberant boudoir scenes. However, as the French Revolution approached, his style fell dramatically out of fashion, and by the time of his death, Fragonard was a forgotten man.

Jean-Honoré Fragonard, *The Swing*, c.1766, oil on canvas (Wallace Collection, London)

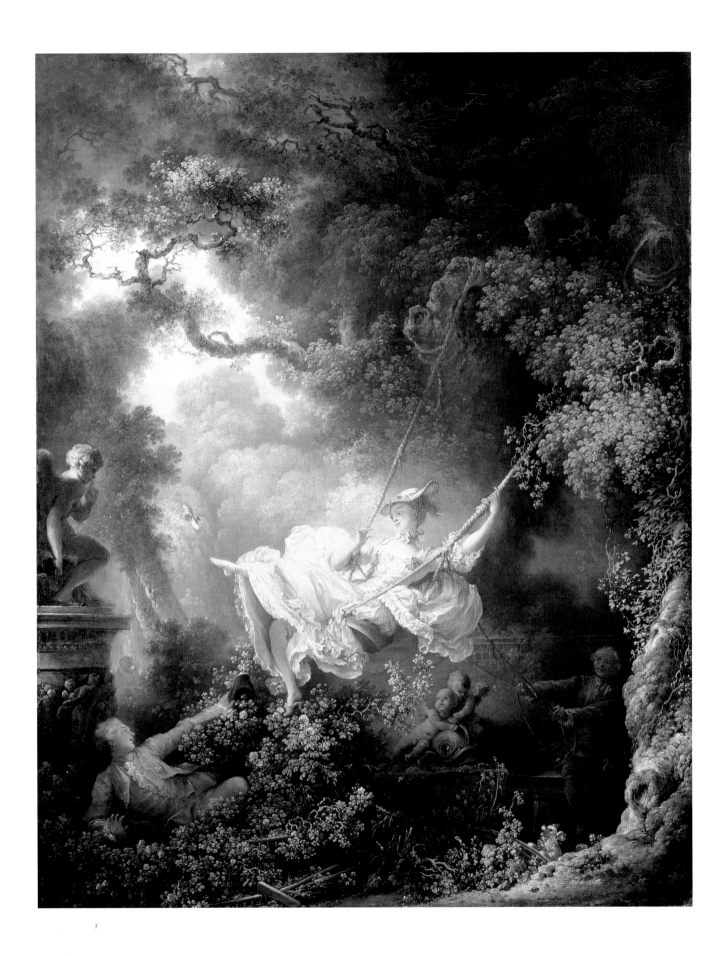

Style and technique

Versatility, speed, and sensuality were the watchwords of Fragonard's style. He painted quickly, determined that his brushwork should seem lively and spontaneous at all times, and his colors were generally light and delicate. He tackled a wide variety of themes—landscapes, portraits, genre scenes, and boudoir pictures—but all of them have the same animated quality. Light seems to flicker across his paintings, spotlighting small, apparently random sections of the canvas. Fragonard also liked to emphasize the sensual aspects of materials. In The Swing, you can almost sense the swish of the petticoats and the rustling of the leaves.

In this statue, the chubby figure of Cupid raises his finger to his mouth as if to keep the amorous young couple's affair secret. Statues often appear to participate in the action in rococo paintings. This conspiratorial Cupid is admirably suited to the occasion, but contemporaries would also have recognized that it was based on a real statue, L'Amour Menaçant ("Cupid's Warning"), by the French sculptor Etienne-Maurice Falconet (1716–91).

Like the statue of Cupid, this sculpture is also relevant to the main subject of the painting. The winged infants, known as putti, and the dolphin are associated with Venus, the goddess of love. The putti are messengers of love while the dolphin relates to the goddess's birth from the sea (see pages 22–25).

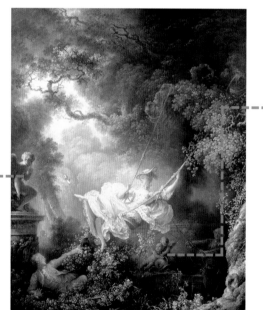

A discarded rake lies in the foreground, confirming that the setting, which at first glance appears to be dense woodland, is in fact a garden. Such parkland backdrops were popular in rococo paintings. Fragonard may have concocted much of the setting in his studio, which he always kept well stocked with luxuriant shrubs for just this sort of purpose. In the twentieth century the society photographer Cecil Beaton (1904–80) used this landscape backdrop as the setting for some of his portraits of members of the British royal family.

The inclusion of this little white lapdog is a nice ironic touch. Dogs were traditional symbols of fidelity (see page 20), and true to this purpose, the dog is yapping loudly to warn of the lovers' affair. The cuckolded husband, however, pays it no attention.

The rococo style

The rococo style embraced the very different fields of architecture, the decorative arts, and painting. In the latter, its greatest achievements can be found in France, particularly in the work of Jean-Antoine Watteau, François Boucher, and Fragonard.

In common with many other trends in art, the style now known as "rococo" was first given its name as a form of abuse. The term was invented at the end of the eighteenth century, when the style was all but defunct, as a humorous combination of the French words *rocaille*—a type of fancy rockwork used for fountains and grottos—and *barocco* (baroque).

The style emerged in the early eighteenth century, largely as a reaction against the pomp and grandeur of the baroque (see page 69). Initially, its effects were felt most strongly in such areas as interior design and furniture, and it is no accident that most rococo painters were also designers. In painting, the movement was characterized by

playfulness, elegance, frivolity, and a lightness of touch. Amorous themes were especially popular, and these often involved pastoral settings or fancy dress. Watteau (1684–1721), in particular, is closely associated with a type of painting known as the *fête galante* (courtship party), in which exquisitely dressed people relax in idealized, rustic landscapes. Boucher's best-known painting, *Reclining Girl* (1751), is executed with a mischievous eroticism typical of the rococo. Fragonard's *The Swing* draws together both these aspects of the style. In almost any other age, the subject of infidelity would have been accompanied by an element of moralizing. Fragonard, however, reveled in the flirtatious atmosphere,

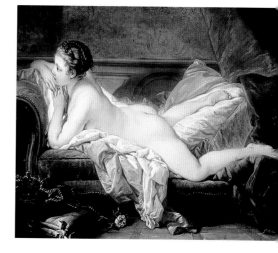

Above: François Boucher's playfully erotic Reclining Girl, *1751, probably shows King Louis XV's mistress Louisa O'Murphy.*

showing no interest at all in the plight of the victim who fades anonymously into the undergrowth.

In France the rococo style was intimately linked with the *ancien régime*, the political and social framework of pre-Revolutionary France, and ultimately shared its fate. By the 1770s the tide of taste was already turning in favor of the stern, moral lessons of neoclassicism (see page 117). For Fragonard, this change was signaled by the reception of one of his finest works, *The Progress of Love* (1771–73), painted for the king's mistress. This set of four pictures was returned to the artist in 1773, because his patron felt it too old-fashioned.

Left: In this fête galante, *or courtship party, by Watteau, couples flirt in a parkland setting under a statue of Venus and Cupid.*

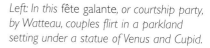

BENJAMIN WEST
THE DEATH OF WOLFE
1770

 he American Benjamin West (1738-1820) was a pioneer of the neoclassical style in England, where he became the first artist to earn a successful living as a history painter. *The Death of Wolfe* was his outstanding work in this vein. West's subject was taken from a recent event in British history. In 1759 Major General James Wolfe (1727-59) had triumphed in a famous battle against the French, when he captured the stronghold of Quebec. This victory was a key event in the contest between the two imperial powers for control of Canada and in their wider struggle for supremacy in the Seven Years' War (1756-63). Success was achieved at a cost, however, for Wolfe was killed, just as victory lay in sight.

The artist has focused on this dramatic moment. At the edge of the battlefield, Wolfe lies stricken, mortally wounded. He is surrounded by his fellow officers, who look on in anguish at their fallen commander. To the left, meanwhile, a messenger arrives with news of victory, a final consolation for the dying man. On hearing this, Wolfe apparently remarked, "Now, God be praised, I will die in peace."

The choice of a comparatively modern subject was unusual in a history painting, although not as revolutionary as West's first biographer John Galt (1779-1839) was later to claim. There was certainly nothing journalistic about the artist's approach. Most of the figures in the composition can be identified, but virtually none of them were actually present at Wolfe's demise. The presence of the Native American, too, is a purely symbolic touch. Nevertheless, the sheer popularity of the painting did mark a watershed in the development of a genre that had never been particularly successful in Britain. In part, its success may have been due to the shrewd marketing of the image. The English engraver William Woollett (1735-85) published a print of the picture in 1776 that sold in huge numbers, both in England and abroad, and netted some £15,000—a vast sum for the time. In its turn, the engraving created a vogue for prints with historical themes.

The Death of Wolfe was exhibited at the Royal Academy in 1771, where it met with great acclaim and was purchased by Lord Grosvenor. In 1918 one of his descendants, the Duke of Westminster, donated the picture to Canada in recognition of the country's outstanding contribution to the Allied forces during World War I.

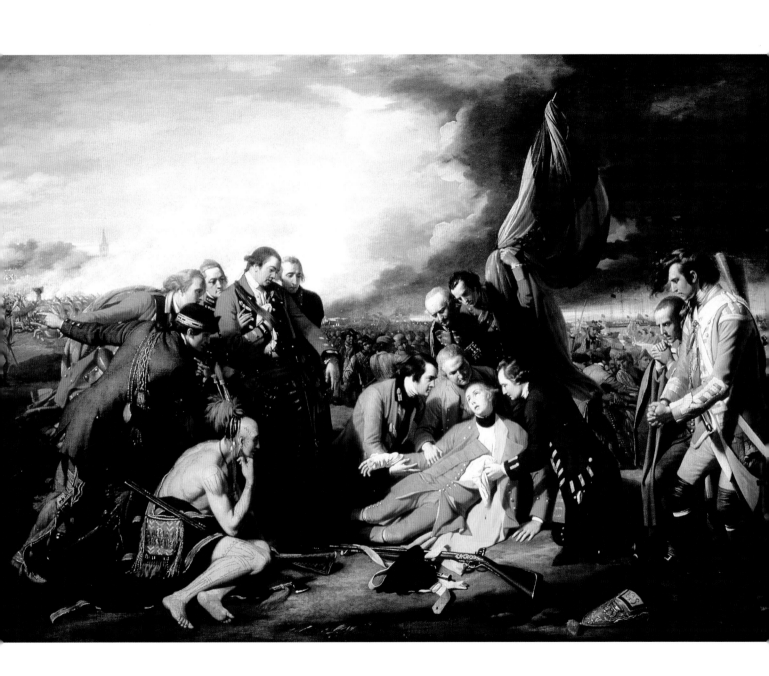

Benjamin West, *The Death of Wolfe*, 1770, oil on canvas (National Gallery of Canada, Ottawa)

Style and technique

It was traditional for history paintings to echo great works of art from the past, although not necessarily subjects from antiquity. In The Death of Wolfe, West has set his composition in the mold of a Lamentation—a scene of mourning over the dead Christ (see pages 10–13). The circle of officers recalls the grieving disciples, while the flag behind the fallen soldier echoes the image of the empty cross. The mood of the painting is mirrored in the sky. Dark clouds loom over the dying man, but conditions are much brighter over the victorious English forces.

West depicted a full range of emotions in the picture. This messenger, removing his hat in celebration, is coming to announce the impending victory. He is unaware of Wolfe's plight.

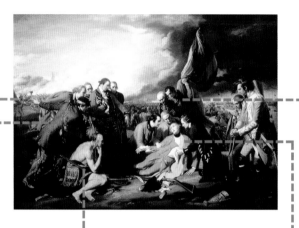

The officer holding the loosely furled flag behind the main group of figures has been identified as Lieutenant Henry Brown. Of all the characters portrayed in this painting, he is probably the only one who was actually present at Wolfe's death.

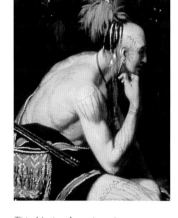

The figure in a green jacket relays the messenger's news of victory. He is an American ranger scout, and some people have identified him as Robert Rogers (1731–95), who, with his men—the Rogers's Rangers—played an important part in the fighting against the French.

This Native American is a symbolic figure, representing the Americas—in his thoughtful pose, he also adds an air of reflection and nobility to the scene. It has been suggested that West introduced him as an exotic feature, which would have had the same distancing effect for a British viewer as the use of classical dress in more conventional history paintings.

Wolfe is supported by his officers, one of whom holds a cloth to the fatal bullet wound in his side. The general's languid pose is that of the fallen hero, but more specifically draws on the Christian theme of the Lamentation. For while West gave his painting immediacy by showing its protagonists in contemporary costume, he also drew on the powerful associations of traditional imagery.

Modernizing history painting

West's depiction of the death of General Wolfe has often been seen as a revolutionary picture, which changed public attitudes to the form and content of history painting.

The reputation of this canvas owes much to an anecdote related by West's biographer John Galt. According to him, Joshua Reynolds, the president of the newly created Royal Academy, was horrified when he learned that West had embarked upon a history painting in which the figures were shown in modern dress. He confronted the American and urged him to portray the figures in classical garb, as this would lend his picture the nobility and timeless quality that were the ultimate aims of the best history painters.

West refused to compromise, however, arguing that the event had taken place "in a region of the world unknown to the Greeks and Romans,"

adding that "the same truth that guides the pen of the historian should govern the pencil of the artist." Reynolds remained unconvinced until he saw the finished picture, when he acknowledged that "Mr. West has conquered. He has treated his subject as it ought to be treated." Furthermore, the president of the Royal Academy expressed his belief that the painting "would occasion a revolution in art."

Although it has often been repeated, this account is highly spurious. Before *The Death of Wolfe*, history paintings had often portrayed their protagonists in modern dress, as Reynolds would certainly have known. Indeed, an earlier version of this very

subject, produced by the English artist Edward Penny in 1763, had shown the participants in contemporary clothing. In fact, English history painters were never as enthusiastic about the idea of classical dress as their counterparts in France, where the issue had republican overtones (see page 117). Nor was West himself a committed modernizer. Years later, when he painted *The Apotheosis of Nelson*, he portrayed the hero in the company of Britannia and an angel. Even so, it is certainly true that, as foreigners working in England, West and his fellow American John Singleton Copley (1738–1815) breathed new life into the genre of history painting.

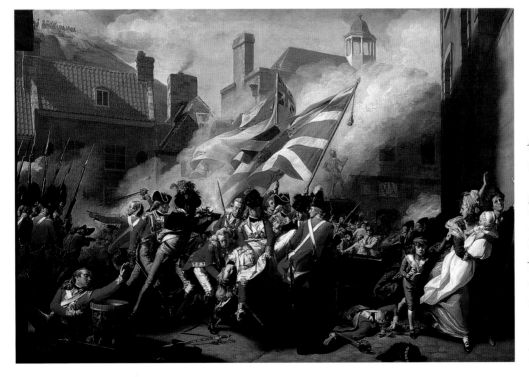

John Singleton Copley, The Death of Major Peirson, January 6, 1781, 1783. One of Copley's greatest history paintings, this picture celebrates the British defeat of French forces on the island of Jersey and pays tribute to the young Major Peirson who lost his life in the process. It develops West's portrayal of the noble modern hero with great drama of color and movement.

JACQUES-LOUIS DAVID
THE DEATH OF MARAT
1793

ew artists have captured the spirit of their age more completely than the French painter David (1748–1825). He lived through the turbulent era of the French Revolution (1789) and was closely involved in its violent aftermath. His passionate commitment to the cause, together with his firsthand knowledge of the leading political figures, placed him in a unique position to capture both the excitement and the terror of the time. This painting commemorates a key incident in the French Revolution. Nicknamed "the friend of the people," Marat was a member of the National Convention (the new political body created after the French Revolution) as well as a leading light of the extremist Jacobin faction. Together with Robespierre and Danton, he was effectively one of the rulers of revolutionary France. His call for a dramatic increase in the execution of his political opponents aroused both fear and hatred, however, and on July 13, 1793, he was killed while taking a bath. His assassin was a young woman named Charlotte Corday, a supporter of the moderate Girondin group, who was guillotined four days later.

David immediately decided to pay tribute to the dead leader by painting this dramatic scene. The artist's involvement was perfectly natural. He was himself an elected member of the National Convention, and had been both a friend and a colleague of Marat. Indeed, he had visited him at his home on the day before the attack.

David's painting is a powerful combination of convincing reportage and striking propaganda. Marat had a serious skin complaint, which prompted him to take frequent, cooling baths. Because this was a time-consuming procedure, he used the opportunity to carry out some of his official duties, as well as to receive visitors. David was among these guests, so he would have known that the statesman frequently wrote letters in the bath. He would also have known that Marat's ailment led him to wear a vinegar-soaked turban and to drape a sheet inside the bath to keep his sores from rubbing against its metal surface. At the same time, David was careful to remove all traces of the dead man's blemishes, while also turning his well-appointed bathroom into the most spartan of settings.

For a time the picture held something of the status of an icon. It was exhibited in the courtyard of the Louvre, along with the fateful bath. After David's fall from favor, however, *The Death of Marat* was returned and he took it with him to Brussels, where he lived out his final years in exile.

Jacques-Louis David, *The Death of Marat*, 1793, oil on canvas (Musées Royaux, Brussels)

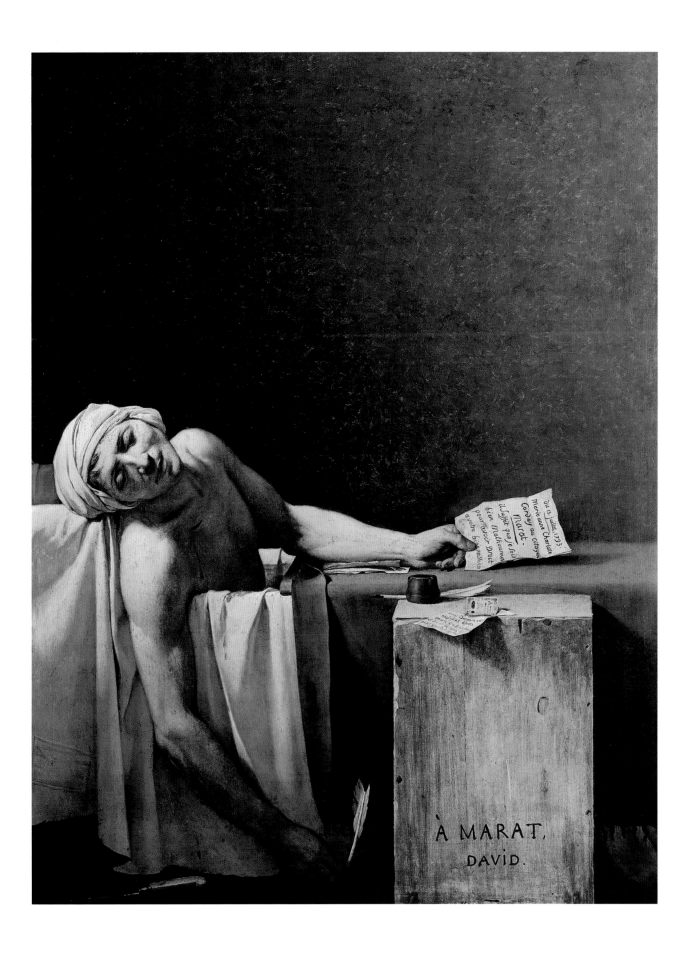

Style and technique

David's austere neoclassical style (see page 117) was admirably suited to the portrayal of martyrdom. He carefully pared down all extraneous details. The background is dark and neutral, and yet, from no apparent source, a strong shaft of light illuminates Marat's face and arms, with the dramatic force of a spotlight. The corpse itself is treated with the same severe discretion. Avoiding any hint of melodrama, David ensured that the wound, the blood, and the knife remained half-hidden in shadows, while the main emphasis was on the tender portrayal of his friend's limp body. For added resonance, he based Marat's pose on that of Christ in the pietà, a traditional type of religious image in which the Virgin cradles Christ's dead body on her lap.

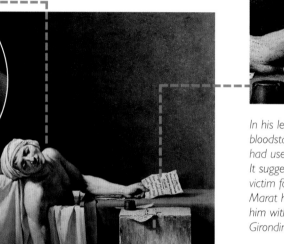

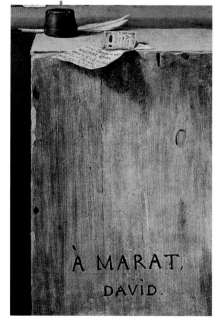

In his left hand, Marat is still holding the bloodstained note that Charlotte Corday had used as her letter of introduction. It suggests that she was going to ask her victim for a kindness, although in reality Marat had hoped that she would provide him with useful information about the Girondin faction.

David has discreetly excised the less tasteful aspects of the scene. There is no trace of Marat's disfiguring skin disease—rather, his smooth, pale body looks like an antique marble sculpture. Even the fatal stab wound in his chest appears rather innocuous.

Drawing inspiration from Caravaggio (see pages 62–65), David placed a stunningly realistic still life in the foreground. It shows a makeshift desk made from an upturned wooden crate, an inkwell, a quill, a letter, and money, the last two intended for a war widow and included as a token of Marat's charitable nature. At the bottom of the wooden crate, the artist has turned his signature into a dedication: "To Marat, David."

The blood-covered butcher's knife with which Charlotte Corday murdered Marat lies discarded on the floor. This detail is another piece of artistic license. In fact, Corday made no attempt to escape, and waited to be arrested.

Neoclassicism and revolution

By the end of the eighteenth century, neoclassicism was the dominant force in Western art. The style was inspired by a desire to revive the spirit of ancient Greece and Rome, but in France it was also linked to revolutionary politics.

In France the spread of neoclassicism coincided with the country's spiraling descent toward revolution. In many ways, the two movements were made for each other. With its emphasis on self-discipline and its hatred of frivolity, the neoclassical spirit was the exact antithesis of the rococo style (see page 109), which had flourished in courtly and aristocratic circles earlier in the century. It corresponded to the revolutionary changes taking place in social and political outlook, namely the desire to restore ancient Roman values into civic life by removing the monarchy and its corrupt excesses.

David responded to the darkening mood in the country, instiling into his paintings a demand for Republican virtue and self-sacrifice. One of his most celebrated pictures, *The Oath of the Horatii* (1784), has as its subject a tale from ancient Roman history, in which three brothers bore arms on behalf of Rome to prevent war with the neighboring kingdom of Alba, even though this brought death and suffering to their family. Similarly, *Brutus Receiving the Bodies of his Sons* (1789) depicts the outcome of the founder of the Roman Republic's decision to place public duty above family considerations when he ordered the execution of his own sons. These paintings have been seen as a call to arms; as an argument that the revolution was necessary, whatever it might cost.

Inevitably, once the fighting got underway, there were real victims for the artist to paint. In all, David depicted three "martyrs" of the French Revolution. The composition of these scenes is dramatically different from the pre-Revolutionary works. In place of the stirring, dramatic images that he produced in the 1780s, the later pictures are quieter and full of pathos. All three are simple male nudes. Apart from Marat, the subjects were Lepelletier de Saint-Fargeau, who was stabbed by a royalist, and Bara, a drummer-boy who was killed during fighting in the Vendée. The painting of Lepelletier was much admired, but

has since been destroyed and is only known through engravings, while the picture of Bara was never completed.

David's stark style loosened in the later works he painted for the emperor Napoleon. Following the emperor's fall and the restoration of the monarchy in 1815, David fled France. Under his pupils, notably Jean-Auguste-Dominique Ingres (see pages 118–21), a more sensual, colorful version of the neoclassical style came to dominate the French art world.

Below: David, The Oath of the Horatii, *1789. This dramatic picture, with its stark style and ancient Roman subject, epitomized the revolutionary mood of 1780s France.*

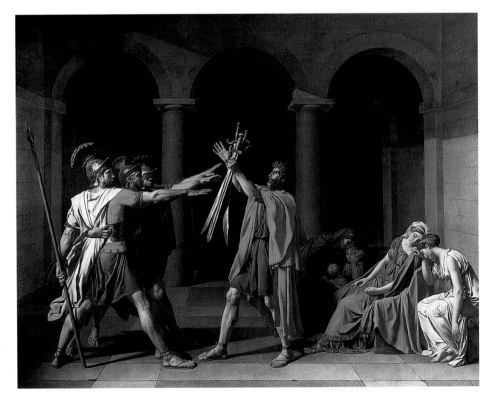

JEAN-AUGUSTE-DOMINIQUE INGRES
THE VALPINÇON BATHER
1808

The guiding principle behind the art of most neoclassical painters and sculptors was the desire to recapture the spirit of antiquity in their work. Few managed this as successfully as the French painter Ingres (1780–1867). In *The Valpinçon Bather*, he created a monumental nude displaying such stillness and grandeur that it can bear comparison with any example of classical statuary. Although at first glance the composition appears very simple and natural, Ingres's painting is full of tiny complexities. The setting is enigmatic. By focusing closely on the woman, the picture space appears tight and cramped, and yet this hardly tallies with the marble column on the left and the sunken pool, which is curtained off behind it. The hanging of the draperies is unexplained, which makes it hard to gauge the dimensions of the room. The couch, with its rumpled linen and pillows, appears more appropriate for a bedroom than a bathing place.

The woman herself is distracted, seemingly lost in another world. Her head is turned away, her profile hidden from view. She has paused while undressing and her shift, which is bunched at her elbow, trails along the floor beside a discarded slipper. The overall effect is both sensual and remote.

This image of the ideal female nude haunted Ingres, and he returned to it in several paintings made at different stages in his career. The earliest version is a half-length figure, dating from 1807, which is now in the Musée Bonnat in Bayonne, France. Then in 1828, the artist returned to the theme in *The Small Bather*. The pose of the figure was virtually identical to the Valpinçon picture, but on this occasion Ingres placed the bather in a harem. Finally, the artist adapted the figure for inclusion in one of his late masterpieces, *The Turkish Bath* (see page 121), painted in 1862–63. Here, he transformed the bather into a musician, sitting cross-legged on the floor and playing a stringed instrument.

The Bather of Valpinçon takes its name from the collector who purchased it for the sum of 400 francs. The painting remained in the possession of the family for much of the century, and Edgar Degas (see pages 170–73), whose parents were acquainted with the Valpinçons, saw and admired it at their home. Indeed, the picture exerted a strong influence on his own depictions of bathers.

Jean-Auguste-Dominique Ingres, *The Valpinçon Bather*, 1808, oil on canvas (Louvre, Paris)

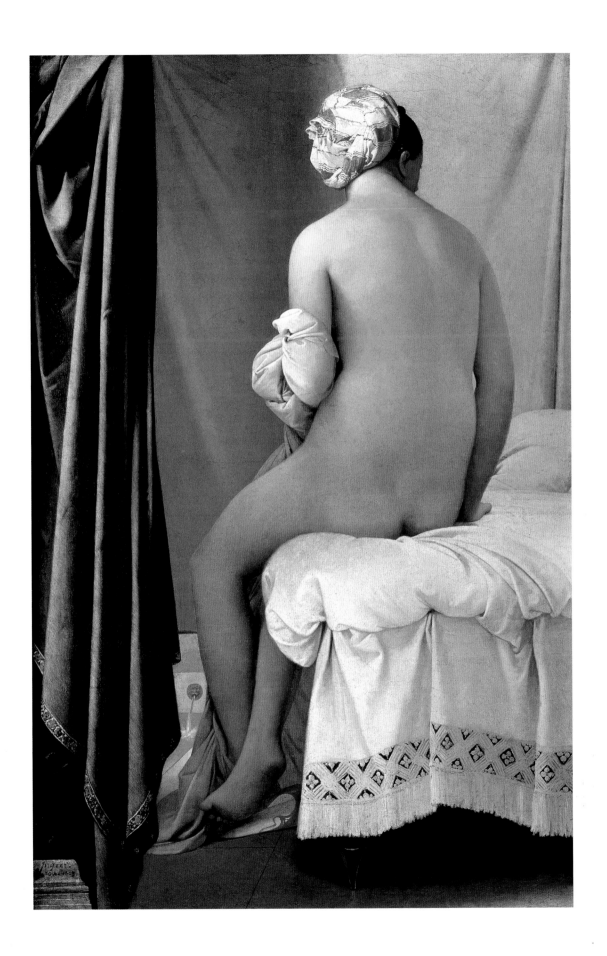

Style and technique

Ingres is known principally as a neoclassical artist, although at times he displayed characteristics associated with romanticism—namely a more sensual and highly colored approach. This painting was produced early in his career when he was living in Italy after winning the Prix de Rome, a scholarship to study in Rome awarded by the French Academy. Accordingly, his style is severely classical. The emphasis is on draftsmanship rather than coloring, and the bather's skin has the smooth, marmoreal appearance of a living statue. There is an air of seclusion about the picture, suggesting that Ingres may have had a harem setting in mind, although this only became explicit in later pictures.

The bather's red-striped turban and the decorative trim on the curtain are the only notes of strong color in the painting. The colorful headgear is also the only sign of orientalism (see page 25), which would become much more apparent in Ingres's later pictures of bathers.

The bather's smooth, marblelike back holds the center of the composition, its immaculate finish, gentle curves, and full forms combining neoclassical clarity with a sensual feeling for the female nude. Despite its idealization, the bather's body exudes an almost tangible plumpness and warmth.

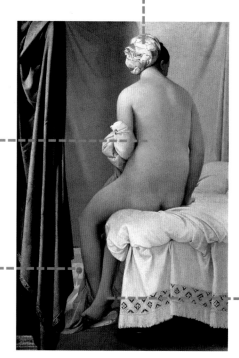

Ingres excelled at capturing the smooth texture of skin and the sensual curves of female nudes. His detractors, however, claimed that his models appeared boneless. Here, for example, the bather's ankle is barely detectable.

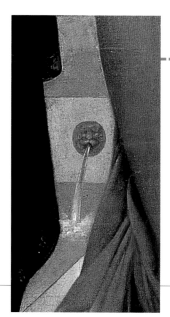

In this detail, tucked away behind the model's crossed legs, water pours into a pool from a spout in the shape of a lion's head. Ingres has kept the setting very vague. It would be easy to miss this tiny view of the spot where the woman is about to bathe.

Orientalism

Although he is known as a champion of classicism, Ingres was also affected by aspects of the romantic movement. This influence is particularly evident in his taste for exotic subjects.

Orientalism was an important trend in Western art and reached the peak of its popularity in the first half of the nineteenth century. Rather misleadingly, the term refers to images of the Near or Middle East; the taste for works of art showing or influenced by the Far East—specifically China—was labeled "chinoiserie." In France, the vogue for orientalism was sparked off by the emperor Napoleon's campaigns in Egypt (1798–1801). Thereafter a host of Egyptian motifs—sphinxes, obelisks, winged globes—were incorporated into the Empire style of furniture and interior design. Further interest was stimulated by a spate of dramatic archeological finds,

most notably the discovery of the Rosetta Stone (196 B.C.) in 1799 and the deciphering of its hieroglyphics by the French scholar J. F. Champollion in 1822. Meanwhile, the publication of various travelers' tales provoked a somewhat prurient fascination with harems. Ingres's depiction of *The Turkish Bath*, for example, was directly inspired by a description in the *Letters of Lady Mary Wortley Montagu*, a book that enjoyed great popularity when it was published in French in 1805.

Some European artists, such as Frederic Leighton (1830–96) and Eugène Delacroix (see pages 138–41),

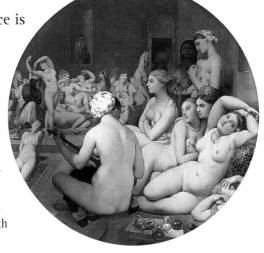

Above: Ingres, The Turkish Bath, *1862–63. This exotic, overtly sensual depiction of female nudes was based on a description of a women's bath house in Constantinople.*

pursued their interest in orientalism by journeying to the Arab world, to witness its lifestyle at first hand. Others, however, were content to give a semblance of authenticity to their eastern scenes by adding various exotic trappings. Ingres followed this second course, as he had access to a wealth of suitable material. He had seen the collection of textiles and ornaments amassed by his fellow artist, Baron Gros (1771–1835). In addition, he was able to study the miniatures owned by Vivant Denon, Napoleon's minister of Fine Arts, and the Turkish carpets belonging to Italinski, the Russian ambassador in Rome. All of these sources helped him to endow his paintings of odalisques (female slaves in harems) with an air of rich and exotic languor.

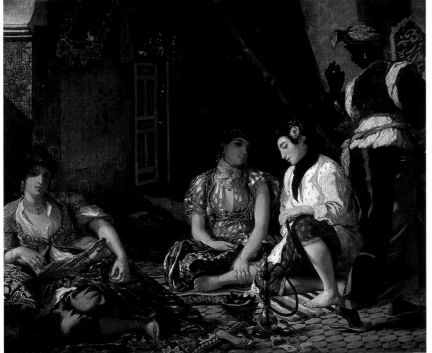

Left: Eugène Delacroix, Women of Algiers, *1834. This evocative picture of a harem was inspired by a six-month trip Delacroix made to North Africa in 1832.*

FRANCISCO DE GOYA
THE THIRD OF MAY, 1808
1814

he greatest works of the Spanish artist Goya (1746–1828) are those investigating the darker side of the human psyche. His images of madness, superstition, and witchcraft have rarely been equaled, while this brutal execution scene remains a uniquely powerful condemnation of the horrors of war. In Goya's later years, as the emperor Napoleon's armies rolled across Europe, Spain became embroiled in the Peninsular War (1808–14). At the start of the conflict, French troops entered the country, ostensibly as Spain's allies against Portugal, although it soon became clear that this was an army of occupation. The monarchy capitulated, allowing Napoleon to install his brother Joseph as the new ruler, but there was considerable resistance from the Spanish population. On May 2, 1808, a violent uprising took place in Madrid, which the French managed to quell. Then, on the following day, the invaders took their revenge, rounding up and executing suspected rebels.

Six years after the event, when the war was finally over, Goya painted two large canvases commemorating the events of those fateful days in May. This, the second of the pictures, shows Napoleon's soldiers ruthlessly carrying out their reprisals. The composition is loosely based on an engraving by Miguel Gamborino, produced in 1813, but the painter transformed his source material, creating in the process a timeless image of suffering.

Most of the killings were carried out during the day, but Goya underlined the nightmarish quality of the event by turning it into a nocturnal scene, illuminated only by a large, rectangular lantern. Amid the somber colors, a single figure stands out. The eye is drawn to the brilliance of his white shirt and to his pose, which echoes that of the crucified Christ. The man's size is equally remarkable. He is shown kneeling, but if he actually stood up, he would tower above his executioners.

Goya received some financial assistance from the government for the two May paintings, but the official response to them was lukewarm and the pictures were not exhibited. In part, this may be due to their unconventional style, although it is more likely that the artist's motives were viewed with some suspicion. Goya had steered an ambiguous, diplomatic course through the difficult years of the occupation. In 1811 he accepted the Royal Order of Spain from Joseph Bonaparte, although, in his defense, he later claimed that he had never worn the award.

Francisco de Goya, *The Third of May, 1808,* 1814, oil on canvas (Prado, Madrid)

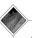
Style and technique
In his later works Goya gave full rein to the free handling of paint, vigorous brushwork, and powerful imagination that guaranteed his lasting fame. These qualities were very different, however, from the smooth precision of the neoclassical style, which was then in vogue. Goya was unrepentant. "Where does one see lines in nature?" he enquired. "I see no lines or details There is no reason why my brush should see more than I do." Goya also broke with tradition by refusing to center his pictures around acts of valor. His war scenes are more notable for their victims than for their heroes.

The composition centers on this rebel, his brilliant white shirt spotlighted amid the otherwise somber colors. In Gamborino's print, the central figure was a priest, raising his arms imploringly to heaven. In Goya's picture, though, the gesture has overtones of the Crucifixion, emphasizing the element of sacrifice.

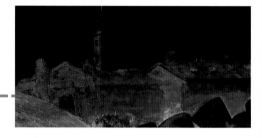

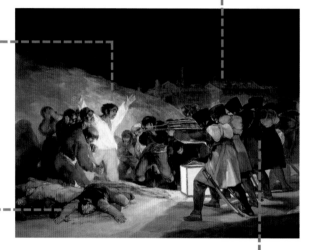

The eerie townscape silhouetted in the background cannot be linked with any specific buildings in Madrid. In fact, there is a closer resemblance to the visionary depiction of the nearby city of Toledo made by El Greco (see pages 58–61) in 1604–14; this part of Goya's painting may well be a conscious recollection of the earlier work.

The corpse of one of the executed rebels lies slumped in the foreground. Goya used considerable artistic license in this picture. In reality, the force of the bullets would have propelled the victims backward, rather than forward.

In chilling contrast to the varied poses of the victims, the soldiers in the firing squad are identical and anonymous. They form an impersonal wall, their backs to the viewer, as they stand braced with their muskets raised to fire.

Images of war

Goya has often been hailed as the first genuine war artist. In his prints and paintings, he focused attention on the suffering caused by fighting, rather than the glory that surrounded it.

As a rule military paintings were commissioned by successful regimes in celebration of their victories. Accordingly, the mood was usually upbeat and the worst of the violence was sanitized. A cursory glance at *The Surrender of Breda* (1634–35)—a memorable war painting by Goya's favorite artist, Diego Velázquez (see pages 86–89)—confirms this reading. Created as part of a series of pictures celebrating Spanish military victories during the reign of King Philip IV (1621–65), the work concentrates on the nobility of the participants, none of whom betray any hint of the trauma they have just been through.

Even in scenes of actual conflict, such as the *Battle of San Romano* (c.1455) by the fifteenth-century Florentine painter Paolo Uccello (c.1397–1475), the eye is immediately drawn to the glamorous escapades of the leading combatants, while the losers are marginalized.

By comparison, Goya's paintings of war are more journalistic. *The Second of May, 1808* is a confused swirl of activity in which the artist deliberately avoided highlighting the heroic sacrifice of two Spanish artillery officers, who had disobeyed orders and tried to aid the rebels. Similarly, in *The Third of May, 1808*, Goya did not

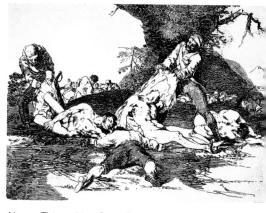

Above: This etching from Goya's The Disasters of War (1810–14) shows the depravity that war brings out in humanity, as men pull the clothes from corpses.

attempt to glorify the victims by making them appear courageous or defiant in the face of death. Instead, their terrified reactions strike a very human chord.

Unconventional though they were, Goya's May pictures still made certain concessions to public taste. However, in his groundbreaking series of etchings, *The Disasters of War*, he pushed back these boundaries. Begun in 1810, the prints present a bleak catalog of the atrocities committed by both sides in Spain's guerrilla war. Patriotism and valor are strikingly absent from these scenes of murder, rape, and torture. Instead, Goya demonstrated how war brutalized all the combatants, ensuring that, whatever the political outcome, there were no real winners.

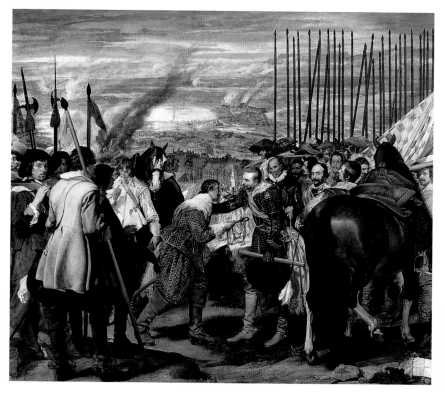

Left: Diego Velázquez's The Surrender of Breda (1634–35) is an image of chivalry rather than bloodshed. It shows the victorious Spanish commander accepting the keys to the fortress of Breda from his defeated Dutch counterpart.

CASPAR DAVID FRIEDRICH
THE WANDERER ABOVE A SEA OF MIST
c. 1 8 1 8

he greatest of the German romantic painters, Friedrich (1774–1840) specialized in mystical landscapes, which reflected his deeply held religious beliefs. Nowhere did he express his highly original spiritual interpretation of nature more perfectly than in this picture, in which a wayfarer surveys a spectacular panorama—a glorious affirmation of God's role as the Creator.

The Wanderer above a Sea of Mist is one of a number of pictures in which Friedrich portrayed a lonely traveler halting to admire the scenery. The view in question is the Elbsandsteingebirge, a range of mountains including Rosenberg at left and Zirkelstein at right. The identity of the wayfarer is less certain. In most cases, Friedrich's travelers were anonymous figures, viewed from behind, so that they could represent a universal figure comparable to the Christian Everyman. However, the theme of a man climbing a mountain is also a traditional metaphor for the journey of life. His arrival at the summit signals life's end. In this context, the image of the misty panorama may be interpreted as heaven or, more probably, as a view of the earthly realm witnessed from heaven.

In the light of this interpretation, some commentators have suggested that the picture is a posthumous portrait, painted as a memorial to someone who had recently died. A theory long associated with the picture, which can no longer be verified, held that its subject was an officer in the Saxon infantry, Colonel Friedrich Gotthard von Brincken. He appears to be wearing the green uniform of the Jäger (Rangers), a detachment of volunteers who served under the Prussian king Wilhelm III during the Wars of Liberation against Napoleon—a cause that Friedrich fervently supported. Von Brincken is thought to have been killed in action in 1813 or 1814, so it is perfectly feasible that *The Wanderer* was designed as an epitaph for a nationalist martyr. This explanation would certainly account for the figure's proud and confident stance. Normally, Friedrich's wayfarers were dwarfed by the sheer scale of nature, but here the traveler confronts it on equal terms.

The painting features one of the artist's finest depictions of a sublime landscape (see page 149). Friedrich believed that mist was an essential component of this genre, declaring that: "When a landscape is covered in fog, it appears larger, more sublime and heightens the strength of the imagination and excites expectation, rather like a veiled woman. The eye and fantasy feel themselves more attracted to the hazy distance than to that which lies near and distinct before us."

Caspar David Friedrich, *The Wanderer above a Sea of Mist*, c.1818, oil on canvas (Kunsthalle, Hamburg)

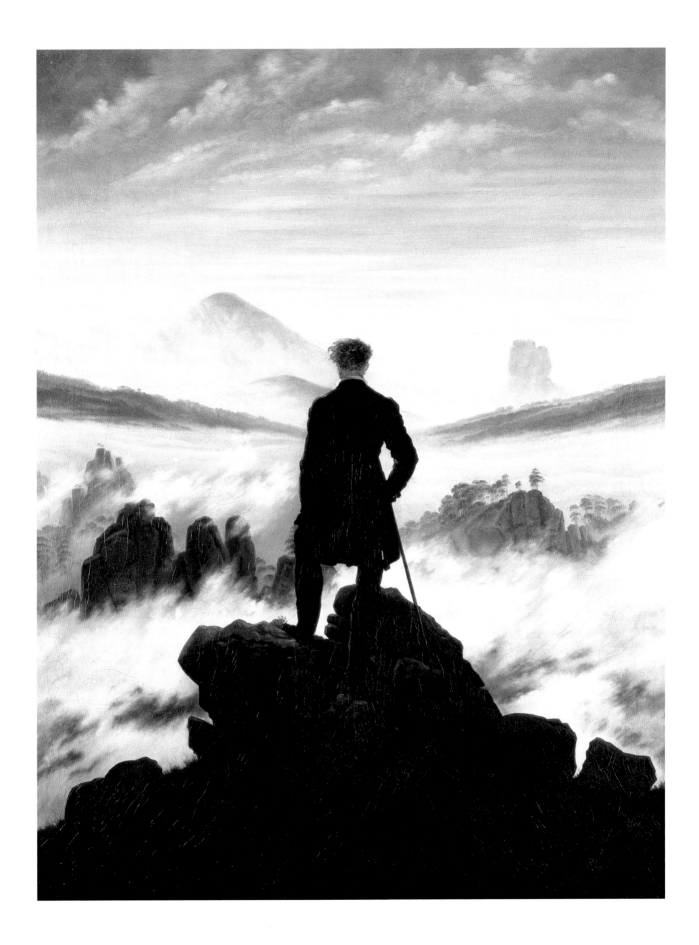

Style and technique
Friedrich honed his technical skills by making regular sketching trips into the mountains. He made an unscheduled visit to the Elbsandsteingebirge region—the setting for this picture—after the Battle of Dresden (1813) forced him to flee his home in the city. Details from Friedrich's sketches often crop up in his pictures, although he never produced preparatory studies for specific pictures. Instead, he visualized the composition in his mind before starting work directly on the canvas—he once advised, "Close your bodily eye, so that you see the picture first with your spiritual eye." He compensated for the lack of a formal sketch by using three layers of underdrawing, in chalk, pencil, and ink.

Friedrich often portrayed figures from behind. Some critics believe that he did so because he lacked confidence in painting faces. It is more probable, though, that he intended the very anonymity of these figures to endow them with a universal relevance.

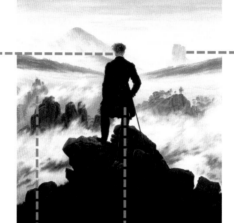

Friedrich used a series of echoing forms to emphasize the bond between nature and humanity. The man's head corresponds with this rock, while the slopes of the left-hand mountain are reflected in the tilt of his right shoulder.

The landscape appears particularly vast because of the way that Friedrich uses the fog to break up the middle ground. Since the eye cannot follow the landscape continuously through to the horizon, it is difficult to gauge the scale of the view.

The man is wearing a green jacket and trousers and has a sword at his side. Some observers have suggested that he is in the uniform of the Jäger, one of the units serving under King Wilhelm III of Prussia.

Landscape and romanticism

Landscape painting gained a new importance in the romantic era—at the end of the eighteenth century and the beginning of the nineteenth century—when artists began to portray nature with reverence, often imbuing it with spiritual meaning.

The initial stimulus for change came from literary sources. Jean-Jacques Rousseau, Novalis, and the English "Lake Poets," such as William Wordsworth, all focused on the spirituality of nature. Some translated this mystical dimension into an overtly Christian message. Friedrich's landscapes, for example, are peppered with religious symbols. A bare, leafless tree signifies transience and mortality, while an evergreen offers the promise of eternal life and a mountain can be perceived as the rock of faith. More often this spirituality took a more general pantheistic form. Novalis, for instance, urged artists to decipher "that marvelous secret writing that one finds everywhere ... in clouds, in snow, in crystals, and the structure of stones, in water when it freezes" and to reproduce it in their paintings.

Many painters demonstrated their awe of nature by depicting human figures as tiny, insignificant specks, isolated in vast, panoramic landscapes. The Americans Asher Durand, Thomas Cole, and Thomas Doughty all produced notable works in this vein (see pages 142–45). At other times, the sheer power of the elements revealed itself in a more threatening guise. The mariners in Turner's seascapes are hurled about like playthings in his violent repertoire of blizzards, storms, and whirlpools (see pages 146–49).

Other artists preferred to infuse their landscapes with visionary qualities. In the work of the English painter Samuel Palmer (1805–81), nature is benevolent and fecund, engendering an earthly paradise. Other romantics, meanwhile, focused on the lyrical effects of moonlight, as it transformed familiar landmarks into places of mysterious beauty. This theme was popular in northern Europe, with artists such as Friedrich and Carl Gustav Carus (1789–1869), and in America, with painters such as Washington Allston (1779–1843).

Below: In Washington Allston's The Moonlit Landscape *(1819), silvery light infuses the scene with a dreamlike quality.*

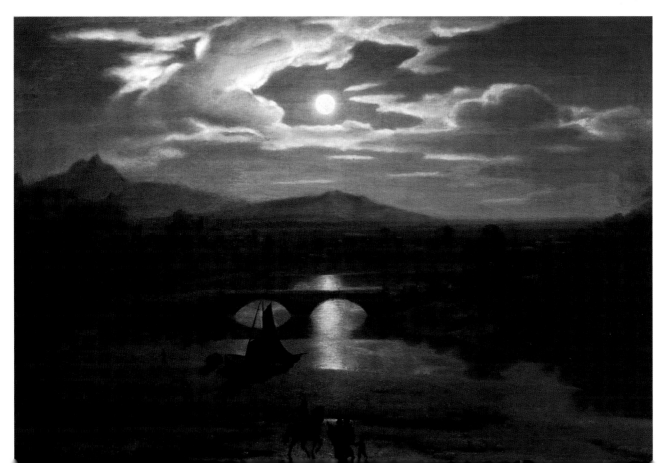

THÉODORE GÉRICAULT
THE RAFT OF THE MEDUSA
1819

his brutal, turbulent picture is a seminal image of the romantic era. Its restless, yearning spirit, its taste for horror and the macabre, and its dynamic sense of energy mark it out as one of most memorable products of the movement. The painting is based on a genuine historical incident. In 1816 a French frigate, the *Medusa*, ran aground on its way to Senegal. There were insufficient lifeboats, so some of the sailors were obliged to pile onto a raft, which was towed by one of the boats. The latter, however, fearing for its own safety, cut the raft adrift, leaving the men to their fate. For twelve terrible days they suffered on the raft before being rescued by the *Argus*. Out of the original crew of 149 who had been left to fend for themselves, just fifteen were picked up, five of whom perished shortly afterward. Back in France, the tragedy became a scandal when two of the survivors wrote their account of the incident, giving graphic details of the sunstroke, starvation, and acts of cannibalism that had occurred. The government was forced to take much of the blame for having placed an inexperienced and incompetent officer in charge of the *Medusa*.

Once he had decided to tackle this theme, Géricault took extreme measures to ensure that his picture captured the full horror of the situation. He talked with the survivors of the disaster, he built a large replica of the raft, even though this meant moving to a larger studio, and he made copious studies of the dead and dying at a local hospital. Even his studio had something of the atmosphere of a mortuary. Géricault worked in complete silence and insisted that his assistant should wear slippers, so that he was not distracted.

The Raft of the Medusa created a sensation when it was exhibited at the Salon in 1819, but not surprisingly perhaps, the government response was lukewarm and it did not purchase the picture. Crestfallen, Géricault made arrangements through an eccentric impresario named Bullock to exhibit the painting elsewhere. In 1820 it was shown at the Egyptian Hall in London and, in the following year, in Dublin. The tour was a great success, netting the artist some 20,000 francs, along with some very favorable reviews. The painting was eventually acquired by the Louvre after Géricault's death.

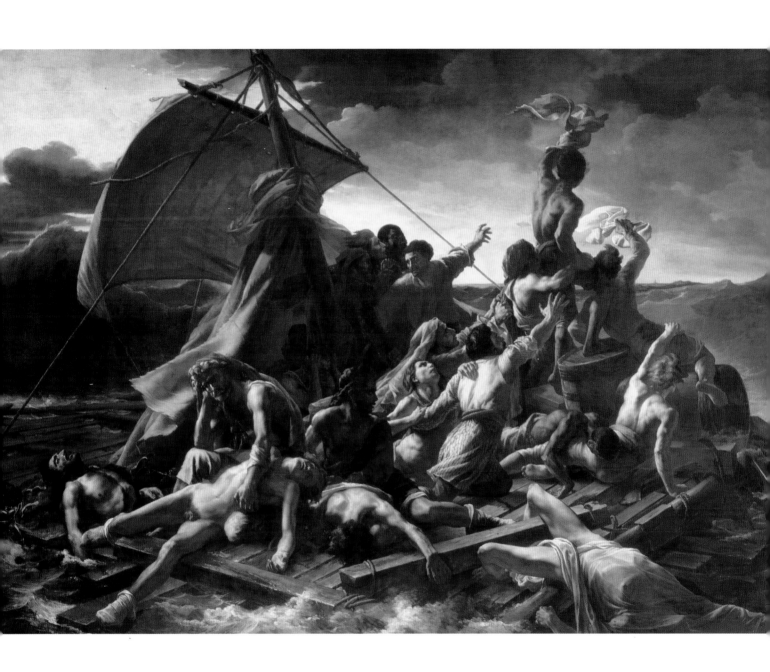

Théodore Géricault, *The Raft of the Medusa*, 1819, oil on canvas (Louvre, Paris)

Style and technique
Contemporaries recognized that there was something radically new about The Raft of the Medusa, although this had little to do with the artist's technique. Stylistically, Géricault's main influences were old masters, such as Michelangelo (see pages 42–45) and Caravaggio (62–65). His approach to the painting, with its emphasis on figure studies and countless preparatory drawings, was also very much in line with conventional academic practice. The painting's novelty lay in the modernity of its subject—critics labeled it a theme more suitable for journalists than artists—and in the artist's supposed emphasis on the more lurid aspects of the episode.

Géricault went to meet the two survivors who had written an account of their time on the Medusa. They were Savigny, the ship's doctor, and Corréard, the engineer. The artist included their portraits in this small group near the mast.

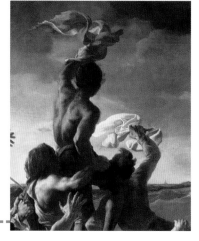

Some of the men have spotted a ship on the horizon and wave at it frantically, hoping to catch its attention. They form the focal point of the image, making up the peak of one of the two interlocking pyramids that underlie the composition. The tiny shape of the ship can just be made out below the elbow of the man on the right.

In order to present a truly graphic depiction of the dead and the dying, Géricault made many studies in the dissecting room of Beaujon hospital, also painting the heads of guillotined criminals. This shrouded corpse, its head already beneath the waves, was a late addition to the painting. It creates a strong diagonal, leading the eye into the painting.

This bearded man is lost in despair as he mourns the loss of his son, who lies dead in his lap. His grief underlines the human tragedy of the event and contrasts with the agitated desperation of the men on the right.

Marine disasters

Marine painting had a long pedigree in Western art and scenes of maritime disaster were far from unusual, but Géricault's masterpiece marked a new departure in this genre.

Pictures of ships had long been popular, but before the nineteenth century, the most violent images of this type had usually been sea battles. The French painter Philippe-Jacques de Loutherbourg's *The Battle of the Nile* (1800) is one of the most notable examples of this type. The chief spectacle is to be found in the fiery explosions that tear apart the enemy craft, but like Géricault, the artist's main interest lay in the human drama of the shipwrecked sailors, who cling desperately to a few floating timbers.

For all its emphasis on suffering, Loutherbourg's picture was still essentially a scene of victory and heroism. Most romantic artists were more pessimistic. J. M. W. Turner, who loved painting the sea, tended to stress the helplessness of those who pitted themselves against the elements. In his marine pictures, the ships are buffeted about by violent winds and storms (see pages 146–49).

The German painter Caspar David Friedrich (see page 126–29), another romantic artist, dealt with maritime disaster in an altogether quieter way. Instead of portraying the battle against the elements, he preferred to show its grim aftermath. In *Arctic Shipwreck* (1824), his most famous marine

Above: Caspar David Friedrich's Arctic Shipwreck *(1824) exudes stillness and spirituality rather than drama and emotion.*

painting, he depicted one of the vessels that was lost during the expeditions made by the nineteenth-century English explorer William Parry to find the North-West Passage. At first glance, the picture simply seems to show some massive slabs of ice, but gradually the broken mast and timbers of the lost ship become apparent, half-submerged beneath the ice.

Géricault's dramatic approach did inspire some of his contemporaries. The young Eugène Delacroix (see pages 138–41), in particular, was impressed by *The Raft of the Medusa* and the first painting he submitted to the Salon—*The Barque of Dante* (1822)—was heavily influenced by it.

Right: Philippe-Jacques de Loutherbourg's The Battle of the Nile *(1800) shows the dramatic conclusion to a sea battle fought between the English and French in 1798. It depicts the moment, at ten at night, when the French flagship exploded.*

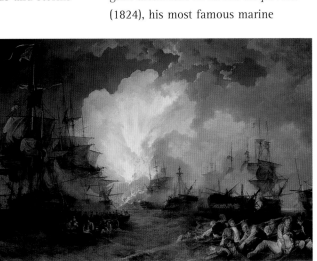

JOHN CONSTABLE
THE HAY WAIN
1821

ritics used to say that the lush, green landscapes of the English painter Constable (1776–1837) looked so convincing that you almost felt you could touch the dew on the grass. In this, his most famous painting, Constable exploited his gift for capturing atmospheric conditions to full effect, producing a timeless image of the English countryside. *The Hay Wain* shows a scene that he knew intimately, a stretch of the Stour River in Flatford, Suffolk, just next to the mill owned by his family (out of the picture, to the right). An empty wagon, or "wain," is setting out to fetch a load of hay from the meadows in the distance. It is passing through the shallow waters of the millstream before venturing over the Stour itself—Flatford takes its name from the ford that makes the river easy to cross at this point.

The immense charm of the painting owes much to Constable's painstaking attention to detail. A boy calls out to a spaniel from the back of the wagon; an intrepid angler fights his way through the undergrowth to his boat; in the foreground, the ruts caused by the wheels of the cart are plainly visible; at left, a trail of smoke curls upward from the chimney of Willy Lott's house.

Constable embarked on *The Hay Wain* in November 1820, intending it as his main exhibit at the Royal Academy show in the following spring. For these exhibitions he usually produced large canvases that he described as his "six-footers"—the precise measurement of the picture is 73 in. x 51 in. (185.5 cm x 130.5 cm). He worked at the painting intensively throughout the winter in his London studio, far away from the landscape that it depicted. When the picture was first exhibited, it was called *Landscape: Noon*, a title reflecting Constable's preoccupation with capturing the fleeting appearances of nature (see page 137).

The critical response was disappointing. Although he had been a painter for over twenty years, Constable was still struggling for recognition in his native land. However, *The Hay Wain* was also shown at the French Salon of 1824, and there it met with a much more favorable reception. It was awarded a gold medal by the Salon committee, and won extravagant praise from artists such as Théodore Géricault (see pages 130–33) and Eugène Delacroix (see pages 138–41). Indeed, the latter repainted some sections of *The Massacre of Chios* (see page 141) in imitation of the Englishman's style.

John Constable, *The Hay Wain*, 1821, oil on canvas (National Gallery, London)

Style and technique

Constable's "six-footers" took several months to complete, largely because of the elaborate preparations involved. In each case, he produced numerous studies as well as a full-size oil sketch to ensure that he was satisfied with his composition. Even so, he sometimes made significant changes to the final layout. In The Hay Wain, for example, there was originally a horse and rider next to the dog. He replaced them with a barrel but later removed this as well, although traces of these earlier inclusions can still be seen. Constable was proud of his sketches and refused to sell them, saying that he had "no objection to parting with the corn, but not the field that grew it."

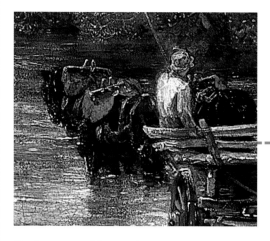

In the background, the tiny figures of farm workers can just be made out bending over as they cut and gather hay in the meadows. It is to these fields that the wagon is headed, to collect a load of hay.

The harnesses of the cart horses are shown with vivid red fringes. Constable often introduced notes of red into his compositions in this way or through people's clothing, in order to enliven the greens of the landscape with which the color contrasted.

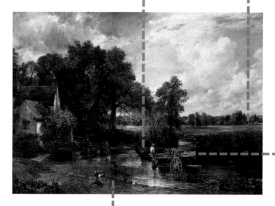

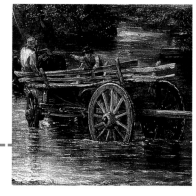

To the right of the spaniel, a dark shadowy shape and the outline of a barrel show through the waters of the river. These "ghost" images are traces of earlier elements in the composition that Constable had painted out. Originally, there was a horse and rider in the dark area.

The wagon is based on sketches made for Constable in Suffolk by his friend John Dunthorne, which the artist effortlessly incorporated into his picture as he worked in London. The detail also shows how Constable used white to enliven his landscapes, adding a sense of flickering light and movement. The brilliant white shirt of the farm worker draws attention to the picture's focal point, while elsewhere white highlights suggest the shimmering surface of water and foliage stirred by a summer breeze.

A fresh approach to landscape

Today Constable's landscapes do not appear controversial, but to his contemporaries they seemed highly unorthodox. It took many years for his work to win public approval.

Many critics were disconcerted by the type of landscape that Constable chose to portray. In the first half of the nineteenth century, art lovers were accustomed to seeing images of nature that were either spectacular or else prettified and artificial. Some painters, like the American Thomas Cole (see pages 142–45), sought out sweeping panoramas or craggy mountains, while others peppered their views with ivy-clad ruins or classical temples. By comparison, Constable's landscapes seemed decidedly unglamorous. He preferred to focus on the realities of rural life, incorporating details of locks, barges, boat-building, and agricultural work into his pictures.

Constable was not solely concerned with creating a sense of place, however, devoting just as much energy to the depiction of the prevailing weather conditions in his chosen scenes. In an essay of 1830, he stated that his artistic aim was to "to mark the influence of light and shadow upon landscape, not only in its general effect ... but also to note the day, the hour, the sunshine, and the shade ... to give to one brief moment caught from fleeting time, a lasting and sober existence." This comment, which is

Above: Constable, Cloud Study, 1822. Constable made many studies of the sky as part of his close observation of nature and to help him when he worked in the studio.

remarkably similar to the views expressed by the impressionists half a century later, indicates the full extent of his influence. It also explains why his preferred title for this painting was *Landscape: Noon*. For, while he enjoyed depicting the minutiae of the local scene, he was equally interested in showing the effects of strong sunshine bursting through the clouds overhead and creating bright patches of light in the distant fields.

Constable also experimented with new stylistic techniques, using broken touches of white paint to convey the flickering reflections of sunlight on water or damp wood. The critics mockingly referred to these specks and dabs as "snowflakes," but the idea was eagerly copied by other landscape painters.

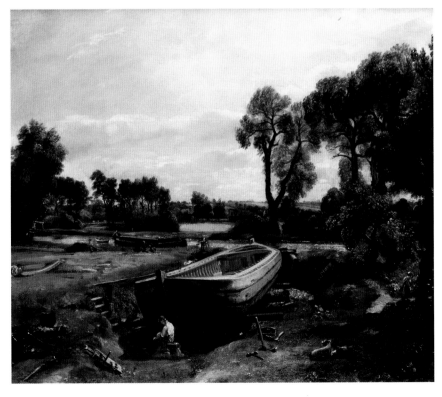

Left: Constable, Boat-Building near Flatford Mill, 1815. The picture shows a barge being built in the boatyard belonging to Constable's father. Unusually, it was painted entirely in front of the subject rather than in the studio.

EUGÈNE DELACROIX
LIBERTY LEADING THE PEOPLE
1830

Before the invention of photography, paintings and prints exerted a considerable influence over the public imagination, often shaping attitudes toward contemporary events. *Liberty Leading the People* by the French painter Delacroix (1798–1863) was one such image. While some members of the establishment viewed it as a rabble-rousing piece of propaganda, others saw it as a rallying point for the forces of democracy. The painting was designed to celebrate the spirit of the July Revolution, the ferocious uprising in which King Charles X was ousted from power in 1830. The monarch had become increasingly unpopular after his attempts to introduce a series of dictatorial measures, including the suppression of certain voting rights, along with a ban on the freedom of the press. As a result, rioting broke out on the streets of Paris. Within three days—from July 27 to 29—Charles's government was toppled from power.

Delacroix's picture is a potent mixture of realism and allegory. In the center, the bare-breasted figure of Liberty leads the rebels as they storm across the barricades. Her presence is calculated to evoke memories of the French Revolution of 1789 (see pages 114–17). She waves the tricolor, the republican banner, and wears the *bonnet rouge*, the red cap of liberty. Her very name recalls the slogan of the revolutionaries, who called for "Liberty, Equality, Fraternity."

It has been suggested that Delacroix drew his inspiration for the figure from accounts of Anne-Charlotte D., a young laundry girl whose exploits were recounted in several contemporary pamphlets. Dressed only in her shift, she had joined the fighting in a desperate attempt to find her younger brother. He had already been killed, however, and it may be that the figure in the left-hand corner of the painting represents his corpse.

Delacroix was in Paris at the time of the uprising, but in spite of his sympathy for the rebels, he did not take part in the fighting. There has been endless conjecture about whether or not he witnessed any of the skirmishes firsthand, but ultimately this has proved fruitless. Nevertheless, he felt sufficiently swept up by events to begin work on the painting immediately. *Liberty Leading the People* was exhibited at the Salon in 1831, where it proved an immense success. The new régime purchased the picture for a generous sum, but swiftly removed it from public view in a bid to lower the political temperature in the capital.

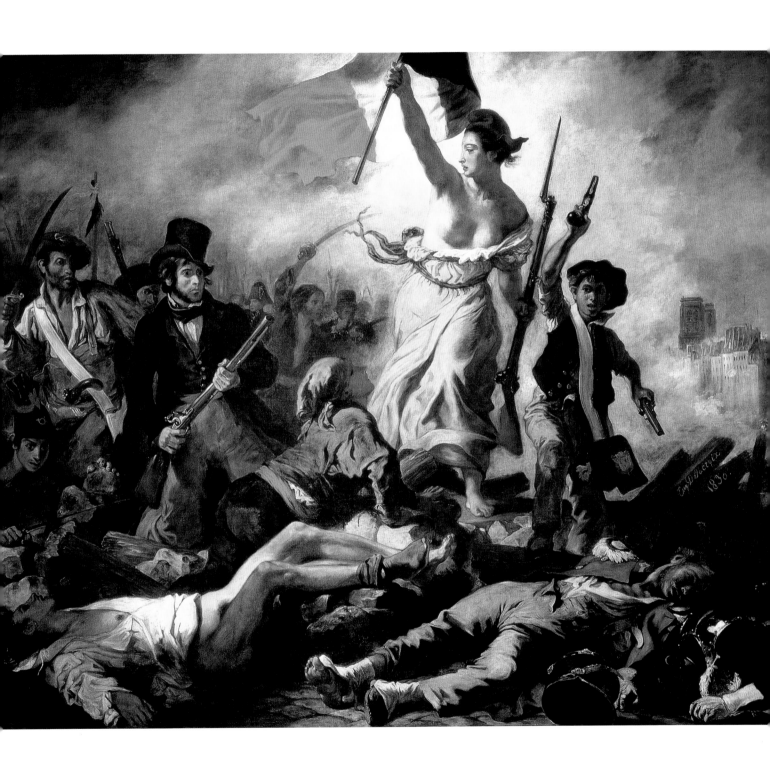

Eugène Delacroix, *Liberty Leading the People*, oil on canvas, 1830 (Louvre, Paris)

Style and technique

Delacroix was the leader of the romantic movement in France. Throughout the 1820s he shocked the art establishment with a succession of provocative canvases until the success of Liberty Leading the People finally secured his reputation. The controversy surrounding Delacroix's work centered on both his style and his choice of subject matter. Critics disliked his use of modern themes and, in particular, the way in which he seemed to focus on the sleazy or gory aspects of his material. They were also disconcerted by the vigorous, sketchlike appearance of his pictures, which they frequently condemned for being "unfinished." His adventurous use of color, however, was widely acclaimed.

Buildings are visible through the smoke, including the two towers on the west front of Notre Dame. The cathedral had been a focal point of some of the fighting, and the rebels had replaced the king's white flag with the republican tricolor, which can just be made out on the nearer of the two towers.

The allegorical figure of Liberty is meant to be a timeless creation, but the gun that she carries strikes a very modern note. On her head she wears a Phrygian cap—the red felt cap that was given to freed slaves in ancient Rome—which had been used as a symbol of the French Revolution in 1789. She is shown carrying the tricolor, the colors of which Delacroix uses to draw together the different elements of the composition.

The well-dressed figure wearing a top hat was once thought to be a self-portrait by Delacroix. However, it actually represents Etienne Arago, a prominent republican. He was the director of the Théâtre du Vaudeville, and handed out arms to the rebels on the premises.

A boy strides over the barricades brandishing pistols in a pose that echoes Liberty's. Some critics believe that he inspired the character of Gavroche in Victor Hugo's novel Les Misérables (1862).

Romanticism and rebellion

The romantic era has often been described as an age of rebellion. This characterization is borne out by the novel ways in which Delacroix and his contemporaries treated scenes of violence and conflict.

The romantics focused on a different type of struggle from those depicted by earlier artists. Previously, military painters had tended to produce images of impressive battles or patriotic triumphs. The emphasis had been on heroism, martial prowess, and national achievement (see page 125). The romantics, on the other hand, were more interested in showing the individual rebelling against authority, or the underdog fighting a losing cause. Delacroix's depiction of civil unrest and Goya's illustrations of the guerrilla war in Spain (see page 125) epitomized this trend. A key cause of concern during the romantic era was the Greek War of Independence (1821–30). For educated westerners, Greece was the cradle of civilization and its struggle to overthrow Turkish rule was monitored with great interest. Delacroix highlighted the conflict in one of his earliest masterpieces, *The Massacre of Chios* (1824), and the theme was also taken up by several of his contemporaries.

The romantic approach to scenes of rebellion was not without controversy. Their emphasis on the victims of war incurred the wrath of academic critics, who believed that serious art should be uplifting. Accordingly, reviewers dismissed the display of suffering in *The Massacre of Chios* as an example of cheap sensationalism, more appropriate to journalism than high art.

If Delacroix's work was ground-breaking in this respect, his use of allegorical figures was rather more conventional. Even though he updated Liberty by giving her a modern weapon, the idea was a very old one and can be traced back to classical statues of Victory. Delacroix had employed a similar figure in *Greece Expiring on the Ruins of Missolonghi* (1827), where the rebel cause was personified by a woman wearing national dress, and he may well have inspired François Rude's celebrated sculpture of Liberty on the Arc de Triomphe (1836).

Below: Delacroix, The Massacre of Chios, *1824. This freely painted scene of slaughter based on a contemporary subject outraged critics but enshrined romantic values.*

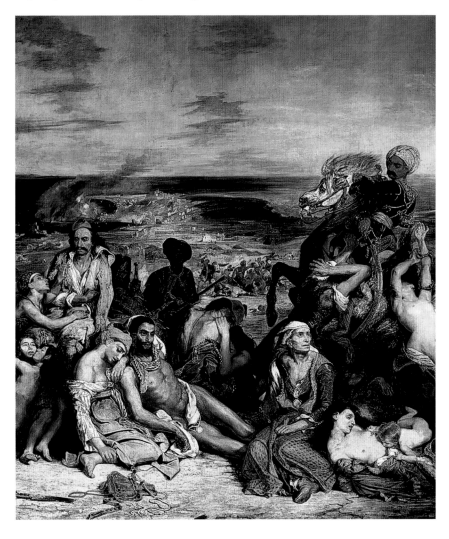

THOMAS COLE
THE OXBOW
1836

merican art was heavily influenced by European traditions in the early stages of its development. The shift toward a more independent viewpoint was pioneered by landscapists such as Thomas Cole (1801–48), who found new ways of depicting the glories of their homeland. The official title of this painting is *View from Mount Holyoke, Northampton, Massachusetts, after a Thunderstorm*, but it has long been known by the less cumbersome name of *The Oxbow*. Cole visited the site during a trip to Boston in 1833, when he made the detailed sketches that formed the basis of his composition. The idea of painting this celebrated landmark had been germinating for some years, however, ever since he had seen a controversial book by the British naval captain Basil Hall entitled *Forty Etchings made with the Camera Lucida in North America* (1829).

Cole was in Europe when the book was published, and immediately took a tracing of the plate of the oxbow. In doing so, he may have been prompted by the aesthetic possibilities of the scene, although it is more likely that he was provoked by the anti-American sentiments in the text. Hall's book created a stir on account of its disparaging remarks about American society and, in particular, about the quality of its artists. *The Oxbow* was probably intended as a visual rebuttal of these insulting views.

Cole was convinced that the American school of landscape painting marked a departure from the European tradition, because it looked to the future rather than being rooted in the past. In his *Essay on American Scenery*, he noted that in pictures of the United States: "You see no ruined tower to tell of outrage, no gorgeous temple to speak of ostentation, but freedom's offspring—peace, security, and happiness ... And in looking over the yet uncultivated scene, the mind's eye may see far into futurity. Mighty deeds shall be done in the now pathless wilderness, and poets yet unborn shall sanctify the soil."

In spite of its present fame, *The Oxbow* did not create a huge impact when it was first unveiled to the public. Indeed, Cole himself did not regard it as one of his finest works. It was exhibited at the National Academy of Design in 1836, and was subsequently sold to Charles Talbot for 500 dollars. The painting was donated to the Metropolitan Museum of Art in 1908.

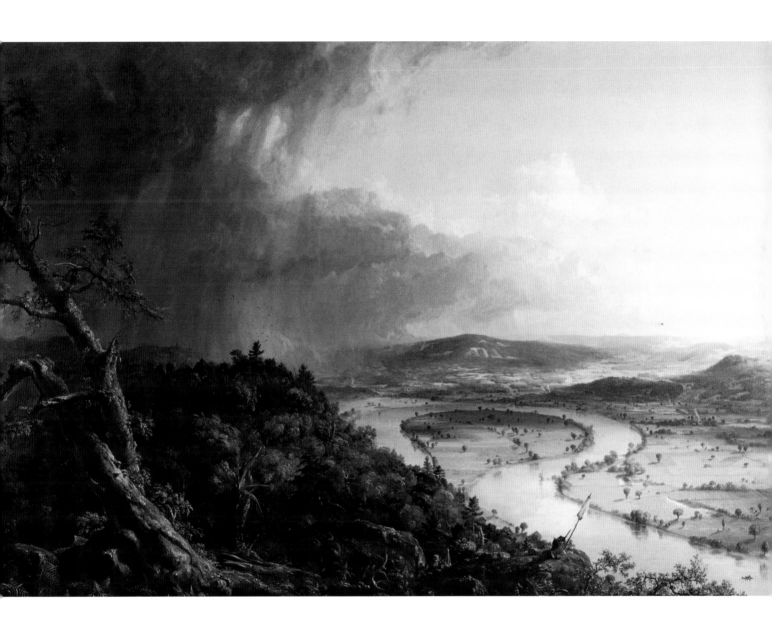

Thomas Cole, *The Oxbow*, 1836, oil on canvas (Metropolitan Museum of Art, New York)

Style and technique

Cole's approach to landscape was very varied. In true romantic fashion, he was fond of portraying nature in its wildest guises. Drawing inspiration from the Neapolitan artist Salvator Rosa (1615–73), he enjoyed depicting stormy scenes, full of craggy rocks and gnarled, windblown trees. In a similar vein, he was also influenced by the "sublime" landscapes of John Martin (see page 149), where human figures were dwarfed by immense, breathtaking panoramas. At the same time, Cole was also impressed by the serene classical landscapes of Claude Lorrain (see page 81), where distant horizons melted into a golden haze. In The Oxbow, he managed to fuse these very different styles in a single painting.

On the left side of the painting dark, thunderous skies envelop the landscape and a storm is lashing the rugged, untamed scenery. This illustration of the awesome power of nature is set against an idyllic view of farmland beneath blue skies on the right side of the picture.

Around the loop in the river, or oxbow, the fertile land is farmed and enclosed in fields. Smoke can be seen rising from the chimneys of scattered farmsteads. Bathed in sunlight, it is a peaceful, idyllic scene, inspired by the arcadian landscapes of Claude.

The tortured form of trees lashed and splintered by the elements dominates the foreground of the picture. Gnarled trees were one of Cole's favorite motifs and were inspired by Salvator Rosa's pictures of wild, natural beauty.

Cole included himself in the painting. He sits in a gully, his back to the viewer as he works at an easel; his parasol on the promontory to the right acts like a marker.

The Hudson River school

By the opening years of the nineteenth century, American art was beginning to diverge from its European roots. The move was spearheaded by a group of landscape painters, who were to become known as the Hudson River school.

Thomas Cole is generally regarded as the driving force behind this new trend. Born in northern England, he emigrated with his family to the United States in 1819, settling in Pennsylvania. He soon made a name for himself, capturing the beauties of his adopted homeland on canvas. By 1825 he was attracting the attention of other artists in the area, most notably William Dunlap (1766–1839), Asher B. Durand (1796–1866), and Thomas Doughty (1793–1853). Because of their shared interests, these artists later came to be regarded as the core of the Hudson River school, even though they were never linked by any formal association. As the name suggests, they focused their attention on the landscape of the Hudson River valley and its surrounding area—the Catskills, the Adirondacks, and the White Mountains. Their work was highly influential in the middle of the century from around 1825 to 1875.

In part, the Hudson River school was a patriotic movement, celebrating the unique qualities of the American countryside. It also reflected the nation's ambiguous attitude toward the wilderness: the awe and fear felt toward these vast tracts of unexplored lands and their hidden dangers, as well as the promise they held for settlement as the frontier gradually moved westward. In this respect, the paintings of the Hudson River school provided a visual equivalent to the nature poetry of William Cullen Bryant or the writings of Washington Irving and James Fenimore Cooper.

In a broader sense, the school belonged to the romantic movement. In common with their European counterparts, the Hudson River painters looked for spiritual and emotional qualities within nature. Cole, in particular, was not content to remain "a mere leaf painter," and tried to invest his landscapes with a feeling of religious awe.

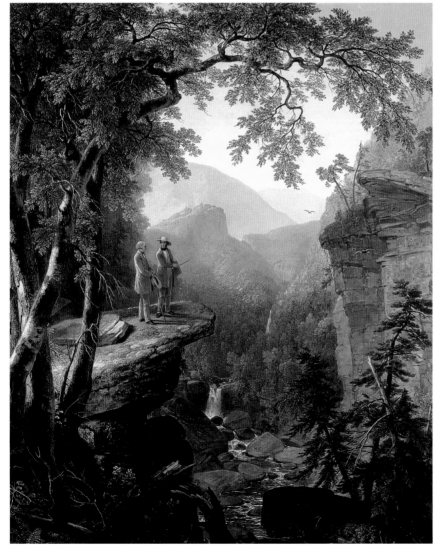

Left: In Asher B. Durand's Kindred Spirits *(1849), Thomas Cole (right) and William Cullen Bryant are shown dwarfed by nature.*

JOSEPH MALLORD WILLIAM TURNER
SNOWSTORM:
STEAMBOAT OFF A HARBOR'S MOUTH
1842

This unsettling masterpiece dates from the climax of Turner's career, when his choice of theme was growing ever more ambitious. No other artist, before or since, has managed to capture the true violence of a storm with such conviction. Turner was, above all, a painter of the sea. He portrayed it in all its moods, from tranquil, classical scenes with placid waters and golden sunsets to raging torrents. This work is his most compelling vision of a tempest. In it, he displayed less interest in depicting the fate of the seamen than in conveying to the viewer what it was like to be caught up in a maelstrom. Amid the thrashing waves and the giddying vortex of winds, the ship and its crew are almost lost from view.

Snowstorm was a daring composition in an age when clear, highly finished pictures were the norm, and as a concession to public taste, Turner included a detailed description of the scene in his title. The full title of the painting is *Snowstorm—Steamboat off a Harbor's Mouth Making Signals in Shallow Water, and Going by the Lead. The Author was in this Storm on the Night the* Ariel *left Harwich.* He also remarked to an acquaintance, "I got the sailors to lash me to the mast to observe it; I was lashed for four hours and I did not expect to escape, but I felt bound to record it if I did."

Some of the artist's claims have to be treated with caution. There is no doubt that Turner had firsthand experience of violent storms, but he was in his late sixties when this picture was painted, and it seems unlikely that he could have survived such a lengthy exposure to the elements lashed to a mast. He may well have undergone this at some stage, but first and foremost, the anecdote is a reference to Ulysses, the most famous sailor of ancient legend, who was tied to a mast so that he could listen to the Sirens and yet resist their song. Similarly, historians have been unable to locate a steamship called *Ariel*. Instead, it is likely that Turner was referring to a recent marine tragedy, when the *Fairy* was lost at Harwich in 1840. He could scarcely have resisted the allusion to Shakespeare's play, *The Tempest*, in which there is a fairylike character named Ariel.

Turner must have known that his *Snowstorm* would attract the wrath of the critics, and they did not disappoint him. One reviewer likened it to "a mass of soapsuds and whitewash." The artist's reaction was typically blunt. "Soapsuds and whitewash! What would they have? I wonder what they think the sea's like? I wish they'd been in it."

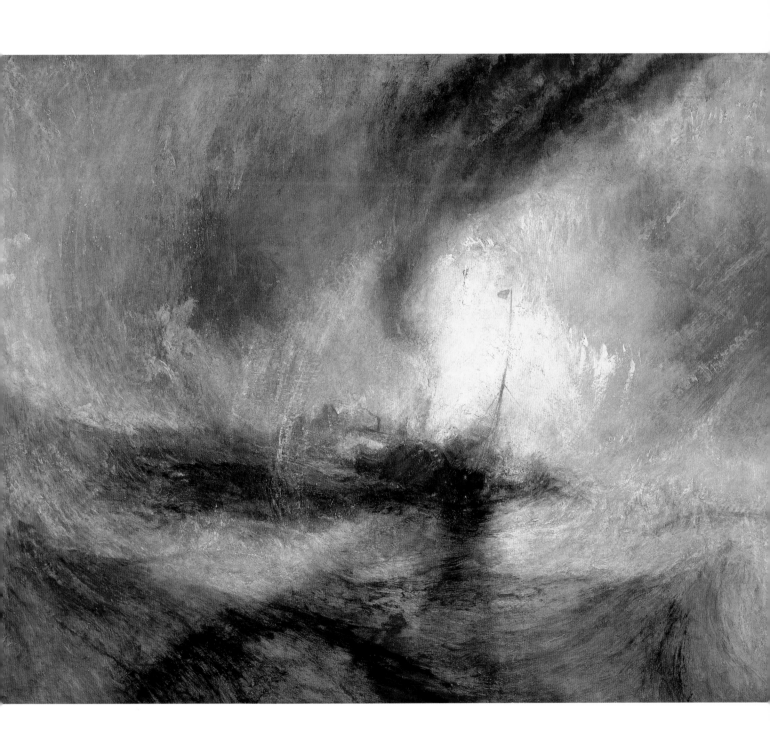

J. M. W. Turner, *Snowstorm: Steamboat off a Harbor's Mouth*, 1842, oil on canvas (Tate Britain, London)

Style and technique

In Turner's later paintings, the depiction of light, movement, and swirling forms took precedence over more conventional subject matter, and his technique became increasingly free and experimental. He heightened these effects on the "varnishing days" at the Royal Academy—the three days before exhibitions opened, when artists added the finishing touches to their pictures as they hung on the Academy walls. Turner often used the opportunity for substantial reworkings, applying impasto, or areas of thick paint, as well as glazes and scumbles—opaque layers of paint, which allowed some areas of the undercoat to show through. He made use of short brushes, held in a quill, as well as his long thumbnail, which he dubbed his "eagle's claw."

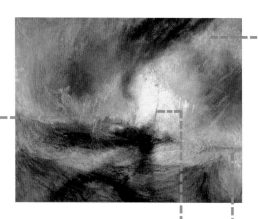

Turner's paint surface is as dynamic as the subject it shows. It has been built up by dragging layers of stiff, thick paint over each other to create a broken effect. Thick, dryish off-whites and yellows laid on with a palette knife and large brushes are set against more thinly applied dark paint.

The vortex was one of Turner's favorite compositional devices. He used it in many of his pictures to convey the force and energy of nature and to draw the viewer into the painting—in this instance to show what it was like to experience such a savage storm.

A flare lights the lashing rain above the ship. Against this area of thickly applied highlights, Turner painted the fragile form of the mast in thin, dark paint. Emphasizing the force of the storm, it is bent and appears so fragile that it may snap at any moment.

The violence of the storm is emphasized by the lack of a clear horizon line; the tumultuous seas seem to slope diagonally down from left to right.

The sublime

Over the course of his career, Turner worked in a variety of different styles. Alongside his classical, picturesque, and romantic scenes, he also produced memorable paintings inspired by contemporary notions of "the sublime."

"The sublime" was an aesthetic concept that gained popularity during the eighteenth century and became one of the cornerstones of the romantic movement. The term, which was contrasted with ideals of the "beautiful" and the "picturesque," was used to describe works of literature or art that evoked a sense of awe or terror. Its usage can be traced back to a seventeenth-century translation of *On the Sublime*, a classical treatise attributed to Longinus (about the first century A.D.), but the key text was the English writer Edmund Burke's *Philosophical Enquiry into the Origin of our Ideas of the Sublime and Beautiful*, published in 1757. This book was particularly important for its acknowledgment that suggestive qualities and the power of the imagination were important in art.

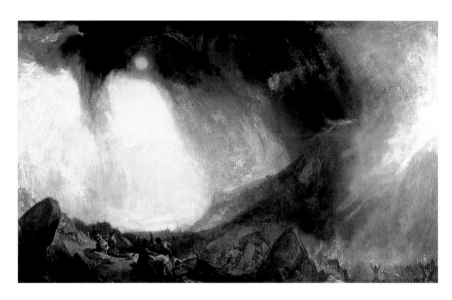

In Turner's paintings, the influence of the sublime is most apparent in the way that humanity and its works are dwarfed by the forces of nature. Boats are buffeted about like toys, and in *Hannibal Crossing the Alps* (c.1812), a powerful army is deluged beneath a

Above: In Turner's Snowstorm: Hannibal and his Army Crossing the Alps *(c.1812) men are dwarfed by the forces of nature.*

blizzard. Turner's contemporary John Martin (1789–1854) followed a similar path. He captured the public imagination with epic depictions of cataclysmic events, which were often based around biblical themes, as in *The Great Day of his Wrath* (1851–53).

The sublime could also manifest itself in less violent scenes. The wild, mysterious landscapes of the Neapolitan painter Salvator Rosa (1615–73) proved immensely popular, while Piranesi (1720–78) tapped into the public's growing taste for horror, which found its ultimate expression in his sinister etchings of imaginary prisons (c.1745–61).

Left: In John Martin's The Great Day of his Wrath *(1851–53), a city is destroyed, crushed, and thrown into an abyss.*

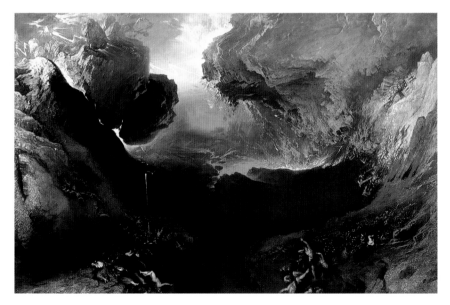

GUSTAVE COURBET
THE BATHERS
1853

ourbet (1819–77) was the leader of the realist movement, which challenged accepted standards in nineteenth-century French painting. As such, he was a seminal figure in the development of modern art. With *The Bathers*, he broke away from the conventions of academic painting, scandalizing the art-going public in the process. The picture caused an outcry when it was exhibited at the Salon of 1853. At the preview, the emperor Napoleon III is said to have struck the canvas with his riding-crop, while the empress likened the bather's backside to a horse's rump. The furor continued when the exhibition opened to the public. Huge crowds gathered in front of the painting and the police considered having it removed, on the grounds of public decency. The critics, too, were universally hostile. Even the painter Eugène Delacroix (see pages 138–41), who had been on the receiving end of similar abuse himself, was scathing about the picture.

Delacroix focused on the two most common objections to *The Bathers*, namely the vulgarity of the figures and the "pointlessness of the idea." His comment about the figures refers, in part, to the sturdy build of the nude, who did not conform to the classical ideals of beauty, and in part to the disheveled appearance of the women. Contemporary viewers, it must be stressed, still expected bathers to look as pristine and spotless as those portrayed by Jean-Auguste-Dominique Ingres (see pages 118–21).

Delacroix's quip about the "pointlessness" of the picture relates to the affected poses of the two women. They suggest that some dramatic incident is taking place, although no hint of it can be detected in the painting itself. As a result, many critics condemned *The Bathers* as meaningless. Various suggestions for the bather's pose have been put forward by modern commentators. Some have claimed, for example, that Courbet simply based the main figure on a photograph, citing a nude study by Julien de Villeneuve—with whose work the artist was certainly familiar—as the likeliest source. By the early 1850s images of this kind were readily available in Paris, and many painters chose to use them in order to save money on modeling fees. For obvious reasons, though, they remained highly secretive about this practice.

In spite of the scandal surrounding the painting, Courbet had no difficulty in selling *The Bathers*. It was purchased by Alfred Bruyas, a wealthy collector who was to become the artist's friend, as well as one of his most important patrons.

Gustave Courbet, *The Bathers*, 1853, oil on canvas (Musée Fabre, Montpellier)

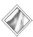

Style and technique

Courbet stirred up controversy because of his subject matter and his approach, rather than his style. His influences were fairly conventional. There are hints of Caravaggio (see pages 62–65) and Diego Velázquez (see pages 86–89) in some of his work, and he was also enamored of the romantics. In purely technical terms, his greatest innovation was the use of a long, flexible palette knife, with which he laid on his paints thickly. He reveled in the rich, uneven surfaces of his pictures, as is readily apparent in the luxuriant foliage in the background landscape of The Bathers.

The bather's discarded clothes are draped over the bow of a tree. Courbet's technical ability was never in question, and amid all the criticism, there was praise for subordinate details, such as the clothes and landscape.

The bather's unusual gesture as she steps from the water, her right arm outstretched, and the dramatic twisting pose of her maid enraged critics. The painting's detractors were angered not at the poses in themselves—for as displays of the painter's skill they drew on a long tradition in art—but because they made no sense in the context of the picture.

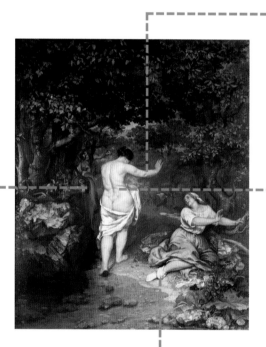

Nudes were commonplace in the Salon, but spectators were accustomed to seeing only idealized forms. The bather's imperfect physique was deemed too ugly to merit being painted. One critic remarked that she would make a crocodile lose its appetite.

A stocking falls down one of the maid's legs, while the other lies discarded beneath her muddy foot. Onlookers were shocked by the maid's disheveled clothing and dirty feet.

An affront to taste

Courbet's paintings caused an outcry when they were first exhibited. Critics attacked them for their willful rejection of academic taste and for what they perceived to be their deliberate crudity and ugliness.

After relatively conventional beginnings, Courbet's career was launched in 1850, when *The Burial at Ornans*—his most controversial picture to date—was put on show at the Salon. It caused a sensation, bringing the artist overnight fame and ensuring that his subsequent paintings were viewed with suspicion by the critics.

Today the revolutionary nature of Courbet's pictures is not immediately apparent, for the subjects themselves seem unremarkable and the quality of the artist's technique cannot be doubted. The answer lies in the rigid hierarchy of the contemporary art establishment. The most talented artists were expected to devote their skill to serious themes, drawn from history, mythology, or the Bible. These subjects were to be portrayed on a grand scale and in a morally uplifting

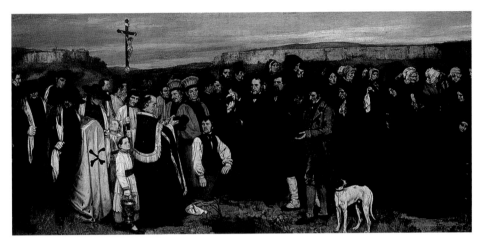

manner, using idealized figures. At the other end of the scale, the lesser themes of landscape, portraiture, and genre (scenes of everyday life) were to be treated in a much more modest fashion. With few exceptions, the artists who specialized in these subjects were regarded as little more than journeymen.

Above: Courbet, The Burial at Ornans, *1849–50. Courbet shot to fame with this huge picture—it is about 20 ft. x 10 ft. (6 m x 3 m)—of a funeral in rural France.*

Courbet's pictures were deemed subversive because they overturned these categories. *The Burial at Ornans*, for example, was produced on an epic scale that was normally reserved for history painting. Its theme, however, classified it as a genre picture, and one which was conspicuously lacking in any moral tone or idealized figures. Similarly, the elaborate gestures of *The Bathers* were appropriate for high art, but the women's dirty feet, rumpled clothing, and imperfect bodies were emphatically not. As a result, the critics accused Courbet of wallowing in ugliness and vulgarity.

Left: Thomas Couture, The Romans of the Decadence, *1847. Huge, meticulously executed history paintings such as this dominated the Salon in the mid-1800s.*

JEAN-FRANÇOIS MILLET
THE GLEANERS
1857

rtists began to broaden the scope of their subject matter in the mid-nineteenth century. Instead of concentrating solely on the concerns of the moneyed classes who employed them, they began to portray characters from all walks of life. This famous canvas by Millet (1814–75) presents an honest depiction of the backbreaking labor carried out by some of the poorest members of society. It shows the last stages of a harvest. In the background, the peasants attached to the farm (top right) have almost completed their task. Under the watchful eyes of their overseer, who is seated on a horse, they have gathered up most of the corn. A cart groans under the weight of the latest load, and several haystacks stand in the fields. Two are situated prominently on the left, but others can be seen in the distance, emphasizing that this is a large and successful business.

The gleaners in the foreground are isolated from these images of prosperity. They are not employed by the farm. Instead, working under license from the local authorities, they are entitled to pick up the leavings of the harvest. It is exhausting work, done entirely by hand, and all the more depressing because the harvesters have left them little more than stubble. Gleaners were, perhaps, the most menial of all agricultural laborers, and Millet has illustrated their plight with an uncompromising directness.

The Gleaners was exhibited at the Salon of 1857, where it met with a fairly hostile reception. The French Revolution of 1848 was still fresh in the memory, and several critics interpreted the painting as a political protest against rural poverty, aimed at provoking further unrest. Millet's personal views on the Revolution are unknown, and the evidence from his paintings is mixed. His earlier depictions of gleaners are quite innocuous. He used them as straightforward seasonal images in *Summer* (1853) and *August* (1852), sometimes including happy children to lighten the mood. *The Gleaners* is certainly more provocative, but Millet's intentions may have been aesthetic rather than political. By the mid-1850s, the realist movement (see page 150) was in full swing, and he may simply have been influenced by this broader trend.

Millet came from peasant stock, and his work was dominated by rural subjects. Initially, his paintings sold poorly, but he exhibited regularly in Boston, at the Athenaeum and the Allston Club, and American collectors played a key part in building his reputation.

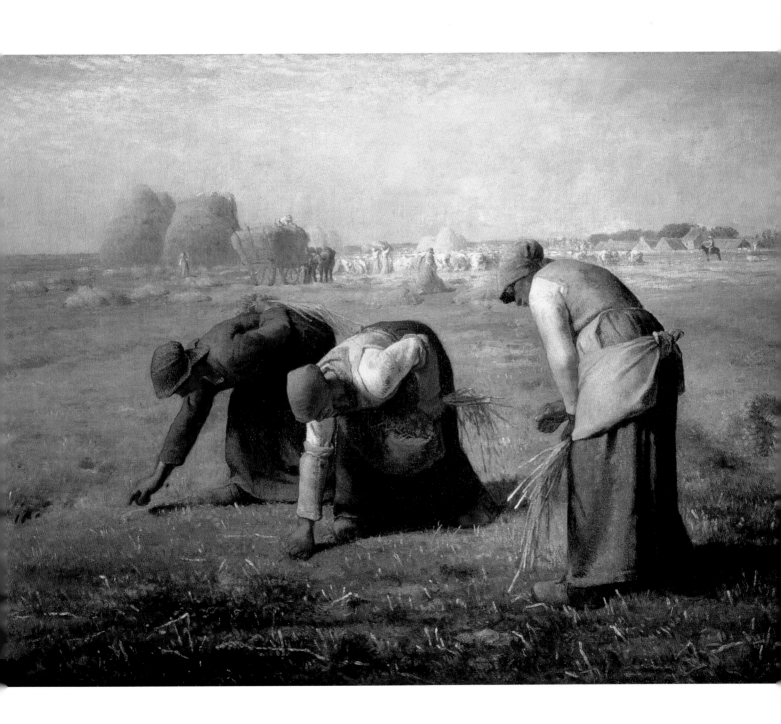

Jean-François Millet, *The Gleaners*, 1857, oil on canvas (Louvre, Paris)

Style and technique

Millet's pictures attracted a storm of criticism, primarily for their subject matter but also for their style. His decision to portray scenes of peasant life on a heroic scale, at a time of political uncertainty, proved highly controversial. Stylistically, his work was attacked as coarse and lacking in finish. His figures are monumental, his colors warm and earthy, and his paint thickly applied. In general, details of physical appearance, character, and expression are all subordinated to his interest in producing bold, sculptural forms. His powerful style, stripped of all detail, influenced many later artists, including Georges Seurat (see pages 182–85) and Vincent van Gogh (see pages 194–97).

The sunlit harvest scene in the background is rendered in pale, chalky colors compared to the darker, more somber tones of the foreground. There is also a pointed contrast between the laden cart and huge haystacks of the farm, and the meager pickings left behind for the gleaners.

In front of the farm buildings is the mounted figure of the overseer. He pays no attention to the gleaners—another example of the division between the rich farm in the background and the poverty in the foreground.

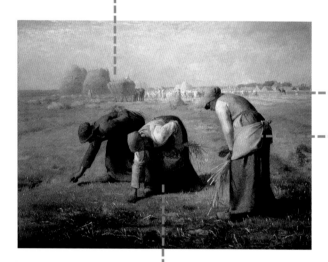

Millet rarely gave much detail to facial features or expressions, and his treatment of hands is similar—they appear as heavy, blocky shapes. The real strength of his paintings lies in the powerfully sculptural forms and strong silhouettes of his figures.

Few artists bettered Millet at depicting the physical strain of labor. This stooping figure has been bent double for so long, that she finds it hard to straighten up.

Peasant life

Artists had been painting pictures of rural life for centuries without provoking a hint of controversy until Millet and Gustave Courbet appeared on the scene. In their work, the theme began to appear far more contentious.

Peasant subjects have a long pedigree in Western art. In Northern Europe, they can be traced back to the Middle Ages, when miniaturists included them in the calendar sections of Books of Hours, in illustrations of the farming activities that were appropriate to each month (see page 57). Similarly, sowing and harvesting scenes became a regular feature of depictions of the Four Seasons, as portrayed in sets of tapestries or paintings.

In Dutch and Flemish art, peasant subjects often carried humorous overtones. In early examples, rustic figures were used to illustrate the follies or vices of mankind (see page 93). By the seventeenth century this trend had been replaced by a taste for "low-life" scenes, which showed peasants drinking, carousing, and brawling. Artists such as Adriaen Brouwer (c.1605–38) and Adriaen van Ostade (1610–85) made their careers out of this type of painting.

Elsewhere, the treatment of rural themes was often sentimental or patronizing. By and large, this was because most pictures of rustic life were produced for towndwellers, who wanted an unthreatening, romanticized view of the countryside. This trend reached a peak in the eighteenth century, when many aristocratic patrons chose to be portrayed in the guise of shepherds and shepherdesses.

The vogue for this type of pastoral fantasy was particularly strong in France, until it was terminated dramatically by the French Revolution of 1789. After this and the subsequent uprisings of 1830 and 1848, the French authorities were distinctly nervous about any pictures that seemed likely to promote rural unrest. The paintings of Millet and Courbet (see pages 150–53) fell within this category, because they portrayed the peasantry on a monumental and heroic scale. In addition, both artists were associated with the realist movement, which, in the eyes of the establishment, had close links with radical politics.

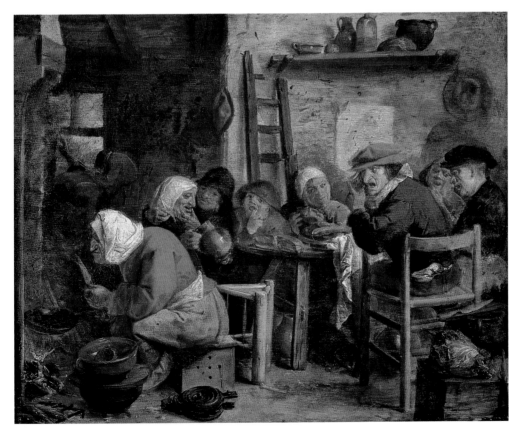

Left: Adriaen Brouwer's A Peasant Meal, *a typical example of the humorous scenes of raucous peasant life that helped popularize "lowlife" subject matter in Dutch and Flemish art.*

ÉDOUARD MANET
LUNCHEON ON THE GRASS
1863

Ithough he is best known today for his links with the impressionists, Manet (1832–83) began his career in a very different vein. This strange painting created an uproar when it was exhibited in Paris in 1863, launching him on the road to fame. *Luncheon on the Grass* (*Le Déjeuner sur l'herbe*) shows a group of Parisians enjoying a day out in the country. The setting is a woodland glade on the banks of a river. In the middle distance a woman is bathing—at first the painting was entitled *Le Bain*, or "Bathing"—and a boat is pulled ashore nearby. Her companions relax in the foreground, and in the bottom left corner a picnic spills out of a basket. Manet's brother posed for one of the male figures, while his future brother-in-law, Ferdinand Leenhoff, sat for the other. The nude was Victorine Meurent, the artist's favorite model.

Manet first got the idea for this painting when he saw some women bathing in the Seine River at Argenteuil, just outside Paris. The spectacle reminded him of a famous Renaissance picture, *Le Concert Champêtre* (see page 161), which he had copied in the Louvre while a student. He now decided to produce an updated version of this work, using lighter colors and portraying the men in modern outfits. Manet can scarcely have failed to realize that the resulting picture would be controversial. A naked woman seated alongside fully dressed men might seem perfectly acceptable in a pastoral idyll painted by a Renaissance artist, but when translated into a modern context, the morality of the situation seemed highly questionable. Indeed, on the question of nudity alone, the hostile reception that greeted *Luncheon on the Grass* carried echoes of the furor surrounding Courbet's *Bathers* (see pages 150–53) ten years earlier.

When Manet submitted the picture for exhibition at the Salon, it was rejected. In any other year, that might have been the end of the matter, but in 1863 the Salon jury had been particularly severe, turning away more than half the entries. Their action provoked such an outcry from the artists that Napoleon III gave orders for an extra exhibition, a Salon des Refusés, or Salon of Rejected Works. The intention was to highlight the poor quality of the rejects, but the exhibition also provided many experimental artists with a public forum. Manet showed three canvases at the Refusés. This painting in particular was greeted with a storm of abuse by the critics, who were shocked by its content. For all the scandal, though, it brought the artist overnight fame.

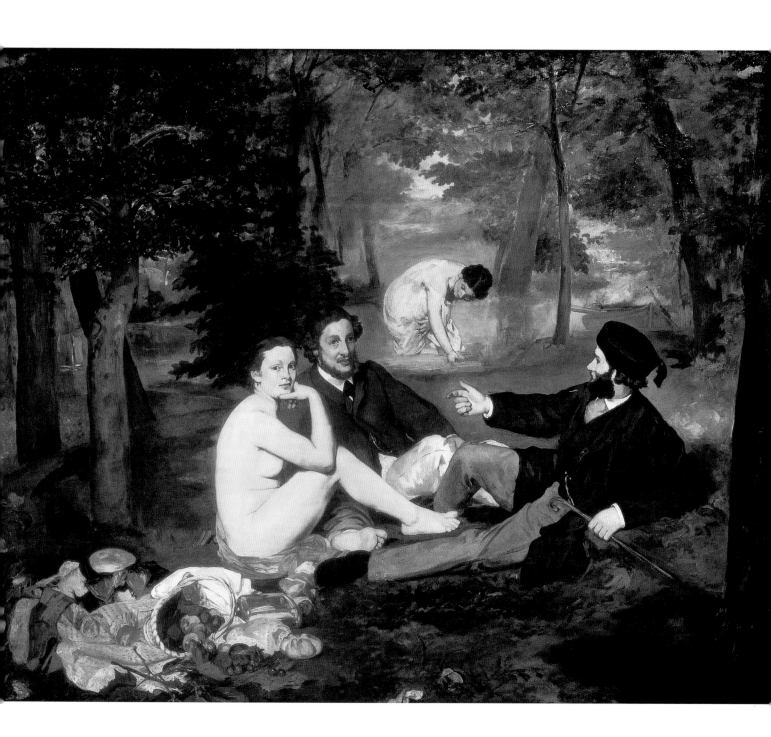

Édouard Manet, *Luncheon on the Grass*, 1863, oil on canvas (Musée d'Orsay, Paris)

Style and technique

Although contemporary critics focused on Manet's portrayal of nudity, there are other disconcerting features about this painting. Victorine's pose, for example, with her elbow not quite resting on her knee and her left leg twisted awkwardly beneath her, looks unnatural and uncomfortable. Stranger still is the bather who appears much too large and prominent for her position in the middle distance. Manet composed his picture in this way in order to flatten out the sense of space in the canvas. He matched the audacity of his subject matter with the boldness of his technique, replacing the fine tonal gradations and finish of academic practice with strong contrasts of light and shade and loose handling.

Manet included some quaint, almost comical elements in Luncheon on the Grass, most notably this bird at the top of the picture and the frog in the bottom left-hand corner.

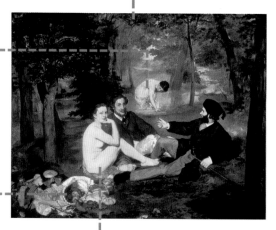

The bather is too large—she dwarfs the rowboat beside her—and is portrayed in sharp focus, without the blurring that would be natural in a figure seen from a distance. This treatment gives her added prominence, as does her position at the top of the pyramidal arrangement of the figures.

Following the practice of many Old Masters, Manet included a still life in the foreground of his painting. Next to a flask and golden loaves of bread, cherries, figs, and peaches tumble from the overturned basket, which rests on the women's discarded clothes.

Critics attacked Manet's depiction of the nude for its lack of idealization and for what they saw as her brazen attitude—seated beside clothed men, she looks directly out of the picture at the viewer. They described the woman as an impudent prostitute. Manet increased the impact of his nude by largely eliminating mid-tones, so that her pale body appears spotlit.

Tradition and modernity

In many ways, Manet was a reluctant rebel. He produced highly unconventional pictures and moved in avant-garde circles, but had the highest respect for the Old Masters and always strived to attain official recognition at the Salon.

In a sense, respect for tradition lies at the heart of *Luncheon on the Grass*. Manet borrowed the overall concept from *The Rustic Concert* (*Le Concert Champêtre*), a painting once attributed to the Venetian artist Giorgione (c.1476–1510) but now often linked to his pupil Titian (see pages 46–49). Likewise, he based the poses of the figures in the foreground on a well-known engraving by Marcantonio Raimondi (c.1480–1534) of a lost painting by Raphael.

In composing his work in this way, Manet was reflecting Renaissance—and later academic—practices of borrowing from classical models. The crucial difference, however, was that the Renaissance masters adapted their sources to suit their own traditions; Manet, on the other hand, deliberately flouted the conventions of his time.

Raimondi's figures made perfect sense within the context of his own composition. They represented three river gods witnessing the Judgment of

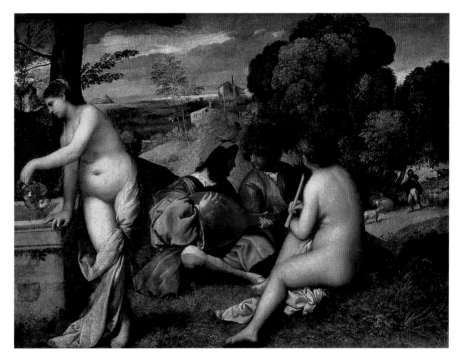

Paris. The right-hand deity holds some rushes, and as befits a mythological scene, all the figures are nude. In translating this group directly into *Luncheon on the Grass*, much of the meaning was lost. Parisian spectators were baffled by the apparently

Above: The famous Renaissance painting The Rustic Concert, *one of the sources on which Manet drew for his picture.*

pointless gesture of the man on the right. Worse still, they were disconcerted by the way that his female companion gazed out shamelessly at the viewer, instead of attempting to cover her nakedness.

Significantly, Manet's next entry at the Salon—*Olympia* (1863)—recast Titian's famous nude *Venus of Urbino* in the guise of a modern prostitute. His intention, undoubtedly, was to subvert the old-fashioned categories that were still applied to French art.

Left: Marcantonio Raimondi (c.1480–1534), The Judgment of Paris. *Manet based his figures on the river gods at bottom right.*

DANTE GABRIEL ROSSETTI
BEATA BEATRIX
c . 1 8 6 4 – 7 0

he Pre-Raphaelites were famed for their portraits of beautiful women, helping to establish the femme fatale as one of the most popular themes of nineteenth-century art. *Beata Beatrix* (Blessed Beatrice) does not fit neatly into this category, however, since Rossetti (1828–82) intended the picture primarily as a memorial to his dead wife, Elizabeth Siddal (1829–62). Outwardly, the painting is a depiction of Beatrice, the young woman immortalized in the verses of the Italian poet Dante (1265–1321). In a letter to a friend, Rossetti specified that the image was based on a passage from the *Vita Nuova*—a series of love poems in which Dante explored his feelings for Beatrice—adding "the picture must of course be viewed not as a representation of the death of Beatrice, but as an ideal of the subject, symbolized by a trance or sudden spiritual transfiguration. Beatrice is rapt visibly into heaven, seeing it as it were through her shut lids." A "radiant bird"—a messenger of death—brings her a white poppy. In the background, in front of a luminous view of the Ponte Vecchio in Dante's home city, Florence, Rossetti shows the poet (right) gazing across at the angel of love. The green and purple of Beatrice's clothing symbolize hope and sorrow respectively.

Rossetti had long been planning to paint a picture on this theme but the death of Elizabeth Siddal in 1862 seems to have given new impetus to the project. Using old sketches of her, some of them dating back to the early 1850s, he portrayed his own ideal woman in the guise of Beatrice. In spite of his initial enthusiasm, however, work progressed slowly and the painting was not actually completed until 1870. By this stage, the picture had already found a buyer, the collector William Cowper-Temple. After his death in 1889, *Beata Beatrix* was bequeathed to the British nation. In 1872 Rossetti produced a replica of the painting for another of his patrons, William Graham, a work that is now housed in the Art Institute of Chicago. Indeed, the picture proved so popular that he made at least five copies of it.

Rossetti's close personal identification with the theme of Dante and Beatrice was the product of a lifelong fascination with the poet. The artist's father had been a dedicated scholar of Dante's work and named his son Gabriel Charles Dante Rossetti. As the young Rossetti grew up, he came to share his father's fascination. He changed his name— dropping Charles and making Dante his first name—to express his allegiance, and Dante's poems provided the inspiration for many of his greatest paintings.

Dante Gabriel Rossetti, *Beata Beatrix*, c.1864–70, oil on canvas (Tate Britain, London)

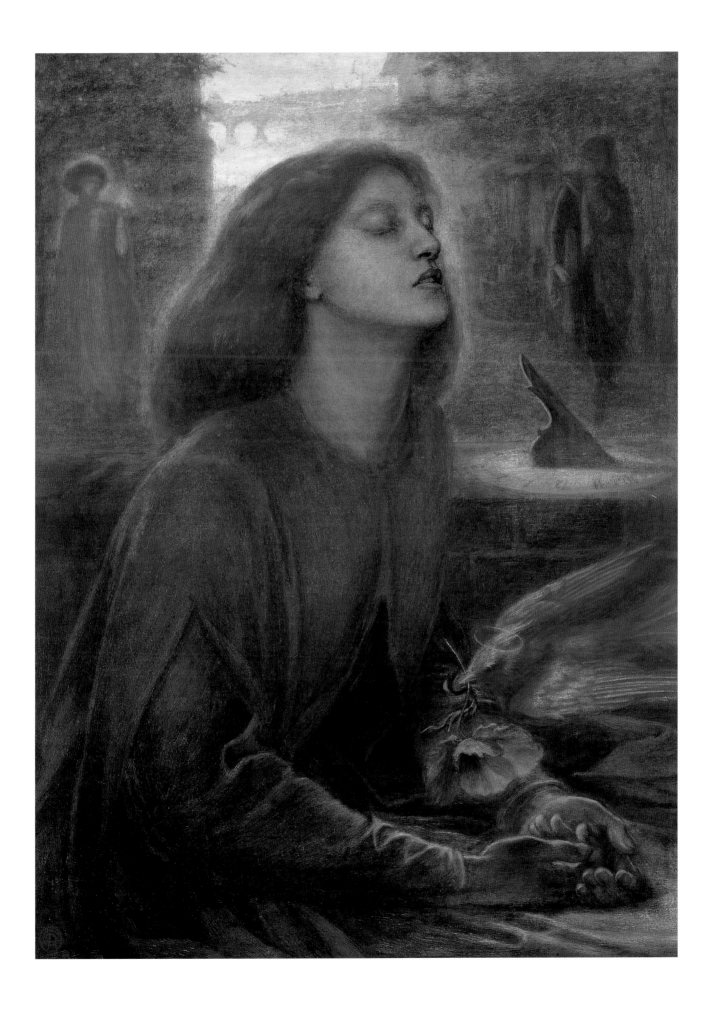

Style and technique

Rossetti worked in many different media, including watercolor, oil, and chalk, and the Beata Beatrix is one of his freest paintings, differing from the finely detailed manner of much Pre-Raphaelite art. The deliberate blurring of contours was meant to enhance the poetic subject of the picture, and may have been influenced by the soft-focus photography of Julia Margaret Cameron (see page 165), which Rossetti is known to have admired. The elusive subject matter is more characteristic of the group and broke away from the narrative precision of most Victorian art, which could be "read" easily by the viewer.

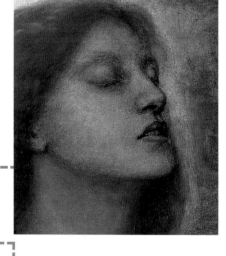

Rossetti's image of Beatrice is a good likeness of Elizabeth Siddal. When she died in 1862, Rossetti was so distraught that as a gesture of his grief, he placed the only complete manuscript of his poems in her coffin—he was an accomplished poet as well as a painter. However, in 1869 he had the manuscript exhumed and his poems were published in 1870.

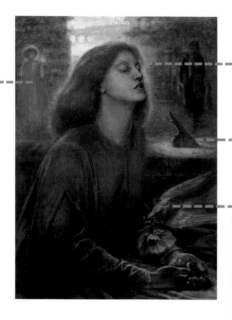

According to Rossetti, this ephemeral figure who turns to look over his shoulder is the angel of love. In his hand he holds a flickering flame, which represents the waning spirit of Beatrice.

Just behind Beatrice is a sundial, on which the shadow falls on nine. Dante had mystically associated this number with Beatrice during her life and at her death, at nine o'clock on June 9, 1290.

Although the "radiant bird" was inspired by Dante's text, its halo evokes the traditional image of the Holy Ghost as a dove with a halo (see page 17), underlining the semireligious character of Rossetti's painting. In its beak the bird holds a poppy, a flower long known for its sleep-inducing properties. It is not only appropriate to the dreamlike reverie of Beatrice, but also had a more personal meaning for Rossetti, since Elizabeth Siddal had died of a laudanum overdose—laudanum is a poppy-based opiate.

The Pre-Raphaelite sisterhood

In common with the impressionists, the Pre-Raphaelite movement attracted a substantial number of talented women artists, the best known of whom was Elizabeth Siddal, Rossetti's wife and model.

Elizabeth Siddal worked as a milliner before making contact with the Pre-Raphaelites. She then modeled for the artists and from 1852 studied informally with Rossetti. She produced her best works in watercolor and, like her mentor, was drawn to romantic themes with medieval settings. John Ruskin, an influential critic and supporter of the Pre-Raphaelites, liked her work and bought many of her pictures.

Like Siddal, Marie Spartali (1843–1927) modeled occasionally for the Pre-Raphaelites, though her principal connection with the group came through her teacher, Ford Madox Brown, who had also taught Rossetti. She was of Greek extraction, but her work had a strong Italianate flavor, often drawing its inspiration from the writings of Dante and Boccaccio.

The pictures of Evelyn de Morgan (1855–1919) also have a pronounced Italian character, although in her case the chief influence was Botticelli (see pages 22–25). She specialized in complex allegorical themes, painted in dazzling colors. Stylistically, her work has close affinities with that of the Pre-Raphaelite painter Edward Burne-Jones and, like him, she was a regular exhibitor at the Grosvenor Gallery in London. She was also linked to the Pre-Raphaelites through her husband, the ceramist William de Morgan, who produced many designs for William Morris's firm.

The most influential woman artist associated with the Pre-Raphaelites was not a painter, but a photographer. Julia Margaret Cameron (1815–79) won great praise for her portraits, but is best remembered for her evocative studies of costumed figures, posing as characters from history, mythology, or literature. These images are closely aligned with the favorite themes of the Pre-Raphaelite painters. Toward the end of the nineteenth century, the Pre-Raphaelite tradition was continued by a number of other female artists, most notably Eleanor Fortescue-Brickdale (1872–1945) and Kate Bunce (1856–1927). One of Bunce's better known works, *The Keepsake*, was based on a poem by Rossetti.

Below: Elizabeth Siddal, Clerk Saunders, *1857. The subject and poetic style of this watercolor reflect Rossetti's influence.*

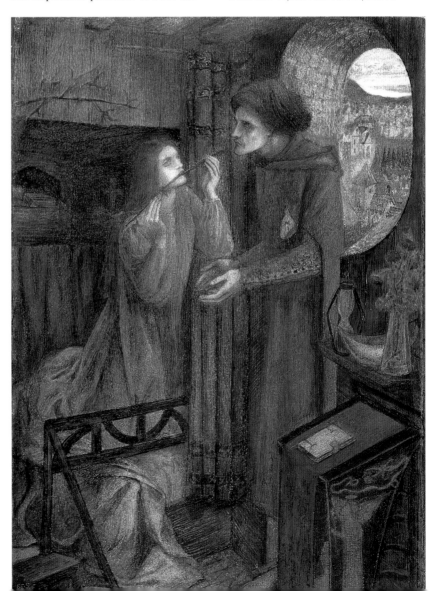

THOMAS EAKINS

THOMAS EAKINS
MAX SCHMITT IN A SINGLE SCULL
1871

homas Eakins (1844–1916) is widely regarded as one of the greatest American artists of the nineteenth century. In this remarkable picture, his first exhibit at a major exhibition, he displayed the precocious brilliance of his meticulous style. Like many American artists of this period, Eakins spent several years in Europe learning his craft (1866–70) before returning home to embark upon his career. He arrived back in Philadelphia in 1870 and immediately began depicting some of the sights and activities that he had missed during his time away from his native land. In this attractive scene, he portrayed one of his favorite pastimes—rowing on the Schuylkill River, which flowed through the city. In the foreground, he painted a portrait of a childhood friend, Max Schmitt (1843–1900), who was both a lawyer and a successful amateur oarsman. He also added his own portrait, in the form of the rower just behind Schmitt.

This type of sporting scene was an extremely unusual subject for a painter. Normally, such images were found only in popular prints, such as those produced by the New York company Currier & Ives, or in illustrated newspapers. Indeed, these journalistic overtones were made explicit in Eakins's own title for the picture—*The Champion Single Sculls*—which underlined the fact that Schmitt had recently triumphed in a prestigious race, the single-scull championship of the Schuylkill Navy Regatta. Eakins decided not to portray the actual contest, but there are several allusions to it in the picture. The autumnal coloring of the trees refers to the date of the race (October 5); the late afternoon sky relates to the time it took place (5:00 P.M.); and Schmitt's scull is shown on the site of the finishing line. In addition, the confident pose of the rower lends him the air of a victor, turning around to acknowledge the applause of the spectators.

Eakins exhibited the picture at the Union League of Philadelphia in April 1871, where it received mixed reviews. The critic of the *Philadelphia Evening Bulletin*, for example, noted that the canvas had "more than ordinary interest," adding that "the artist, in dealing so boldly and broadly with the commonplace in nature ... gives promise of a conspicuous future." The painting remained with Schmitt's family until 1930, when Mrs. Eakins purchased it from his widow. Four years later, she sold it to the Metropolitan Museum of Art in New York.

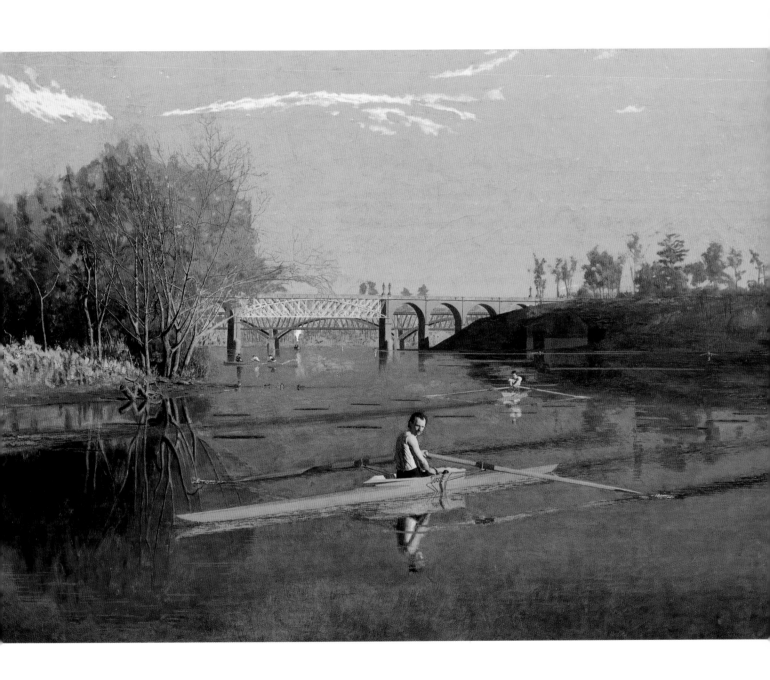

Thomas Eakins, *Max Schmitt in a Single Scull*, 1871, oil on canvas (Metropolitan Museum of Art, New York)

Style and technique

Eakins trained in Paris under the academic painter Jean-Léon Gérôme (1824–1904), and inherited his taste for producing detailed, highly finished pictures—though not his idealized subject matter. These works required elaborate preparation. Before Eakins started painting his rowing pictures, he made pencil or charcoal drawings of individual elements—including a series of precise perspective studies of boats—as well as broadly painted oil sketches that he used to help him establish the main tonal relationships. Then he traced certain markings on the canvas in order to plot out the composition.

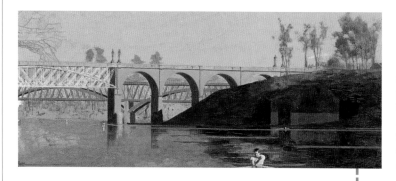

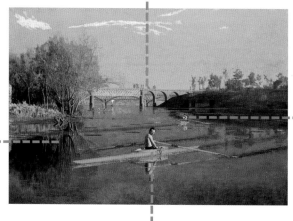

Eakins took considerable trouble to ensure that his painting was topographically accurate. By including the Girard Avenue Bridge and the Connecting Railroad Bridge, he made it possible for the viewer to pinpoint the precise spot on the river, where this scene is set. The passing train adds a nice, decorative touch.

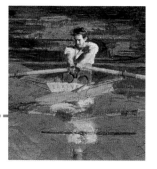

The clump of trees, like the rowers, catches the golden afternoon sunlight and casts a perfect reflection on the still river. Eakins made numerous studies of water reflections for the painting.

Eakins was a keen oarsman himself, and brimming with confidence at the prospect of participating in his first major exhibition, he included this self-portrait in a prominent part of the painting. His signature and the picture's date are shown on the boat's transom.

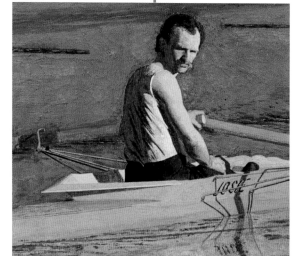

Eakins shows Max Schmitt in his white sports jersey, turning to look over his shoulder, as he momentarily rests his oars. Rowers offered Eakins an opportunity to paint the male body in a realistic—rather than idealized—scene, while the structure of boats and how to render them fascinated him. "I know of no prettier problem in perspective," he once told his students.

Art and medicine

Although the early part of his career was dominated by scenes of rowers and bathers, Eakins later became associated with more scientific themes, most notably in the fields of surgery and medicine.

From the outset of his career, Eakins painted in a blunt, realistic style, which set his work apart from the more decorative concoctions of his contemporaries. This approach did not always win him favorable reviews, but neither did it provoke the kind of outrage that the European realists had suffered (see pages 150–57). To a large extent, this was due to Eakins's subjects. His matter-of-fact depictions of rowers and the probing, psychological insights of his portraits may not have been to everyone's taste, but they were hardly controversial. However, his two magnificent medical pictures—*The Gross Clinic* (1875) and *The Agnew Clinic* (1889)—did touch a raw nerve.

Both paintings were essentially portraits in which surgeons were shown lecturing to their students while an operation was taking place. This theme fascinated Eakins. In his youth, he had seriously considered medicine as a career, and the study of anatomy remained one of his principal passions. Artistically, he also drew inspiration from one of his favorite paintings, Rembrandt's *Anatomy Lesson of Doctor Tulp* (1632). These combined interests led Eakins to record the gruesome business of the clinics with what many found an uncomfortable amount of detail.

In *The Gross Clinic*, which is now regarded as one of Eakins's finest paintings, many observers were shocked by the bloodstained hands and coats of the doctor and his assistants. One critic lamented that "The scene is so real that [viewers] might as well go to a dissecting room and have done with it." Bearing this in mind, Doctor Agnew asked the artist to tone down the gore when his portrait was painted, but the public reaction was still largely negative. A genuine shift in opinion was not apparent until 1904, when *The Gross Clinic* was awarded a gold medal at the Saint Louis World's Fair.

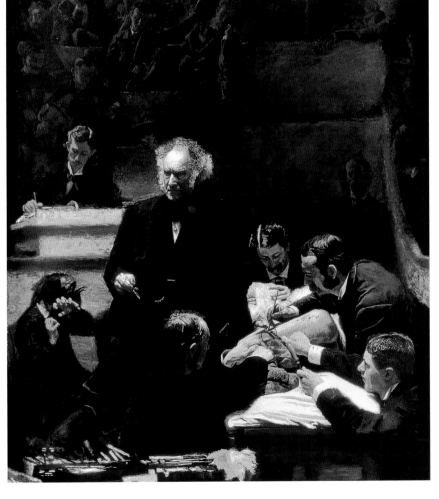

Left: In The Gross Clinic *(1875), Eakins portrayed one of Philadelphia's leading surgeons with dramatic realism. The doctor pauses from operating, his bloodied hand and scalpel raised as he prepares to speak.*

EDGAR DEGAS

THE REHEARSAL

1874

mpressionism came in many different guises. Degas (1834–1917) did not share his colleagues' enthusiasm for painting out of doors or for cataloging minute changes in light or weather conditions (see pages 206–09). Instead, he concentrated his energies on presenting a fresh and challenging vision of modern life (see page 181). Degas had two abiding passions that dominated his art: horse racing and the ballet. He began painting the latter in the early 1870s, and by the end of the decade, it was proving one of his most fruitful themes. Initially he portrayed performances in progress, but increasingly he was drawn to activities offstage, producing a long series of paintings of rehearsals and dance classes.

This painting is one of Degas's most elliptical ballet scenes. A rehearsal is taking place, but the spectator is allowed only a very restricted view. Most of the dancers are hidden behind a large spiral staircase, which obscures much of the left-hand side of the canvas. Similarly, the ballet master who is running the rehearsal is tucked away in the top right corner of the picture. Instead, Degas has devoted his attention to details that most traditionalists would have regarded as insignificant. On the far right, an older woman—either the wardrobe mistress or one of the girls' mothers—makes some adjustment to a dancer's costume. Next to them, a young girl is seated, taking a rest. She is wearing a shawl and her skirt is draped untidily over the back of her chair.

Degas's decision to concentrate on these "minor" incidents was totally in keeping with impressionist ideas. In Salon paintings of the day, artists took pains to portray their figures in attractive or dignified poses, often basing them on classical statues or Old Master paintings. The impressionists, by contrast, were anxious that their pictures should have no such associations with the past, but should simply depict the reality they saw before them. Accordingly, Degas's ballet pictures often showed dancers in unglamorous poses—stretching their muscles, scratching themselves, or tying up their shoes.

The Goncourt brothers, some of the most famous critics of the day, saw this picture in Degas' studio, when they visited him in February 1874. They remarked very favorably on the "white, ballooning clouds" of the dancers' dresses and on the "graceful movements and gestures of the little monkey-girls."

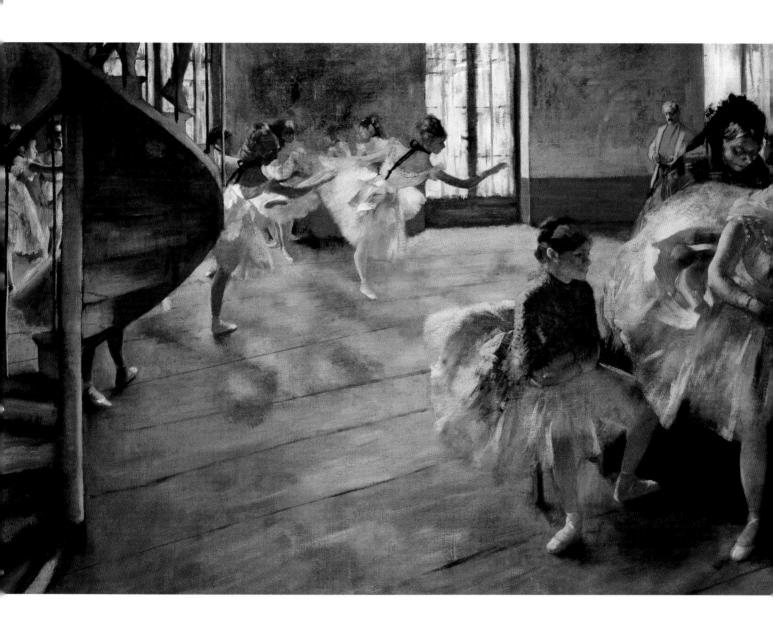

Edgar Degas, *The Rehearsal*, 1874, oil on canvas (Burrell Collection, Glasgow)

Style and technique

Some of the impressionists enjoyed the spontaneity of painting their pictures on the spot, but in this respect, Degas was more traditional. He worked in the studio and frequently built up his compositions from sketches of individual figures made on separate occasions. In the case of The Rehearsal, he is known to have used at least four preparatory drawings and to have made a model of a spiral staircase to help him plan his picture. Despite Degas's careful preparations, the painting has an air of informality—in its free, sketchy brushwork and its bold, snapshotlike composition—that typifies impressionism.

This ballerina performing an arabesque occupies a key position in the informal composition. Degas shows her face and arm silhouetted against a window, emphasizing the elegant lines of her pose, while her costume of delicate white and pink gauze is freely brushed in. A row of girls, who stand and chat behind the dancer, are indicated with little more than a few dabs of color.

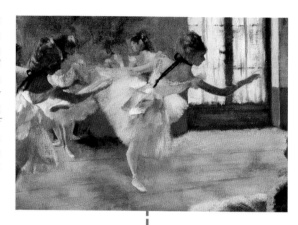

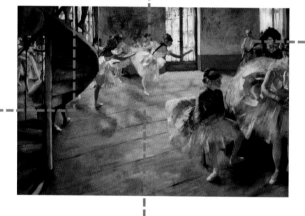

At the top left, Degas showed the feet and lower legs of a ballerina as she descends the spiral staircase. It is one of several instances in the painting in which figures are obscured or cropped, a feature mimicking the chance effects of snapshots. Similar effects could also be found in some Japanese prints.

In a bold move, much of the composition is left empty of figures. Bare floorboards occupy a large part of the foreground and lead the eye in a zigzag to the back of the room. Rapidly painted, the boards are dappled with the shadows of the young ballerinas.

The ballet master who is conducting the class is not at the center of the composition, as might be expected, but is placed unobtrusively at the top right corner of the picture. He is probably Jules Perrot (1810–92), a famous dancer, who went on to become a choreographer. He appears more prominently in several of Degas's other dance-class scenes, wearing precisely the same outfit—a red shirt and white jacket.

Snapshots of life

Some artists were alarmed by the emergence of photography, fearing that it would threaten their livelihoods, but the impressionists were fascinated by it.

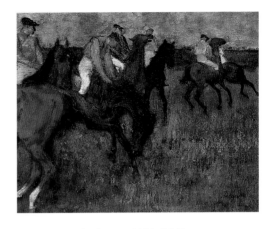

Above: Degas, Jockeys, c.1886–90. The way the horses and jockeys are cropped by the picture edge lends an air of spontaneity.

Degas was particularly interested in photography and owned several cameras. The new medium influenced artists on several levels: through the insights it afforded into nature and through the often accidental appearance of the images it produced. The camera revealed for the first time optical phenomena invisible to the naked eye, such as the way that animals move. Generations of painters had portrayed racehorses in the so-called flying gallop, with all four legs in the air at the same time, until Eadweard Muybridge's experiments with motion photography clearly demonstrated that this was a mistake. Muybridge (1830–1904) published his photographs in a book called *The Horse in Motion* (1878) and went on to study the movement of other animals, including humans, recording his results in a number of volumes such as *Animal Locomotion* (1887). His images inspired many artists, among them Degas and Thomas Eakins (see pages 166–69).

Photography also changed the way artists constructed their compositions. For centuries painters had followed certain conventions when creating their works—ensuring that they were balanced and self-contained. The arrival of snapshot photography, however, made it clear that some of these rules were unnecessary. The impressionists created informal compositions, often lacking clear focal points. They also abandoned the idea that paintings were self-contained images, preferring to see their scenes as fragments of a larger reality. They achieved this effect by cropping figures at the picture's edge or showing them interacting with unseen forces outside the picture. Degas, like many of the impressionists, adapted his style to mimic the randomness and spontaneity of the snapshot. It required years of study to achieve this, for as Degas proudly boasted, "no art was ever less spontaneous than mine."

Below: Two sequences of photographs of a man on a galloping horse from Eadweard Muybridge's Animal Locomotion (1887).

JAMES ABBOTT McNEILL WHISTLER
NOCTURNE IN BLACK AND GOLD: THE FALLING ROCKET
1875

This painting has become a landmark in the development of modern art, if only because it was the subject of a notorious trial in which the boundaries of artistic taste and liberty were openly debated. At first glance, the picture may appear to be virtually abstract. In fact, it depicts a firework display at Cremorne Gardens, which was a popular entertainment spot in London. In the foreground, a few shadowy spectators are watching from a winding path that leads toward the firework platform. Above them, a glittering trail of falling rockets lights up the night sky.

The Falling Rocket was one of a series of "Nocturnes" produced by the American artist Whistler (1834–1903) in the 1870s, most of which were misty evocative scenes of the Thames River. He chose to give these paintings musical titles, to dispel any notion that he was trying to present a precise and accurate record of a particular scene. "By using the word Nocturne," he argued, "I wished to indicate an artistic interest alone, divesting the picture of any outside anecdotal interest which might have been otherwise attached to it. A Nocturne is an arrangement of line, form, and color first." It was a highly controversial artistic approach and ran directly counter to the prevailing taste for realistic narrative scenes. *The Falling Rocket* itself was also one of Whistler's least distinct Nocturnes. Many of the others display a pale evening sky, against which buildings, bridges, and boats are plainly silhouetted. As a result, viewers had a reasonable idea of the subject before them, while in this instance, the only real clue lies in the title.

In 1877 Whistler exhibited the *Nocturne in Black and Gold*, along with seven other pictures, at the Grosvenor Gallery in London. He was used to having his work mocked in the press, but was stung by the ferocity of an attack by John Ruskin (1819–1900), the leading critic of the day. "I have seen and heard much of Cockney impudence before now," the latter railed, "but never expected to hear a coxcomb ask two hundred guineas for flinging a pot of paint in the public's face." Enraged, Whistler sued Ruskin for libel, initiating one of the most famous trials of the century. Whistler won both the argument and the judgment, but it was an expensive victory. The court awarded him just a farthing in damages and no costs, and he was driven into bankruptcy.

James Whistler, *Nocturne in Black and Gold: The Falling Rocket*, 1875, oil on canvas (Detroit Institute of Arts)

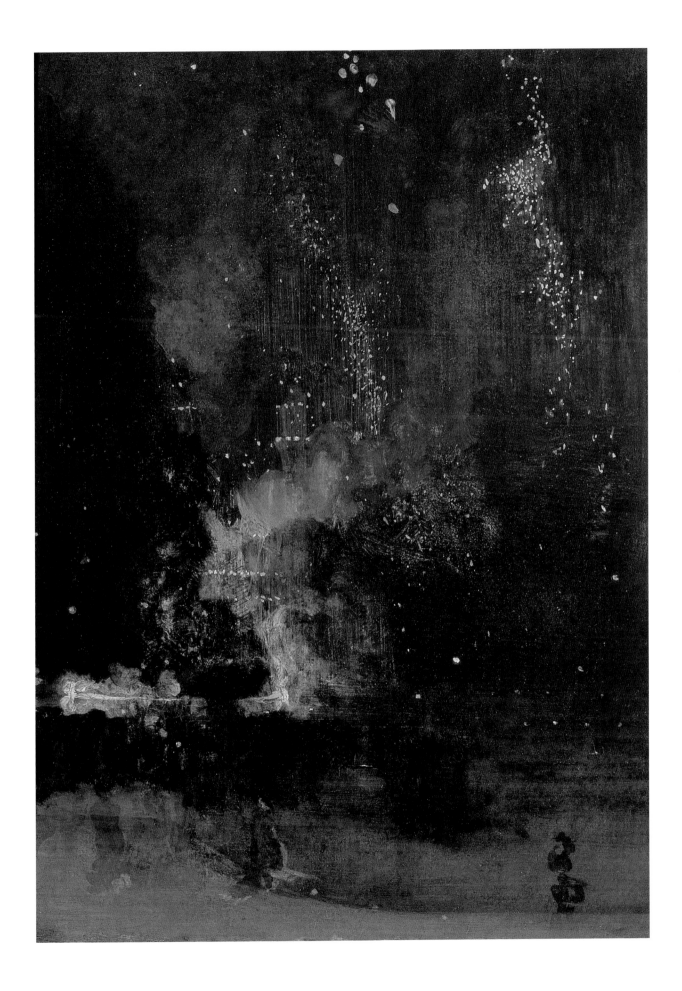

Style and technique

The ultimate inspiration for Whistler's Nocturnes came from Japanese prints, with their simplified forms, poetic mood, and decorative effects. Whistler began by priming his canvas with a dark ground of red or brown to give added resonance to the blues and greens that dominated his Nocturnes. Then he mixed his paints, diluting them very thinly into what he called his "sauces." When he applied these mixes, Whistler would often lay his canvas flat on the floor to prevent the colors from running. He worked very quickly, and once the picture was finished, he put it out in the garden to dry.

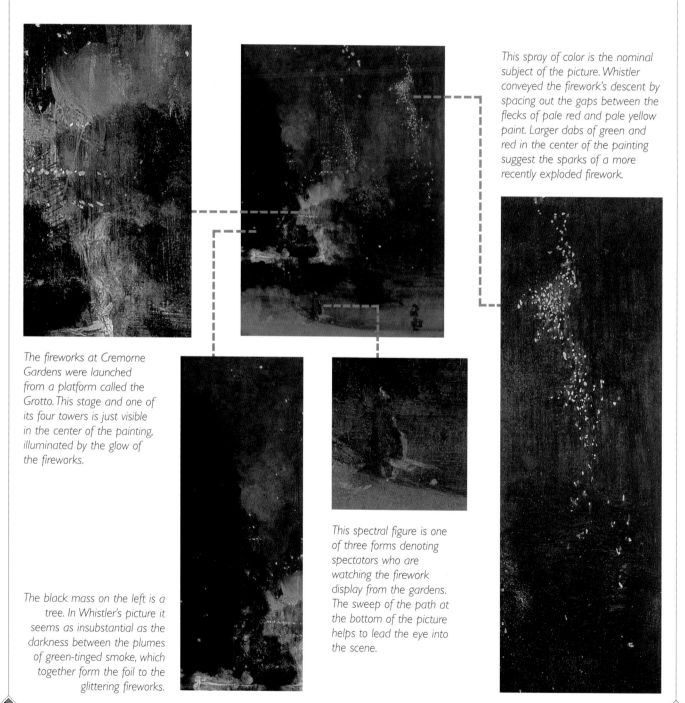

This spray of color is the nominal subject of the picture. Whistler conveyed the firework's descent by spacing out the gaps between the flecks of pale red and pale yellow paint. Larger dabs of green and red in the center of the painting suggest the sparks of a more recently exploded firework.

The fireworks at Cremorne Gardens were launched from a platform called the Grotto. This stage and one of its four towers is just visible in the center of the painting, illuminated by the glow of the fireworks.

The black mass on the left is a tree. In Whistler's picture it seems as insubstantial as the darkness between the plumes of green-tinged smoke, which together form the foil to the glittering fireworks.

This spectral figure is one of three forms denoting spectators who are watching the firework display from the gardens. The sweep of the path at the bottom of the picture helps to lead the eye into the scene.

Pushing the boundaries

Although the arguments in the Ruskin court case were ostensibly about a single painting, Whistler used the occasion as an opportunity to explain his entire artistic philosophy.

During the trial, the defense lawyers focused on the price of the *Nocturne in Black and Gold* and the amount of time that it had taken to paint. These were predictable concerns, in an age when most exhibition pictures were full of meticulously finished detail, and it seemed reasonable to suppose that there was a direct correlation between the amount of energy expended on a painting and its intrinsic worth. Whistler was unabashed. When asked if he thought that 200 guineas was a fair price for a picture that, by his own admission, had taken just two days to paint, he replied that he was charging "for the knowledge gained through a lifetime."

Whistler's approach drew on ideas from symbolism—with its emphasis on mood and evocation— and the aesthetic movement, which stressed the formal qualities of art. Adopting the slogan "art for art's sake," which had been popularized by the French critic Théophile Gautier, he argued vehemently that paintings should not be burdened with moral, literary, or historical associations. "Art should be independent of all clap-trap," he declared. "It should stand alone and appeal to the artistic sense of eye or ear, without confounding this with emotions entirely foreign to it, as devotion, pity, love, patriotism, and the like."

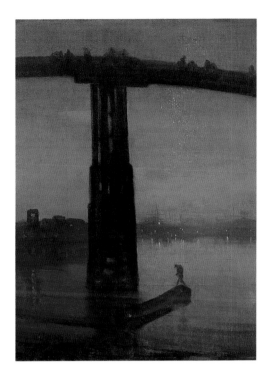

Above: Whistler said of his Nocturne: Blue and Gold—Old Battersea Bridge *(c.1872–77): "My whole scheme was only to bring about a certain harmony of color."*

Instead, Whistler was anxious that his paintings should be seen, first and foremost, as decorative orchestrations of form and color. For this reason, musical titles appeared particularly appropriate. The Nocturnes are probably his most famous works in this vein, but Whistler also described some of his portraits as "Harmonies" or "Arrangements," while his more general figure studies were dubbed "Symphonies," "Caprices," or "Variations." Even the celebrated portrait of his mother painted in 1871 should properly be known as *Arrangement in Gray and Black: Portrait of the Artist's Mother.*

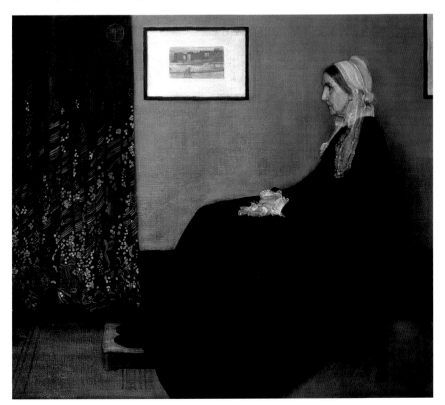

Left: Whistler, Arrangement in Gray and Black: Portrait of the Artist's Mother, *1871. Whistler explained that the painting's importance lay principally in its formal qualities rather than in its—rather sober and austere—portrayal of an individual.*

PIERRE-AUGUSTE RENOIR
DANCE AT THE MOULIN DE LA GALETTE
1876

Renoir (1841–1919) is probably the best-loved of all the impressionists. Few other artists have captured the simple pleasures of life so effectively. In this painting, as in his other works, there are no messages or morals. Instead, Renoir has taken delight in portraying a group of friends who meet, talk, drink, and dance together. The Moulin de la Galette was a well-known Parisian venue situated on the hill of Montmartre. This district is now a familiar tourist spot, famed as the city's artistic quarter, but in the 1870s it was still a semirural area, attracting a fairly bohemian crowd. The Moulin was a converted windmill, which had a café-bar inside and a trellised garden outside used for dances. Although it appears very picturesque here, surviving photographs show that the Moulin was a ramshackle affair, located on waste ground and surrounded by wooden sheds.

In true impressionist fashion, Renoir painted the picture on the spot—a considerable feat, given the size of the painting (69 in. x 52 in./175 cm x 131 cm). He moved into a new studio in the nearby Rue Cortot in order to make this task easier. The place was falling apart, but it was close to the Moulin, and every day, a friend helped him carry the bulky canvas up to the windmill. The studio also had a sizeable garden, where Renoir could sketch his friends—most of the drinkers and dancers portrayed in the foreground of the painting were fellow artists, models, or other acquaintances.

Dance at the Moulin de la Galette was produced at a time when impressionism was still a highly controversial style. The painting was generally received more favorably than Renoir's other work of the period, but his treatment of light still disturbed some viewers. In particular, there were comments on the dappled effect of the sunlight, which is apparent in the foreground. One critic, for example, remarked that the dance-floor resembled "the purplish clouds that darken the sky on a thundery day."

The painting was purchased in 1877 by Gustave Caillebotte (1848–94), one of the lesser known impressionists. He came from a wealthy family, and in the early days of the movement, provided invaluable assistance to his friends by buying their pictures. After his premature death, Caillebotte's collection was bequeathed to the French state, forming the nucleus of the impressive displays that can now be seen in the Musée d'Orsay.

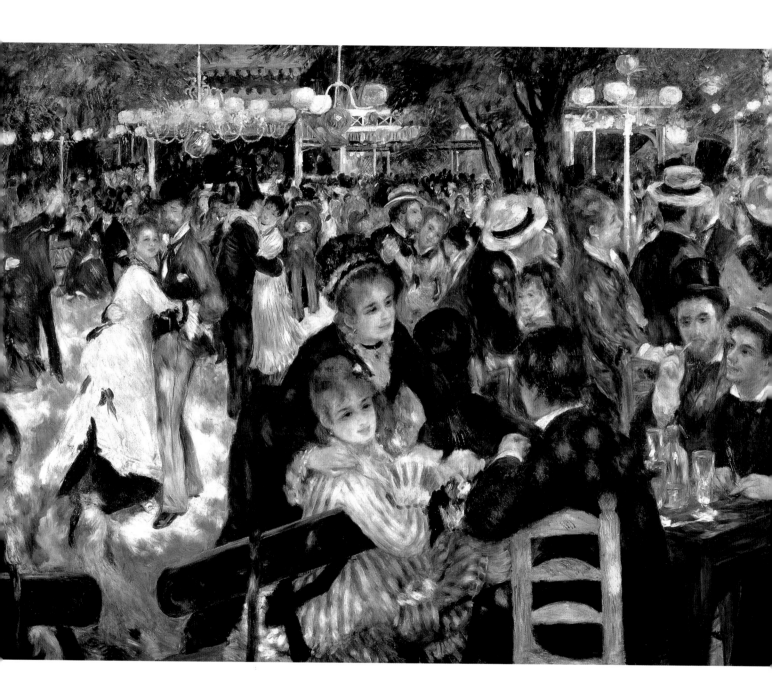

Pierre-Auguste Renoir, *Dance at the Moulin de la Galette*, 1876, oil on canvas (Musée d'Orsay, Paris)

Style and technique

In their quest for immediacy and directness, the impressionists liked to paint outdoors, at the spot they were depicting, rather than in the studio. For a picture of the size and complexity of Dance at the Moulin de la Galette, such an approach was a formidable challenge. Renoir had to paint quickly in order to capture the ever-changing light conditions and the moving people. Many of the foreground figures were portraits of friends, whose features could be sketched at leisure, but the other revelers had to be set down rapidly. As a result, they often consist of little more than a few deft brush strokes of paint.

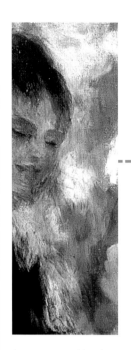

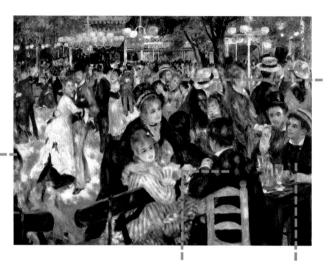

The elegantly dressed young Parisians are rapidly sketched in with deft brush strokes in pearly whites, blues, and black, enlivened with touches of pure red. In the background the swirling, dancing figures become a blur.

In common with other impressionist painters, Renoir frequently cropped figures at the edges of his pictures. This technique was partly inspired by the accidents of snapshot photography and by the bold compositions of Japanese prints, which were much admired by artists at the end of the nineteenth century. The effect was designed to show that the picture was not a self-contained image, but a fragment of a larger reality.

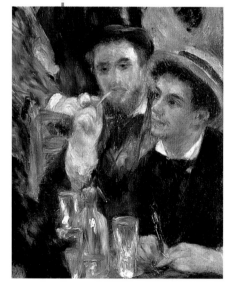

Critics objected to the dappled effect that can be seen in much of the painting, particularly on this figure's dark jacket. However, it perfectly captures the effect of sunlight glinting through the trees, just as the flickering brushwork in the rest of the painting expresses movement.

The young men at the table are Renoir's friends: Franc-Lamy and Norbert Goenutte, both artists, and Georges Rivière, who became his biographer. Rivière described the painting's significance as "a page of history, a precious and strictly accurate memento of Parisian life. No one before Renoir had thought of taking some everyday happening as the subject of so large a canvas."

Scenes of contemporary life

The impressionists are widely celebrated for their radical new style, but their subject matter was equally revolutionary. Along with the fleeting appearances of nature, they made scenes of contemporary urban life the focus of their work.

The trend toward a direct, unidealized portrayal of modern life developed over a period of several decades in French art. Romantic artists such as Théodore Géricault (see pages 130–33) and Eugène Delacroix (see pages 138–41) had reacted against academic convention by portraying scenes of modern history, rather than events from earlier times. A generation later, Gustave Courbet (see pages 150–53) and Édouard Manet (158–61) took this further, updating traditional subjects in an ironic, modern fashion, while Jean-Françoise Millet (see pages 154–57) showed the peasants of rural France. In their turn, the impressionists tackled subjects that were wholly modern, with no reference to the past.

They looked to the countryside around Paris, but more importantly to the suburbs and center of the city

Above: Claude Monet, The Gare Saint-Lazaar, *1877. In choosing to depict this recently completed station, Monet opted for a subject synonymous with modernity.*

itself. Claude Monet (see pages 206–09), for example, found it just as challenging to depict the steam from the locomotives at the Gare Saint-Lazare as the cloud formations on a blustery day. Similarly, the boulevards and parks of Paris, which had been drastically remodeled in the 1830s, proved another popular theme.

Some of the impressionists' most compelling works offer informal glimpses of ordinary Parisians—in cafés and bars, dancing, boating, and working—and the entertainments they

enjoyed. Edgar Degas (see pages 170–73) showed circus and theater performers, ballerinas, and horse racing, as well as washer women, bathers, and solitary drinkers. Renoir celebrated beautifully dressed, young Parisians relaxing in sunlit bars, parks, and riverside restaurants, while Mary Cassatt (1844–1926) concentrated on tranquil domestic scenes of mothers and their children. At the other extreme, Henri de Toulouse-Lautrec (1864–1901) produced striking images of music halls, circuses, and brothels.

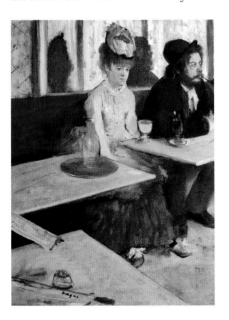

Left: Edgar Degas, The Absinthe Drinker, *1875–76. This picture of a solitary woman in a bar shocked Degas's contemporaries with its unidealized view of modern life.*

GEORGES SEURAT

SUNDAY AFTERNOON ON THE ISLAND OF LA GRANDE JATTE

1884–86

This famous painting is the defining masterpiece of neo-impressionism, one of the many artistic movements that grew out of impressionism. The picture brought international renown to its creator Georges Seurat (1859–1891), who in his brief career pioneered the style. Like the impressionists, the neo-impressionists were concerned with ways of rendering light and color, but they adopted a much more rigorous approach. Following Seurat's lead, they applied dots of pure color to the canvas using a technique known as "pointillism" (see page 185).

On the surface, this massive painting—which measures about 120 in. x 81 in. (308 cm x 207 cm)—deals with the type of subject matter that had been popularized by the impressionists. The island of La Grande Jatte, which is situated on the Seine River in the western suburbs of Paris, was well known as a boating center. On the weekends it was crowded with Parisians rowing, strolling, or enjoying a leisurely picnic. Unlike the impressionists, however, Seurat was not interested in capturing a single, fleeting moment on canvas. He wanted to transcend the influence of momentary sensations and create a composition that would have the same enduring qualities as a piece of classical art.

He achieved this aim not only through the pointillist technique, which required thorough planning and meticulous execution, but also through his unusual figure style. The Parisians in *La Grande Jatte* are mainly shown in rigid frontal poses or in sharp profile. Rarely is there any sense of movement or individuality. Indeed, several critics likened the people in Seurat's paintings to toys or illustrations from children's books. Others, more accurately, recognized in them the artist's taste for ancient traditions, one commentator remarking: "an angler, an ordinary apprentice ... are caught in hieratic stances, like an ibis on an obelisk. Promenaders ... take on the simplified and definitive character of a cortège of pharaohs." Egyptian art was certainly one of the sources for *La Grande Jatte*, but the picture also owed much to the styles of classical Greece and the early Renaissance.

Seurat worked on the painting for two years, and when it was finally complete, he showed it at the final impressionist exhibition in 1886. *La Grande Jatte* created a huge stir. With few exceptions, reviewers realized that it signaled a radically new approach to art, hailing the picture as "the banner of a new school."

Georges Seurat, *Sunday Afternoon on the Island of La Grande Jatte*, 1884–86, oil on canvas (Art Institute of Chicago)

Style and technique

Seurat made exhaustive preparations for La Grande Jatte, including drawings of all the figures and oil studies of larger sections of the picture. He worked out the composition by setting out the landscape and the disposition of shadows before adding the figures. The final painting has a remarkable sense of depth, as the eye is led from the dark shadows of the foreground to the brighter areas in the background. There are, however, some discrepancies of scale. The man in the top hat (left) appears tiny when compared to the promenading figures (right). This discrepancy probably occurred because Seurat worked in cramped conditions in a small studio, and so could not stand back to judge the overall effect of his painting.

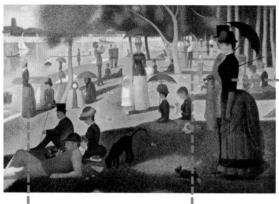

Seurat applied pure colors in small meticulous dabs so that when viewed from a distance, they seem to react together, creating more vibrant effects than if the pigments had been mixed on the palette. Green and orange dominate the canvas, along with a range of gray-blues and black.

The shadows of the trees fall as a series of parallel lines across the park. With the progressively smaller figures placed between them, they help to create a sense of depth within the painting.

The life-size figure of this woman, shown in profile, dominates the painting. Fashionably dressed with her large bustle, bonnet, and parasol, she is accompanied by a cigar-smoking gentleman and a monkey on a leash. Women with monkeys were sometimes featured in contemporary advertisements, but singesse ("female monkey") was also a slang word for a prostitute. Seurat's purpose here is unclear. He may simply have wished to satirize the woman's pretensions to sophistication by teaming her up with a wild animal.

A woman in an orange dress stands fishing, her left hand resting on her hip as she waits for her catch. Some critics think that Seurat included social comment in his picture and have interpreted this lady as a reference to prostitution. Contemporary writers and cartoonists often made use of the pun that associated the words pêcher ("to fish") and pécher ("to sin").

Science and color

Seurat admired the vibrant, luminous effects that the impressionists achieved in their paintings, but replaced their empirical approach with a technique based on the latest scientific theories.

Initially, Seurat looked to artists of the past for inspiration, in particular Eugène Delacroix (see pages 138–41), a painter famed as a colorist. Delacroix had based some aspects of his style on the theories of Michel-Eugène Chevreul, a chemist working at the Gobelins tapestry factory in Paris. Chevreul had noted how the intensity of his colored dyes depended not so much on the actual pigments, as on their contrast with adjacent colors. When complementary colors were placed side by side, it seemed that they were fused in the viewer's eye, producing an optical mixture with a rich visual impact.

Delacroix made use of Chevreul's observations, employing combinations of complementary colors in key sections of his paintings. Seurat went much further. He painted entire canvases that consisted solely of tiny dots of contrasting color. He described this technique as "divisionism," although the term "pointillism" has become better known.

In addition to Chevreul, Seurat also read a translation of *Modern Chromatics* (1879) by the American physicist Ogden Rood. This work was particularly useful, since Rood himself was an amateur painter. His book included a color wheel, which gave a ready guide to the complementaries of twenty-two different pigments and contained information on the scientific links between color and light.

Ultimately, neo-impressionism proved a relatively short-lived trend in art, since painters found pointillism slow and labor intensive, with little room for self-expression. However, the work of Seurat and his follower Paul Signac (1863–1935) was extremely influential in the exploration of the abstract values of color in the early twentieth century. It inspired the experimental work of the French painter Robert Delaunay (1885–1941) and influenced the paintings of Henri Matisse (see pages 218–22).

Above: Paul Signac, Portriux, Brittany, 1888. This harbor scene painted in the pointillist technique is typical of the work of Signac, who, after Seurat's death in 1891, became the leader of the neo-impressionist group.

JOHN SINGER SARGENT
CARNATION, LILY, LILY, ROSE
1885–86

The American painter Sargent (1856–1925) is remembered primarily for his stunning society portraits, but he was a versatile artist who excelled in a number of different fields. He produced lively watercolors, large-scale murals, and *Gassed* (1919), one of the finest war paintings of the twentieth century. He also pioneered the introduction of the impressionist style in England, using it to particularly fine effect in this picture. In 1885 Sargent left Paris, which had been his base since 1874, and settled in London. Almost immediately, he made contact with an artists' colony in the Cotswold village of Broadway. There were several fellow Americans in this group, among them the painter and illustrator Francis Millet. *Carnation, Lily, Lily, Rose* was set in his garden and his daughter Kate was the first model—the painting was begun as a single-figure composition. Soon, however, Sargent decided it would be easier to use two slightly older girls, the daughters of another artist, Frederick Barnard.

Sargent began the painting in August 1885 and wrote shortly afterward to a friend, explaining the project: "I am trying to paint a charming thing I saw the other evening. Two little girls in a garden at dusk lighting paper lanterns, hung among the flowers from rose-tree to rose-tree." In true impressionist fashion, Sargent was determined to paint the subject on the spot, rather than in the studio, so that he could capture the light conditions precisely. Inevitably, the choice of a twilight subject complicated matters considerably. The artist could only work on the painting for a very limited time each day, so the preparation of his paints had to be organized in advance. Then, at the appropriate moment, he started work. The writer Edmund Gosse described how Sargent would lunge at the picture "with the action of a wag-tail, planting ... rapid dabs of paint on the picture, and then retiring again, only, with equal suddenness, to repeat the wag-tail action."

The painting took two summers to complete and proved a chilly experience for the young models, who had to pose for much of the time in thick sweaters. The slow progress exasperated Sargent, who was tempted to adopt James Abbott McNeill Whistler's witty name for the picture: "Darnation, Silly, Silly, Pose"—the original title came from the lyrics of a popular song. His efforts were rewarded, however, when the picture became the hit of the Royal Academy show in 1887, establishing his reputation in England.

John Singer Sargent, *Carnation, Lily, Lily, Rose*, 1885–86, oil on canvas (Tate Britain, London)

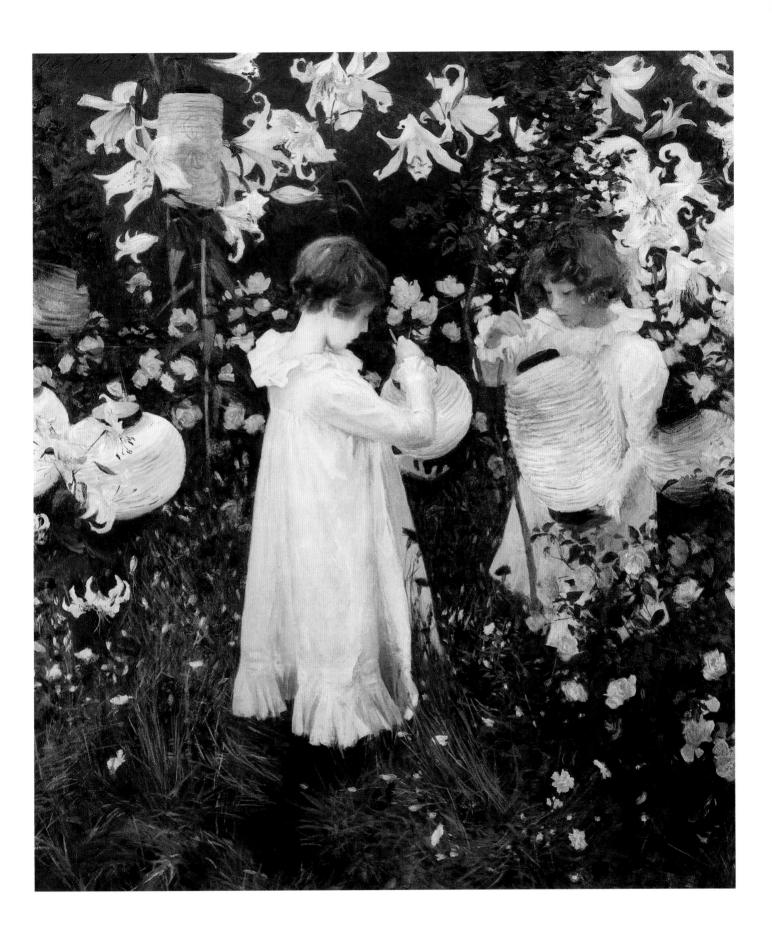

Style and technique

Sargent's time in Paris coincided with the impressionist exhibitions, and he became interested in the movement when it was still regarded with suspicion by most critics. He first attempted painting out of doors in 1877, during a stay in Brittany and continued to work in this way after his move to England. He adhered to the principle of capturing specific light effects in Carnation, Lily, Lily, Rose by limiting his work to a brief period at dusk. However, he combined this approach with careful planning—he made numerous studies for this painting—and his forms are more solidly modeled and his brushwork more highly finished than those of artists like Monet (see pages 206–09), whose work he admired.

The graceful, stylized heads of the white lilies stand out at the top of the picture, set off against the dark green background. With the profusion of delicate pink roses and red and white carnations, they add to the richly decorative appeal of the painting.

Sargent's main interest was in depicting the complex effects created by the cool, waning light of dusk and the warm glow of the lanterns. Here, with great subtlety, he shows the way the candlelight casts an orange light on the girl's face and fingers, while using more freely applied strokes of red paint to pick out its glow on her hair.

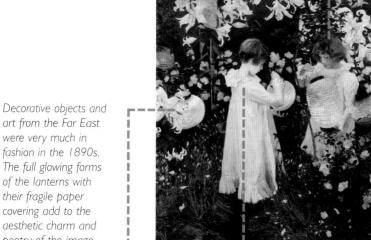

Decorative objects and art from the Far East were very much in fashion in the 1890s. The full glowing forms of the lanterns with their fragile paper covering add to the aesthetic charm and poetry of the image.

The girls posed in two specially made white dresses, which provided the perfect starting point for Sargent's exploration of subtle light effects. He painted the fabric using a lyrical palette of white, gray, pale blue, pale pink, and pale green.

The American abroad

Sargent belonged to the last generation of American painters who regarded recognition in Europe as a crucial ingredient of artistic success. Even though he spent most of his career abroad, however, he retained strong links with his homeland.

Sargent was born to wealthy American parents in Florence and had an international upbringing and education. He was cultured and cosmopolitan, one writer describing him as "an American born in Italy, educated in France, who looks like a German, speaks like an Englishman, and paints like a Spaniard." Nevertheless, he remained true to his roots, gaining many of his most important commissions from American clients. Some of these were arranged during working trips Sargent made to the United States in 1887–88 and 1889–90, but he was also in demand as a portraitist among expatriate Americans.

Sargent's American portraits are subtly different from their European counterparts. While the latter tended to emphasize the wealth and glamour of the sitters, most American clients preferred a more direct and less formal approach. Women, in particular, appeared more modern and independent. The portrait of Mrs. Stokes, for example, showed her in the practical, everyday wear that was associated with the "New Woman," rather than the evening dress more commonly associated with society portraits. Simpler still was Sargent's depiction of Isabella Stewart Gardner, who later created the famous art collection bearing her name in Boston. Completed in 1888, it shows its subject in a static pose, her black gown

creating an imposing silhouette. It was also in Boston that Sargent received his most prestigious commission, for mural decorations in the city's Public Library and Museum of Fine Arts. These ambitious projects occupied him intermittently for over thirty years between 1890 and 1921.

As an expatriate American, Sargent has often been compared with his friend the novelist Henry James (1843–1916), whose portrait he painted in 1913. Both were fascinated by European culture while remaining steadfastly American. Other painters followed a similar course. Whistler (see pages 174–77) and the impressionist artist Mary Cassatt (1844–1926) were among the many who chose to work in Europe, feeling that it might offer a more responsive outlet for their art. However, the phenomenal impact of the Armory Show in 1913 changed this attitude forever. First staged in New York, this pioneering exhibition traced the evolution of modern European art and presented the work of contemporary American artists. It generated a huge amount of interest and created a fertile environment for experimental art in the United States.

Right: Sargent, Portrait of Isabella Stewart Gardner, *1888. This restrained but striking image is centered on Gardner's simple pose and the contrasts between her black gown, white skin, and the richly colored, freely executed backdrop.*

PAUL CÉZANNE
MONT SAINTE-VICTOIRE
1885–87

Paul Cézanne (1839–1906) was a key figure in the development of modern art, providing a link between the impressionists and the cubists. He achieved this transition through the medium of his landscapes and, above all, through his many depictions of Mont Sainte-Victoire. Cézanne spent the early part of his career in Paris, where he mingled with the impressionists and absorbed some of their ideas. He was never a committed member of the group, however, and when his father died in 1886, leaving him a sizeable inheritance, he returned to live in his native Provence. There he pursued a solitary course, developing his own unique brand of landscape painting.

He summarized his aims, saying that he wanted "to do Poussin again, from nature," meaning that he wanted to combine the tradition of French classicism (see page 81)—with its emphasis on structure and a rational approach—with the naturalism of his contemporaries, who worked directly from nature. In order to refine his style, Cézanne chose to concentrate on a limited number of scenes, painting them again and again. Mont Sainte-Victoire, situated five miles to the east of the town of Aix, was his favorite subject. He painted the mountain more than sixty times, using both watercolor and oils. As the series progressed, he gradually stripped the scene of unnecessary topographical details, such as individual houses and roads, and loosened the overall system of perspective. Instead, he concentrated on the underlying geometry of the landscape, conveying this through a complex series of interlocking shapes. The angular blocks of color lend an air of stability to the scene. Cézanne also manipulated some elements of nature to suit the aesthetic needs of his vision. The upper part of the pine forms a gentle curve to complement the sloping lines of the mountain, while to the right, swaying branches from a neighboring tree echo the contours of the valley.

Cézanne gave this painting to a local poet, Joachim Gasquet. They met in 1869 and corresponded regularly, remaining close friends until a serious quarrel in 1904. Gasquet later wrote a book about Cézanne, and he has left a lengthy description of this picture: "One day we were sitting under a tall pine tree on the edge of a green and red hill, looking out over the Arc valley ... Before us were the huge mass of Sainte-Victoire, hazy and bluish in the Virgilian sunlight, the houses, the rustling trees and the square fields of the Aix countryside. This was the landscape Cézanne was painting."

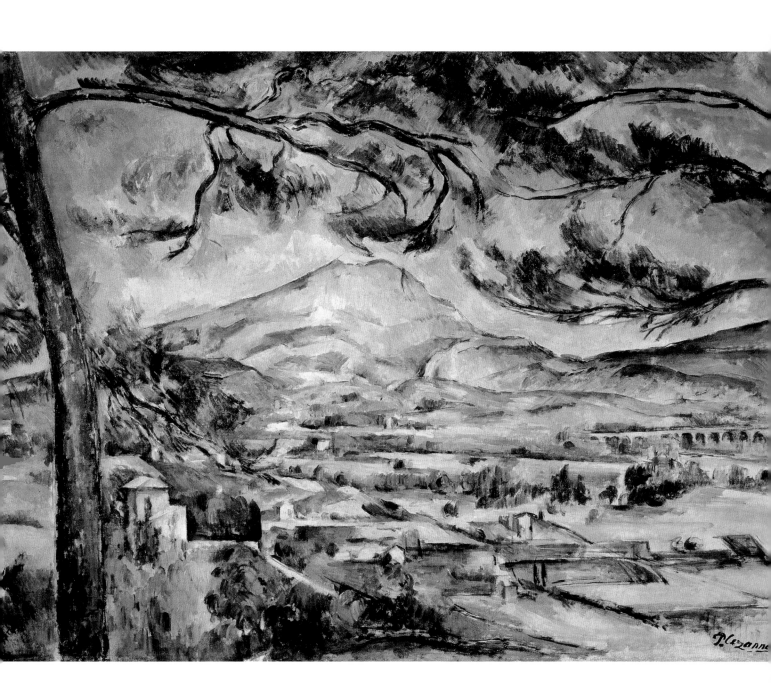

Paul Cézanne, *Mont Sainte-Victoire*, 1885–87, oil on canvas (Courtauld Institute Galleries, London)

Style and technique

Cézanne painted this view from his brother-in-law's property, where he was working concurrently on two different pictures. He devoted his afternoons to this canvas after working each morning on another scene. He selected this precise viewpoint because it enabled him to work in the shade of a clump of trees—a considerable advantage in the heat of a Provençal summer. Gasquet noted that he started by locating the main forms with rapid strokes of charcoal before adding patches of color and orchestrating his tones with infinite care until "the landscape seemed to shimmer."

The mountain is darkly outlined against the sky, its contours and bulk suggested by changing nuances in color—from pinks, violets, blues, and greens to orange—and the strong directional brush strokes that characterize Cézanne's style.

Cézanne's landscapes are full of echoing forms—here the boughs of the pine mirror the hollow in the landscape. The device of framing a view with trees in the foreground had a long tradition in landscape painting, going back to French classicism (see page 81).

In front of the mountain Cézanne showed the Pont de l'Arc aqueduct. In his later paintings of Mont Sainte-Victoire, he often omitted all such recognizable landmarks.

Detail is omitted in favor of broadly brushed in forms and patches of color that emphasize the picture surface as much as the scene they represent. The geometrical shapes of houses and fields are sketchily outlined in dark paint, while the countryside beyond is broken down into areas of green and ocher, with vertically brushed blue denoting trees and hedges.

Postimpressionist landscapes

Although he was well acquainted with the impressionists, Cézanne's approach to landscape was markedly different and he is usually described as a postimpressionist.

The term "postimpressionism" was coined by the British critic Roger Fry (1866–1934), when he organized an exhibition entitled *Manet and the Postimpressionists* in 1910. The name signified little more than the heirs of impressionism, and, indeed, the aims and styles of the four leading figures in the "movement"—Paul Gauguin, Vincent van Gogh, Cézanne, and Georges Seurat—were very dissimilar.

Most of the postimpressionists continued to paint outdoors, as the impressionists had done, but were no longer interested in concentrating solely on fleeting atmospheric effects. Instead, they were keen to produce something of more lasting value—in Cézanne's words, "something solid and enduring, like the art of the museums." The neo-impressionists (see page 185) wanted to emulate the luminous qualities that impressionism had achieved, but were determined to base their methods on a more rational approach, making use of the latest scientific theories about color and optics. Led by Seurat and Paul Signac, they adopted a pointillist technique in which tiny dots of pure color were placed side by side.

For Gauguin (see pages 202–05) and van Gogh (see pages 194–97), the main shortcoming of impressionism had been its exclusive concern with physical phenomena. In their different

Above: Georges Seurat, The Shore at Bas-Butin, Honfleur, *1886. This sunlit coastal scene is rendered using tiny dots of color.*

ways, both artists tried to introduce a spiritual dimension into their art. By using symbolic colors and linear simplifications, Gauguin hoped that his landscapes would convey a mood or an idea. His experiments were pushed still further by his followers, the nabis, and, just as Cézanne laid the foundations of cubism, so they facilitated the emergence of art nouveau.

Van Gogh's style owed something to Gauguin's theories, but was also deeply influenced by the bright colors and radical stylizations of Japanese prints. He used these elements as a vehicle for his emotions, declaring that "instead of trying to reproduce exactly what I have before my eyes, I use color more arbitrarily so as to express myself more forcibly." In doing so, his work proved a major inspiration for expressionism (see page 201).

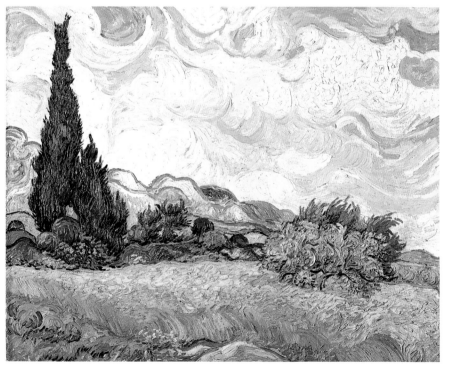

Left: Van Gogh expressed his troubled state of mind in vigorously executed landscapes such as Cornfield with Cypresses *(1889).*

VINCENT VAN GOGH
SUNFLOWERS

an Gogh (1853–90) is normally regarded as a tragic, isolated figure, but there were times in his life when his outlook was extremely positive. This famous painting was produced during one of these optimistic periods; it is radiant, glowing with life, an eloquent reflection of his joyful mood. In February 1888, van Gogh moved from Paris to Arles, in the south of France. He had recently become very enthusiastic about Japanese prints and hoped that Arles, with its warmer climate and brighter light, would be something akin to a "Japan of the south." He was also keen to found an artists' colony there, and his brother Theo, as willing as ever, did his best to help him. In the summer of 1888, Theo persuaded Paul Gauguin (see pages 202–05) to join Vincent in Arles, sharing his house. With the benefit of hindsight, it is clear that this was a bad idea. Gauguin was attracted principally by the money that Theo was offering and regarded the entire venture as a convenient business arrangement. For Vincent, it was the fulfillment of a dream and he pursued it wholeheartedly. The consequences are well known. Within months, relations between the two artists had deteriorated badly, leading to the crisis point in December 1888 when van Gogh cut off part of his ear.

This painting dates from the happy period before the friendship went sour. While he was awaiting Gauguin's arrival, Vincent decided to decorate his friend's room with a series of pictures of sunflowers. He did not choose this subject because of the flowers themselves, but on account of their color. In Japan, yellow was the color of friendship and van Gogh wanted to make his home as welcoming as possible. Working at a furious pace, he finished four sunflower paintings in August, hoping eventually to produce twelve.

When Gauguin saw these pictures, he was very impressed. He painted a portrait of Vincent at work on one of the canvases and tried to swap some of his own sketches for one of the sunflower paintings. Even after their quarrel, van Gogh continued to produce further versions of this theme. He intended to use two of these later sunflower pictures as side-panels on a portrait he was painting of Madame Roulin, the wife of the local postman. Van Gogh's friends were well aware of his fondness for these blooms, and when he died, they placed sunflowers on his coffin. Always popular, van Gogh's sunflower paintings gained added fame in 1987, when one was sold for £24 million, which, at the time, was the highest price paid for a painting at auction.

Vincent van Gogh, *Sunflowers*, 1888, oil on canvas (National Gallery, London)

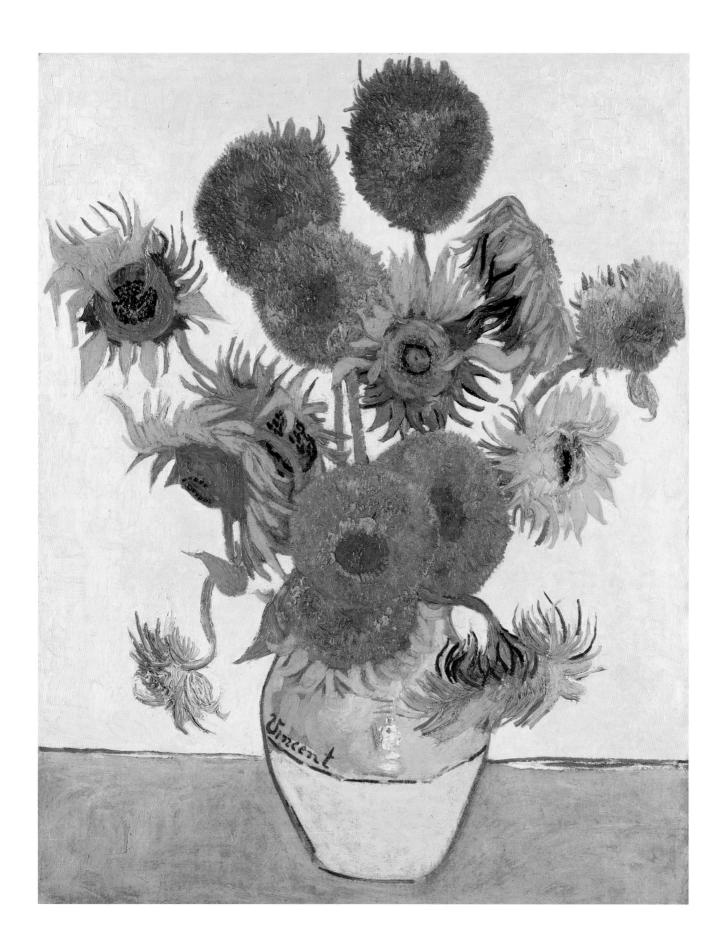

Style and technique

Van Gogh's style developed rapidly in the late 1880s. During his spell in Paris between 1886 and 1888, he absorbed the ideas of the impressionists and the symbolists—and their love of Japanese prints—and these varied influences can all be detected in his mature works. His bold use of color, his spontaneous brushwork, and his taste for thickly applied paint were highly original, as was his emotive approach. "Instead of trying to reproduce exactly what I have before my eyes," van Gogh said, "I use color more arbitrarily, in order to express myself forcibly." As a result, he has often been claimed as a forerunner of the expressionists (see page 201).

The surface texture of van Gogh's paintings is often as important as the color and forms. He tended to lay his paints on very thickly, a practice that was assisted by the stiff consistency of nineteenth-century, machine-made paints. On the seed heads of these petal-less flowers, he appears to have squeezed the paint directly onto the canvas from the tube.

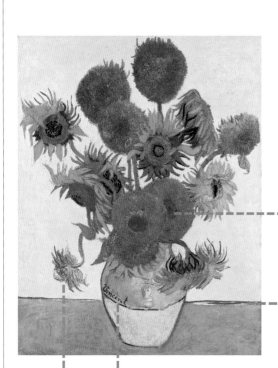

The pale yellow paint in the background is applied with neat, interlocking brush strokes, like the weave of cloth, providing a foil for the vigorously worked sunflowers. It is separated from the darker yellow ground by a blue line. These elements—like the painting of the vase—show the influence of Japanese prints and the "cloisonnist" style of Gauguin, in which areas of bright color are enclosed by dark lines.

This ragged flower head is vigorously worked; the paint appears to have been scraped away with the handle of a brush.

Van Gogh painted several versions of the sunflowers, but he decided that only two of them were good enough to sign. He placed his signature in a prominent position, its dark lines picking up those of the sunflower petals.

Insanity and creativity

Van Gogh's most prolific period as an artist coincided with his mental collapse. This type of mental instability has often been closely associated with the creative process.

Always a neurotic character, van Gogh's health deteriorated in the winter of 1888. At the time his illness was diagnosed as epilepsy. He suffered from convulsions, accompanied by terrible hallucinations, violent impulses, and bouts of deep depression. Since his death, doctors have theorized about other conditions, most notably schizophrenia or a latent, genetic condition, triggered off by sunstroke. However, no definite diagnosis can be made, and as one expert put it, Vincent's illness appears to have been as unique as his art.

Van Gogh could not paint during his periods of depression, but he compensated for this by working at a frenzied pace at other times. He seems to have derived some therapeutic benefit from this activity. "I'm alright when I completely immerse myself in work," he said, "but I'll always remain half crazy." He was equally aware that, to some degree, his creativity was fueled by his nervous tensions.

This view was echoed by Edvard Munch (see pages 198–201), who suffered a series of mental crises leading up to a breakdown in 1908. "I would not cast off my illness," he declared, "for there is much in my art that I owe to it." Indeed, he made it his goal to portray the inner life, the "modern psyche," rather than the world around him. This subject found its greatest outlet in the neurotic masterpieces of the 1890s—*Anxiety*, *Despair*, *The Scream*, and *Spring Evening on Karl Johan Street.*

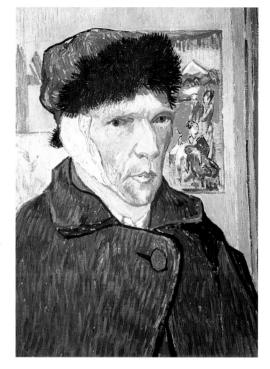

Above: Van Gogh, Self-Portrait with Bandaged Ear, *1889. This picture has become the archetypal image of the artist as tormented, tragic genius.*

The expressionists and the surrealists both professed an interest in the art of the insane, believing that it offered a direct route to the subconscious. Salvador Dalí (see pages 230–33) even tried to mimic some forms of mental illness, in order to give his art a hallucinatory quality. The reality was often far less dramatic. The English painter Richard Dadd (1819–97) produced an impressive range of work while confined in the asylums of Bedlam and Broadmoor, after killing his father. His paintings display few signs of mental turmoil, revealing instead a taste for fantasy and fairy subjects rendered with an obsessive attention to detail.

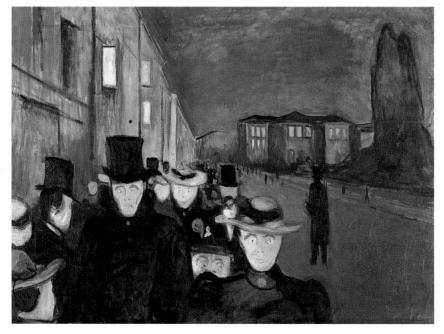

Left: Edvard Munch, Spring Evening on Karl Johan Street, *1892. The haunting faces and blank stares of the figures typify the anxiety and isolation that Munch expressed in his paintings of the 1890s.*

EDVARD MUNCH

THE SCREAM

1893

his terrifying image is Munch's (1863-1944) most famous painting, as well as one of the best known icons of modern art. It has been parodied endlessly in cartoons and advertisements, reproduced as a comic inflatable, and yet, despite its familiarity, it remains uniquely disturbing. The origins of the image appear to be rooted in a form of panic attack suffered by the artist, of which he has left his own account: "One evening, I was walking along a road with two friends. On one side lay the town, below me the fjord. I felt tired and ill ... The sun was setting and the clouds turned a bloody red. I sensed a scream passing through nature. It seemed to me that I could hear the scream. I painted this picture, painted the clouds as actual blood. The colors shrieked."

Munch first mentioned this incident in a diary entry of January 1892, specifying that it took place on a hillside path outside Kristiania (now Oslo). He immediately became obsessed with the idea of portraying the event, but was unsure how to go about it. His initial version of the subject was called *Despair*. This painting featured a faceless man and a blood-red sky, but the figure was looking away from the spectator, gazing out over the fjord. As a result, the picture conveyed a romantic melancholy rather than the terror that the artist was seeking.

Munch experimented with several variations of this theme, but it was only in the latter part of 1893 that he refined the image into *The Scream*. By turning the figure toward the viewer, he made the horror of the situation far more tangible. This figure was no longer Munch himself, but an ageless, sexless creature—a symbol of all humanity. Two paintings and two pastels of this final version of the motif survive—the other painting is housed in the National Gallery, Oslo.

The shock waves from the scream distort the head, elongated hands, and body of the figure, but have no apparent effect on his companions, suggesting that the real trauma comes from within, rather than from nature itself. There has been much speculation about the possible causes of this expression of individual torment. Some attribute it to Munch's fragile mental state or to alcoholic excess, while others see it as an attack of agoraphobia—a theory supported by the dizzying structure of the composition, with its emphasis on the steeply rising diagonal line of the railings.

Edvard Munch, *The Scream*, 1893, oil on card (Munch Museum, Oslo)

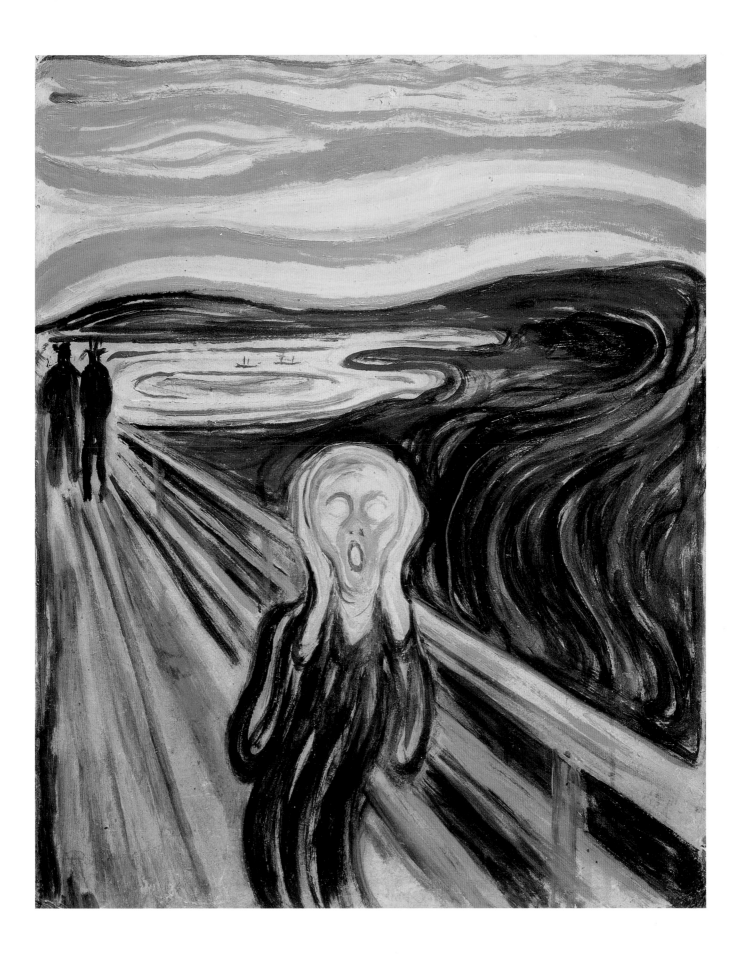

Style and technique

Munch produced several versions of The Scream as he grappled with the problem of conveying a deafening sound by purely visual means. His initial attempt was roughed out in pastel on a piece of cardboard. The symbolists had created a precedent for using simplified forms and pure, unmixed colors as a way of depicting strong emotions, but no one had taken these methods to the same extremes as Munch. He sought to make his lines and colors "quiver with movement" and "vibrate like a phonograph," so that he could conjure up his convulsive state of mind.

Some critics regard these figures as sinister, threatening presences, although it is possible that they are the two friends mentioned in Munch's account of the picture. Either way, it is clear that they are immune from the horrifying shock waves that affect the figure in the foreground.

The original inspiration for the garish coloring of the sky may well have come from a sunset, but Munch stressed that he meant to paint it as real, clotted blood. On the other painted version of The Scream Munch wrote in pencil in the sky: "Can only have been painted by a madman."

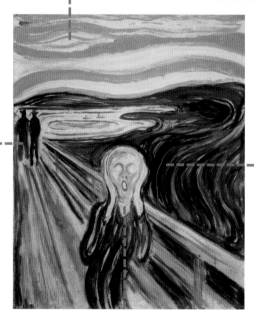

This pale, skeletal face is a primal image of fear and despair, its hands clasped over its ears, and its eyes and mouth wide open. The curving, melting form of the insubstantial figure looks as if it is going to be sucked into the threatening vortex around it.

The frenzied, sweeping brushwork of the background appears to radiate out from the figure, distorting the landscape and sky with unnatural forms and colors. The writhing, tumultuous lines of the hills, fjord, sky, and figure contrast with the straight lines of the pathway, though even these lines are unsettling, with their steeply raking angle.

Expressionism

Because of the anguish which is visible in some of their paintings, both Munch and Vincent van Gogh are often regarded as forerunners of expressionism, a style that emerged in early twentieth-century Germany.

The term "expressionist" is often used very loosely. In its most basic sense, it refers to any painting in which form and color are distorted to convey a personal mood or emotion. Using these criteria, the religious paintings of Matthias Grünewald (c.1470/80–1528) or El Greco (see pages 58–61) could be described as "expressionist."

These stylistic traits became more common at the end of the nineteenth century, as artists increasingly moved away from a naturalistic approach. Paul Gauguin (see pages 202–05), van Gogh (see pages 194–97), and Munch all employed linear distortions and symbolic colors in order to intensify the impact of their pictures. Munch wrote: "I followed the impressions my eye took in at heightened moments ... I painted only memories, adding nothing, no details that I did not see ... By painting colors and lines and forms seen in quickened mood, I was seeking to make this mood vibrate."

Munch's influence was greatest in Germany, where he spent much of his career, and it was there that the real expressionist movement emerged. German expressionism revolved around two groups: *Die Brücke* (The Bridge), founded in Dresden in 1905 and led by Ernst Kirchner, and *Der Blaue Reiter* (The Blue Rider), a loose association of artists including August Macke, Franz Marc, and Wassily Kandinsky, who came together in 1911 in Munich. In different ways, these painters brought expressionism to the brink of abstraction (see page 225).

The movement suffered a major reverse during World War I (1914–18), when several key members were killed in action, but some aspects of the style were preserved in the work of George Grosz, Otto Dix, and Max Beckmann. Their powerful paintings continued to cast a critical eye on the failings of the Weimar Republic, until the Nazis branded expressionism a degenerate art form and outlawed it in 1933.

Left: Ernst Kirchner, Berlin Street Scene, *1913. Kirchner (1880–1938) was a key figure in the German expressionist movement, and his sardonic images of fashionable Berliners are recognized as some of his greatest works. With their jagged, elongated forms and masklike faces, the figures show a jaded society.*

Right: George Grosz, Pillars of Society, *1926. Grosz (1893–1959) was closely involved with avant-garde art movements in Berlin after World War I. His biting satires on the corruption of society continued the expressionist concern with social criticism, but in a more detailed style.*

PAUL GAUGUIN
WHERE DO WE COME FROM?
WHAT ARE WE? WHERE ARE WE GOING?

1897

This painting is Gauguin's (1848–1903) largest and most ambitious work. He painted it at a time when he was in the depths of despair and intended it to represent the summation of his life's work. In 1897 Gauguin's career appeared to be at its lowest ebb. He was spending a second spell in Tahiti following an abortive return to Paris between 1893 and 1895, but he was short of money and in poor health, and recognition of his talent seemed as far off as ever. Then, in March 1897, he learned of the death of Aline, his favorite daughter. It seemed the final straw. Gauguin decided to paint one last masterpiece, encapsulating all the lessons he had learned about art and human experience, before ending his life.

By his own account, Gauguin executed the work very quickly, completing it in less than a month. The condition of the picture appears to confirm this, for it was painted very thinly on a long strip of coarse sacking. When it was finished, Gauguin tried to commit suicide by taking a massive dose of arsenic, but he took too much and simply vomited most of it up. Accepting this outcome as the will of fate, he did not make a second attempt and lived on until 1903.

Where Do We Come From? is now regarded as a fitting testament to Gauguin's art. In its huge expanse—it measures 164 in. x 56 in. (376 cm x 141 cm)—the picture touches on many of Gauguin's favorite themes, although the painter was keen to stress that they did not constitute an allegory with a precise meaning. In essence, the scene is reminiscent of the Garden of Eden, inhabited by a variety of "primitive," or innocent, people and animals. However, it is a tainted paradise. The idol and the white bird are portents of death, a fate to which the old woman at left seems grimly reconciled. Worse still, the happiness of the other natives appears threatened by the intrusion of "civilization." The figure in the center, although male, carries overtones of Eve plucking the fatal fruit from the Tree of Knowledge. Behind him, a girl raises a hand to her head in puzzlement, as—in Gauguin's words—"two sinister figures" walk by, discussing this dangerous learning.

The painting was exhibited in Paris in 1898 to a lukewarm reception. The critic André Fontainas summed up the general air of bewilderment when he condemned the "dream figures" as dry and colorless, "produced by an imagination maladroitly metaphysical, for which meaning is difficult and expression arbitrary."

Paul Gauguin, *Where Do We Come From? What Are We? Where Are We Going?*, 1897, oil on sack cloth (Museum of Fine Arts, Boston)

Style and technique

Gauguin claimed that he painted this picture spontaneously without making any prior studies. However, a squared-up preparatory sketch has survived and several of the figures were borrowed from previous compositions. The reclining figure on the left-hand side, along with the white bird, was copied from his depiction of a mythical Polynesian character, Vairumati, that he had completed earlier in the year. The rich, unnatural colors and simplified, often strongly outlined, forms are typical of his style, while the friezelike composition may owe something to Botticelli's Primavera (see page 49), a photograph of which Gauguin kept pinned up in his hut.

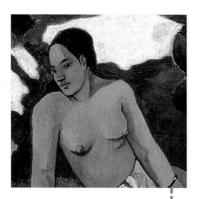

This young woman seems lost in her thoughts. With the exception of the two "sinister figures," all the people seem silent and contemplative, adding to the meditative quality of the painting. Gauguin intended the picture to function in an abstract way like poetry or music.

For Gauguin, the image of plucking ripe fruit was meant to symbolize the enjoyment of life's pleasures, although it also has overtones of the Fall of Man.

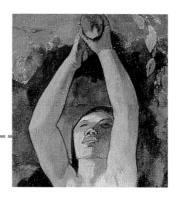

Set against a dark background and illuminated by an unearthly red glow, two figures are engaged in discussion—according to Gauguin about their anguish at the intrusion of Western civilization.

In a letter written shortly after he completed the painting, Gauguin described the figures as an illustration of the passage between life and death, reading from right to left. A baby lies at the right-hand edge, and at the left sits an old woman.

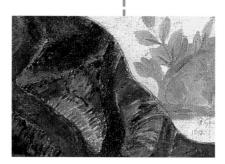

The twisting trees and vegetation are represented with simplified forms, rhythmic patterns, and rich, unnaturalistic colors. Gauguin wanted his paintings to have a decorative and emotional effect.

Primitivism

By the end of the nineteenth century, many avant-garde artists began to look to non-European cultures for inspiration, particularly to so-called primitive art.

In this context the term "primitive" refers to art produced outside the European tradition of academic art. Interest in non-Western art had been awakened in the late nineteenth century by Japanese prints, with their bold compositions and flat colors. They prompted artists to look to other cultures to find the vitality and sincerity they thought lacking from their own traditions. Gauguin was a genuine pioneer in this respect. He drew inspiration from the carvings that he saw on his travels in Tahiti and the Marquesas Islands, and developed an interest in Javanese art after seeing the ethnic displays at the World Fair in Paris in 1889.

Gauguin's absence from the European scene—from 1891 he lived mainly in the South Seas—meant that his true influence did not become apparent until the retrospective exhibitions that followed his death. The 1906 Salon d'Automne in Paris included some two hundred of his works and established his reputation.

However, by this time many painters had already turned their attention to African art. France's wide-ranging colonial connections meant that tribal masks and sculptures could be purchased very cheaply in Paris, or else studied at the ethnographic museum in the Trocadéro. The young French painters known as the fauves, or wild beasts—notably Maurice de Vlaminck (1876–1958), Henri Matisse

(see pages 218–21), and André Derain (1880–1954)—were the first to make use of this material from about 1904. Further echoes of African art can be detected in the simplified forms of the cubists, particularly Picasso's work of around 1907 (see pages 210–13).

The elongated shapes in the sculptures and paintings of Amedeo Modigliani (1884–1920) also reflect the influence of primitivism. His interest in African, Oceanic, and Cycladic carvings was filtered through the abstracting tendencies of his mentor, the sculptor Constantin Brancusi (1876–1957).

Above: Amedeo Modigliani, Head of a Woman, *c.1909–14. The long proportions and abbreviated features were influenced by the simplified forms of African carvings and masks.*

Right: Pablo Picasso, Nude with Draperies, *1907. The strongly outlined, jagged forms were inspired by African art, particularly from the Ivory Coast and the Congo.*

CLAUDE MONET
THE WATER LILY POND
1899

laude Monet (1840–1926) was the most committed of the impressionists. Long after his former colleagues had begun to diverge from the movement in order to explore new avenues, he remained true to its basic principles. Until the end of his career he enjoyed painting outdoors, capturing on canvas all the momentary sensations of light and color that nature had to offer. The impressionist movement was centered on eight exhibitions, which took place in Paris between 1874 and 1886. After the last of these shows, the members of the group began to disperse, largely because they had achieved their aims. The impressionists' revolutionary style had gained acceptance and the individual painters were finding it far easier to sell their work. However, while some began to pursue other artistic goals, Monet embarked on the most radically impressionist phase of his career. In the early 1890s he started producing series of paintings depicting the same subject over and over again, so that he could study in minute detail the way that everchanging light conditions altered its appearance. Initially Monet traveled to different parts of France in his quest for suitable locations—Rouen Cathedral provided the subject of one of his best-known series (1891–95)—but by the late 1890s his new garden at Giverny had become the main focus of his work (see page 209), particularly the water garden he created there.

A water lily pond lay at the heart of this water garden, crossed at one end by an arching wooden footbridge, which was based on a Japanese print by Hiroshige. Behind it, clumps of weeping willow and ash trees provided a dense curtain of luxuriant foliage. On either side, the banks of the pond were planted with irises, spiraea, coltsfoot, and bamboo.

This is one of Monet's earliest pictures of the pond, which rapidly became one of his favorite themes. In 1899 alone he painted eighteen versions of it, twelve of which were shown at an exhibition organized by his dealer Paul Durand-Ruel. The motif of the bridge was particularly useful, since it anchored the composition amid Monet's increasingly abstract patterns of flowers and foliage. Its curving base echoed the circular banks of the pond, helping to create a sense of depth, while its vertical struts formed a pleasing contrast to the horizontal bands of water lilies. Monet continued to paint the water lily pond and Japanese bridge even when his sight began to fail. These late canvases have been hailed as a foretaste of abstract expressionism (see page 245), but in reality, they are a sad indication that the artist was losing the most precious of his senses.

Claude Monet, *The Water Lily Pond*, 1899, oil on canvas (National Gallery, London)

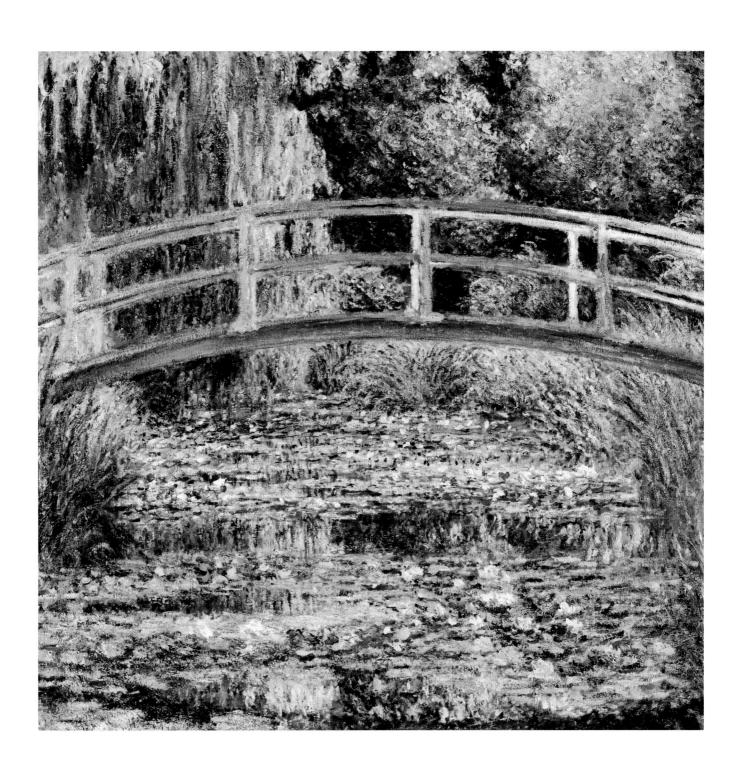

Style and technique
In his paintings of Giverny, Monet's style became increasingly decorative. Taking the flowers, luxuriant foliage, and shimmering reflections of the water as his starting point, his paintings became webs of richly worked color. When making this painting, he set up his easel very close to the bridge, so that the sky did not feature in his composition, and he exaggerated the density of the distant foliage. These decorative tendencies were highlighted by the "Whistlerian" subtitles that he gave to some of his works—he described certain versions of his water lily paintings as Harmony in Rose or Harmony in Green.

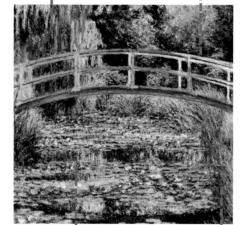

Vertically applied strokes of thick yellow, pale green, and pale blue paint suggest the foliage of a weeping willow. As in many of his paintings of Giverny, Monet removed all traces of the sky, replacing it with swathes of greenery. Contemporary photographs make it clear that even when the foliage was at its most profuse, the distant hills and meadows were always visible.

Glints of sunlight fall on the right-hand section of the bridge. In the absence of sky, they are the only clear indication of the weather conditions that had been a key concern in Monet's earlier work.

The surface of the canvas is richly textured, with paint applied thickly, using a variety of marks to evoke different forms. Long strokes and flicks of the brush suggest iris leaves at the edge of the pond.

The water lilies are painted in broad, horizontal bands, their flowers picked out with dabs of white and pink paint and their leaves suggested with touches of blue and green. Between them vertical strokes denote the reflections of the willow, which appear as substantial as the water lilies themselves.

Monet's garden at Giverny

From 1883 Monet lived at Giverny in the Normandy countryside, where he created a spectacular garden that inspired some of his greatest paintings.

When Monet settled in the village of Giverny, his career was beginning to prosper. By 1890 he was sufficiently wealthy to purchase the property that he had been renting, and shortly afterward he took on a team of six full-time gardeners. Immediately he set about transforming the place, uprooting trees in the orchard and replacing them with flower beds and arches draped with climbing plants. Monet's priority was for densely packed areas of tiny blooms, so that however formal the layout of the garden might seem on paper—it was divided into neat squares—its actual appearance was never too ordered or regular. The profusion of flowers overspilled its borders, narrowing the gravel paths and concealing their straight edges.

In 1893 Monet purchased a marshy strip of land, separated from the rest of his grounds by a disused railroad track. There he created the water garden that featured so heavily in his later work. His aim was to emulate the calming, tranquil spirit that he admired in Japanese prints, and to this end, he introduced a range of Asian plants and features, including Japanese apple and cherry trees, peonies, bamboo, ferns, azaleas, and every imaginable variety of water lily.

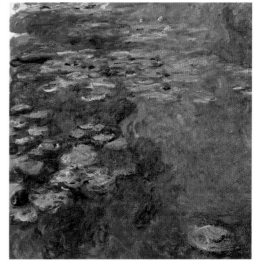

Above: Monet, Waterlilies, *1917. Monet's later paintings became increasingly free, focusing on the flower-covered water.*

Monet enlarged the existing pond by diverting the local river, but with his customary lack of diplomacy, he managed to alienate the local farmers, who became convinced that his exotic blooms would poison the water, which their cattle drank.

In 1914, when Monet's eyesight began to deteriorate and he found it difficult to observe and record the fleeting changes of nature, he had a studio built in the middle of his garden. There he began a series of huge reflective paintings, which he saw as a "kind of synthesis or summing up" of his life's work. These lyrical evocations of his water lily pond—some of the finest of which are now installed in the Orangerie, Paris—along with the garden that inspired them, are among the most eloquent testaments to Monet's vision.

Left: Monet, Garden at Giverny, *1900. This border brimming with blue irises is typical of the dense planting effects Monet created.*

PABLO PICASSO
LES DEMOISELLES D'AVIGNON
1907

his unsettling image has long been accepted as one of the most significant landmarks of modern art. In a giant leap forward from his previous style, Picasso (1881–1973) abandoned most of the pictorial values that artists had cherished since the Renaissance—in particular, their desire for a lifelike rendering of form and space. On its most basic level, the painting shows five female nudes in an interior. More specifically, they are prostitutes in a brothel, for Avignon was the name of a street located in the heart of the red light district in Barcelona. The title was suggested as a joke by André Salmon, one of the artist's friends—the word *demoiselles* implies that the girls are respectable young ladies. In the foreground, there is a still life consisting of various items of fruit. This arrangement serves as a *vanitas* or *memento mori*—a reminder that earthly pleasures are short-lived, and that both human flesh and ripe fruit will soon decay.

Originally, Picasso intended to include two male figures in the composition: a sailor on shore leave sitting at the table and a medical student entering the room with a skull. In the end, he dispensed with them, preferring to place the viewer in the role of the voyeur inside the brothel.

Picasso worked on *Les Demoiselles d'Avignon* in two distinct phases. The left-hand side dates from early 1907, when his primary influence was pre-Roman Iberian sculpture. A few months later, the figures on the right were drastically reworked. Their masklike faces have usually been ascribed to the influence of primitive African art, which was becoming popular among avant-garde artists in Paris (see page 205).

Picasso's personal opinion of this picture is difficult to determine. He made no attempt to exhibit the painting until years after its completion, although it had already been seen in his studio by many of the most experimental young artists in Paris. It may be that he was concerned about the public reaction to his radical innovations, but it is much more likely that he still regarded the painting as a work in progress. Either way, the picture was not seen openly until 1916, after which it passed into a private collection. Subsequently, it was reproduced in the 1925 edition of the surrealist publication *La Révolution Surréaliste*, but it did not feature in a major public exhibition until 1937, when it was shown at the World Fair in Paris. Two years later it was purchased by the Museum of Modern Art in New York.

Pablo Picasso, *Les Demoiselles d'Avignon*, 1907, oil on canvas (Museum of Modern Art, New York)

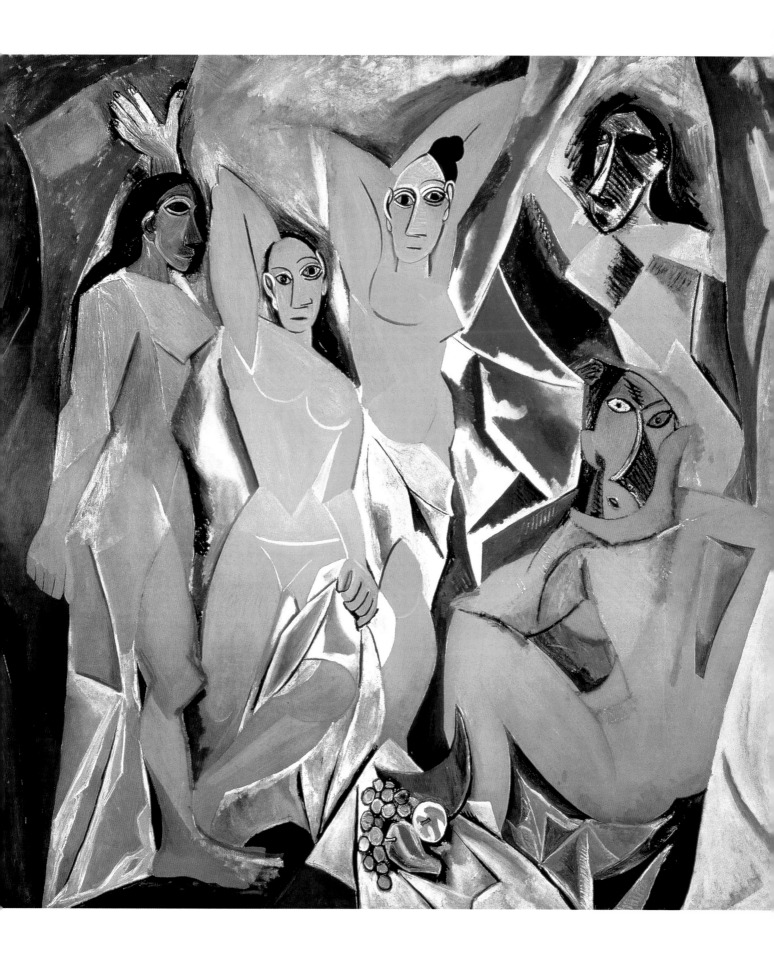

Style and technique

Les Demoiselles d'Avignon *dates from Picasso's most inventive period, when every month seemed to bring new revelations. Accordingly, when the artist was working on this painting, he was not thinking in terms of selling or exhibiting it. Instead, this gigantic canvas—it measures 92 in. x 96 in. (233 cm x 244 cm)—acted as a testing ground for his ideas. Scores of drawings can be related to the composition. Many show the gradual evolution of individual figures, while others are later developments, taking forward ideas first explored in* Les Demoiselles *(see page 205). In view of the jarring styles of the figures, as well as the later history of the painting, it is unlikely that Picasso considered it finished.*

The woman on the left is drawing back a reddish curtain just as the standing figure on the right appears to be parting two blue drapes. The background is difficult to decipher among the fractured forms and flattened space.

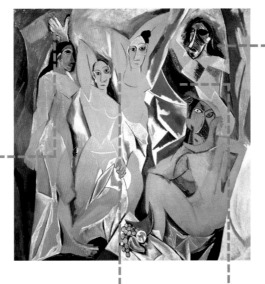

The two figures on the right appear to reflect Picasso's newfound interest in African art, an influence most clearly seen in their masklike faces with their emphatic striations. Avant-garde artists were beginning to collect ethnic carvings, which were also on public display at the Trocadéro ethnographic museum in Paris.

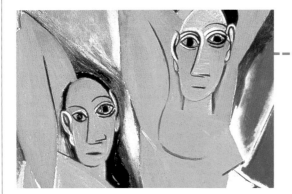

The simplification of the forms of these two figures was inspired by ancient Iberian carvings, which Picasso was able to see in an exhibition at the Louvre in 1906. The women's provocative poses and expressions—their darkly outlined eyes, angular noses, and straight mouths—are emphasized by the harsh style in which they are rendered.

The forms of the women and the background are broken down into sharp, jagged shapes, which add to the unsettling effect of the image. The systematic fragmentation and dislocation of form came to epitomize the cubist style.

The birth of cubism

Of the many famous and innovative paintings Picasso created, *Les Demoiselles d'Avignon* was the most influential. It was the foundation stone of cubism, the movement that more than any other shaped the course of modern art.

Cubism encapsulated a new stylistic approach to the art of representation. It abandoned the traditional convention of creating the illusion of three-dimensional space and volume on the two-dimensional picture surface. Rather than showing an object as it appears when seen by the human eye at a particular moment and in a particular setting, cubist artists combined into a single image different views of the object that would never be visible together at the same time in the real world. Cubist paintings are typified by the fragmentation of forms into many different facets, which has the effect of emphasizing the formal qualities of the picture rather than its nominal subject.

Picasso was inspired to embark on this course in *Les Demoiselles* by a number of different influences. The basic idea of the nudes and the notion of reducing three-dimensional surfaces to geometric planes came from paintings of bathers by Paul Cézanne (see pages 190–93). Picasso was also prompted to take a step further in his retreat from naturalism by the bold, nondescriptive use of color he saw in the work of a group of painters known as the fauves. In addition, he was intrigued by the way that two of these artists—Henri Matisse (see pages 218–21) and André Derain (1880–1954)—had absorbed the influence of "primitive" art into their style (see page 205).

The most important factor in the development of cubism, however, was Picasso's meeting with the French artist Georges Braque (1882–1963) in 1907. Braque was impressed by the fragmentation of the figures in Picasso's painting, but his own experiments in landscape—based largely on the geometric abstractions of Cézanne—were further advanced. After their meeting the two artists collaborated closely, working—in Braque's words—"like mountaineers roped together," as they created a revolutionary new style.

Below: Georges Braque, The Portuguese, *1911. The painting's fragmented, dislocated forms are typical of the cubist style.*

GUSTAV KLIMT

THE KISS

1907-08

ustav Klimt (1862-1918) was Austria's most famous artist and the driving force behind the Vienna Sezession (see page 217). In this, his most celebrated painting, he achieved a heady blend of opulence and eroticism. Klimt was haunted by the theme of the kiss, producing three distinctive variations of it. The first two formed part of decorative schemes—the *Beethoven Frieze* and the *Stoclet Frieze* (see page 217)—but this, his final painting on the subject, is the definitive version.

The Kiss shows a couple locked together in a passionate embrace. They are cocooned in richly patterned golden robes, emphasizing their union and setting them apart from the outside world. It is a sumptuous image: The stylized forms are set against the flat, abstract designs of the fabric and flowers. The proportions of the couple are subordinate to the overall composition. Although at first glance the pose seems convincing, the woman is kneeling down and would tower over her partner if she stood up. There are also ambiguities about the setting. The couple is shown on a flowery bank that falls away sharply behind the woman, leaving her feet dangling over the edge of a golden abyss.

The kiss was a popular theme among symbolist artists. The symbolist movement flourished at the end of the nineteenth century and the beginning of the twentieth century, and was characterized by a rejection of direct, literal representation in favor of evocation and suggestion. Edvard Munch (see pages 198–201), in particular, produced compelling versions of the kiss, often with overtones of vampirism. There are symbolist influences, too, in the poses that Klimt chose for the couple's heads. The woman's closed eyes and the horizontal tilt of her face evoke memories of one of the most ubiquitous themes at the turn of the century—the severed head. This impression is reinforced by the way that the man cradles the head in his hands, much as the decapitated heads of John the Baptist or Orpheus were held in the paintings of other symbolist artists such as Gustave Moreau (1826–98).

Klimt's earlier work had caused much controversy. Murals he painted for Vienna University on the themes of jurisprudence, medicine, and philosophy had been attacked on moral grounds, and he abandoned the project in 1905. Yet in spite of such earlier troubles, when *The Kiss* was exhibited in 1908, it was purchased immediately by the Austrian government.

Gustav Klimt, *The Kiss*, 1907–08, oil and gold leaf on canvas (Osterreichische Galerie, Vienna)

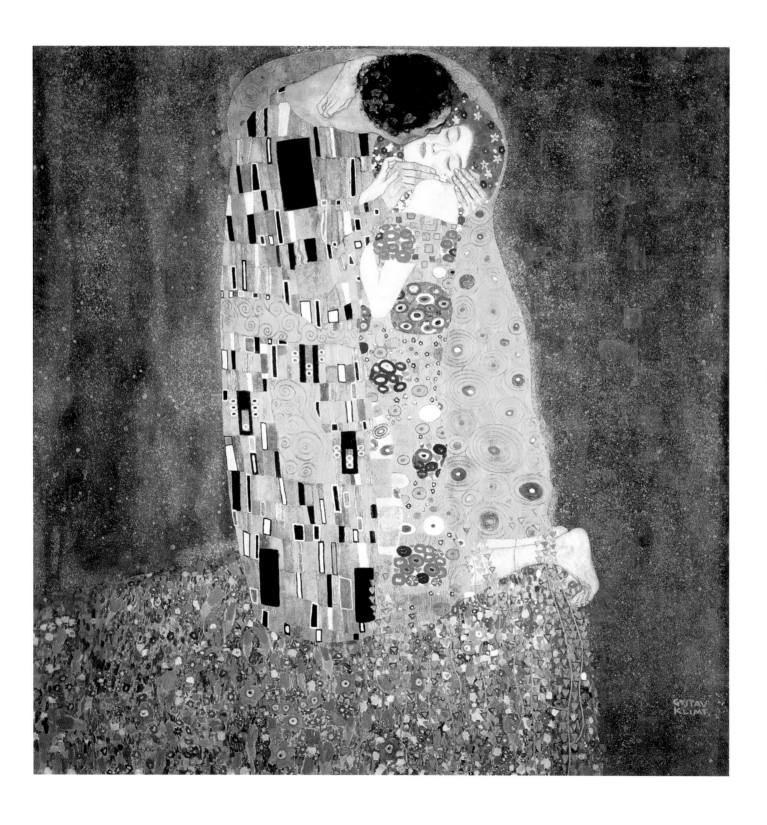

Style and technique

Klimt's lavish use of gold leaf gives his paintings a sumptuous, even decadent appearance. He was inspired by Byzantine art, particularly mosaics, and in 1903 visited the Italian city of Ravenna, where he was overwhelmed by the mosaics in the church of San Vitale. His taste for opulent materials had been awakened by his father, who was a goldsmith, and was further stimulated by his training at the School of Applied Arts in Vienna, which included instruction in making mosaics. Klimt's elegant, stylized forms and sense of abstract pattern, typical of art nouveau, were also inspired by Japanese prints.

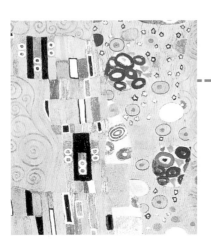

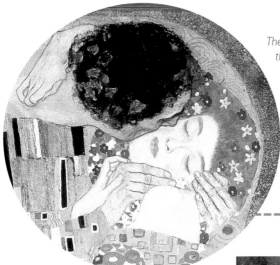

The woman's face is tilted toward the viewer, her eyes shut in rapture, while the man's head is averted. He wears an ivy coronet, a traditional attribute of satyrs, who were notorious for their lustful escapades. Klimt's mistress, Emilie Flöge, apparently believed that the couple represented Gustav and herself.

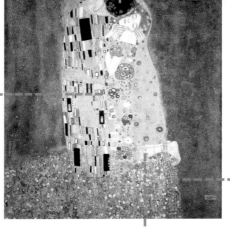

The patterns on the couple's gowns are symbolic as well as decorative. The rectangular, phallic shapes on the man's garment contrast with the circular patterns on the woman's robes.

Streamers of golden triangles on delicate threads trail beneath the woman. It is possible that they were intended to suggest long, flowing hair, a common motif in symbolist paintings. In the Beethoven Frieze (see page 217), the feet of the embracing couple are bound together with hair.

Although the setting is deliberately vague, the woman's feet appear to be dangling precariously over the edge of a richly decorative, flower-covered mound.

Sezession: art and decoration

Although he is mainly remembered today for his paintings, Klimt was also closely associated with the decorative arts, which constituted an important part of his work with the Vienna Sezession and the Wiener Werkstätte.

At the end of the nineteenth century, several groups of progressive artists in Austria and Germany withdrew, or "seceded," from conservative academies and set up their own organizations. The three principal groups were founded in Munich (1892), Berlin (1899), and Vienna (1897). The latter was led by Josef Hoffmann (1870–1956), Joseph Olbrich (1867–1908), and Klimt, who became its first president.

Olbrich designed for the group a purpose-built exhibition hall, which was nicknamed the "Golden Cabbage" on account of its unusual golden dome. Over its main entrance, the Sezession's motto was displayed: "To the Age its Art, to Art its Freedom." Unlike some of the other organizations, the Vienna Sezession encouraged the participation of foreign artists in its shows. It also made a point of focusing on applied art as well as painting. As such, it became an important forum for the latest developments in both art nouveau and the arts and crafts movement. In 1900, for example, the work of the Scottish architect and designer Charles Rennie Mackintosh (1868–1928) and his wife, Margaret Macdonald (1865–1933), was prominently featured, along with that of the English architect and designer Charles Ashbee (1863–1942).

In 1902 Klimt left a lasting mark on the Sezession building when he executed his *Beethoven Frieze* in one of its exhibition rooms. That year's show was dedicated to the great composer, who was featured in its centerpiece—a statue by the German artist, Max Klinger. Klimt's frieze was designed as a backdrop to the sculpture and was inspired by sections of Beethoven's Ninth Symphony.

By 1905 the Sezession was losing some of its impetus and Klimt withdrew from the group, devoting more of his energy to a similar organization, the Wiener Werkstätte (Viennese Workshops). His most important project for this body was the *Stoclet Frieze*, a glorious decorative scheme for the dining room of the Palais Stoclet, a mansion in Brussels designed by Hoffmann.

Below: Klimt, Beethoven Frieze, *1902. This opulent mosaic features an early version of the kiss in the figures at right.*

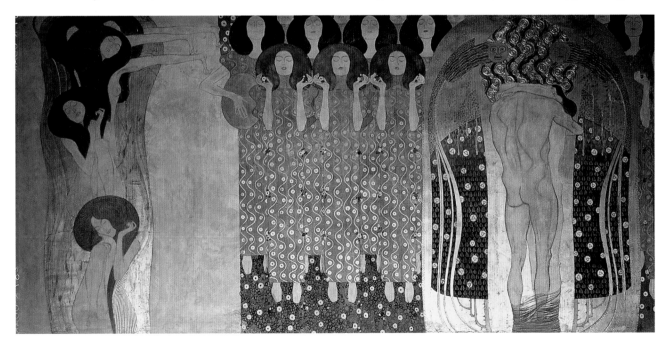

HENRI MATISSE

DANCE

1909–10

This painting is the perfect synthesis of Matisse's (1869–1954) style, marrying his taste for decoration with pure, glowing colors and rhythmic energy. He defined the essence of his approach in an interview in 1909, claiming that he viewed painting as "an invocation; an appeal for serenity, concentration, and peace of mind." This particular "invocation" was commissioned by Sergei Shchukin (1854–1936), an important Russian collector. He had already purchased work by Matisse, most notably *Harmony in Red* (1908), and in 1909 approached the artist with a new proposal: to decorate the staircase of his Moscow home with a series of large painted panels. Originally, Matisse visualized three pictures, one for each floor of the house. *Dance* was to be on the ground floor, with similar panels on music and a more contemplative subject on the upper floors. The last of these paintings, *Bathers by a River*, was only completed years later in 1916 and was never installed.

The composition of *Dance* was enlarged from a minor detail in one of Matisse's earlier paintings, *The Joy of Life* (1905–06). The latter represented an earthly paradise, a brilliantly colored Garden of Eden, and some of this spirit was retained in *Dance*. However, Matisse translated the action from a sunny Mediterranean beach to a sacred hilltop. He also reduced the number of dancers from six to five to enhance the impression of speed and movement. Some critics have tried to link the painting with a specific dance, suggesting that it was based on one of the folk dances the artist had witnessed at Collioure, a small town on the coast of southern France. Matisse himself denied this link, stating that his main source of inspiration came from the energetic farandoles—lively Provençal dances—that he had seen at the Moulin de la Galette (see page 178). In its turn, *Dance* influenced the art form that inspired it. The painting has often been cited as an influence on the choreography that Nijinsky produced for Stravinsky's highly original ballet *The Rite of Spring*, which was first performed in Paris in 1913.

Both *Music* and *Dance* were exhibited at the 1910 Salon d'Automne in Paris, where they caused an uproar. For a time Shchukin wavered over the purchase, fearing that the nudes might be too indecorous to hang in his home. He soon changed his mind, however, and in 1911 Matisse traveled to Moscow to supervise the installation of the panels. Shchukin went on to become the artist's most loyal patron, eventually owning thirty-seven of his paintings.

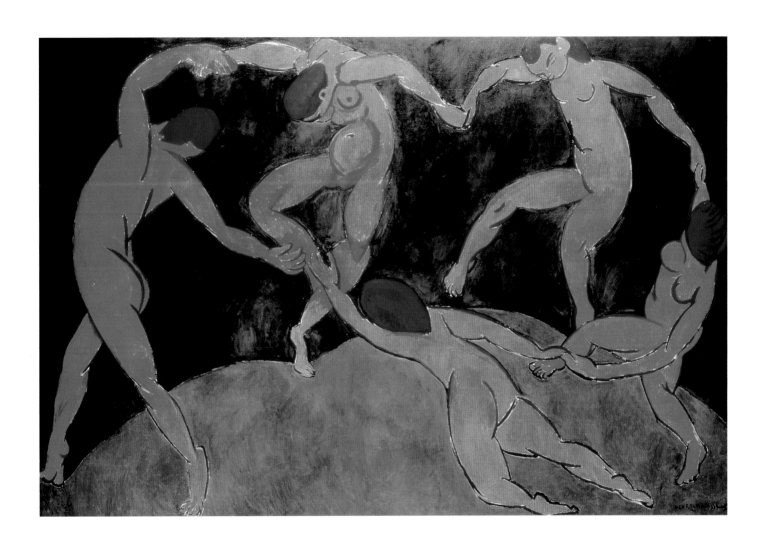

Henri Matisse, *Dance*, 1909–10, oil on canvas (The Hermitage, Saint Petersburg)

Style and technique

Matisse was a leading member of a group of painters who were christened the "fauves," or wild beasts, when their work was included in the 1905 Salon d'Automne in Paris. They received this name for their striking use of intensely vivid colors, which expressed feelings or sensations rather than imitating nature. They also abandoned perspective and other naturalistic features in their paintings. In spite of these simplifications, however, Matisse still made extensive preparations before embarking on Dance. He produced a charcoal drawing, a watercolor study, and a large oil sketch of the entire composition, as well as a number of drawings and models of individual feet.

The bent and compressed torso of this dancer conveys a powerful sense of energy and vigor. Matisse himself was disturbed by the almost aggressive frenzy of the figures in this version of Dance.

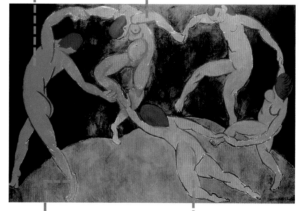

The boldly colored form of this dancer demonstrates the ways in which Matisse developed his initial ideas for the painting. In an oil sketch made in 1909 for Shchukin, he used more conventional pink flesh tones and showed the dancers as women. In the final work, Matisse intensified the color to red and made the gender of three of the dancers more ambiguous.

Matisse used the thrusting diagonal of this figure's body to create a dynamic foreground link in the circular composition; the pose also conveys the speed and energy of the dance.

Although the painting is essentially decorative, Matisse took pains to make the poses of the figures look believable. He made a pencil study of the extended left foot of this dancer, as well as a bronze statuette, which is now in the Hermitage.

Images of dance

Dancing is a subject that has captivated artists throughout the centuries, whether as an expression of religious fervor, a metaphor for the cycle of life, or a simple social custom.

Above: Gustave Moreau, The Apparition, *1876. The painting shows the dance of Salome and the reward—the head of John the Baptist—that she requested from her entranced stepfather Herod.*

Below: Nicolas Poussin, Dance to the Music of Time, *c.1639–40. The circle of dancers represents the perpetual cycle of human life, while the old man and infants symbolize the passage of time.*

Some commentators have suggested that *Dance* was partially inspired by the sinuous designs on Grecian red-figure vases, and the frenzied, naked cavortings of Matisse's dancers do indeed appear to evoke the primeval energy of some ancient ritual. In particular, there are affinities with the wild dances of the maenads and satyrs. In their attempts to revive the spirit of antiquity, many later artists attempted to portray these classical dances. Titian (see pages 46–49) and Nicolas Poussin (see pages 78–81) both depicted the lively antics of the followers of the god Bacchus, while Andrea Mantegna's *Parnassus* (1497) and Sandro Botticelli's *Primavera* (see page 49) presented more stately

images of dance in which the activity became a symbol of harmony.

From the Middle Ages dancing was also used as a metaphor for the transience of life. In particular, the Dance of Death became a popular subject for wall paintings in medieval churches. Most versions showed a line of skeletons leading their victims on a macabre conga to the grave. Invariably, the artist liked to stress that these reluctant dancers came from all walks of society, from the most powerful king to his lowliest subject. This gloomy reflection on the brevity of life survived beyond the Middle Ages, although in a much modified form. Poussin's *Dance to the Music of Time* (c.1639–40) and Edvard Munch's *Dance of Life* (1899–1900) are, perhaps, the most notable versions.

Dancing was also portrayed in a more naturalistic vein. In the sixteenth century Pieter Brueghel painted lifelike peasant dances, although these scenes were also packed with symbolic details (see page 157). In the nineteenth century various forms of dance became a popular impressionist subject. Ballet was a principal theme in Edgar Degas's work (see pages 170–73), while Parisian dance halls featured in Renoir's paintings (see pages 178–81). The symbolists, by contrast, had more exotic tastes. One of their favorite themes was the erotic dance of Salome, performed in return for the head of John the Baptist.

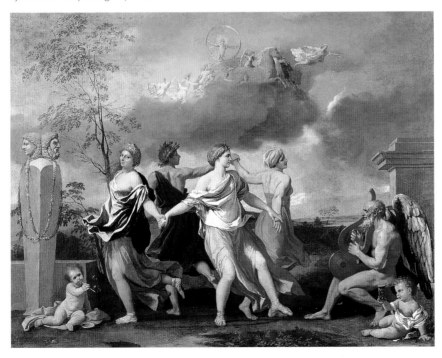

PIET MONDRIAN
COMPOSITION IN RED, YELLOW, AND BLUE
1920

T he "grid" paintings of the Dutch artist Piet Mondrian (1872–1944) are among the most distinctive examples of abstract art (see page 225). Their grids of black lines and blocks of bright colors have passed into popular culture—in the 1960s, for example, they inspired a range of dresses by fashion designer Yves Saint Laurent. Seeking to avoid any reference to the natural world, Mondrian developed an austere, geometric style, which he termed "neoplasticism," or "new plasticism." His early work had been in the symbolist style (see page 214), but after moving to Paris in 1911 he was heavily influenced by Pablo Picasso and the cubists (see pages 210–13), whose pictures laid increasing stress upon the formal, as opposed to representational, qualities of art. During World War I (1914–18) Mondrian returned to Holland, and it was there that he developed his unique style.

His contacts with two people in particular shaped his ideas: the artist Theo van Doesburg (1883–1931) and the philosopher Matthieu Schoenmaekers (1875–1944). With the former, he founded De Stijl—Dutch for "the Style"—a group of painters and architects dedicated to exploring ideas of universal harmony and their expression in art. Mondrian used the group's journal to expound his theories on abstraction. From Schoenmaekers, he derived the rationale behind the two main components of neoplasticism: the emphasis on vertical and horizontal lines and the prominence of the primary colors—red, yellow, and blue. The philosopher had described the first of these components as the two "contraries, which shape our earth," namely "the horizontal line of power that is the course of the earth around the sun, and the vertical ... movement of rays that originate in the center of the sun." Schoenmaekers went on to link these with the primary colors: "Yellow is the color of the ray, blue is the firmament ... yellow radiates, blue recedes, and red floats."

In 1919 Mondrian returned to Paris, where he was gratified to find that his severe brand of abstraction was considerably more daring than the work of his contemporaries. By the following year, he had already embarked on the revolutionary grid paintings that would eventually make his name. However, the radical nature of his art also made it largely unsaleable. During the early 1920s, a substantial part of his income came from painting conventional flower-pieces for the popular market. Unable to sell this picture, he gave it instead to a friend, Peter Alma, as a wedding present.

Piet Mondrian, *Composition in Red, Yellow, and Blue*, 1920, oil on canvas (Stedelijk Museum, Amsterdam)

Style and technique

In his first abstract paintings, Mondrian often distributed his colors more or less at random, but he soon began to agonize over the relative position of his rectangular blocks and their colors. He tried to solve this problem by painting an assortment of colored cards, which he proceeded to arrange in different combinations on the walls of his studio. Despite this preparatory work, Mondrian's canvases still show considerable evidence of overpainting. These changes frustrated the artist, particularly since the oil paint took a long time to dry. In a bid to speed the process up, he often used petroleum as a solvent, although in the long run this caused his pictures to deteriorate prematurely.

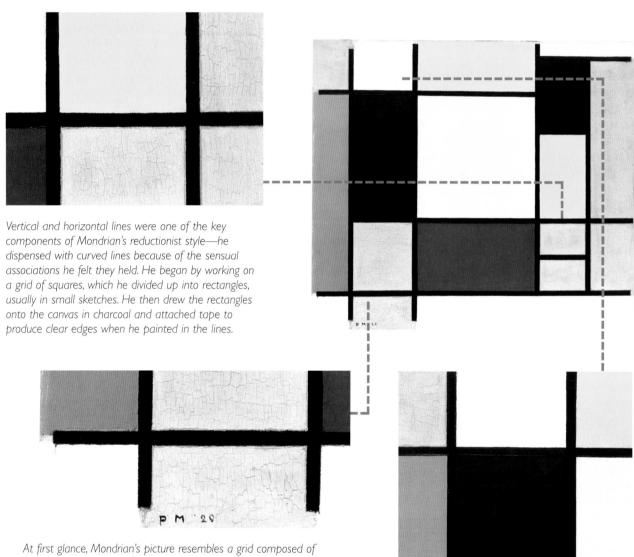

Vertical and horizontal lines were one of the key components of Mondrian's reductionist style—he dispensed with curved lines because of the sensual associations he felt they held. He began by working on a grid of squares, which he divided up into rectangles, usually in small sketches. He then drew the rectangles onto the canvas in charcoal and attached tape to produce clear edges when he painted in the lines.

At first glance, Mondrian's picture resembles a grid composed of interlocking rectangles. Closer examination reveals, however, that some of the lines stop short of the picture's edge. This feature undercuts the notion that the lines exist solely to enclose the colors, and raises the possibility that they form part of a separate structure, which floats freely over the background. In some of his compositions, Mondrian experimented with the idea of rotating his canvases by 45 degrees behind his grid of horizontal and vertical lines.

Mondrian used a very limited range of colors in his search for a pure, universal pictorial language. His compositions are based on the primaries— red, yellow, and blue—along with black, white, and gray, all applied in flat, unmodulated areas.

The birth of abstraction

Mondrian belonged to a pioneering generation of painters and sculptors who made the transition from figurative to abstract art, one of the most radical developments in twentieth-century visual culture.

The abstract work of art does not depict recognizable objects or scenes, but instead is made up of forms and colors that exist for their own purpose. The roots of abstraction can be traced back to the emergence of photography in 1839. Once the business of representing nature accurately had been taken over by a mechanical device, it was logical that artists should seek other outlets for their talents. Some groups—such as the impressionists, neo-impressionists (see page 185), and cubists (see page 213)—found radical new ways of representing the natural world, while others, such as the symbolists and the expressionists (see page 201), sought to depict ideas or emotions rather than physical reality.

Critics have long contested the identity of the first abstract painting. Some have placed it as far back as Paul Sérusier's *Talisman* (1888), a small painting based on a landscape with broad areas of brilliant, unnaturalistic color. Others, more realistically, have opted for a series of *Compositions, Improvisations,* and *Impressions* painted between 1910 and 1914 by the Russian-born artist Wassily Kandinsky (1866–1944).

Mondrian's own route to abstraction passed through symbolism and cubism. The former appealed to him because of its links with theosophy, a religious philosophy tinged with mysticism, which became increasingly popular from the late nineteenth century. He was deeply influenced by theosophy for many years, always believing that his art had a strong spiritual dimension. In purely visual terms, though, the cubist fragmentation of forms proved an even greater inspiration. While the cubists remained committed to the representation of the natural world, however, Mondrian repudiated it.

In the years between 1910 and 1920 the pioneering work of individuals such as Kandinsky and Mondrian was developed by groups of artists. Early movements devoted to abstraction included orphism and synchromism in France; constructivism, rayonism, and suprematism in Russia; and Mondrian's De Stijl group in Holland. They developed abstraction in different directions—orphism and synchromism were concerned with color, for example, and constructivism with modern technology and materials—but all the artists involved regarded abstraction as more than a mere style. Like Mondrian, they saw it as a medium through which to express deeply felt ideas about the world.

Abstraction had a profound influence on subsequent artistic practice, influencing not only painters and sculptors, but also architects and designers. The next great development came with the emergence of abstract expressionism (see page 245).

Below: Wassily Kandinsky, Composition 4. *Kandinsky aimed to present the reality of spiritual rather than sensual experience.*

RENÉ MAGRITTE
THE TREACHERY OF IMAGES
1929

he Belgian painter René Magritte (1898–1967) was one of the most influential members of the surrealist group. The sly humor of his teasing images captivated the public and, even today, is still providing a fertile source of inspiration for filmmakers and advertising copywriters. This famous picture dates from the start of Magritte's career, shortly after he had moved to Paris and made contact with the surrealists. At first glance, it appears nonsensical. An image of a pipe is accompanied by a caption, which states precisely the opposite, "This is not a pipe." On one level, though, the text is accurate. This is not a pipe—it is a painting, an illusion of a pipe.

Magritte produced a number of other "pipe" paintings that revolved around this basic conundrum. In some of these images, he gave the object a more realistic appearance, either by making it cast a shadow or by showing it lit, with a flame issuing from the bowl. Alternatively, he made the pipe appear less real by portraying it within a second, painted frame or else as a drawing on an easel; in other words, as a picture within a picture. In all of these variations, the essential paradox remains the same.

The Pipe paintings formed part of a larger series of word-pictures, which dated back to *The Interpretation of Dreams* in 1927. The inspiration for these images may have come from a number of different sources. The French artist Georges Braque (1882–1963) had introduced lettering into his cubist paintings in 1911 with *The Portuguese* (see page 213), although this had no bearing on the objects depicted. On an intellectual level, there are parallels with the philosopher Ludwig Wittgenstein's analysis of the relationship between language and meaning. There are also links with more popular material. The simple images and captions resemble the illustrations in a child's reading primer. Similarly, some of the word-pictures are reminiscent of a rebus, a type of puzzle where pictures replace part of a word.

Magritte made copies of several of his word-pictures, including *The Treachery of Images*, when he held his first one-man show in America in 1936. In these works, he translated the captions into English. The copy of *Treachery* was purchased by an art dealer called Geert van Bruaene. There is some irony in this, since the latter may have given Magritte the germ of the idea for his Pipe series. For, blazoned over his gallery in Brussels, he had a placard which read: *Ceci n'est pas de l'Art*—"This is not art."

René Magritte, *The Treachery of Images*, 1929, oil on canvas (Los Angeles County Museum of Art)

Style and technique

Early in his career, Magritte worked extensively as a commercial artist and this did much to shape the bland precision of his style. Until 1924 he produced designs for a company of wallpaper manufacturers, and afterward he worked on catalog illustrations for a firm of furriers. These fashion advertisements, which combined simple images and brief captions, were produced at precisely the same time as Magritte's word-pictures, and there is obviously a degree of interplay between the two formats. Clarity remained an important factor in his style, since the ideas contained in his paintings were always more important than their execution.

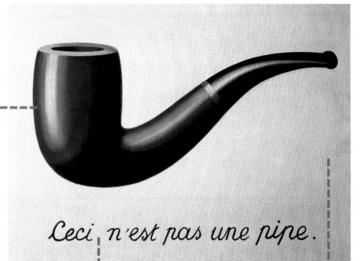

The pipe is rendered in Magritte's meticulous, highly finished style and is carefully modeled with light and shade defining its form. In this way Magritte made the object seem real, even though the caption is telling us that it is not.

The caption is part of the same paradox as the image. It looks like a caption, but it is actually just part of a painting. Within the context of an artwork, there is no definitive reason why it should make any truthful statement about the object pictured above it.

The pipe is pictured against a plain beige background on which there is no illusionistic detail. Later pictures in the Pipe series develop the theme of the illusion. Some show a shadow cast by the pipe or smoke coming out of its bowl, while others depict the image set within an elaborate frame or behind a tree.

Image and reality

The art of Magritte has a mischievous, playful quality, unparalleled in the work of the other surrealists. He liked to confound spectators by making familiar, everyday objects appear strange and sometimes threatening.

In many of his pictures, Magritte employed the same kind of conundrum that was apparent in his Pipe series. There is no reason why an object or a situation portrayed in a painting should obey the laws of physics, however realistic the images may appear. In Magritte's work, a big object may cast a smaller shadow than a tiny one; a weighty item, such as a huge boulder, may float in the air; a rose may fill an entire room. Often, the mystery is compounded by the use of inappropriate materials. A bird made out of stone soars in the sky; a ship composed of waves sails across the sea.

Sometimes Magritte startled his viewers by blurring the boundaries between animate and inanimate objects. A pair of boots mutates into human feet; a nightdress develops real breasts. At other times, he used the dislocation of time as the basis of his effects. He made copies of paintings by Édouard Manet and Jacques-Louis David, but depicted coffins in place of the figures, since the models who had originally posed for the pictures would now be dead. Similarly, he produced a portrait of himself busily working on a painting of a bird while using an egg as his model.

Right: Magritte, Perspective: Madame Récamier by David, *1949. The setting and furniture of David's famous painting are reproduced in meticulous detail but a coffin takes the place of Madame Récamier.*

Alongside these very distinctive themes, Magritte also tackled more typical surrealist subject matter, such as the juxtaposition of apparently unrelated objects. In *Time Transfixed* (1939), for example, he showed a miniature locomotive emerging from a mantelpiece. Although the image makes no rational sense, there are visual associations that tease the imagination: a mantelpiece bears a superficial resemblance to a railway tunnel, while the chimney provides a practical outlet for the train's smoke.

Right: Magritte, The Red Model II, *1937. This arresting painting of a pair of boots mutating into bare feet is typical of Magritte's games with reality.*

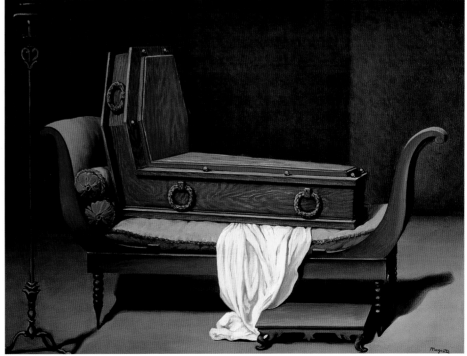

SALVADOR DALÍ
THE PERSISTENCE OF MEMORY
1931

alvador Dalí (1904–89) was both the most famous and the most ostentatious of the surrealists. This dreamlike picture, painted near the start of his career, features the soft watches, which, appropriately enough, have become one of his most timeless images. Dalí has left a detailed description of the genesis of *The Persistence of Memory*. He had been painting a landscape of the coastline in northern Spain, near the village of Port Lligat, "whose rocks were lit by a transparent and melancholy twilight." He knew that this scene was to be "the setting for some idea, for some surprising image," but his inspiration deserted him. Then one evening, he stayed home with a headache while his wife Gala went out with some friends. They had finished their meal with a ripe Camembert cheese, and while he was sitting alone, the solution suddenly came to him. By now, Dalí recalled, his migraine had become extremely painful, but even so, "I avidly prepared my palette and set to work. When Gala returned two hours later the picture was completed."

Before this painting, Dalí had already been absorbed with the problem of depicting what he termed "soft" and "supersoft" imagery. To some extent this preoccupation was a sexual one, which many critics have ascribed to a fear of impotence. The soft watch draped over the branch sticking out from the lifeless, phallic stump of an olive tree would appear to confirm such an interpretation. In addition, another watch is draped over a strange, mouthless head on the ground. This bizarre motif, which is partly a self-portrait and partly based on a local rock formation, had formed the centerpiece of Dalí's painting *The Great Masturbator* (1929). Dalí also related the notion of "softness" to his psychological state. Fearing for his own sanity, he regarded his inner, creative state as "supersoft," and was full of gratitude to Gala for helping him to build a protective shell as "hard as a hermit-crab's" around his public persona.

Dalí's original title for this painting was *Soft Watches*. It was exhibited under this name in his one-man show in the United States and was purchased by the American dealer Julien Levy. In the 1950s Dalí reinterpreted the picture, describing it as an image of the theory of relativity in which time was softened and compressed. This interpretation led him to produce a fragmented version of the painting, entitled *The Disintegration of the Persistence of Memory* (1952–54).

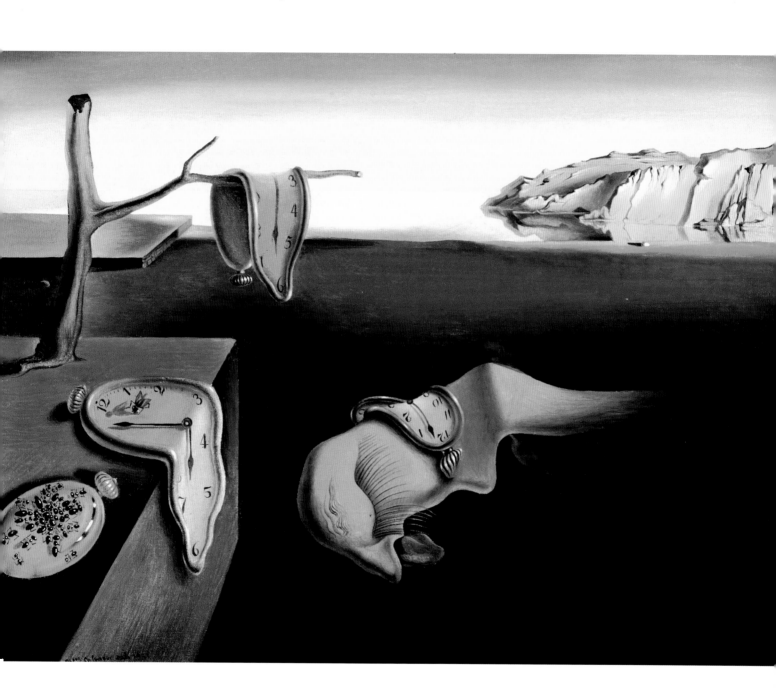

Salvador Dalí, *The Persistence of Memory*, 1931, oil on canvas (Museum of Modern Art, New York)

Style and technique

In common with René Magritte (see pages 226–29), Dalí used a strikingly realistic style to give his dreamlike images added conviction. He actually described these pictures as "handmade photographs." One of the key factors was the setting. In The Persistence of Memory, as in many of his other pictures, a series of fantastic objects are arranged across a deserted beach. The stretch of coastline in the background is painted with great clarity and accuracy, but it remains unnatural. There is no haziness or blurring at the horizon, and the bright lighting contrasts sharply with the shadowy foreground.

This part of the picture shows a stretch of coastline in northern Spain, near Port Lligat, a village where Dalí had a house. Dalí explained that The Persistence of Memory started out as a landscape painting.

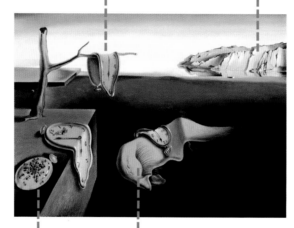

This lurid, facelike form with its strong sexual overtones is based on an earlier painting by Dalí entitled The Great Masturbator (1929), in which he expressed his sexual anxieties. The strange shape of the face is based on Dalí's self-portrait and the silhouette of a group of rocks, although here the form has become limply two-dimensional and is itself draped over stones.

This is the first painting in which Dalí's trademark soft watches were given a prominent role. However, he had already depicted a distorted clock in The Premature Ossification of a Station, produced in the previous year. Ultimately, the motif of the timepiece was probably inspired by the work of the metaphysical painter Giorgio de Chirico (1888–1978), who exerted a huge influence on the surrealists.

This watch is covered in ants. Dalí associated these insects with decay, stemming from a childhood memory he had of a swarm of ants consuming the decomposing body of a dead lizard.

Mind games

Along with other members of the surrealist movement, Dalí introduced an air of comic absurdity into the art scene, producing works in which reason is suspended.

Dalí was particularly fascinated by the illusionistic possibilities of the double image, pictures that could be interpreted in two different ways. In his *Phantom Wagon* (c.1933), for example, the forms enclosed by the canopy of the cart could be interpreted either as figures or as towers in the distant townscape. Dalí related this type of optical trickery to his "paranoiac-critical method," in which he attempted to conjure up self-induced hallucinations.

He was also a shameless attention-seeker, pulling endless publicity stunts and producing outlandish works of art that were designed to capture the headlines. In 1936, for instance, he gave a lecture at a surrealist exhibition in London while dressed in a diving suit, almost suffocating in the process. Similarly, his bizarre creations included a shocking-pink sofa (1936–37), based on the lips of the screen idol Mae West, and a telephone with a lobster in place of a handset (1936). Some of the other surrealists balked at Dalí's antics. André Breton, for example, argued that Dalí's paranoiac-critical methods had reduced him to "concocting entertainment on the level of crossword puzzles."

There were precedents for many of these playful features. The double image, for example, can be traced as far back as the sixteenth century to the Italian painter Giuseppe Arcimboldo (1527–93), whom the

Above: Dalí's Lobster Telephone *(1936), which—like many of his works—attracts attention through its bizarre and improbable juxtaposition of objects.*

surrealists acknowledged as an early influence. He painted allegorical heads of the seasons, which were composed entirely of fruit or flowers, while his portrait of a librarian consisted solely of books. Dalí mimicked this idea when, in collaboration with the photographer Phillippe Halsman, he designed *The Face of War* (1940), a human skull formed by a group of nude models.

Nor was there anything new about Dalí's publicity-seeking methods. The dadaists, for example, had already taken the business of self-promotion to extremes. In 1920 the German artist Max Ernst (1891–1976) had organized an exhibition at which visitors were given hatchets in order to attack the displays, while three years earlier the French artist Marcel Duchamp (1887–1968) had attempted to exhibit a urinal at the Society of Independent Artists in New York.

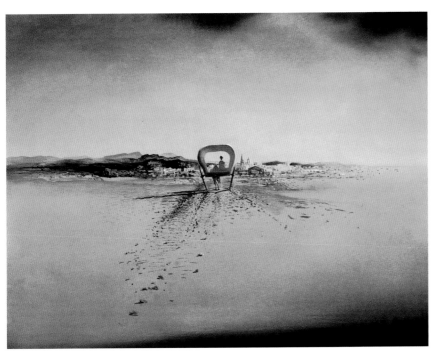

Left: Dalí's Phantom Wagon *(c.1933), an early painting in which he explored the possibilities of the double image.*

GEORGIA O'KEEFFE
RAM'S HEAD WITH HOLLYHOCK
1935

eorgia O'Keeffe was a leading exponent of modern figurative art in America. This picture is one of a series of mesmerizing "bonescapes" that she produced in the 1930s in celebration of the desert region of New Mexico. She was greatly attracted to this arid area and spent part of each year painting there, finally settling at Abiquiu in 1946. Throughout her career, O'Keeffe made a habit of collecting natural objects for use in her paintings, and in the parched wastelands of New Mexico, she focused her attention on the bleached bones of dead animals. She explained her fascination: "The bones are as beautiful as anything I know. To me they are strangely more living than the animals walking around ... The bones seem to cut sharply to the center of something that is keenly alive on the desert, even though it is vast and empty and untouchable—and knows no kindness with all its beauty."

O'Keeffe embarked on her series of bone paintings at the start of the 1930s. In essence, the early versions were still-life paintings although, as with her earlier flower pictures, the objects were viewed from so close up that they generated an overpowering presence. After a long break, due to ill health, she took up the theme again in the mid-1930s. This time, however, the pictures displayed a new hallucinatory quality. Instead of resting on solid supports, the skulls floated mysteriously in the sky, dwarfing the stylized landscapes beneath them. Sometimes, although not always, the bones were accompanied by oversized flowers. This practice had started by accident, when O'Keeffe placed an artificial rose in the eye socket of a horse's skull and was pleased with the effect. The combination was highly appropriate for paintings dealing with New Mexico, however, for there was a Hispanic custom of decorating graves with delicate fabric flowers.

Ram's Head with Hollyhock was one of a group of bone pictures exhibited at Alfred Stieglitz's gallery in 1936. Stieglitz, a photographer, editor, and art dealer, was a key figure in promoting modern European art in the United States and in encouraging contemporary American painters—including O'Keeffe, whom he married in 1924. The public reaction to the bone paintings was largely favorable, although many critics looked for hidden meanings. Some believed that the images were intended as a form of *vanitas* (see page 210), others that the artist was flirting with surrealism (see pages 226–33). However, O'Keeffe suggested that the pictures were simply meant as a homage to a region of America that she loved.

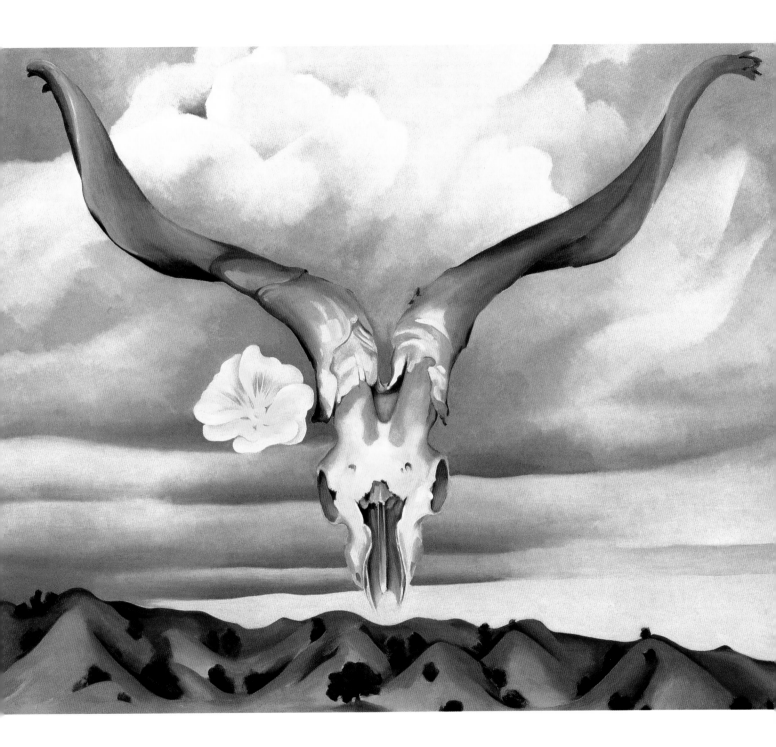

Georgia O'Keeffe, *Ram's Head with Hollyhock*, 1935, oil on canvas (Brooklyn Museum of Art, New York)

Style and technique
O'Keeffe painted in a style known as precisionism, which flourished in the United States in the 1920s and 1930s. This approach is characterized by a smooth, precise technique, with crisply delineated forms and unnaturally bright light. Human figures are generally absent from precisionist compositions. The painters working in this style did not operate as a formal group, although some of them occasionally exhibited together. Apart from O'Keeffe, the leading exponents of precisionism were Charles Demuth (1883–1935) and Charles Sheeler (1883–1965). At various times, they were also described as cubo-realists, immaculates, or sterilists.

O'Keeffe's depictions of nature are very stylish, but also highly stylized. This is a typical feature of precisionism, in which forms were sometimes rendered in a semiabstract manner.

In her earlier bone paintings, O'Keeffe depicted the supports upon which the objects were hanging. In later versions, as here, the skull floats mysteriously in the sky.

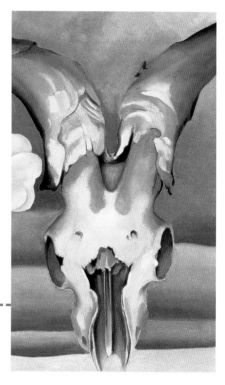

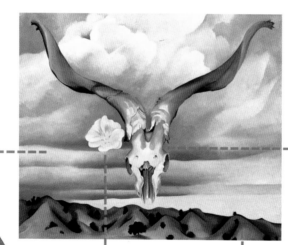

O'Keeffe's juxtaposition of conventional images of life and death caused critics to link her with the surrealists, although the artist herself denied this connection. Her highly polished technique also has superficial similarities to the slick finishes characteristic of artists such as René Magritte (see pages 226–29) and Salvador Dalí (see pages 230–33).

The painting is set amid the red hills of the Chama River Valley, close to the artist's New Mexico home. The dual perspective creates a disorienting effect. The skull is seen head on and close up, while the landscape is viewed from a distant, aerial perspective.

The regionalists

Although reticent about her work, O'Keeffe admitted that some of her bone pictures were intended as a riposte to the work of an influential group of artists known as the "regionalists."

The regionalists spearheaded the revival of traditional figurative painting that took place in 1930s America. In doing so, they were part of a broader trend, often termed "American scene painting," which included artists such as Edward Hopper (see pages 238–41). To some degree, the success of the regionalists can be linked to the nation's mood during the bleak years of the Great Depression. Amid all the misery, there was an air of staunch patriotism, as well as a longing for the return of comforting, old-fashioned artistic values. The regionalists responded to these needs by reacting against the avant-garde impulses of European art and by providing in its place a genuinely patriotic art, which focused on life in rural and small-town America. They were encouraged after 1935 by the Federal Art Project, which was set up as part of President Roosevelt's New Deal to provide artists with work and to decorate public buildings and spaces.

The regionalist circle was dominated by Thomas Hart Benton (1889–1975), John Steuart Curry (1897–1946), and Grant Wood (1892–1942). Benton, the spokesman of the group, produced a series of fine murals, notably those showing scenes of American life at the New School for Social Research in New York. Curry,

Above: American Gothic (1930), Grant Wood's sober image of rural America in which a father stands protectively in front of his daughter and their gothic-style home.

who believed that art should grow out of everyday experiences, specialized in scenes of his native Midwest, while Wood is best known for *American Gothic* (1930), one of the quintessential images of the movement.

O'Keeffe, who had traveled widely within the United States, was skeptical about some of the achievements of the lesser regionalists. Although she applauded their patriotic intent, she felt that much of their work was clichéd and presented a distinctly misleading image of the American provinces. Her skull paintings were partly intended as a satirical response to the more hackneyed output of the regionalists, but also as a demonstration that it was possible to glorify the American countryside in a fresh and exciting way.

Left: John Steuart Curry, Baptism in Kansas, 1928. Born on a farm in Kansas, Curry made the people and prairies of the Midwest the subject of his paintings.

EDWARD HOPPER

NIGHTHAWKS

1942

dward Hopper (1882–1967) was one of the greatest exponents of American scene painting, the name given to the trend for realistic depictions of American life that became increasingly widespread in the 1920s and 1930s. In his paintings, he documented the wealth and diversity of his native land, creating poetic insights into the most ordinary locations—drab offices, half-empty diners, cheerless motel rooms, and isolated gas stations. This picture is the artist's most striking image of urban solitude. In a quiet corner of New York, a group of night owls while away the hours of darkness. The emptiness of the streets suggests that it is very late, but no one seems in any hurry to move on. The main focus is on the man and woman on the far side of the counter. Their hands almost touch, suggesting that they are a couple, but their faces are expressionless and they make no attempt to communicate with each other. Like the man on the left, they are wrapped up in their own thoughts.

Hopper was notoriously reluctant to discuss his work, but in this case he did make a few comments. He stated that the picture was loosely based on a diner on Greenwich Avenue, adding that "*Nighthawks* seems to be the way I think of a night street. I didn't see it as particularly lonely. I simplified the scene a great deal and made the restaurant bigger. Unconsciously, probably, I was painting the loneliness of a large city."

Critics often dwelled on the air of loneliness in Hopper's pictures, much to the painter's annoyance. In many ways, though, this was an inevitable consequence of his artistic tastes. Hopper rarely depicted crowds, preferring to concentrate on one or two figures—*Nighthawks* is unusual in showing four. In compositional terms, he also liked to include large areas of empty space in his canvases. Few other artists tackling a theme of this kind would have dared to devote so much of their picture to the deserted street. In addition, Hopper's figures seldom make eye contact, either with each other or with the spectator. Instead, they are usually absorbed in their own affairs.

Often Hopper was less interested in the psychological undercurrents in his pictures than in the technical problems that they presented. In particular, he was fascinated by the depiction of dual light sources. Many of his daytime scenes show bright sunlight flooding into a darkened room. Here, the situation is reversed. The harsh lighting within the diner contrasts sharply with the subdued lighting outside, provided by an unseen streetlamp.

Edward Hopper, *Nighthawks*, 1942, oil on canvas (Art Institute of Chicago)

Style and technique

Early in his career Hopper worked very quickly, often producing a painting a week. A great deal more thought and preparation went into his later works, so that, by the 1940s, he completed only two or three major oils each year. For these pictures he made a series of preparatory drawings in which he experimented with the poses of the figures. In the main sketch for Nighthawks, for example, the man and woman in the couple are shown talking to each other. Hopper avoided making his drawings too precise, since he preferred to work out the fine details of the image on the canvas itself.

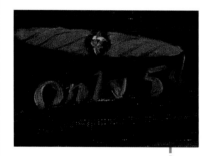

Even in the darkness, the sign advertising "only 5c" is sufficiently visible to underline the shabbiness of the surroundings.

Hopper makes the relationship between these two people rather ambiguous. Their hands are almost touching, suggesting a degree of intimacy, but otherwise there is no contact between them. The harsh lighting turns their faces into whitened masks, adding to the air of bleakness in the scene.

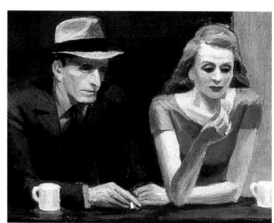

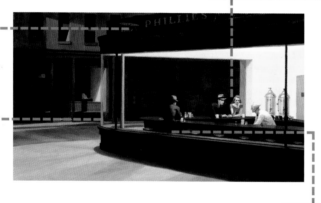

The anonymity of this figure, bathed in shadows and gripping his glass tightly, reinforces the sense of loneliness in the picture.

The left half of the painting contains no figures—which, in fact, occupy only a narrow strip of the bottom-right quarter of the composition. Most of the picture surface is taken up with the deserted street and the curving forms of the diner. Together with Hopper's discreet handling of paint and simplification of form, this adds to the sense of stillness and isolation exuded by the image.

Chronicles of urban life

Hopper owed much of his success to the sheer familiarity of his material.
In his paintings, he traveled down one of the most popular avenues of modern
art, charting the stresses and strains of city life.

The vogue for this type of subject matter had been created at the end of the nineteenth century by the impressionists. They abandoned the histories and mythologies that had traditionally offered the surest route to artistic success, preferring instead to highlight the lifestyles of their fellow Parisians (see page 181). Mostly they focused on the city's entertainments—the dance halls, bars, and boating on the Seine River—but they also painted its seamier aspects, such as brothels and absinthe drinkers, as well as newer developments like the railroads. The neo-impressionists—including Georges Seurat (see pages 182–85)—continued in this vein, although they often included less picturesque elements, such as factories and docks.

In England the subject of city life was taken up by the Camden Town group, who were active in London in the years leading up to World War I. Taking their lead from Walter Sickert (1860–1942), they chose to portray Camden, one of the dreariest and least fashionable districts of the city. They also depicted the living conditions of the poor, their shabby boardinghouses and cheap cafés, along with popular entertainments such as the music hall.

During the same period the ashcan school was exploring similar themes in the United States. Led by artists such as Robert Henri (1865–1929), John Sloan (1871–1951), and George Bellows (1882–1925), this influential

Above: George Bellows, Dempsey and Firpo, *1924. Boxing matches were a central theme in Bellows's paintings of city life.*

Below: Walter Sickert's Ambrosian Nights *(1906) focuses on the rowdy reactions of an audience at a London music hall.*

group produced a realistic impression of life in New York in the early 1900s. In common with their English counterparts, they concentrated on the less affluent elements of society, painting spirited pictures of boxing matches and overcrowding in the slums. Hopper was linked to this movement through his teacher, Henri, but his own images of New York were very different. In contrast to the bustling scenes of his predecessors, his deserted streets and bleak automats presented a more melancholy image of city life.

JACKSON POLLOCK
AUTUMN RHYTHM: NUMBER 30, 1950
1950

ackson Pollock (1912–56) was launched on the road to fame in the late 1940s with a series of stunning abstract paintings that captured the public imagination. With these large, vigorously executed canvases—known as "action paintings"—he was hailed as the leader of abstract expressionism (see page 245), and became the first real superstar of American art. *Autumn Rhythm* is the last of the paintings he made using his famous drip technique. This method entailed placing the unprimed canvas on the studio floor and then dripping, flicking, and splattering its surface with paint, which was then manipulated with an assortment of sticks, trowels, and knives to create a hypnotic web of color. In this instance, just four colors were used: white, black, light brown, and blue-gray. They produced the subdued, autumnal mood that gave the picture its name. Some critics have suggested that Pollock deliberately chose these tones to evoke the landscape around his studio on Long Island— the slate-gray sea, the biscuit-colored sand, and the occasional ice-floes and snow along the Hudson River—but the artist himself never confirmed this.

Pollock's working methods on *Autumn Rhythm* are particularly well documented, since he allowed the photographer Hans Namuth (1915–90) to film him while he painted. These sessions, which took place in late October 1950, show how the artist immersed himself totally in the act of creation. With earlier drip paintings propped against his studio wall, he stepped onto the empty canvas and began to work on it from within. As Namuth's camera recorded the fidgety, staccato choreography of Pollock's movements, one thing became clear: The act of painting was every bit as important as the finished work.

Pollock was at the peak of his career when he executed *Autumn Rhythm*. The monumental drip paintings that established his reputation were produced in a brief, four-year period between 1947 and 1951. When the first of these canvases were exhibited in 1948 at Betty Parsons' gallery in New York, they created a sensation. *Life* magazine ran an article entitled: "Jackson Pollock: Is he the Greatest Living Painter in the United States?" while more skeptical critics dubbed him "Jack the Dripper." One unexpected source of support came from the English photographer Cecil Beaton (1904–80), who found the vitality and energy of Pollock's work so impressive that he used *Autumn Rhythm* as a backdrop for one of his most lavish fashion shoots, for the March 1951 issue of *Vogue*.

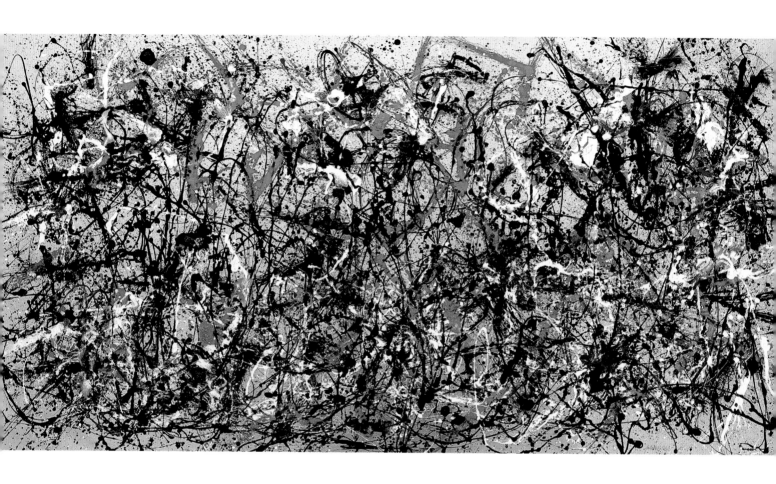

Jackson Pollock, *Autumn Rhythm, Number 30, 1950*, 1950, oil and enamel paint on canvas (Metropolitan Museum of Art, New York)

Style and technique
Namuth's film and photographs have left a fascinating record of Pollock's working methods. As the artist crouched, prowled, and stalked his way across the canvas, he seemed to be participating in some ancient ritualistic dance. Indeed, there may be a residual influence from Native American ceremonies that he had witnessed in Arizona in his youth, in which sand-paintings were created on the floor as part of a religious rite. In spite of the emphasis on speed and improvisation, however, Pollock fervently denied the charge that his pictures were random or chaotic. When this was suggested in an article in Time, he sent a telegram saying: "NO CHAOS DAMN IT."

Although the paint is most densely applied in the middle of the canvas, drips and splashes continue right up to the edges. Pollock cut and stretched his canvases after painting was complete to help achieve this "all over" effect, which—along with the large size of the work (207 in. x 105 in./ 526 cm x 267 cm)—is a common characteristic of all abstract expressionist works.

The buff color of the unprimed canvas is visible throughout the painting. Pollock used oil paint but also experimented with other materials. In Autumn Rhythm the black is enamel, a fluid paint suited to his working method.

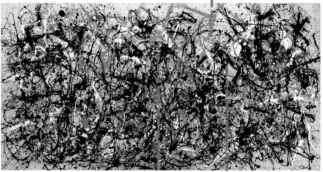

In places the paint is applied so thickly that it has formed pools, which, in drying, have formed an uneven surface. Sometimes Pollock also scooped off the skin that gathered on the surface of cans of oil paint to add texture to his paintings. Here, a lump of brown paint is surrounded by a thick pool of the same color that has wrinkled as it dried.

Namuth's photographs of the work in progress enable us know the sequence of painting. This upward-pointing inverted V, a powerful black arrowhead of paint, was one of the first marks to be made.

Abstract expressionism

Abstract expressionism burst upon the American scene in the late 1940s, swiftly becoming the dominant artistic movement of the period. Its most enduring achievement was to shift the focus of artistic attention from Paris to New York.

The term "abstract expressionist" was used as early as 1919 to describe the work of Wassily Kandinsky (1866–1944). Since he was both a leading member of the German expressionists (see page 201) and a pioneer of abstract art (see page 225), the description was perfectly logical. The label does not appear to have been applied to modern American art until 1945 when it was used to describe the work of a number of painters who created powerful abstract pictures on a grand scale. Their key influence came from the surrealists, some of whom had escaped to the United States during World War II (1939–45). They were particularly indebted to the surrealists' emphasis on the role of the subconscious in creativity. Pollock confirmed the importance of these ideas during a radio interview he gave in 1951. "The thing that interests me is that today painters do not have to go to a subject matter outside themselves. Modern painters work in a different way. They work from within." This approach also accords with the theory that Pollock drew some of his inspiration from the Jungian psychotherapy sessions that he attended in a bid to conquer his chronic alcoholism.

In geographical terms, the abstract expressionist movement was focused on New York, which rapidly replaced Paris as the main center for avant-garde art. Stylistically, it is far more difficult to define, since the term embraced a wide variety of approaches, ranging from those of Willem de Kooning, Pollock, and Franz Kline, whom one critic described as "the wild men from downtown," to the serene "color field" paintings of Mark Rothko and Barnett Newman.

Left: Franz Kline, Untitled, c.1952–56. Kline's vigorous, calligraphic style was inspired by enlarged details of his drawings.

ANDY WARHOL
TWO HUNDRED CAMPBELL'S SOUP CANS
1962

ndy Warhol (1928–87) once joked that he wanted to be remembered as a soup can, and, in a sense, his wish has been fulfilled. This type of image helped to establish his reputation and has since become one of the best known icons of pop art (see page 249). Initially, Warhol was employed as a commercial artist, and his first paintings drew heavily on this experience. In the early 1960s he depicted a range of everyday consumer items, including Coca-Cola bottles, Brillo soap pads, and Campbell's soup cans. The choice of product was determined partly by its popularity—Campbell's was the best-selling brand of canned soup in the United States—and partly by the artist's personal habits. Warhol's lunch normally consisted of soup and a soda, and the empty containers simply accumulated on his desk.

Once he had settled on this subject matter, Warhol treated it in many different ways. Usually, he portrayed a single can on a larger-than-life scale. The impact of these pictures stemmed from the contrast between traditional notions of artistic subject matter—as something that was important, permanent, or attractive—and an object that was both cheap and disposable. Alternatively, Warhol painted grids consisting of one hundred or two hundred soup cans. These bore a superficial resemblance to assembly lines in a factory or stacks of cans at a supermarket. As such, they epitomized the rise of mass production and the consumer society. Warhol also developed a third variant of the subject, which showed the can after use, either crushed or with its label torn off. These pictures often exude an air of violation, even though the object depicted is nothing more than a straightforward piece of garbage.

Warhol was not the first artist to tackle subjects of this kind. In 1960, for example, his fellow American Jasper Johns (1930–) had created a stir with *Painted Bronze*, a sculpture of two beer cans. It took Warhol time to find the most appropriate style. In his earliest paintings of soup cans, he often included the type of gestural mannerisms that were normally associated with abstract expressionism (see page 245). By 1962, however, he had removed these affectations in favor of an antiaesthetic approach, which he described as his "cold 'no comment' style." He applied this approach not only to inanimate objects but also to the stars of popular culture—most famously Marilyn Monroe and Elvis Presley—treating them too as if they were products of consumerism.

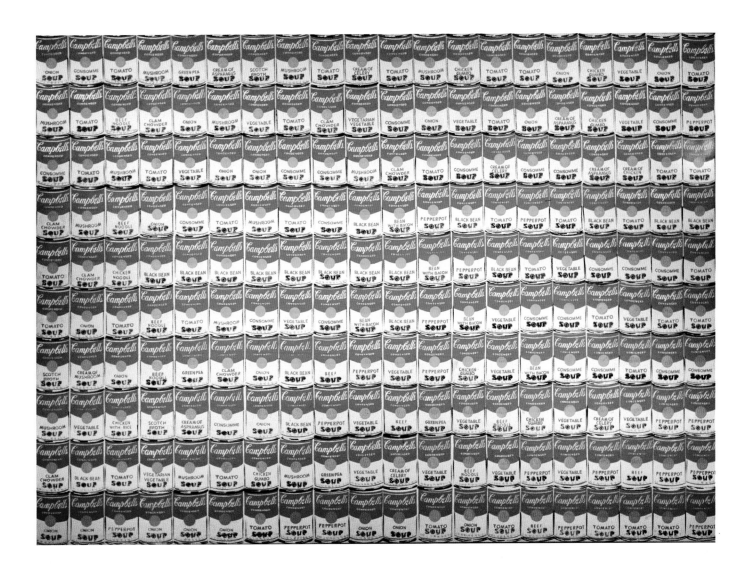

Andy Warhol, *Two Hundred Campbell's Soup Cans*, 1962, oil on canvas (Leo Castelli Gallery, New York)

Style and technique

Warhol's earliest multiple images such as Two Hundred Campbell's Soup Cans were often painted by hand, which proved a laborious process. He therefore experimented with a number of labor-saving techniques. In his grids, he made extensive use of hand-cut stencils, while some of his larger soup cans were traced directly onto the canvas by means of an overhead projector. Increasingly, though, he found that screen printing was the ideal medium for this type of image. He began by taking a photographic image—often from a newspaper—which he enlarged and transferred to a silk screen to create a stencil that could be used time and again. In this way his method reflected the infinite multiplication of the mass-produced objects that he showed.

Warhol produced many minor variations of the grid theme. In some cases, all the titles on the cans were the same, reinforcing the similarities with production lines or supermarket stacks. Here, however, he opted for a random pattern of different flavors.

Warhol wanted the sheer monotony of his multiple images to create a dulling, antiaesthetic effect. Accordingly, the labels of the cans are displayed in a uniform, frontal manner.

On some of his larger images of soup cans, Warhol retained the gold medallion that is normally found on Campbell's packaging. On the grids, however, he preferred to simplify the image as much as possible, replacing the medallion with a gold circle.

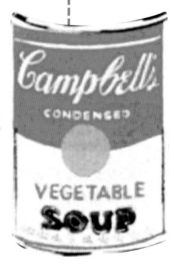

Pop art

With his chameleonlike personality and his talent for manipulating the media, Warhol rapidly became the most famous and controversial figure in American pop art.

Above: Claes Oldenburg, Floor Burger, *1962. Oldenburg's giant sculptures of fast food encapsulate pop art's concern with consumerism and mass production.*

The term "pop art" was coined in the mid-1950s by the critic Lawrence Alloway (1926–90). The movement itself emerged in America and Britain, largely as a reaction against the various abstract styles that had dominated art from the late 1940s. Determined to discard the more elitist implications of fine art, pop artists made a conscious attempt to focus on subjects that were accessible to all. As Warhol remarked, they "did images that anybody walking down Broadway could recognize in a split second—comics, celebrities, refrigerators, Coke bottles—all the great modern things that the abstract expressionists tried so hard not to notice at all."

There was a particular emphasis on mass-produced, disposable articles, such as food packaging, newspaper illustrations, or advertisements. Often, these were reproduced in a surprising medium or format. Roy Lichtenstein (1923–), for example, made his name with enlarged versions of comic strips, which were painted rather than printed. In a similar vein, Claes Oldenburg (1929–) produced soft sculptures, stuffed with kapok, based on fast-food items.

Pop art blurred the boundaries between commercial art and fine art. Many of the leading figures of modern art had started out as commercial

artists—Warhol, René Magritte (see pages 226–29), and Salvador Dalí (see pages 230–33), for example—but this field had always been regarded as the poor relation of fine art. Indeed, at the start of his career, Warhol used to hide his commercial designs whenever an art dealer visited his studio. However, such disparaging attitudes soon disappeared. Pop artists drew their inspiration from commonplace forms of advertising and packaging, they used synthetic paints and industrial

printing techniques, and they continued to accept commissions for commercial art. It is no accident that one of the most celebrated examples of pop art was neither a painting nor a sculpture, but an album cover—the Beatles' *Sergeant Pepper's Lonely Hearts Club Band* (1967) designed by Peter Blake (1932–).

Right: British pop artist Peter Blake's album cover for Sergeant Pepper's Lonely Hearts Club Band *(1967) by the Beatles.*

FURTHER READING

General

Gombrich, E.H. *The Story of Art.* Englewood Cliffs, NJ: Prentice Hall, 1995.

Hughes, Robert. *American Visions: The Epic History of Art in America.* New York: Alfred Knopf, 1999.

Januszczak, Waldemar. *Techniques of the World's Great Painters.* London: Phaidon, 1980.

Kemp, Martin (ed). *The Oxford History of Western Art.* New York: Oxford University Press, 2000.

Monographs on featured artists

Angelico, Fra
Lloyd, Christopher. *Fra Angelico.* New York: Dutton, 1979.

Bosch
Koldeweij, Jos. *Hieronymous Bosch: The Complete Paintings and Drawings.* New York: Harry N. Abrams, 2001.

Botticelli
Lightbrown, Ronald. *Botticelli: Life and Work.* New York: Abbeville Press, 1996.

Bruegel
Roberts, Keith. *Bruegel.* London: Phaidon Press, 1994.

Canaletto
Bomford, David, and Gabriele Finaldi. *Venice Through Canaletto's Eyes.* London: National Gallery Publications, 1998.

Caravaggio
Wilson-Smith, Timothy. *Caravaggio.* London: Phaidon Press, 1998.

Cézanne
Machotka, Pavel. *Cézanne: Landscape into Art.* New Haven, CT: Yale University Press, 1996.

Cole
Powell, Earl. *Thomas Cole.* New York: Harry N. Abrams, 1990.

Constable
Vaughan, William. *John Constable.* London: Tate Gallery Publishing, 2002.

Courbet
Rubin, James. *Courbet.* London: Phaidon Press, 1997.

Dalí
Ades, Dawn. *Dalí.* New York: Thames and Hudson, 1995.

David
Vaughn, Will, and Helen Weston (eds.). *Jacques-Louis David's "Marat."* New York: Cambridge University Press, 1999.

Degas
Roberts, Keith. *Degas.* London: Phaidon Press, 1992.

Delacroix
Jobert, Barthelemy. *Delacroix.* Princeton, NJ: Princeton University Press, 1998.

Dürer
Bailey, Martin. *Dürer.* London: Phaidon Press, 1995.

Eakins
Innes-Homer, William. *Thomas Eakins: His Life and Work.* New York: Abbeville Press, 1992.

El Greco
Serraller, Francisco Calvo. *El Greco: The Burial of Count Orgaz.* London: Thames and Hudson, 1995.

Fragonard
Massengale, Jean Montague. *Fragonard.* New York: Harry N. Abrams, 1993.

Friedrich
Hofmann, Werner. *Caspar David Friedrich.* New York: Thames and Hudson, 2000.

Gainsborough
Rosenthal, Michael, and Martin Myrone (eds). *Thomas Gainsborough.* London: Tate Gallery Publishing, 2002.

Gauguin
Bowness, Alan. *Gauguin.* London: Phaidon Press, 1994.

Gericault
Eitner, Lorenz. *Gericault's "Raft of the Medusa."* London: Phaidon Press, 1972.

Giotto
Cole, Bruce. *Giotto: The Scrovegni Chapel, Padua.* New York: George Braziller, 1993.

Goya
Tomlinson, Janis. *Goya.* London: Phaidon Press, 1999.

Hals
Baard, H.P. *Frans Hals.* New York: Harry N. Abrams, 1981.

Hogarth
Hallett, Mark. *Hogarth.* London: Phaidon Press, 2001.

Holbein
North, John. *The Ambassador's Secret: Holbein and the World of the Renaissance.* New York: Hambledon and London, 2002.

Hopper
Goodrich, Lloyd. *Edward Hopper.* New York: Harry N. Abrams, 1993.

Ingres
Rosenblum, Robert. *Ingres.* New York: Harry N. Abrams, 1990.

Klimt
Frodl, Gerbert, and Tobias Natter (eds). *Klimt's Women.* New Haven, CT: Yale University Press, 2000.

Leonardo
Kemp, Martin. *Leonardo da Vinci: The Marvellous Works of Nature and Man.* Cambridge, Mass.: Harvard University Press, 1981.

Magritte
Gablik, Suzi. *Magritte.* New York: Thames and Hudson, 1985.

Manet
Tucker, Paul Hayes (ed.). *Manet's "Le Dejeuner sur l'herbe."* New York: Cambridge University Press, 1998.

Matisse
Watkins, Nicholas. *Matisse.* London: Phaidon Press, 1993.

Michelangelo
Hall, Marcia and Takashi Okamura (photo.). *Michelangelo: The Sistine Chapel Frescoes.* New York: Harry N. Abrams, 2002.

Millet
Murphy, Alexandra. *Jean-François Millet: Drawn into the Light.* New Haven, CT: Yale University Press, 1999.

Mondrian
Milner, John. *Mondrian.* London: Phaidon Press, 1995.

Monet
Tucker, Paul Hayes. *Claude Monet: Life and Art.* New Haven, CT: Yale University Press, 1995.

Munch
Wood, Mara-Helen (ed.). *Edvard Munch: The Frieze of Life*. New Haven, CT: Yale University Press, 1992.

O'Keeffe
Georgia O'Keeffe. London: Phaidon Press, 1997.

Picasso
Hilton, Timothy. *Picasso*. London: Thames and Hudson, 1994.

Pollock
Varnedoe, Kirk. *Jackson Pollock*. New York: Museum of Modern Art, 2002.

Poussin
Blunt, Anthony. *Nicolas Poussin*. London: Pallas Athene, 1995.

Raphael
Oberhuber, Konrad. *Raphael: The Paintings*. New York: Prestel Publishing, 1999.

Rembrandt
White, Christopher. *Rembrandt*. New York: Thames and Hudson, 1984.

Renoir
Adraini, Gotz. *Renoir: Oil Paintings, 1860–1917*. New Haven, CT: Yale University Press, 1999.

Rossetti
Rodgers, David. *Rossetti*. London: Phaidon, 1996.

Rubens
Belkin, Kristin Lohse. *Rubens*. London: Phaidon Press, 1998.

Sargent
Kilmurray, Elaine, and Richard Ormond. *John Singer Sargent*. Princeton, NJ: Princeton University Press, 1998.

Seurat
Herbert, Robert. *Seurat: Drawings and Paintings*. New Haven, CT: Yale University Press, 2001.

Titian
Pedrocco, Filippo. *Titian: The Complete Paintings*. New York: Rizzoli International Publications, 2001.

Turner
Brown, David Blayney. *Turner in the Tate Collection*. New York: Harry N. Abrams, 2002.

Van Dyck
Brown, Christopher. *Van Dyck*. New York: Rizzoli, 1999.

Van Eyck
Harbinson, Craig. *Jan van Eyck: The Play of Realism*. London: Reaktion Books, 1995.

Van Gogh
Uhde, Wilhelm. *Van Gogh*. London: Phaidon Press, 1994.

Velázquez
Brown, Jonathan. *Velázquez: Painter and Courtier*. New Haven, CT: Yale University Press, 1986.

Vermeer
Bailey, Martin. *Vermeer*. London: Phaidon Press, 1995.

Warhol
Bastian, Heiner (ed.). *Andy Warhol: A Retrospective*. London: Tate Gallery Publishing, 2002.

West
Von Erffa, Helmut. *The Paintings of Benjamin West*. Newhaven, CT: Yale University Press, 1986.

Whistler
Dorment, Richard, and Margaret MacDonald. *Whistler*. New York: Harry N. Abrams, 1995.

Websites

General
Art archive site with entries on artists, movements, and terms, providing biographies, extracts from published books, and images: http://artchive.com/ftp_site.htm

Artcyclopedia search engine for art subjects: http://www.artcyclopedia.com/

Olga's Gallery entries on artists including biographies, picture information, and images: http://www.abcgallery.com/

Web Gallery of Art virtual museum and searchable database of European painting and sculpture from 1150 to 1800: http://gallery.euroweb.hu/

Museums and galleries
The Art Institute of Chicago http://www.artic.edu/aic/

Brooklyn Museum of Art http://www.brooklynart.org/

The Burrell Collection, Glasgow http://www.clyde-valley.com/glasgow/burrell.htm

The Courtauld Institute of Art, London http://www.somerset-house.org.uk/attractions/courtauld/

The Detroit Institute of Art http://www.dia.org/

Hermitage, Saint Petersburg http://www.hermitagemuseum.org/html_En/index.html

Kunsthalle, Hamburg http://www.hamburger-kunsthalle.de/start/en_start.html

Kunsthistorisches Museum, Vienna http://www.khm.at/homeE/homeE.html

Los Angeles County Museum of Art http://www.lacma.org/

Louvre, Paris http://www.louvre.fr/louvrea.htm

Metropolitan Museum of Art, New York http://www.metmuseum.org/

Musée d'Orsay, Paris http://www.musee-orsay.fr:8081/ORSAY/orsaygb/HTML.NSF/By+Filename/mosimple+index?OpenDocument

Musées Royaux, Brussels http://www.fine-arts-museum.be/

Museo Thyssen-Bornemisza, Madrid http://www.museothyssen.org/Ingles/sinflash1.asp?enlace=undefined

Museum of Fine Arts, Boston http://www.mfa.org/home.htm

National Gallery, London http://www.nationalgallery.org.uk/

National Gallery of Canada, Ottawa http://national.gallery.ca/index_e.html

National Gallery, Oslo http://www.museumsnett.no/nasjonalgalleriet/flash_versjon_engelsk/index.htm

Museum of Modern Art, New York http://www.moma.org/

Österreichische Galerie Belvedere, Vienna http://www.belvedere.at/english/dmain/main.html

Prado, Madrid http://museoprado.mcu.es/prado/html/ihome.html

Rijksmuseum, Amsterdam http://www.rijksmuseum.nl/asp/start.asp?language=uk

Sistine Chapel, The Vatican, Rome http://www.christusrex.org/www1/sistine/0-Tour.html

Stanze della Segnatura, The Vatican, Rome http://www.christusrex.org/www1/stanzas/0-Raphael.html

Stedelijk Museum, Amsterdam http://www.stedelijk.nl/eng/index.html

Tate Britain, London http://www.tate.org.uk/britain/default.htm

Uffizi, Florence http://www.uffizi.firenze.it/welcomeE.html

The Wallace Collection, London http://www.the-wallace-collection.org.uk/

INDEX

Page numbers in *italics* refer
to illustrations.

A

Absinthe Drinker, The (Degas) *181*
abstract expressionism 242, 245
abstraction 225
 Composition in Red, Yellow, and Blue
 (Mondrian) *222–4*
action paintings 242
African art, influence of *205*, 210
Agnew Clinic, The (Eakins) 169
Allston, Washington, *The Moonlit*
 Landscape 129
Ambassadors, The (Holbein) *50–2*
Ambrosian Nights (Sickert) 241
American art
 Ashcan school 241
 Hudson River school *145*
 regionalists, the 237
 see also Eakins; Hopper; Pollock; Sargent;
 Warhol; West
American Gothic (Wood) 237
Angelico, Fra 14
 The Annunciation 14–16
Animal Locomotion (Muybridge) *173*
Annunciation, the 17, 93
 by Fra Angelico *14–16*
 by Leonardo da Vinci *17*
Antonello da Messina, portrait by *21*
Aphrodite Anadyomene (Titian) 49
Apparition, The (Moreau) 221
Arcimboldo, Giuseppe 233
Arctic Shipwreck (Friedrich) *133*
"Armada Portrait" *53*
Arnolfini Wedding, The (van Eyck) *18–20*
Arrangement in Gray and Black: Portrait of
 the Artist's Mother (Whistler) *177*
"art for art's sake" 177
Ashbee, Charles 217
Ashcan school 241
Autumn Rhythm: Number 30, 1950
 (Pollock) *242–4*

B

Bacchus and Ariadne (Titian) *46–8*, 49
Banquet of the Officers of the Saint George
 Militia Company, The (Hals) *85*
Baptism in Kansas (Curry) 237
baroque style 69
Barque of Dante, The (Delacroix) *133*
Bathers, The (Courbet) *150–2*
Battle of the Nile (de Loutherbourg) *133*
Battle of San Romano (Uccello) *125*
Beata Beatrix (Rossetti) *162–4*

Beckmann, Max 201
Beethoven Frieze (Klimt) 214, *217*
Bellows, George 241
 A Stag at Starkeys 241
Benton, Thomas Hart 237
Berlin Street Scene (Kirchner) *201*
Bernini, Gian Lorenzo, *Ecstasy of Saint*
 Theresa 61
Beware of Luxury (Steen) *93*
Birth of Venus, The (Botticelli) *8*, *22–4*
Blake, Peter *249*
 Sergeant Pepper's Lonely Hearts Club
 Band (album cover for) 249
Blaue Reiter, Der (The Blue Rider) 201
Boat-Building near Flatford Mill
 (Constable) *137*
bone paintings, by O'Keeffe *234–6*
Books of Hours 57
Bosch, Hieronymus 26–8
 Hell 26–8
 The Ship of Fools 101
Botticelli, Sandro 22–5
 The Birth of Venus 8, 22–4
 Primavera 49, 221
Boucher, François 106
 Reclining Girl 109
Braque, Georges 213
 The Portuguese 213, 226
Brouwer, Adriaen, *A Peasant Meal 157*
Brücke, Die (The Bridge) 201
Bruegel, Pieter 54–6, 221
 Hunters in the Snow 54–6
 The Peasant Dance 93
Brutus Receiving the Bodies of His Sons
 (David) 117
Bunce, Kate 165
Burial at Ornans, The (Courbet) *153*
Burial of Count Orgaz, The (El Greco) *58–60*
Byzantine art *13*

C

Caillebotte, Gustave 178
Camden Town group 241
camera obscura *92*
Cameron, Julia Margaret 165
Canaletto 94–7
 A Regatta on the Grand Canal
 94–6
Capitoline Venus, The (sculpture) *25*
Caravaggio 62–5, 69
 The Conversion of Saint Paul 62, 65
 The Crucifixion of Saint Peter 62–4
Carnation, Lily, Lily, Rose (Sargent) *186–8*
Carracci, Annibale 62
Carus, Carl Gustav 129
Cassatt, Mary 181, 189

Catholic church, and the Counter-
 Reformation 61
Cézanne, Paul 190–2, 213
 Mont Sainte-Victoire 190–2
Chancellor Rolin's Madonna (van Eyck) *21*
Charles I, King 74, 77
Charles V, Holy Roman emperor 46
 Charles V After the Battle of Mühlberg
 (Titian) *77*
chiaroscuro 64
Christ Among the Doctors (Dürer) *34–6*
Cimabue 10
classical legends 49
 Bacchus and Ariadne 46–8, 49
 see also Venus, in art
classicism, French *81*
 Et in Arcadia Ego 78–80
Claude, *Seaport with the Embarkation of the*
 Queen of Sheba 81
Clerk Saunders (Siddal) *165*
Cloud Study (Constable) *137*
Cole, Thomas 142–5
 The Oxbow 142–4
Composition 4 (Kandinsky) *225*
Composition in Red, Yellow, and Blue
 (Mondrian) *222–4*
Concert Champêtre, Le 158, *161*
Constable, John 134–7
 Boat-Building near Flatford Mill 137
 Cloud Study 137
 The Hay Wain 134–6
constructivism 225
conversation pieces 105
 George Rogers with His Wife Margaret and
 His Sister Margaret Rogers (Hayman) *105*
 Mr. and Mrs. Andrews (Gainsborough)
 102–4, 105
Conversion of Saint Paul, The (Caravaggio)
 62, *65*
Copley, John Singleton, *The Death of Major*
 Peirson 113
Cornfield with Cypresses (van Gogh) *193*
Counter-Reformation, art and the 61, 69
Courbet, Gustave 150–3, 157, 181
 The Bathers 150–2
 The Burial at Ornans 153
Couture, Thomas, *The Romans of the*
 Decadence 153
Creation of Adam, The (Michelangelo) *42–4*
Crucifixion of Saint Peter, The
 (Caravaggio) *62–4*
cubism 213, *222*
 Les Demoiselles d'Avignon (Picasso) *210–13*
 The Portuguese (Braque) *213*, 226
Curry, John Steuart 237
 Baptism in Kansas 237

D

dadaists 233
Dadd, Richard 197
Dalí, Salvador 197, 230-3
 The Face of War 233
 The Great Masturbator 230, *232*
 Lobster Telephone 233
 The Persistence of Memory 230-2
 The Phantom Wagon 233
dance, images of *221*
 Dance (Matisse) *218-20*, 221
 Dance at the Moulin de la Galette (Renoir)
 178-80
 Dance to the Music of Time (Poussin) *221*
 Primavera (Botticelli) *49*, 221
 The Rehearsal (Degas) *170-2*
David (Michelangelo) *45*
David, Jacques-Louis 114-17
 Brutus Receiving the Bodies of His
 Sons 117
 The Death of Marat 114-16
 The Oath of the Horatii 117
Death of Major Peirson, The (Copley) *113*
Death of Marat, The (David) *114-16*
Death of Wolfe, The (West) 110-12, 113
Degas, Edgar 170, 173, 181
 The Absinthe Drinker 181
 Jockeys 173
 The Rehearsal 170-2
Déjeuner sur l'herbe, Le (Luncheon on the
 Grass; Manet) 158-60, 161
de Kooning, Willem 245
Delacroix, Eugène 121, 138-41, 150, 181
 The Barque of Dante 133
 Greece Expiring on the Ruins of
 Missolonghi 141
 Liberty Leading the People 138-40
 The Massacre of Chios 134, *141*
 Women of Algiers 121
Delaunay, Robert 185
Demoiselles d'Avignon, Les (Picasso) *210-12*
de Morgan, Evelyn 165
Derain, André 205, 213
Descent from the Cross, The (Rubens) 66-8
Disasters of War, The (Goya) *125*
Disputà (Raphael) 38, *41*
Dix, Otto 201
Duchamp, Marcel 233
Durand, Asher B., *Kindred Spirits* *145*
Dürer, Albrecht 34-7
 Christ Among the Doctors 34-6
 Knight, Death, and the Devil 37
 A Young Hare 37
Dutch art
 group portraits *82-5*
 symbols in *93*
dwarfs, portraits of *89*

E

Eakins, Thomas 166-9, 173
 The Agnew Clinic 169
 The Gross Clinic 169
 Max Schmitt in a Single Scull 166-8
Ecstasy of Saint Theresa (Bernini) 61
Elizabeth I, Queen, portrait *53*

equestrian portraits *74-7*
Ernst, Max 233
Et in Arcadia Ego (Poussin) *78-80*
expressionism 197, *201*

F

Face of War, The (Dali) 233
fauves, the 205, 213
fête galante 109
Floor Burger (Oldenburg) *249*
Fragonard, Jean-Honoré 106-9
 The Progress of Love 109
 The Swing 106-8, 109
French classicism *see* classicism, French
French neoclassicism 117, 118
French Revolution (1789) *117*, 157
 The Death of Marat (David) *114-16*
frescoes, technique of 12
Friedrich, Caspar David 133
 Arctic Shipwreck *133*
 The Wanderer Above a Sea of Mist *126-8*

G

Gainsborough, Thomas, *Mr. and Mrs.*
 Andrews *102-4*, 105
Garden of Earthly Delights, The (Bosch) 26
Garden at Giverny (Monet) *209*
Gare Saint-Lazaar, The (Monet) *181*
Gauguin, Paul 193, 201, 202-5
 Where Do We Come From? Who Are We?
 Where Are We Going? 202-4
George Rogers with His Wife Margaret and
 His Sister Margaret Rogers (Hayman) *105*
Géricault, Théodore 130-3, 181
 The Raft of the Medusa 130-2, *133*
Giotto di Bondone 10-13
 The Lamentation *10-12*
Gleaners, The (Millet) *154-6*
Gower, George *53*
Goya, Francisco de 122-5
 The Disasters of War *125*
 The Second of May *125*
 The Third of May, 1808 122-4, *125*
Great Day of his Wrath, The (Martin) *149*
Great Masturbator, The (Dali) 230, *232*
Greco, El 58-61, 201
 The Burial of Count Orgaz 58-60
Greece Expiring on the Ruins of Missolonghi
 (Delacroix) *141*
Gross Clinic, The (Eakins) *169*
Grosz, George 201
 Pillars of Society *201*
Grünewald, Matthias 201

H

Hals, Frans 70-3, 85
 The Banquet of the Officers of the Saint
 George Militia Company 85
 The Laughing Cavalier 70-2, *73*
 The Married Couple 73
Harlot's Progress, A (Hogarth) 98, *101*
Hayman, Francis 105
 George Rogers with His Wife Margaret and
 His Sister Margaret Rogers 105
Hay Wain, The (Constable) 134-6

Head of a Woman (Modigliani) 205
Hebron, Jerusalem (Roberts) 97
hell, images of 29
 Hell (Bosch) 26-8
Henri, Robert 241
Henry VIII, King, portrait *53*
history painting *113*
 Brutus Receiving the Bodies of His
 Sons (David) 17
 The Death of Marat (David) *114-16*
 The Death of Wolfe (West) *110-12*, 113
 The Oath of the Horatii (David) *117*
Hogarth, William 98-101
 A Harlot's Progress 98, *101*
 The Marriage Contract 98-100
Holbein, Hans 50-3
 The Ambassadors 50-2
 Portrait of Henry VIII 53
Hopper, Edward 238-41
 Nighthawks 238-40
Hudson River school 145
Hunters in the Snow (Bruegel) 54-6

I

icons, Byzantine *13*
impressionism 170, 181, 206
 see also Degas; Monet; neo-impressionism;
 postimpressionism; Renoir; Sargeant
Inferno (Dante), illustration for 29
Ingres, Jean-Auguste-Dominique 117, 118-21
 The Small Bather 118
 The Turkish Bath 121
 The Valpinçon Bather 118-20
insanity, and creativity 197

J

Jesuits 61
Jockeys (Degas) *173*
Judgment of Paris, The (Raimondi) *161*
July Revolution 138

K

Kandinsky, Wassily 201, 225, 245
 Composition 4 225
Kindred Spirits (Durand) *145*
Kirchner, Ernst 201
 Berlin Street Scene 201
Kiss, The (Klimt) 9, *214-16*
Klimt, Gustav 214-17
 Beethoven Frieze 214, *217*
 The Kiss 9, *214-16*
 Stoclet Frieze 214, 217
Kline, Franz 245
 Untitled 245
Knight, Death, and the Devil (Dürer) 37

L

Lady Standing at the Virginals
 (Vermeer) *93*
Lamentation, The (Giotto) *10-12*
landscapes, American 145
 Kindred Spirits (Durand) *145*
 Ram's Head with Hollyhock
 (O'Keefe) *234-6*
 The Moonlit Landscape (Allston) *129*

landscapes, American
 The Oxbow (Cole) 142–4
landscapes, English *137*
 Mr. and Mrs. Andrews
 (Gainsborough) 102–4
 Snowstorm (Turner) *149*
 The Great Day of His Wrath (Martin) *149*
 The Hay Wain (Constable) 134–6
landscapes, postimpressionist *193*
 Cornfield with Cypresses (Van Gogh) *193*
 Mont Sainte-Victoire (Cézanne) *190–2*
 Portrieux, Brittany (Signac) *185*
 The Shore at Bas-Butin, Honfleur
 (Seurat) *193*
landscapes and romanticism *129, 145*
 The Wanderer Above a Sea of Mist
 (Friedrich) *126–8*
Laocoön 48, 49, 68
Laughing Cavalier, The (Hals) *70–2, 73*
Leighton, Frederic 121
Leonardo da Vinci 8–9, 30–3
 The Annunciation 17
 Mona Lisa 30–3
Liberty Leading the People (Delacroix) *138–40*
Lichtenstein, Roy 249
Limbourg brothers, *Très Riches Heures 57*
Lobster Telephone (Dali) *233*
Luncheon on the Grass (*Le Déjeuner sur*
 l'herbe; Manet) *158–60*, 161

M

Mackintosh, Charles Rennie 217
Magritte, René 226
 Perspective: Madame Récamier by
 David 229
 The Red Model II 229
 Time Transfixed 229
 The Treachery of Images 226–8
Maid Pouring Milk (Vermeer) *90–2*, 93
Maids of Honor, The (Las Meninas,
 Velázquez) *86–8*
Manet, Edouard *158–61*, 181
 Luncheon on the Grass 158–60
 Olympia 161
Marcus Aurelius, statue of *77*
Marie de' Médici Arriving at Marseilles
 (Rubens) 69
marine disasters *133*
 The Raft of the Medusa (Géricault)
 130–2, 133
Marriage Contract, The (Hogarth) *98–100*
Married Couple, The (Hals) *73*
Martin, John 149
 The Great Day of His Wrath 149
Massacre of Chios, The (Delacroix) 134, *141*
Matisse, Henri 185, 205, 213
 Dance 218–20, 221
Max Schmitt in a Single Scull (Eakins) *166–8*
medicine, art and *169*
memento mori 210
Meninas, Las see *Maids of Honor*
mental instability, and art 197, 198
Michelangelo 42–5
 The Creation of Adam 42–4
 David 45

Miereveld, Michiel van, *Portrait of Hugo*
 Grotius 73
Millet, Jean-François *154–7*, 181
 The Gleaners 154–6
Modigliani, Amedeo 205
 Head of a Woman 205
Mona Lisa (Leonardo) *30–3*
Mona Lisa (Warhol) *33*
Mondrian, Piet 222–5
 Composition in Red, Yellow, and
 Blue 222–4
Monet, Claude 206–9
 garden at Giverny 206, 209
 Gare Saint-Lazaar 181
 Water Lilies 209
 The Water Lily Pond 206–8
Mont Sainte-Victoire (Cézanne) *190–2*
Moonlit Landscape, The (Allston) *129*
moralizing art 98, *101*, 157
Moreau, Gustave, *The Apparition 221*
Moreelse, Paul 73
Mr. and Mrs. Andrews (Gainsborough)
 102–4, 105
Munch, Edvard 197, 201, 214
 Dance of Life 221
 The Scream 198–200
 Spring Evening on Karl Johan Street 197
Muybridge, Eadweard 173
 Animal Locomotion 173

N

neoclassicism, French 117, 118
neo-impressionism 182, 185, 193, 241
Nighthawks (Hopper) *238–40*
Night Watch, The (Rembrandt) *82–4*, 85
Nocturne: Blue and Gold–Old Battersea Bridge
 (Whistler) *177*
Nocturne in Black and Gold: The Falling
 Rocket (Whistler) *174–6*, 177
Nude with Draperies (Picasso) *205*

O

Oath of the Horatii, The (David) *117*
oil painting, development of *21*
O'Keeffe, Georgia 234–6, 237
 Ram's Head with Hollyhock 234–6
Olbrich, Joseph 217
Oldenburg, Claes 249
 Floor Burger 249
Olympia (Manet) *161*
orientalism *120*, 121
orphism 225
Oxbow, The (Cole) *142–4*

P

Padua, Arena Chapel frescoes *10–13*
Palmer, Samuel 129
patronage 7–8
Peasant Dance, The (Bruegel) *93*
peasant life *157*
 The Gleaners (Millet) *154–6*
Peasant Meal, A (Brouwer) *157*
Persistence of Memory, The (Dali) *230–2*
Perspective: Madame Récamier by David
 (Magritte) *229*

Phantom Wagon, The (Dali) *233*
photography *173*
Picasso, Pablo 213
 Les Demoiselles d'Avignon 210–12, 213
 Nude with Draperies 205
Piranesi 149
 Roman Forum 97
pointillism 182, 185, 193
Pollock, Jackson 242–4, 245
 Autumn Rhythm: Number 30, 1950 242–4
pop art 249
 Two Hundred Campbell's Soup Cans 246–8
Portrait of Henry VIII (Holbein) *53*
Portrait of Hugo Grotius (van Miereveld) *73*
Portrait of Isabella Stuart Gardner
 (Sargent) *189*
portraits 53
 by Hals *70–2*, 73
 by Holbein *50–3*
 by Rubens 69
 by Sargent *189*
 by van Dyck *74–6*
 Dutch group portraits *82–5*
 equestrian *74–7*
Portrieux, Brittany (Signac) *185*
Portuguese, The (Braque) 213, *226*
postimpressionism 193
 landscapes *190–2, 193*
 see also Cézanne; Gauguin; van Gogh;
 Seurat
Poussin, Nicolas 78–81
 Dance to the Music of Time 221
 Et in Arcadia Ego 78–80
precisionism 236
Pre-Raphaelite sisterhood 165
Primavera (Botticelli) *49*, 221
primitivism *205*
Primo, El (Velázquez) *89*
Progress of Love, The (Fragonard) *109*

R

Raft of the Medusa, The (Géricault)
 130–2, 133
Raimondi, Marcantonio, *The Judgment of*
 Paris 161
Ram's Head with Hollyhock (O'Keeffe) *234–6*
Raphael *40*, 41
 Disputà 38, *41*
 The School of Athens 38–40
Reclining Girl (Boucher) *109*
Red Model II, The (Magritte) *229*
Reformation 61
Regatta on the Grand Canal, A
 (Canaletto) *94–6*
regionalists 237
Rehearsal, The (Degas) *170–2*
Rembrandt 82–5
 The Night Watch 82–4, 85
Renaissance 7–9, 25, 37, 38
Renoir, Pierre-Auguste 178–81, 221
 Dance at the Moulin de la Galette 178–80
Reynolds, Joshua 113
Roberts, David 97
 Hebron, Jerusalem 97
rococo style 106–9